The Voices of Women Artists

Wendy Slatkin
University of Redlands
Redlands, California

Prentice Hall
Englewood Cliffs, New Jersey 07632

Library of Congress Cataloging-in-Publication Data

Slatkin, Wendy.
The voices of women artists / Wendy Slatkin.
p. cm.
Includes bibliographical references and index.
ISBN 0-13-951427-9
1. Women artists--Biography. 2. Arts. I. Title.
NX164.W65S5 1993
700'.82--dc20
92-19849
CIP

Editorial/production supervision and interior design: **Jordan Ochs**
Acquisitions editor: **Bud Therien**
Copyeditor: **Mark Stevens**
Prepress buyer: **Herb Klein**
Manufacturing buyer: **Patrice Fraccio**
Cover design: **Anne Ricigliano**

To Fred, with all my love and appreciation, for everything

© 1993 by Prentice-Hall, Inc.
A Simon & Schuster Company
Englewood Cliffs, New Jersey 07632

Printed in the United States of America
10 9 8 7 6 5 4 3 2

ISBN 0-13-951427-9

Prentice-Hall International (UK) Limited, *London*
Prentice-Hall of Australia Pty. Limited, *Sydney*
Prentice-Hall Canada Inc., *Toronto*
Prentice-Hall Hispanoamericana, S.A., *Mexico*
Prentice-Hall of India Private Limited, *New Delhi*
Prentice-Hall of Japan, Inc., *Tokyo*
Simon & Schuster Asia Pte. Ltd., *Singapore*
Editora Prentice-Hall do Brasil, Ltda., *Rio de Janeiro*

Contents

Part IV: The United States: 1945–1970

237

Part V: Contemporary Trends: 1970–1985

277

Acknowledgements

This book existed for more then four years in the proposal phase before it even began to take form on paper. During that early period, a number of key persons helped keep this concept alive before it was anywhere close to becoming a book. The first person whose contribution must be acknowledged is John Giannotti, my friend, former colleague, and chair of the Art Department at Rutgers University, Camden College of Arts and Sciences. He telephoned me with the original idea of putting together a book with the writings of women artists, comparable to Chipp's *Theories of Modern Art* or Goldwater's *Artists on Art*. To my best recollection, this occurred in the spring of 1987. Then, on a leave from the University of Redlands, I revised *Women Artists in History* for the second edition and worked up a proposal for this sort of book. At the University of Redlands, both Dean Neal Mangham (Whitehead Center) and Prof. Robert Fisher assisted in providing office space and secretarial help. Sandra Richey, of the Armacost Library, was of great assistance in securing often obscure books through inter–library loan.

The first professional in the publishing field to express support for this concept was Scott Mahler, then at the University of California Press. Under his guidance, the first proposal was considerably expanded, bringing the book closer to its present form. When a series of circumstances resulted in the release of the proposal, my terrific editor at Prentice Hall, Bud Therien, committed to the project. I want to express my sincere appreciation to my production editor, Jordan Ochs, for his expertise and patience.

As the proposal evolved, my sincere thanks are due to Elsa Honig Fine, editor of the *Woman's Art Journal*, who made many useful suggestions which I gratefully acknowledge. I used as many of her ideas as possible within the scope of the present text. Charlotte Rubenstein made some valuable suggestions, especially regarding Yandell, which have also been incorporated.

At Cal Poly-Pomona, I am grateful to Dean James Williams, College of Arts, for providing me with an office and use of the library system which was essential for the work on the book, conducted during the summer of 1991. Kari Lasser turned my very rough draft into legible copy.

I am most grateful to my family; my mother and father, Helen and Robert Slatkin, and my cousin Kitty Bateman, whose support is consistent and whole hearted. They have surely invested more time, love, and energy in me than I could possibly return. But this book is dedicated to my husband, Fred Cohen, without whom there would be no book. And finally, to Joshua and Sara, simply more apologies for my absences. Bringing a book into the world is a time-consuming and exhausting task, as the creators whose works are reprinted here were no doubt aware. I have always been conscious of the time spent away from my children.

A book such as this, designed specifically to be used in college classrooms, owes a great deal to the inspiration of one's students. A small, but extremely committed, group of women students at the University of Redlands inspired my persistence and dedication during the forma-

tive stages of the manuscript. At Cal Poly-Pomona, my class of largely English majors in Art 312 during the Winter Quarter of 1991 provided a more immediate model of the ways in which the active incorporation of texts can enhance the classroom process. Two former students, Lisa Rodriguez and Sarah Brownfeld, read the first part of this manuscript in a very early draft. Their many helpful suggestions are gratefully acknowledged.

Recognition must certainly be given to the extraordinary, talented, gifted, powerful, and fascinating women authors whose texts form the core of this book. Without their writings and the scholars who have edited and published some of these texts, there could be no volume such as this. Reading this material has, to a great extent, been its own reward for this effort.

Finally, we gratefully acknowledge the following institutions, publishers and individuals who granted permission to reproduce these texts: Gentileschi's letters: Princeton Unversity Press; Letters of Carriera: Leo S. Olschki, Editore, Florence; *Memoirs of Vigée-Lebrun:* Camden Press, London; Letters of Morisot: Moyer Bell Ltd.; Memoirs of Lea Merritt: Museum of Fine Arts, Boston; Cassatt's letters: Members of the Cassatt family; Letters from Cassatt to Sartain and Morris: The Pennsylvania Academy of Fine Arts; Cassatt's letters to Theodate Pope: The Hill-Stead Museum; Cassatt's letters to Bertha Palmer: The Art Institute of Chicago; Texts by Modersohn-Becker and Käthe Kollwitz: Northwestern University Press; Hepworth's statements: Praeger; Texts by O'Keeffe: The Georgia O'Keeffe Foundation; Texts by Carr: Stoddard Publishing Co., Ltd.; Texts by Kahlo: © Hayden Herrera and Harper Collins Publishers; Hesse interview: Cindy Nesmer; *Through the Flower:* Judy Chicago; Kelly interview: Artscribe; All Antin texts: Eleanor Antin; Antin interview: Leo Rubinfien and *Art in America; Thoughts on Autobiography: Sun and Moon: A Journal of Literature and Art;* Truitt journal: Viking Penguin, a division of Penguin Books, USA, Inc.; Sherman interview: UMI Research Press; Ringgold interview: The Fine Arts Museum of Long Island, Hempstead, New York.

Introduction

This book presents edited and excerpted selections of autobiographical texts written by women who were actively involved in the visual arts since the seventeenth century. Included are all forms of personal narratives ranging from letters and journal entries to more formal, published autobiography, written retrospectively towards the end of the author's life span. For the contemporary era, published interviews are also included.

A separate volume reprinting key texts by women artists is necessary because practically none of these writings are integrated into existing source books. The exclusion of women artists from the mainstream of the history of art is reflected in a parallel exclusion from textbooks of primary sources. Furthermore, the types of writings included here vary dramatically from those most commonly found in related compilations of texts by male artists. Women artists focus more consistently than their male colleagues on the personal, rather than the theoretical. With few exceptions women artists have avoided the types of writings most often practiced by their male colleagues. The subtitle of this book "Autobiographical Texts" was derived only after the selection process had been almost completed and it was clear that the autobiographical mode had been most consistently favored by the vast majority of women artists who wrote texts.

In making the selections, priority was given to excerpts which pertain directly to the history of the visual arts. Creators, whose works are significant for the development of art history have been favored. The artists' early sense of vocation and experiences in acquiring the necessary skills to become practicing, successful professional artists, is often included. Excerpts which provide insights into the artists' major works were also selected.

Another set of texts deals with opinions on prevailing gender stereotypes. What were these artists' attitudes toward marriage, motherhood and the culturally-defined identity of "Woman?" How is the author's awareness of being a "woman artist" constructed? When appropriate, selections were also made concerning the political feminism of the period. What political position did each artist adopt towards women's rights?

In summary, excerpts were selected, and reprinted in this book which distill the essence of the author's attitudes towards artistic creation, both visual and literary, and their identity, as a woman, in a given historical context.

None of the categories: women, author, text, on which this book depends are neutral and uncomplicated terms in the post-modernist/post-structuralist theoretical climate of the early 1990s. All categories need to be defined and described from a theoretical stance before proceeding to the specifc investigation of each historical and national context and individual text. Fortunately, an extremely intelligent body of writings mostly published since 1985, from feminist philosophers, literary critics and visual arts critics exists to assist in this task.

The Cultural/Social Construction of "Woman"

There appears to be scholarly consensus at present that the nature of sexual difference is rooted in the specific cultural matrix in which women lived at any given time. There is no essential, unchanging, "eternal" nature of "Woman" that transcends historical contexts. This position is codified as "poststructuralist feminism" defined by Chris Weedon. In this philosophy, women's experience is seen as "discursively produced by the constitution of women as subjects within historically and socially specific discourses."[1]

In their recently published *Feminism/Postmodernism,* Nancy Fraser and Linda J. Nicholson build a case for a postmodernist feminist theory which would "be explicitly historical, attuned to the cultural specificity of different societies and periods, and to that of different groups within societies and periods."[2]

This "nonuniversalist" position appears to be consistent with Griselda Pollock's theoretical formulaton of sexual difference:

> [Sexual] Difference is not essential but understood as a social structure which positions male and female people asymmetrically in relation to language, to social and economic power and to meaning. Feminist analysis undermines on bias of patriarchal power by refuting the myths of universal or general meaning . . . To perceive women's specificity is to analyze historically a particular configuration of difference.[3]

This theoretical stance diverges from French feminist theories of a "Female language" or *ecriture féminine.* Luce Irigaray, and Hélène Cixous, both Lacanian trained psychoanalysts, are most closely identified with this theory.

This book seeks to highlight the writings of unique and specific individuals; "women" as defined by Theresa de Laurentis:

> By women, . . . I will mean the real historical beings who cannot as yet be defined outside of those discursive formations, but whose material existence is nonetheless certain, . . . The relation between women as historical subjects and the notion of a woman as it is produced by hegemonic discourses is neither a direct relation of identity, a one-to-one correspondence, nor a relation of simple implication. Like all other relations expressed in language, it is an arbitrary and symbolic one; that is to say, culturally set up . . .[4]

She concludes *Alice Doesn't* with a call for a feminist theory which is centered in that political, theoretical, self-analyzing practice by which the relations of the subject in social reality can be rearticulated from the historical experience of women."[5] *The Voices of Women Artists* is clearly an effort towards such "rearticulation" of specific individuals who were also women artists living in a given cultural framework, which varied in different historical periods and for different national cultures.

The Death and Life of the Woman Author

Contemporary theories of subjectivity now recognize the complex, historical and culturally determined forces which act upon women's sense of identity. When we address the issue of women as authors (either literary or visual) we are confronted with another literary debate in academic circles. Initiated by Barthès and Foucault, the deconstructionist idea of the "Death of the Author," has been influential. A wide range of feminist theories have resisted accepting the presumed end of identity and agency within literary texts and by implication, creations of visual arts. As Nancy K. Miller has argued:

. . . the postmodernist decision that the Author is dead, and subjctive agency along with him, does not necessarily work for women and *prematurely forecloses the question of identity for them* . . . Because the female subject has juridically been excluded from the polis, and hence decentered, disoriginated, deinstitutionalized, etc . . . , her relation to integrity and textuality, desire and authority is structurally different.[6]

Yet another persuasive critique of the Barthès-Foucault definition of the author comes from Katherine R. Goodman. She builds a convincing argument against these ideas from an interest in the epistolary autobiography of a German author of the eighteenth century, Elisabeth Stageman.

It is difficult to imagine a concept of writing and expression more antithetical to traditional definitions of autobiography or to recent feminist concerns with women's experience . . . Feminists . . . know that it makes a great deal of difference who is speaking . . . Similarly women have known things about themselves (from experience) which men have never known when they articulated a discourse on the family or women. But such a statement already carries a conviction of the concreteness of women's (and men's) existence and of some subjectivity in experience.[7]

A recent issue of *Art Journal,* edited by Joanna Frueh and Arlene Raven, is devoted to an appraisal of the current situation of feminist art criticism. Many of these articles critique postmodernist and deconstructivist theories.

In this issue, Linda S. Klinger presents a vigorous attack on the "poststructural critics of authorship:"

The premises upon which post-modern critical practices are based simply do not accommodate the intricate sociology of feminist art, nor of the artist. Instead, they neutralize the full identity of women artists within the interplay of social, critical and representational systems, privileging the image as a text. Conceptually postulating the artist as a critical trope, poststructuralist theories of authorship reify her as an abstraction and return that abstraction to us as the subject of art.[8]

Klinger pursues her argument, building a similar case to that of Miller, and Goodman. "Since women had never enjoyed in the first place the privileges of transcendent subjecthood and 'Authority,' the tactics of deconstruction prematurely silence women's voices."[9]

How to Read a Text Written by a Woman

In her influential and frequently quoted theoretical essay "Feminist Criticism in the Wildernes," Elaine Showalter identifies an evolutionary phase of feminist criticism by the term "gynocritics." Gynocriticism as opposed to *écriture féminine,* is centered in the investigation of texts written by women. Clearly this book is involved with the privileging of texts not *about* women, but written *by* women artists and so is located in this school of thought.

Showalter then identifies a model of "women's culture" as more valid and useful than a biological, linguistic, or psychological model. Her view of women's culture, adapted from Ardener's model poses the co-existence of a dominant and a muted group. The "muted space" of most of women's culture coincides with the male cultural sphere. As Showalter asserts "There can be no writing or criticism totally outside of the dominant structure; no publication is fully independent from the economical and political pressures of the male-dominated society.". . . . Women writing [or women making art] are not, then, *inside* and *outside* of the male tradition; they are inside two traditions simultaneously, . . . The difference of women's writing, then can only be understood in terms of this complex and historically grounded cultural relation."[10]

Showalter's model opposes a view of culture which either presents women as helpless "victims" of patriarchy or as existing in a polarized and independent realm.

Susan Rubin Suleiman maintains a similar position for women artists active in today's avant-garde:

> I argue that a double allegiance characterizes much of the best contemporary work by women: on the one hand, an allegiance to the formal experiments and some of the cultural aspirations of the historical male avant-gardes; on the other hand, an allegiance to the feminist critique of dominant sexual ideologies including the sexual ideology of those same avant-gardes.[11]

Women artists participated in the male mainstream culture to a great extent. In the very fact of professionalization, they were actively involved in "speaking" the "male language" of the visual arts. Their efforts to learn the language and find acceptance within the academies helped developed an identification with that language which would be at least as powerful, if not more powerful, than activity within the marginalized, more privatized spheres which hegemonic discourse sought to allocate to women.

However, as all the texts excerpted below clearly document, woman artists were constantly aware of their "differences" as women from their male colleagues. They could not ignore or avoid their gender. This self-consciousness of difference unites women artists living in very different historical circumstances.

For the set of texts excerpted in this volume, a useful critical system is one defined by Judith Newton and Deborah Rosenfelt as "materialist-feminist criticism."

> A materialist-feminist analysis offers a more complex and in the end less tragic view of history than one polarizing male and female, masculine and feminist; constructing gender relations as a simple and unified patriarchy; and constructing women as universally powerless and universlly good. A materialist-feminist analysis actively encourages us to hold in our minds the both-ands of experience: that women at different moments in history have been both oppressed and oppressive, submissive and subversive, victim and agent, allies and enemies both of men and one another. Such an analysis prompts us to grasp at once the power of ideas, language and literature; their importance as a focus of ideological struggle and their simultaneous embeddedness in and difference from the material conditions of our lives. Such an analysis, of course, does not offer us simple answers. Indeed, the uncompromising complexity of its vision may sometimes discourage those who long for certainty and simplicity. Nonetheless, in its insistent inclusiveness, in its willingness to embrace contradictions, materialist-feminist analysis seems to us the most compelling and potentially transformative critical approach to culture and society, offering us theory for our practice as we work toward a more egalitarian world.[12]

This system also acknowledges the active role played by readers. Readers in different historical situations will produce different versions of the text, each with its own political effect. The political function of a text will change along with the goals and strategies of a reader in different historical situations."[13] Materialist-feminist criticism recognizes the bonding between men and women of the same class or racial group, and stresses "men's relative imprisonment in ideology."[14] In this system, class and race ideologies, in addition to those of gender are given importance. Materialist-feminist criticism seeks to understand the internalization of gender ideologies.

The role of the critic in a Feminist-Materialist system, according to Catharine Belsey:

> . . . is to seek not the unity of the work, but the multiplicity and diversity of its possible meanings, its incompleteness, the omissions which it displays but cannot describe, and

above all its contradictions. In its absences, and in the collisions between its divergent meanings, the text implicitly criticizes its own ideology . . .[15]

How to Read Women's Autobiographies

If fictional texts present the literary critic with certain difficulties of ideological meaning, there are other layers of complexity to the understanding of texts which fall into the category of "autobiographies" by women. In the 1990s, we can understand that an individual or any one of our authors do not comprehend their own "self" as a simple unified construct. Rather, as de Lauretis defines, contemporary feminist writers understand the nature of the "self" as composed of "a multiple, shifting, and often self-contradictory identity . . . an identity made up of heterogeneous and heteronomous representations of gender, race, and class."[16] We frequently find, therefore, in these texts a complex and not easily reducible identity in which categories such as "artist," "bourgeois women," American late-nineteenth century person" co-exist and overlap.

Sidonie Smith's, *The Poetics of Women's Autobiography* is useful for a theoretical overview which is especially relevant for the published, public forms of autobiography, as opposed to letters and journals or diaries, which are more private means of communication. Smith believes that women's autobiographies form a separate category as an "engendered text." The formation of the female self functions differently than the male attitude of selfhood, since women are necessarily involved with the ideology of sexual difference promoted in the discourse of her time. The publication of an autobiography "signals her transgression of cultural expectations."[17] Most relevant for our texts, Smith discerns a parallel in the lives of famous women who transgressed the privacy of gender ideology and then published memoirs. "There have always been women who cross the line between private and public utterance, unmasking their desire for the empowering self-interpretation of autobiography as they unmasked in their life the desire for publicity."[18] For the highly successful artists included in this volume, such as Elisabeth Vigée-Lebrun, Janet Scudder or Cecilia Beaux, those who wrote at the end of their successful careers, this analysis is especially appropriate.

Susan Stanford Friedman argues against the position of post-structuralist and Lacanian critics who perceive the "self" in autobiography as "an empty play of words on the page disconnected from the realm of referentality . . ."[19] Friedman constructs the self in women's autobiographical writing as "often based in, but not limited to, a group consciousness—an awareness of the meaning of the cultural category WOMAN for the patterns of women's individual destiny."[20] We can modify this statement by saying that the authors, whose texts are reprinted in this book, are aware of themselves as "Women Artists," an even more precise cultural category. Women then are more aware of a collective identity than a unique, ego-centric, isolated sense of individuality more characteristic of male authors. Friedman then goes on to further critique post-structuralist critics:

> Alienation is not the result of creating a self in language, as it is for Lancanian and Barthesian critics of autobiography. Instead, alienation from the historically imposed image of the self is what motivates the writing, the creation of an alternate self in the autobiographical act. Writing the self shatters the cultural hall of mirrors and breaks the silence imposed by male speech.[21]

Jane Marcus's essay: "Invincible Mediocrity, the Private Selves of Public Women" also provides insight into much of the published writing included in this text. She notes that "autobiography" was, in fact, a literary form deemed appropriate for women.

> Because autobiography was a 'lesser' form, requiring from its author keen observation rather than divine creativity, men were less likely to criticize women for engaging in a harmless activity that required only talent, not genius.[22]

Women stimulated to write their memoirs were anticipating their imminent erasure from history. This perception is most appropriate for women active in the visual arts. Addressed primarily to an audience of women readers, the autobiography is "a bid for immortality":

. . . What seems significant is not the female struggle to enter male public discourse, which feminist scholars have documented, but the recognition of the inability of that discourse to include their voices in its history, the necessity of the return to the personal.[23]

As we shall see, the formal, published autobiographies of women do not follow the forms and models of the genre established by contemporary males from the late eighteenth to the early twentieth centuries.

Some women resolve the conflict between the "silence" imposed by patriarchal discouse and the desire to speak by writing in a private or domestic context, in the forms of letters, diaries and journals. In any form, the choice of self-writing is still an act of asserting "autobiographical authority out of cultural silence."[24]

The journal or diary format is a type of writing which was traditionally viewed as well suited to women. Mary Jane Moffat and Charlotte Painter, editors of a volume of diaries, propose these reasons why women have pursued journal writing; "It is analogous to their lives: emotional, fragmentary, interrupted, modest, not to be taken seriously, private, restricted, daily trivial, formless, concerned with self, as endless as their tasks"[25] Many diarists, such as Marie Bashkirtseff, project a sympathetic, intimate reader.

Virginia Walcott Beauchamp alerts us to the wide gulf which often separates diaries and letters. "The diary . . . affirms an inner reality of the writer . . . The letter . . . represents . . . the acceptance of responsibility and obligation between two human beings and with a larger society . . . It is a fiction."[26]

In their totality, the works excerpted and reprinted provide a wealth of insights into the complexities and variety of personalities of the individual women who negotiated a complex professional identity as a "woman artist" in different historical epochs and cultures. In the classroom, the following set of questions may be used to stimulate discussion. The individual reader may utilize them to activate a critical analysis of these texts.

1. At what point in the artist's career was the text constructed? How does this affect the content of the text?
2. What support systems existed in that culture for the women artist? In what ways do the political organizations of women artists affect the writer's viewpoints on her career?
3. To what audience is this text addressed? Is it public or private? If this can be identified how does the projected attitude of that target audience affect the text? How might our reading of the text differ from that of a reader in the author's lifetime?
4. What is the intended purpose of the text? What does the author expect to achieve, if anything, from the text?
5. If the text is a verbal interview: How does the attitude and directional role of the interviewer affect the text?
6. What attitude did the author adopt towards the gender ideology of her society and more specifically the culturally dominant attitudes towards the "Woman Artist"?
7. What was her attitude towards marriage and motherhood?
8. How does the author define the "self"?
9. What function, role or purpose does her artistic activity appear to play for her formulation of identity? Is her art activity and its exhibition central or peripheral to her sense of individuality?
10. What is the artists' attitudes towards the public reception of her works, their exhibition and her reputation as an artist? How does she define "success"?
11. What seems to be missing, or not discussed, that one might expect to be included? Are there any glaring omissions?
12. What rhetorical strategy has the author selected to present her text? What is the usefulness of the particular literary mode? What goal is thus achieved in structuring the text in this way?

PART I

European Artists, 1600-1800

Compared to the second half of the nineteenth century, written evidence of any sort for women artists in this period is quite limited. This scarcity of texts reflects the small number of active, professional artists during these years. This number, however, was steadily increasing. In the fifteenth century, fewer than ten women throughout all of Europe are recorded as artists. By the eighteenth century almost 300 women were working as visual artists, and, as Harris states, "by 1750 or so it was no longer exceptionally eccentric for a woman with artistic gifts to decide to earn her living in this way."[1] Some women might have supported themselves by providing drawing lessons to the aristocracy. By this time, amateur skills in drawing were considered necessary accomplishments of upper-class girls. Amateur artists in the Victorian era were established as the norm, and provided the cultural background against which serious professional women artists constantly struggled.

Certainly the women artists of this period faced widespread institutional obstacles. Their professional positions were not equal to those of male contemporaries who chose similar careers in the visual arts. Outside of Holland, women were excluded from guilds. They were denied access to all academic or specialized training systems for artists. Women artists in this period were most frequently daughters of artists, who could acquire their initial training at home from their fathers. There was also a pattern of precocity; talent was usually exhibited before the age of 20. This early evidence of talent may have been the result of a number of factors. Embarking on a career before the age of marriage and the interruptions of childbearing might have helped establish women artists of talent as professionals. Also, since women were not eligible for lengthy training in anatomy, perspective, or fresco, they could develop skills in oil painting more quickly than their male colleagues.[2]

In this epoch, there were no professional organizations of women artists such as those established in the second half of the nineteenth century. Each woman artist was perceived, by herself and her culture, as a unique exception to her sex, a glorious token but essentially an isolated individual. It was not until the nineteenth century that women artists began to locate themselves in some sort of community, which in turn lobbied politically to the advantage of women artists as a group.

The surviving literary documents from women artists between 1600 and 1800 are very few. This is not so surprising when we remember the very small number of active professionals. Artemisia Gentileschi was a self-supporting professional artist until her death. Though she acquired literacy later than painting skills, twenty-eight letters have survived. These letters are mostly addressed to patrons, royal or otherwise influential, and concern the core financial and business conditions of her existence. They also reveal her sensitivity to being an exceptional woman in the male-dominated art world of her epoch.

The correspondence of Rosalba Carriera, the most successful woman artist of the first half of the eighteenth century, documents the esteem in which her pastels and miniature paintings were held. Carriera sustained a complex network of interpersonal relationships through letter writing, not only to patrons, but also to family members and colleagues. In addition, a few written statements addressing issues of concern to the artist have also survived.

Artemisia Gentileschi (1593–1652/3)

As a result of the contributions of scholars in the past twenty years, we can now appreciate that Artemisia Gentileschi was one of the major artists of the Baroque era and clearly the most important woman artist of the seventeenth century. Like most women artists of this era, she was the daughter of an artist, the painter Orazio Gentileschi, and she demonstrated precocious talents. She received her initial artistic training at home. Gentileschi rapidly surpassed her father, especially in her ability to develop new compositional formulae and to reinterpret popular themes concerning "female heroes" that from a contemporary standpoint may justifiably be called "feminist."

We are indebted to Mary Garrard for our insights into the earliest signed and dated painting by Gentileschi, *Susannah and the Elders* (Fig. 1). If we accept the inscribed date of 1610 as authentic, this work demonstrates Gentileschi's highly developed technical expertise by the age of 17 and her ability to paint a convincing female nude. Iconographically, the work differs markedly from male artists' versions of this theme. "The expressive core . . . is the heroine's plight, not the villains' anticipated pleasure."[1] The artistic source for the pose of Susannah is not the usual Venus prototype, but a figure from a classical Orestes sarcophagus (also used, in reverse, by Michelangelo for the figure of Adam expelled from Eden on the Sistine ceiling). This pose suggests the anguish of the heroine and the punitive consequences of the event. The whispering, conspiratorial collusion of the two males is another unique factor in Gentileschi's image. Garrard explains this as an allusion to sexual harassment, the threat of rape which Artemisia probably experienced for some time before her actual rape by Agostino Tassi, in 1611 (Tassi had been hired by Orazio Gentileschi to instruct Artemisia in perspective).

Charges of rape were brought against Tassi by Orazio Gentileschi, and the trial took place in 1612. The 19-year-old Artemisia, admittedly illiterate, was tortured with *sibille,* metal rings tightened around her fingers, to assess the truth of her testimony. In the extant trial transcript she is quoted as saying, "This is the ring that you give me and these are your promises," and repeated over and over, "It is true."[2] As a victim of forcible rape, and thus no longer a virgin, the only honorable course of action was to be married to her assailant. However, only one month after the conclusion of the rape

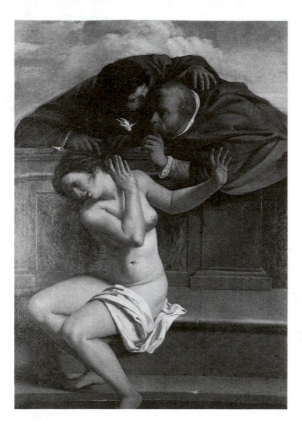

Figure 1. Artemesia Gentileschi,
Susanna and the Elders.
Graf von Schonborn
Kunstsammlungen,
Pommersfelden,
Germany.

trial, in November 1612, she married a Florentine artist named Pietro Antonio de Vincenzo Stiattesi, and records survive showing the couple living in Florence by November 1614. Around 1618 she bore a daughter, Prudentia, and she bore a second daughter sometime after 1624.

Her Florentine period, lasting from 1614 to 1620, was active and productive. Her works exhibit a distinctive personal style and expressive iconography. She became an official member of the Accademia del Disegno in 1616. Introduced into Florentine circles by Michelangelo Buonarroti the Younger, great-nephew of the famous artist, and supported by Cosimo II, a Medici and Duke of Florence, she produced a series of impressive works including the Uffizi *Judith Slaying Holofernes,* and received several major commissions.

During the decade of the 1620s, Artemisia worked in different Italian cities. She went to Genoa, where her father was employed, in the early 1620s, and returned to Rome in 1622, where she painted the impressive *Judith and Her Maidservant* (now in the Detroit Institute of Arts).

After 1630 Gentileschi lived mainly in Naples, the largest city in Europe after

Paris, where she found a wide patronage base. She died in 1652 or 1653 from causes unknown.

From almost forty years of virtually uninterrupted professional activity as a painter, only about thirty-four paintings survive. However, a supplement to the visual evidence is a group of twenty-eight letters written by Gentileschi, which help us reconstruct her life, personality, and artistic practices.

These surviving letters document a relationship with six important patrons spanning a thirty-year period from 1620 to 1651. The seven letters selected for inclusion here were all written during the late phase of the artist's career, from 1635 to 1649. In her first letter, to the Duke of Modena, Francesco I d'Este, we find two themes that recur consistently in this correspondence: Gentileschi's awareness of being a women at a specific time in her life and career, and her stated humility paired simultaneously with pride in her achievements. While her talent is ''meager,'' her work has been appreciated by ''all the major rulers of Europe.'' Apparently, the Duke did not respond favorably, as no known works by Gentileschi were actually purchased for his collection.

The second letter, to the famous scientist Galileo Galilei, is the only example included here that is not a direct communication with a patron. Gentileschi appeals to him as her intermediary to Duke Cosimo I, requesting the noted gentleman to find out why she has not yet been paid for two paintings already delivered to the court.

The third letter is addressed to one of her most active and consistent patrons, Cassiano dal Pozzo. He was one of the major scholars, collectors, and art patrons in Rome in this period, whose most famous protégé was Nicholas Poussin. This letter is of interest since it documents the artist's total assumption of the financial responsibility for her daughter's dowry. Since dal Pozzo was actually employed in the Barberini household, Gentileschi solicits his assistance as an intermediary to two extremely wealthy brothers, nephews of Pope Urban VIII. Her rather surprising postscript indicates her total separation from Stiattesi and her assumption of full responsibility for her children.

The remaining letters reprinted here are addressed to Don Antonio Ruffo. This important art patron lived in Messina, Sicily, and amassed a major collection of paintings that included works by Rembrandt, Van Dyck, and Poussin.

By the time of the letter of January 30, 1649, Gentileschi's relationship with Ruffo is already well established. She states that ''a woman's name raises doubts until her work is seen,'' indicating that even in these last few years of her life, after all her successes, she is still sensitive to the fact that as a woman her talents are assumed to be inferior to those of male colleagues. Another letter to Ruffo written several months later, in March 1649, finds Gentileschi in serious financial difficulties caused by the need to fund another dowry, for her second daughter. She asks for additional patronage from Ruffo. Her self-deprecating remark about ''womanly chatter'' is immediately paired with a self-assured comment, ''The works will speak for themselves.''

The letter of October 1649 is noteworthy for Gentileschi's strong resistance to negotiating the prices of her paintings. With this patron she is much more forthright and demands just payment clearly and directly. This attitude contrasts with her earlier request to Galileo to intercede for her payments from Duke Cosimo.

In the final letter to Ruffo, from November 1649, we again find her very much in control of her prices. Other shrewd business practices involve not quoting prices before the painting is completed, and not relinquishing drawings, since another artist could then steal her conception. She also complains about the expense of models and displays pride in always varying her works, even those of the same subject.

As a group, these letters are valuable documents providing insight into the sense of self and active professional life of this exceptional woman artist.

To Duke Francesco I d'Este, January 25, 1635

Most Serene Lord,

As I am sending His Eminence Cardinal D[on] Antonio [Barberini] some paintings by my hand, I take this opportunity also to send to Your Most Serene Highness those works which I did for you with great pleasure. I am sending these works with the bearer, my brother, dispatched by His Majesty the King of England to take me into his service. However, it seems to me that for three reasons I rightly should devote part of my meager talent to Your Highness. First, because my most humble house is at the service of your illustrious house. Second, because I have served all the major rulers of Europe, who appreciate my work, even though it is the fruit of a barren tree.[3] And third, because it would provide the evidence of my fame.

Therefore please forgive my daring but ambitiously honorable gesture, and please accept these small works which I am sending with my brother. Disregard their faults and consider them in relation to the person who made them, noting only the devotion with which I offer them.

I beseech you to accept this gift as a tribute that I owe you, and so that I may fulfill my debt, please, Your Highness, be so kind as to honor my wishes. In the meantime, I humbly bow to you and pray to the Divine Majesty for the prosperity of Your Serene Highness's household.

From Naples, 25 January 1635.
The most humble servant of Your Most Serene Highness,

Artemisia Gentileschi

To Galileo Galilei, October 9, 1635

My Most Illustrious Sir and Most Respected Master,

I know that Your Lordship will say that if I had not had the occasion to avail myself of your assistance, I would never have thought of writing to you; and, indeed, because of the infinite obligations I have toward you, you could draw that logical conclu-

sion, since you did not know how often I tried to have news of you without being able to obtain reliable information from anyone. But now that I know you are there in good health, thank God, I want to disregard other possible avenues and appeal to you, whom I can depend on for favorable assistance, without relying on any other gentleman. And I do this all the more spontaneously because another situation has developed similar to the one concerning the painting of that Judith which I gave to His Serene Highness the Grand Duke Cosimo of glorious memory, which would have been lost to memory if it had not been revived by Your Lordship's assistance. By virtue of that [assistance] I obtained an excellent remuneration. Therefore I beg you to do the same thing now, because I see that no one is mentioning the two large paintings that I recently sent to His Serene Highness with one of my brothers. I don't know whether he liked them; I only know, through a third person, that the Grand Duke has received them, and nothing else. This humiliates me considerably, for I have seen myself honored by all the kings and rulers of Europe to whom I have sent my works, not only with great gifts but also with most favored letters, which I keep with me. Most recently, the Lord Duke of Ghisa gave my brother 200 *piastre* in payment for a painting of mine which my brother had brought him, but I never received [the money] because my brother went on somewhere else. From His Most Serene Highness, my natural prince [i.e., Ferdinando II], I have received no favor. I assure Your Lordship that I would have valued the smallest of favors from him more than the many I have received from the king of France, the king of Spain, the king of England, and all the other princes of Europe, given my desire to serve him and to return to my home city, and in consideration of the service I rendered His Serene Highness his father for many years.

His Most Serene Highness's generosity, to which all skilled and learned persons resort, is well known. It is no wonder then, that I, having placed myself among them, should have resolved to dedicate some product of my efforts to him: indeed, it is I more than anyone who ought to pay him this debt, on account of both vassalage and servitude. So I cannot believe that I have not satisfied His Highness, since I have fulfilled my obligation. Therefore, I wish to learn the truth from you, including every detail regarding the Prince in this matter. This will alleviate the displeasure I feel, that this most devoted demonstration of mine was passed over in so deep a silence. You will be doing me a great favor, which I will value above any other I have received from Your Lordship. I kiss your hands a thousand times and I shall live always as your grateful servant. And here I pay my profound reverence.

From Naples, the 9th of October, 1635.
From the most obliged servant of Your Most Illustrious Lordship,

Artimitia [*sic*] Gentileschi

If Your Lordship will be so kind as to answer me, please write to me in care of Signor Francesco Maria Maringhi.

To Cassiano dal Pozzo,
October 24, 1637

The confidence that I have always had in Your Lordship's kindness, and the now-urgent matter of placing my daughter in marriage, impel me to appeal to your generosity and to ask your assistance and advice, which I trust I will obtain, as on other occasions. My Lord, to bring this marriage to conclusion, I need a small amount of money. I have kept for this purpose, since I do not have any wealth or income, some paintings measuring eleven and twelve *palmi* each. It is my intention to offer them to Cardinals Francesco *padrone* and D[on] Antonio [Barberini]. However, I do not want to carry out this plan without Your Lordship's excellent advice, as I wish to act only under your auspices and not otherwise. With my greatest affection, I thus beg you to honor me with your reply, giving me your opinion on the matter, so that if necessary I can dispatch someone immediately with the abovementioned paintings. Among the paintings, there is one for Monsignor Filomarino and another for Your Lordship, in addition to my portrait, which you once requested, to be included among [your] renowned painters.

I assure you that as soon as I have freed myself from the burden of this daughter, I hope to come there immediately to enjoy my native city and to serve my friends and patrons.

And now, to end, I kiss Your Lordship's hands with affection, and I pray for all good things from Heaven.

Naples, 24 October 1637.
Please send me news of whether my husband is alive or dead.

To Don Antonio Ruffo,
January 30, 1649

Most Illustrious Sir and My Master,
By God's will, Your Most Illustrious Lordship has received the painting and I believe that by now you must have seen it. I fear that before you saw the painting you must have thought me arrogant and presumptuous. But I hope to God that after seeing it, you will agree that I was not totally out of line. In fact, if it were not for Your Most Illustrious Lordship, of whom I am so affectionate a servant, I would not have been induced to give it for one hundred and sixty, because everywhere else I have been I was paid one hundred *scudi* per figure. And this was in Florence, as well as Venice and Rome, and even in Naples when there was more money. Whether this is due to [my] merit or luck, Your Most Illustrious Lordship, a discriminating nobleman with all of the worldly virtues, will [be the best] judge.

You think me pitiful, because a woman's name raises doubts until her work is seen. Please forgive me, for God's sake, if I gave you reason to think me greedy. As for the rest, I will not trouble you any more. I will only say that on another occasion, I

shall serve you with greater perfection, and if Your Lordship likes my work, I will also send you my portrait, which you may keep in your gallery as all the other Princes do.

And thus I end, and I pay my most humble reverence to Your Most Illustrious Lordship with the assurance that as long as I live I am prepared to carry out your every command. To end, I kiss your hands.

Naples, 30 January 1649.
The most humble servant of Your Most Illustrious Lordship,

Artemisia Gentileschi

To Don Antonio Ruffo, March 13, 1649

My Most Illustrious Sir,

I wish to inform you that I received your letter of 21st February, so full of that kindness which Your Most Illustrious Lordship habitually conveys to your servant Artemisia, and with the enclosed note of exchange for one hundred ducats. I acknowledge also your commission for a work that I am to do for you. I hope with God's help to make something greatly to your liking, and Your Most Illustrious Lordship will see how much I value kindness in a noble heart.

I am very sorry that the *Galatea* was damaged at sea. This would not have happened if I had been permitted to carry out your orders myself, as I would have taken care of it with my own hands. But this will not happen again with the other work, as I will take it upon myself to follow your instructions.

As soon as possible I will send my portrait, along with some small works done by my daughter, whom I have married off today to a knight of the Order of St. James.[4] This marriage has broken me. For that reason, if there should be any opportunities for work in your city, I ask Your Most Illustrious Lordship to assist me with your usual benevolence and to keep me informed, because I need work very badly and I assure Your Most Illustrious Lordship that I am bankrupt.

Further, I want Your Most Illustrious Lordship to promise me that as long as I live you will protect me as if I were a lowly slave born into your household. I have never seen Your Most Illustrious Lordship, but my love and my desire to serve you are beyond imagination. I shall not bore you any longer with this womanly chatter. The works will speak for themselves. And with this I end with a most humble bow.

Naples, today the 13th of March, 1649.
The most humble servant of Your Most Illustrious Lordship,

Artemisia Gentileschi

Please send any letters that you write to me in the name of Signor Tommaso Guaragna.

To Don Antonio Ruffo,
October 23, 1649

My Most Illustrious Sir,

I received your letter of the 12th of this month, filled with your customary kind words. However, I was mortified to hear that you want to deduct one third from the already very low price that I had asked. I must tell Your Most Illustrious Lordship that this is impossible and that I cannot accept a reduction, both because of the value of the painting and of my great need. Were this not so, I would give it to Your Most Illustrious Lordship as a present. And I am displeased that for the second time I am being treated like a novice. It must be that in your heart Your Most Illustrious Lordship finds little merit in me, and truly, as Your Most Illustrious Lordship saw that I originally put a low price on it, you must believe in your mind that the painting is not worth much. I thought I was serving you well to charge you 115 less than I asked for the painting for the Marchese del Guasto, and [for a work] with two more figures. However, so that you are not left with the wrong impression of me, I think it would be a good idea for you to have it appraised.

As for my doing the Prior[5] special favors, whenever I have done any paintings for him, until today he has paid me what I asked for them. We have to make a new agreement about the ones that remain to be done, because the terms that we set resulted from my extreme need to collect the money in advance, to attend to a very important matter. With God's help, I was able to take care of it without bothering the Prior. Therefore, Your Most Illustrious Lordship has no reason to complain about me and to say that I care more about [working for] your nephews than for you. As for me, I have strongly resolved always to be a vassal and subject of Your Most Illustrious Lordship as long as I live, and you will indeed see that of this little talent which God has given me, a small part I will continually dedicate to Your Most Illustrious Lordship. If, then, Your Most Illustrious Lordship does not want to accept my services, I shall resign myself to it and endure my bad fortune.

And with this I close, wishing you great happiness from Heaven.

Today, from my house in Naples, The 23rd of October, 1649.
The most humble servant of Your Most Illustrious Lordship,

Artemisia Gentileschi

To Don Antonio Ruffo,
November 13, 1649

My Most Illustrious Sir,

I have received a letter of October 26th, which I deeply appreciated, particularly noting how my master always concerns himself with favoring me, contrary to my merit.

In it, you tell me about that gentleman who wishes to have some paintings by me, that he would like a Galatea and a Judgment of Paris, and that the Galatea should be different from the one that Your Most Illustrious Lordship owns. There was no need for you to urge me to do this, since by the grace of God and the Most Holy Virgin, they [clients] come to a woman with this kind of talent, that is, to vary the subjects in my painting; never has anyone found in my pictures any repetition of invention, not even of one hand.

As for the fact that this gentleman wishes to know the price before the work is done, believe me, as I am your servant, that I do it most unwillingly, since it is very important to me not to err and thus burden my conscience, which I value more than all the gold in the world. I know that by erring I will offend my Lord God, and I thus fear that God will not bestow his grace on me. Therefore, I never quote a price for my works until they are done. However, since Your Most Illustrious Lordship wants me to do this, I will do what you command. Tell this gentleman that I want five hundred ducats for both; he can show them to the whole world and, should he find anyone who does not think the paintings are worth two hundred *scudi* more, I won't ask him to pay me the agreed price. I assure Your Most Illustrious Lordship that these are paintings with nude figures requiring very expensive female models, which is a big headache. When I find good ones they fleece me, and at other times, one must suffer [their] pettiness with the patience of Job.

As for my doing a drawing and sending it, I have made a solemn vow never to send my drawings because people have cheated me. In particular, just today I found myself [in the situation] that, having done a drawing of souls in Purgatory for the Bishop of St. Gata, he, in order to spend less, commissioned another painter to do the painting using my work. If I were a man, I can't imagine it would have turned out this way, because when the concept has been realized and defined with lights and darks, and established by means of planes, the rest is a trifle. Therefore, it seems to me that this gentleman is very wrong to ask for drawings, when he can see the design and composition of the *Galatea*.

I have nothing else to say, except that I kiss Your Most Illustrious Lordship's hands and pay you most humble reverence, praying for the greatest happiness from Heaven.

From Naples, the 13th of November, 1649.
The most humble servant of Your Most Illustrious Lordship,

Artemisia Gentileschi

I must caution Your Most Illustrious Lordship that when I ask a price, I don't follow the custom in Naples, where they ask thirty and then give it for four. I am Roman, and therefore I shall act always in the Roman manner.

2

Rosalba Carriera (1675–1752)

The professional success of Rosalba Carriera set new standards for women artists on the international stage of Europe. Prior to Carriera, no woman artist had achieved the extended fame and secured the patronage of aristocrats in most of the major courts of Europe. She was the first non-French woman to be elected to the French Academy of Fine Arts. Carriera's artistic achievements occurred in the "marginal" media of miniature painting and pastel portraiture. For both media, she invented significant formal devices. She was the first person to use ivory as a support for miniature painting; this guaranteed her success and affected the course of this type of painting. As the inventor of pastel portraiture she influenced a large number of successors in this field during the eighteenth century, many of whom were women.

Published in a modern two volume edition, Carriera's surviving correspondence is an excellent source for reconstructing the course of her career and the scope of her patronage. Her own letters and many letters from her patrons have survived. Carriera's travels, necessitating separations from her family, also stimulated correspondence. Finally, a few brief essays concerning issues of interest to the artist have also survived in her papers. It is from this body of documentation (edited by Bernardina Sani and published in 1985) that the following selection of writings has been taken.[1]

Carriera's family background is not typical of most successful women artists prior to the nineteenth century. Unlike Gentileschi or Vigée-Lebrun, her father was not a painter. Her mother was a lacemaker, and Harris suggests that the decline of the lace industry encouraged her to shift to the decoration of ivory snuffboxes, popular with the tourist trade.[2] By 1700 she was selling miniatures and her first recorded pastel portrait dates from 1703. Since her earliest works are distinctive technically and iconographically from her contemporaries, her genius appears quite original. As her correspondence documents, her works were already in demand from aristocratic clients by the first decade of the eighteenth century. The first two letters, part of an extensive correspondence with the Duke of Mecklenberg in Switzerland, are characteristic of the tone of the correspondence in the early part of her career as she is building her patronage base. The humility paired with modest pride in her works is familiar from Gentileschi's correspondence, although Carriera does not appear to focus on her gender as consistently as Gentileschi.

In the next letter to a patron living in Florence, Carriera defends the time needed to complete her works. Her self-imposed standards of excellence and the time required to finish her work, is phrased in a polite, yet assertive, manner to her impatient correspondent.

As early as 1716, Carreria had met Pierre Crozat, one of the most important art patrons in Paris. Crozat had first assisted Watteau in building his career. A wealthy banker, Crozat's home was the center of early Rococo activities in Paris. Crozat had met Carriera on a trip to Venice in 1716. In the spring of 1720, at his invitation, Carriera traveled to Paris. Her surviving diary records a constant sequence of sitters and social commitments. By the following spring, Carriera returned to Venice. These two letters to Crozat and Antoine Coypel were written after her Paris sojourn and in response to her admission into the French Academy in October, 1720.

Carriera remained closely bonded to her family throughout her life. She lived with her mother and unmarried sister, Giovanna in Venice. The following letter is characteristic of the surviving correspondence to her mother, even when separated only temporarily, and in the following year, 1730, Rosalba worked in Vienna for Emperor Charles VI.

Despite these periods of time spent away from Venice, Carriera was generally quite reluctant to travel and became more resistant, as she aged. The next letter to Felicità Sartori, her best pupil, demonstrates the emotional warmth between teacher and student. Sartori was working for Augustus III, Elector of Saxony and King of Poland, at his court in Dresden. She was married to one of the members of the court. Augustus had amassed the largest collection of Carriera's works.

The last letter to Pierre Jean Mariette, one of Carriera's most constant patrons, dates from the last years of her working life. Mariette had met Carriera during her trip to Paris in 1720–21 and maintained an active correspondence with her. Carriera went blind sometime after 1746. In 1750, Mariette refers to a third operation, hoping for success, one assumes to restore her eyesight. The intermingling of personal and professional information is typical of the relationship Carriera had formed over the course of her life with some of her patrons.

The last two excerpts are not letters but essays which have survived in Carriera's papers. The first is of great interest because it addresses the contemporary debates on the ''Woman Question'' or the ''Querelles des Femmes,'' and shows Carriera's awareness of this discourse, in her time. She vehemently rebukes a writer using the argument of the ''Women Worthies.'' The final excerpt is, to my knowledge, the earliest surviving autobiographical text by a woman artist. In this brief essay, Carriera characterizes her temperament and articulates her perceptions of her own personality.

In sum, these documents are a valuable group of writings showing the full range of the correspondence of the most famous woman artist of her epoch whose works were consistently in demand from an international group of patrons.

Rosalba Carriera in Venice to [Christian Ludwig, Duke of Mecklenberg, in Schwerin] Venice, June 10, 1707

Serene Highness,

The good fortune which my little works have in prevailing above others, comes

not from their perfection, but from the goodness of Your Serene Highness, who considers [them] with favor. It is too much generosity, Serene Highness, and the excess of your graces, which is without limit, throws me into a confusion which will never end. I would as much take all the care possible to make my works more acceptable to Your Serene Highness by the promptitude of sending them according to his wishes, as I would demonstrate my obedience and make known to everyone that all my glory is in the honor of being of Your Serene Highness, Monseigneur,

His very humble and very obedient Servant,

<div style="text-align: right">Rosalba Carriera</div>

Rosalba Carriera [in Venice] to Christian Ludwig, Duke of Mecklenberg, [in Switzerland]. Venice, October 7, 1707

Serene Highness,
As I meditate without ceasing the means of fulfilling my duty as regards Your Serene Highness and of corresponding in some manner to the pleasure that he shows at the weakness of my little works, I did not wish to neglect the favorable occasion to make my zeal known, by sending him a little painting of a half figure in pastel and of another in miniature by Mon. [Seigneur] V.
My audacity is without second, but the goodness of Your Serene Highness, which is without equal, will know how to pardon it, assuring him, at the same time, that soon I will give him stronger proofs of the eagerness that I have to make myself known, with all possible respect, of your Serene Highness.

Very humble and very obedient Servant,

<div style="text-align: right">Rosalba Carriera</div>

Rosalba Carriera [in Venice] to Federico de Walter [in Florence] 1709

Sir,
In the impatience where I was to learn if truly the two little portraits had had the good fortune of pleasing His Majesty, you may believe that your letter was very dear to me, assuring me of this advantage. I know, however, that this comes more from this surprising goodness that makes him even more admirable than his quality as King, every possible care taken to perform my duty being incapable of meriting it.
The new obligation to unite Flora to Venus should only come from you, knowing how much you love flowers; without considering, however, that in order to paint them one must employ more time than in doing another portrait.
I also found it desirable to distinguish the one that merited it, and still I protest

to you that the zeal that I have to serve His Majesty well would make me find greater pleasure where there is greater difficulty, if it were not necessary to make them all different. You cannot hope to see in my works this perfection which is difficult and almost impossible for the most gifted, not being talented enough for that; but for the little that I do know, it seems to me that you have no reason to write it to me in each letter, having very strong proofs that I work more in order to make my little works agreeable than for the money. I showed to M[onsieur] Jacini, who assures you of his very humble respects, the chapter which concerns him, and I will demonstrate to you by the execution of your commands how much I esteem your merit, . . .

Rosalba Carriera [in Venice] to Antoine Coypel [in Paris] [Venice, October 10, 1721]

I have given myself the honor of writing twice to Monsieur your son, once from Fuessen, the other from Venice, sending him in the first that we had been obliged to remain absent, in the second our fortunate arrival in Venice and our acknowledgement of the loss that he has just had, as well as you, M[onsieur] Z. having told us of it in one of his letters, and I am most distressed at recalling it to your memory for the purpose of persuading you that I have not forgotten my duty. I have not, however, received any reply to them, which has led me to believe that my letters are unwanted. I have, therefore, remained silent; but at present, in spite of my hesitation, I could no longer keep [silent]. I am sending the pastel to the Academy and how would it dare to present itself without your protection? I come, therefore, to procure it by these two lines and I would consider having done harm to the goodness that you have had in bringing all these illustrious to accord me the great honor of being among them, if I did not profess that you will be able to persuade them still that I have done everything I can to demonstrate to them my gratitude, even though this does not appear to be enough, as I would have wished in this painting. I have tried to make a young girl, knowing that one pardons many faults in the young. She also represents a nymph in Apollo's entourage who is offering a present, on her part, of a crown of laurel to the Academy of Fine Arts, judging it the only one worthy of wearing it and of presiding over all the others. She is also determined to take up residence in this city, preferring to occupy the last place in this illustrious Academy than the peak of Parnassus. It is up to you, therefore, I reply, to procure for her this advantage and for me, too, that of enjoying your good graces and those of all the illustrious of the Academy, to whom you will have the goodness of making my compliments and of believing me. . . .

Rosalba Carriera [in Venice] to Pierre Crozat [in Paris] March, 1722

I owe a reply to two of your obliging letters, namely those of February 24 and of March 10. I will begin by the last, which was accompanied by that of M[onsieur] the Secretary

of the Academy and you will protest, in the first place, that I should be ashamed to be the cause of your being bothered and to feel the need of abusing your patience, in even sending you the replies, for fear that they might get lost if I send them by another route. Every effort that you have made to transmit the Mercure Galant to me, will only serve, I assure you, to confuse me even more, because I was only too persuaded that my good friends would only know how to speak totally other than I merited. I am infinitely obliged to you, Monsieur, as well as to Mlle d'Argenon[3] who knowing my inclination, one and the other remember me when the highest honors are accorded; everything manages to make me regret not having strong enough expressions for each [of you] to persuade you how grateful I am for the trouble that you have given yourselves concerning the pastel that I sent to the Academy, because, if it was received favorably, this was by your efforts, and I am so very distressed at being able merely to thank you in return. I am convinced that by now you will have received news of M[onsieur] Zanetti, since it has been several days since his return from Bologna and I believe that it is easier for him to write you than to come see us, our districts being a little distance apart and this matter still pressing. If you would like some news of my dear mother, I will tell you that she is as well as if she had never been ill. She sends you many compliments along with my sister Jeanne, who shares all the debts of gratitude with which you have laden me.

I reply now to the portion of the letter of January 19 where you wish to know the reason why among the works of early artists some are well preserved and some are greatly damaged. I have asked several experts and all are in agreement that this results, neither from the thickness [of the paint] which they took great care to distribute very well, nor from the varnish, which they did not use too much, but more from the location where they were placed and from the different climate, because, for example, we see and you will have noticed, that paintings on land are much more preserved than those from Venice. This can also happen through the negligence and the slight care taken to preserve them well. My brother-in-law, who humbly thanks you for not forgetting him, is of the same opinion and sends you his compliments along with [those of] his wife. Finally I pray you to deliver the enclosed to whom they are addressed and to pardon the liberty I am taking in sending you such a large package. I am, with a very particular respect,. . . .

To Her Mother in Venice, July 4, 1729

Dearest Honored Mother

[coman parblé] Oh my goodness; this is not the way to leave your daughters for four days when we have sent you news through two great conduits, Mr. Zanetti and Mr. Las.

To complete our happiness, at the home of the most kind and benevolent Excellency Labia, we require two lines from you telling us the truth about your health and telling us how the people around you and your maids are treating you. I beg you to

send us these lines, quickly, quickly, quickly and put a thank you to his Excellency, Anzoletto who started the efforts to improve your health. . . .

You might have heard from Mr. Zanetti, that Miss Elena was in Padua with her uncle and they have not yet returned. Her Excellency, the Lady of the House, is very busy in the most precious leisure and in her precious laces. Since we have the gift of not being able to do anything right we stay in our corsets like wealthy ladies with fans in our hands since Her Excellency is so good-hearted to let us stay without our clothes so we don't suffer from the heat, which today is especially intense. Tell me how you are doing and if, for this same heat, which I think is even stronger in Venice, you don't have the energy to write, let your secretaries Nane and Felicità write. . . . I am asking you to do this, this evening, so that it leaves before twelve, so we can have it sooner. Make it long, so that it may compensate our great impatience and we would like your news to include our sister and her friends, including our neighbor Mrs. Laura, to whom I ask you to send my regards, and to whomever visits you in our absence which may continue for another week, because so great is the kindness and generosity of these Excellencies who I will say send their regards to you, because when they know I have written to you, I know they will ask me if I have done it and if I haven't I'm sure they would reproach me. . . . [mother you are] kissed a thousand times by Giovanna, who sleeps more than usual and is fine, and by your affectionate and respectful daughter,

<div align="right">Rosalba, Ca.</div>

Rosalba Carriera [in Venice] to Felicità Sartori [in Dresden], September 4, 1741

My dear, since I am almost ready to seal the envelope, let me write you two lines, in the strictest confidence, which you will tear up as soon as you and your husband have read them. This concerns what, with great affection and warmth towards me, the Brother wrote and his feelings were stronger than the feelings of a son. I understood his feelings only when the long letter had already been written so I couldn't say anything but simply thank him. Now, I ask you, my dear (knowing how these things are) not to put yourself into a situation, that you might be pressured into from your love for me. I ask only that you let the Lord do things his way because to speak plainly, while you are busy working for me and if I should die, your efforts would be useless. I am feeling much better, but I am not well.

If by chance, the Majesty of the King, that which makes him superior to any other King, made him speak further to my advantage, your loving husband with his customary goodness, whatever advantage I might acquire from this, I would always be grateful to you and your husband because without the favour which the King has for him, the king would have never held me in his favor; not even Mr. Counselor, would have any regard for me if he didn't know that favoring me, he would please you. That's enough, my dear, whether I recover or not, this business cannot last too long because you know

how old I am, otherwise If I wasn't so old, I wouldn't hesitate to come and kiss you and your husband as I am doing now.

To Pierre Jean Mariette in Paris—Venice, February 5, 1746

Monsieur,

Mr. Zanetti by promising you the little picture that I prepared of good quality, which can never be either beautiful or good, puts me in a bad position, because You when seeing it, will find it (unfortunately it might really be so) homely and unworthy of being close to you. I put all my good will into it, but it is true that often this is not enough. You will finally see it and, in advance, I am asking you to have pity on it. I thank you a thousand times for supplying me with the pastels although I am sure that I will not have the time to use them up. Moreover, thank you for the fact that you were kind enough to inform me of your whole family's happiness for the arrival of a husband whom I imagine to be of equal merit, if not superior to that of your daughter. I congratulate you, together with my sister, and I pray the Lord to send you all the special blessings that our old friendship wishes for you. When you do me the honor of writing to me, I hope you will tell me something about Mlle. Argenon. I would like you to know that the crate containing the pastel, which represents a boy is ready.

To send it, I will wait for an opportunity which your friend Zanetti will suggest, because, fortunately, I missed one which I thought was appropriate, but was not safe. I would like to have already sent it, because you are so good as to ask for it. I hope this will happen soon, so that you will have a small proof of my esteem, with which I remain, yours, etc.

Rosalba Carriera

Concerning Feminine Studies

. . . The defense of our gender against so many great intellects who have so strongly attacked it, can appear to be a too complicated task to be undertaken by a woman. This doesn't mean that I am going to admit that we are by nature less able than men for such enterprises and I hope that I'll be able to show plausible reasons before finishing.

But due to men's oppression (especially here in England), there are only very few women, who because of the education of their [minds] or instruction are sufficiently capable of these enterprises. As far as I am concerned, I confess that although there are very few of these women, there may be and there is a great number of women who in their discussions prove more able in the defense of our cause than I, and I am very sorry that due either to their business activities or other occupations or their laziness they are diverted from doing justice to their gender.

Men, through interest or inclination are generally so against us, that we cannot expect any man to be so generous as to stand up and be the champion of our sex, against

the offenses and oppression of their own sex. Those romantic days are gone and not even one *Don Quixote* is left to help the unfortunate ladies.

It is true that some apology of similar nature was made three or four years ago by one of them; but although his Eugenia might have been grateful to him, in my opinion, the rest of her sex was not very grateful to him. Because, as you noticed, Signora, he took more care in sharpening his satire than in giving strength to his apology.

He plundered a bad loot and he received more blows than he gave and, just like a renegade, he fought under our banner just to have a better opportunity to betray us, but what could you have expected from a Ganymede? an animal who couldn't really praise the spirit of a woman more than the physical body of a man, who compliments us only to show his own good upbringing and manners. He extends the scandal to all women and he believes us sufficiently strong if in the history of 2,000 years he was able to pick a few examples of women famous for their intelligence, wisdom or virtue and men infamous for the opposite. Although I think that the most persistent of our enemies would have saved him this effort, admitting that all epochs produced famous or infamous people of both genders: or they have to abandon all pretence of modesty or reason.

I don't have enough knowledge or inclination to make any use of the book as it was used by Mr. N and I will leave it to the scholars and pedants to dig into the leftovers of Antiquity and to show all the heroes and heroines they can find to provide material for some poor discourse or fill a narrow-minded declaration with meaningful addresses or arguments. I will not enter into any debate if men or women are more intelligent or gifted because of the advantages which men have over us for their education, freedom of speech, and for the varieties of business and social activities. But when some disparity is found between the sexes, this great difference in circumstances must be taken into consideration. I am not going to discuss the superiority of our virtues. I know there are many vicious people and I hope there are a great number of virtuous people of both genders. I can say that whatever vice is found among us, the source usually derives from these differences.

The question I discuss now is whether the time that one sensitive gentle man spends in the company of women could be considered wasted or not?

I put the question in general terms.

Autobiographical Notes

No one loves cheerfulness as I do: I want to have it in my family: I try to inspire it where ever I go and I believe that for all things pleasure and amusements are the best and most universal remedy we can apply to our troubles. I am not an enemy of pleasure; but I think that one has to enjoy these pleasures with much sobriety and moderation.

I dare say that no one has a greater aversion to excesses and disorders than I. I look at them as obstacles to be avoided and I flee from libertines and degenerates as from people infected with a contagious disease.

You are very right: because when everything is done, excesses in pleasures, even

in those that are permissible, can lead one not only into disgrace but into pain. A man who loses his credit for excesses, very commonly loses his health and he offends his physical constitution as well as his honor. Besides ruining his reputation and his health, we can add that excesses in pleasure and amusements, invariably ruin assets and businesses. So that, according to me, one must enjoy pleasures only as refreshment. . . . Please, what are the pleasures in which you indulge as past times? Besides eating well I take walks and have conversations, I like to see a comedy, I enjoy music, I play sometimes. I consider your choice very reasonable, but what do you mean by 'eating well'? In a delicious way of eating and drinking, accompanied by temperance and sobriety and I love good food so much that not only does it keep a good body in health, but it also contributes to the liveliness of the spirit.

Taking walks contributes to the health as much as good food does. This eliminates the humors that commonly trouble sedentary people that make our bodies strong and vigorous. As far as conversation is concerned, in my opinion, it is the best pleasure of life, it is the knot of society; and through conversation people communicate their thoughts; it is through conversation that hearts express their affection, and friendships begin and are maintained. Finally, if it is true that its study increases knowledge, then conversation is a gift of nature that uses knowledge and polishes it.

I know very well the advantages of conversation, but which ones do you find in play?

Comedies are, as you know, representations of ordinary life, and of a variety of humors: the different traits of shrewdness, trickiness, simplicity, greed, galantery, falseness, fantasy, humor, etc are recreated on the stage; they are not less instructive than amusing. . . .

PART II

Expanding Opportunities, 1800 - 1914

The nineteenth century witnessed a steadily increasing population of women artists in Europe and in America. With that growing population came professional organizations which served as political pressure groups for improved educational opportunities and greater visibility from exhibitions of works of art. Exhibitions were designed to generate sales, which could translate into financial independence or at least a minimum level of financial security for the woman artist. On the eve of World War I, women artists had broken down most major institutional barriers to equal education, if not the more subtle obstacles of social expectations and prejudices. Significant numbers of women artists were actively painting in a full range of stylistic modes, from the most conservatively academic mainstream style to the most radical avant-garde fringe.

Similar developments occurred in the field of literature. Many women became published authors during this period. As Estelle Jellinek, author of the only study to deal with the full history of women's self-writing, states:

The [nineteenth] century . . . ushered in a plethora of autobiographies, the result of the revolution in printing, increased economic stability, and, especially for women, advancements in education. There was a booming book industry . . . a proliferation of reprints, and hundreds of new autobiographies eagerly consumed by an increasingly literate populace.[1]

It should be remembered that all the women included here were exceptional in their seriousness and determination to become professional painters. To write about their careers meant breaching yet another layer of resistance to attain a different sort of exposure. As Nancy K. Miller has noted, "To justify an unorthodox life by writing about it is to reinscribe the original violation, to reviolate masculine turf."[2] Carolyn Heilbron has made the further appropriate generalization:

Well into the twentieth century it continued to be impossible for women to admit into their autobiographical narrative the claim of achievement, the admission of ambition, the recognition that accomplishment was neither luck nor the result of the generosity of others.[3]

Such generalizations help prepare us for the modest tone of the self-writing selected for this volume.

Another type of writing that emerges in this era is the journal. Written sporadically throughout all or portions of the authors' lifetimes, the journal is often the most intimate, least censored type of self-writing. The three journals excerpted here—those of Marie Bashkirtseff, Paula Modersohn-Becker, and Käthe Kollwitz—were all published posthumously.

The literary activity of many of the women included in this section was not in the form of published texts but as letters intended for private communication with family and friends when physically separated from them. In the specific historical context of Victorian America, Carroll Smith-Rosenberg has described the enduring emotional relationships between women sustained through correspondence across the spans of lifetimes.[4] For the purposes of our anthology, we can extrapolate from her research the key role of letter writing in the nineteenth century to maintain emotional ties and to express psychologically important information.

During the nineteenth century, the unique national characteristics of different regions, both in Europe and in America, affected ambitious women artists in very direct ways. Political and class structures, patriarchal cultural discourses, attitudes and access to all forms of education, both academic and artistic, all varied widely from country to country. For that reason, Part II is divided into five sections, according to geography. The introductions to each section deal with the components of the specific national historical situation of greatest significance for women artists.

FRANCE

Despite enormous institutional obstacles, the number of women artists continued to grow in France in the first third of the nineteenth century. Twenty-eight women exhibited at the Salon of 1801 (14.6 percent). In 1810, 70 women (17.9 percent) showed; in 1835, 178 artists (22.2 percent) in the Salon were women.[1] Such women had acquired skills in a society where there were very few formal schools in which they could be trained. As early as 1790, Adélaïde Labille-Guiard (1747–1803), a contemporary of Vigée-Lebrun, had tried to establish drawing schools for girls, pleading her case before the revolutionary government. It was only in 1805 that the first free drawing school for girls was opened in France. In 1848 Rosa Bonheur's father, Raymond, became director of this establishment. After his death Rosa Bonheur ran the school with her sister, Juliette, in the 1850s. Throughout the nineteenth century in France, as in Victorian England, drawing and painting skills were acceptable for noble and bourgeois women as long as these activities remained amateur and confined to the home.

With the establishment of the Third Republic, some new educational options opened for aspiring women artists. By 1879 there were twenty new schools in Paris solely designed to train women for positions in arts industries, such as fan painting and procelain decoration. For the "fine art" of painting, the Atelier Julian opened a separate class for women in the early 1870s; this is where May Alcott, Marie Bashkirtseff, and Cecilia Beaux studied in the later decades of the century. With the increasing range of educational opportunities, growing numbers of women began to exhibit their works.

23

In 1874, 286 women showed works at the Salon. Three years later that figure had grown to 648. By 1880, 1,081 women were exhibiting in the official Salon.[2]

The decade of the 1870s also witnessed an upsurge in moderate feminist activities. Feminist issues and causes in France had been deferred until the Second Empire was overthrown and a more democratic government was not only in place but secured from monarchist and radical leftist takeovers. The history of active French feminism only begins in 1878 (relatively late compared with England), when the first Congress for Women's Rights was convened. A mere three years later, in 1881, the Union des Femmes Peintres et Sculpteurs (UFPS) was founded. It was first led by a sculptor, Mme. Hélène Bertaux (1825–1909); The UFPS, like the Society of Female Artists in England, provided exhibition opportunities for women in an annual Salon.

While large numbers of women were showing their works at the Salon, the proportion of awards, most often an honorable mention or third-class medal, remained low. Soon the placement of women on the Salon jury would become an issue for the UFPS, as would the admission of women into the most prestigious art school in France, the Ecole des Beaux-Arts. The UFPS Salons became large exhibitions. By the early 1890s, between 600 and 800 works were being exhibited each year. The largest exhibition took place in 1906, when over 1,500 works were shown. As Tamar Garb has noted, "The sheer numbers of women who exhibited with the Union is testimony to the need it filled."[3]

At the International Congress of Women's Works and Institutions, held in 1889, a motion was passed to admit women into a separate class at the Ecole des Beaux-Arts. After a long series of tortuous negotiations with the highly entrenched Ecole and governmental bureaucracies, this became law on April 3, 1897; by May the first group of women was on the premises of this male bastion of artistic privilege. Despite the relatively late arrival of women at this prestigious art school, Paris exercised a strong fascination for women artists in the final third of the nineteenth century.

The texts included in this section fall into two broad categories: the retrospective autobiography written at the end of the artist's lifetime, when her period of greatest productivity was passed, and private writing never intended for publication.

Elisabeth Vigée-Lebrun's *Souvenirs,* written in an epistolary mode, were formulated as a record of her own story and to deflect possible slander, to which she had been repeatedly exposed during her lifetime. This was a final bid to secure her reputation for posterity.

Like Vigée-Lebrun, Rosa Bonheur's project of writing her memoirs was undertaken very late in her life as the culmination of a once successful painting career. Bonheur, too, had lived long enough to witness her realistic painting style supplanted by Impressionist and Post-Impressionist innovations. Like Vigée-Lebrun and the English artists Elizabeth Thompson Butler, Louise Jopling, and Anna Lea Merritt, Bonheur was anticipating her erasure from history.

Since France did not have the same active literary market as England, there is not a comparable outpouring of memoir and autobiography. For most French women artists, the invasion of masculine spheres is largely confined to the activity of painting, not writing.

Berthe Morisot's letters were intended strictly for family and very close friends, never for publication. The decision to publish Marie Bashkirtseff's journal was made only as her progressive debilitation from tuberculosis made it clear that she would not live long enough to establish an important painting oeuvre.

3

Elisabeth Vigée-Lebrun (1755–1842)

At the peak of her career as a portrait painter, in the 1780s and 1790s, Elisabeth Vigée-Lebrun was one of the most prominent artists of her epoch. She moved in international aristocratic circles, and was called upon by the French monarchy to create the official images of Marie Antoinette, the last queen of the *ancien régime*. She was widely respected by her colleagues, and was elected to the Royal Academy of Fine Arts in 1783.

In the 1830s, when the artist was in her eighties, she wrote her *Souvenirs* (Memoirs). The first two volumes were published in 1835 and the third in 1837. By this time, the original monarchy to which Lebrun was closely attached had been gone for over forty years. Joseph Baillio, an authority on the artist, has described *Souvenirs* as "an apologia written in a spirit of self-protection by a woman who all her life had experienced hatred and envy." He goes on to describe the "saccharine style," summarizing their tone as "tedious" and "self-adulatory."[1]

This rather harsh judgment can be softened when this literary work is placed in the context of women's self-writing of the eighteenth and nineteenth centuries. Vigée-Lebrun writes in the epistolary mode, prevalent in the eighteenth century. This was the sort of writing believed to be eminently suitable for women in this period.[2] Writing letters from the home was a means of involving oneself with the larger world while maintaining respectable domesticity. Letters were thus a type of writing that women were expected to do well. The publication of letters became one acceptable form of public writing for women. Eventually, epistolary novels, growing out of this peculiarly female type of writing, would become popular in England.

Most of Vigée-Lebrun's *Souvenirs* is written as letters to a Russian friend, Princess Natalia Kourakin, for whom the artist had previously composed a brief autobiography before the former's death in 1831. Vigée-Lebrun's highly successful painting career was long finished by the time she wrote her memoirs. One could argue that they fit the category of eighteenth-century English memoirs as defined by Valerie Sanders: "Whereas men concentrate on their careers and write, for the most part, in a stately prose style without rancor, women focus on the vicissitudes of their private lives and tell stories of endurance and survival in a society where they had no prominence and few claims."[3]

Vigée-Lebrun never earned her living selling sausages like Charlotte Charke, nor was she mistress to an earl at the age of 15 like Harriette Wilson; but like these eighteenth-century memoirists, she had good cause to feel abused and ultimately rejected by her society. As Sanders notes: "All female autobiographies before the nineteenth century testify even more than men's to the writer's exceptional sense of selfhood. To survive at all as a middle-class woman was a feat of will: to write about that act of survival was a further defiance of convention, and remained so for the Victorians."[4]

Women of achievement were especially sensitive to charges of vanity, and the cautious, reserved style of Vigée-Lebrun is entirely characteristic of the literary activity of women who were famous in other fields.

Vigée-Lebrun's *Souvenirs* is not a collection of brief letters in random order but rather resembles the more common forms of autobiography in that they were written as a group and follow a roughly chronological order, beginning with Vigée-Lebrun's early home life. She describes her career through the years of the *ancien régime,* her travels through the aristocratic courts of Europe, her return to Paris during the Napoleonic Era, and her subsequent life into the 1820s.

Vigée-Lebrun certainly had the time available to devote to writing. By 1800 her most active and productive years of painting had passed. A surviving letter casts light on her motivation for writing her autobiography. She states that a M. de Gasperiny had encouraged her to write, warning her "if you do not do it yourself, it will be done for you, and God knows what will be written. . . . I understood his reasoning, having often been so misunderstood, so maligned, . . . I resigned myself to it."[5] Surviving manuscripts document that most of the text was written by the artist in her own hand, although others, including her nieces, certainly assisted in editing it. Although begun reluctantly, this text is as honest and forthright as was possible for a woman in this epoch.

Each excerpt reprinted here reveals a different facet of the life and experiences of this fascinating artist. The first segment recounts the artist's memories of her early training and artistic development following her father's death. It fills in the picture of the teenage artist developing her skills before the era when any formal schools or apprenticeships were available to young women. The second segment recounts the circumstances of her marriage, the birth of her daughter, and her trend-setting tastes in aristocratic portraiture.

The next excerpt is devoted to her relationship with Queen Marie Antoinette and establishes her political allegiances to the monarchy.

The next two excerpts describe Vigée-Lebrun's life during the 1780s, her absorption of Rubens's coloristic brilliance, her admission to the academy, and her life as one of the foremost painters of her time.

The *Self-Portrait with Her Daughter* (Fig. 2) was painted in 1789, at the height of the artist's career, shortly before the flight from Paris. Julie would have been 9 years old. The work demonstrates Vigée-Lebrun's technical expertise. The shallow background is characteristic of her commissioned portraits of the era. The simple, unadorned gowns, embroidered sashes, and natural, unpowdered hair are also trademarks of Vigée-Lebrun's

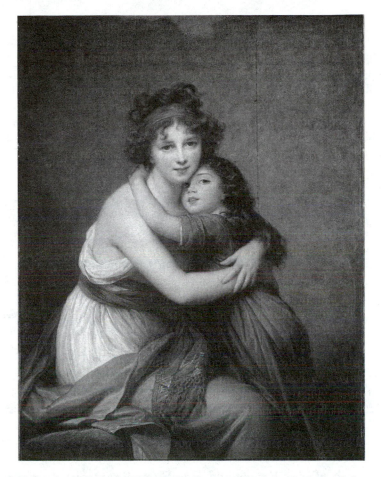

Figure 2. Elisabeth Vigee Lebrun, *Portrait of the Artist with her Daughter.* Musée du Louvre, Paris, © photo R.M.N.

imagery. Vigée-Lebrun was to use a similar intertwining pose for a commissioned work, *Countess von Schonfeld and Her Daughter,* painted in Vienna in 1793. Baillio states that the compositional formula was inspired by Raphael's *Madonna della Sedia.*[6]

Iconographically, this image tells us a great deal about the concerns of the artist. The desire to impress the viewer with her fulfillment as a "happy mother" is of utmost importance. This new bourgeois concept of family, replacing aristocratic ideas of dynasty, has been discussed by Carol Duncan.[7] Vigée-Lebrun had used this concept for her official image of Marie Antoinette (1788). Women who had distinguished themselves in any manner were anxious to promote this "normal" role as "happy mothers" to deflect slanderous innuendoes of improper and unwomanly conduct.

Griselda Pollock has discussed the self-portraiture of Vigée-Lebrun. The artist's image becomes a spectacle for the viewer, a passive object for the active male viewer's gaze. In this self-portrait, "the artist doubly stresses the contemporary conception of woman. Partly revealed, smooth-limbed and beautifully, 'naturally' coiffed, she is viewed also as an affectionate mother."[8]

Following her departure from France in 1789, Vigée-Lebrun lived in Italy. The next group of excerpts discusses a number of topics from her experiences there, such as her impressions of High Renaissance masters and classical sculpture, and her contacts with other artists in Italy, such as Angelica Kauffman and the French artists in residence at the Academy of Rome. In recounting her reception by a group of art students in Parma, she articulates her sense of vulnerability to charges of vanity. Similar sensitivity, as we have seen, permeates the entire literary activity of writing her memoirs. Her account of the commission for Napoleon's sister, Mme. Murat, provides the author with yet another opportunity to disparage the "upstart" political systems that followed upon the revolution.

The third volume of *Souvenirs* concludes with a series of "pen portraits," brief essays on famous individuals. Of greatest interest to art history is her perception of Jacques-Louis David, whose activities during the Reign of Terror are cited as the rationale for her highly negative account. This excerpt also contains the revealing self-criticism by David, "One would think that my painting was done by a woman and the portrait of Paisello [sic] by a man." The conjunction of artistic quality with masculinity could be no more self-evident than in this statement.

Written at the very end of her life, when she was isolated from contemporary painting activities during the July Monarchy, Vigée-Lebrun's lengthy autobiography, although often modest in tone, is in fact a defiant final bid for fame and the survival of her reputation for posterity.

On the Death of Her Father and Her Early Training: "My Aptitude for Painting Was Remarkable"

Until this moment, my dearest, I have chosen to speak only of life's pleasures. Now I must tell you of my first heartfelt sorrow, my first real pain.

I had just spent a very happy year in the family home, when my father fell ill. He had accidentally swallowed a fish bone which had become lodged in his stomach. In order to remove it he had to undergo several operations. These were performed by the cleverest surgeon of our time, Brother Côme. We had every confidence in this man, a man who had something of the saint about him. He cared for my father with a devotion born of love; however, in spite of his zeal, the wounds festered and after two months of suffering, my father's condition left little hope of his recovery. My mother cried day and night and I shall not attempt to convey my despair. I felt that I was about to lose the very best of fathers; he was my support, my guide and it was his kind encouragement that had fostered my first attempts at painting.

When he knew that he had little time to live, he summoned both my brother and I. Sobbing, we drew near to the bedside. His features were cruelly altered, his eyes, his expression, usually so animated, were now motionless, for death's chill pallor had already spread across his face. We took up an icy hand and covered it with kisses, soaking it with our tears. He made a great effort and lifted himself up to give us his blessing: "Be happy my children," he said. One hour later our excellent father had left us forever.

I was so overcome with grief that it was a long while before I could resume work. Doyen came to see us occasionally and his visits were a great comfort to us. It was thanks to him that I continued in my beloved profession, which proved to be the only effective distraction in softening my feelings of regret and steering my mind away from sad thoughts. It was during this period that I began to paint from nature, completing several pastel and oil portraits in quick succession. I also drew from nature, continuing the work at home by lamp light, usually with Mlle Boquet with whom I was friendly at the time. I would go to her house in the evenings, on the Rue St Denis opposite Rue Truanderie, where her father owned a bric-a-brac shop. The route was a fairly lengthy one since we lived on the Rue de Cléry opposite the Hôtel de Lubert but my mother always made sure I was chaperoned. In those days Mlle Boquet and I often went to draw at the house of the painter Briard and he lent us his drawings and classical sculptures to copy. Briard was a painter of middling ability, although he did paint some remarkable ceilings, noted for their fine composition. He was also a talented line artist. For this reason several young people sought him out as their teacher. He had a residence at the Louvre and in order to be able to spend more time drawing there, we would each bring a basket containing some light midday fare; the maid usually carried this. I can still remember the fun of buying delicious morsels of beef from the concierge at the Louvre gates; they were always cooked to perfection. I don't think I have eaten anything quite so tasty since.

Mlle Boquet was then fifteen and I was fourteen; we were rivals in beauty, for I have forgotten to mention, dear friend, that a metamorphosis had taken place and I was now really quite pretty. My aptitude for painting was remarkable and my progress so rapid that I became a topic of conversation in high places; all this led to my making the agreeable acquaintance of Joseph Vernet. This famous artist encouraged me and gave me some excellent advice: "My child," he said, "do not follow any school of painting. Look only to the old Italian and Flemish masters; but above all, draw as much as you can from nature, nature is the greatest teacher of all. Study her carefully and you will avoid falling into mannerisms." I have always followed this advice, for I have never really had a teacher as such. Vernet himself has proved his theory through his work, which has been and always will be justly admired.

I also made the acquaintance of the Academician, the Abbé Arnault. He was a man who possessed both a keen imagination and a passion for literature and the arts; his conversation was a rich source of ideas and I drank deeply thereof. He spoke of painting and music with the liveliest enthusiasm. An ardent admirer of Gluck, he took me to see his great composer for I was passionately fond of music.

My mother became very proud of my features and also my figure for I had finally

rounded out and now had the freshness of a young woman. On Sundays she took me to the Tuileries; indeed she herself was still very beautiful. So many years have passed since then that I feel I can now tell you that people used to follow us about, and in a manner I found more embarrassing than flattering.

Seeing that I was still grief stricken by the cruel loss of my father, my mother decided that there could be no better distraction than the art galleries. Consequently she took me off to the Palais de Luxembourg whose walls were hung with the masterpieces of Rubens; in fact there were many rooms full of paintings by the greatest of old masters. These days there are only modern French paintings on view here and I am the only painter who has not been included in the collection. The other paintings have since been transferred to the Louvre where the Rubens lose a great deal for not being seen in their place of origin—the difference between a well lit and a badly lit painting is as great as that between a well acted and a badly acted play.

We also used to go and see some splendid private collections. Rendon de Boisset owned a gallery of Flemish and French painting. The Duc de Praslin and the Marquis de Lévis had wonderful collections of great masters from every school. M. Harens de Presle also had a very fine collection of the Italian masters; but none of these could compare with that of the Palais-Royal. This collection had been gathered by the Regent and was full of grand Italian masterpieces. The palace was sold during the Revolution; an Englishman, Lord Stafford, bought up most of it.

As soon as I entered these great galleries, I behaved just like a bee, gathering knowledge and ideas that I might apply to my own art. I became intoxicated with pleasure as I contemplated the work of my great forbears. I would copy the paintings by Rubens, the portraits by Rembrandt and van Dyke as well as several paintings of young girls by Greuze, all of which I hoped would strengthen my own skill. Greuze gave a perfect illustration of how to use half tones, to be found in his delicate flesh tints. Van Dyke's paintings show this too, but more subtly.

From studying this work, I learnt the important skill of shading light as it falls onto the salient parts of the head, shading which I so admired in the work of Raphael; but then perhaps he is the most perfect of all painters. It is worth noting that one can only really judge Raphael's work under the beautiful Italian sky. Later, I was able to view those masterpieces which had never left Italy and I found Raphael to be even greater than his reputation suggested.

My father had not left us a great amount of money, but, in truth, I was already earning a fine sum from the many portrait commissions I had received. However, this sum was not enough to cover household expenses, especially since I was expected to pay my brother's school fees and buy his clothes, books etc. So my mother was obliged to remarry. She wed a wealthy jeweller and we never suspected his miserliness until after the wedding;[7] then he showed himself to be such a skinflint that he refused us everything, in spite of the fact that I had the goodness to give him all my earnings. Joseph Vernet was furious; he kept telling me to pay for my board alone and to keep any money that was left over for myself. But I could do nothing of the kind, being fearful for my mother, for it was she who would suffer with such a mean man for a husband.

I hated this man; even more so since he made use of my father's personal possessions. He wore his clothes, just as they were, without even altering them to fit his figure. So, you can understand, my dear, what a miserable effect he had on me!

As I have already said, I was much in demand as a portrait painter and already my reputation was attracting attention from outside France. Several important figures from Russia came to see me; among others the notorious Count Orloff, one of the assassins of Peter III. He was an enormous man and I remember he wore a huge diamond on one finger.

Marriage to Lebrun and Birth of a Daughter

Dear friend, when my stepfather retired from business, we went to live at a mansion called Lubert on Rue de Cléry. A M. Le Brun had just bought the house and was in fact living there himself. As soon as we had settled in, I went to his apartment to see his collection of paintings; his walls were adorned with examples from every school imaginable. I was thrilled to be living near so many great masterpieces and to have the opportunity of viewing them at my leisure. M. Le Brun was extremely kind and gave me permission to borrow the paintings so that I might copy them. This was no small favour, for they were both extremely fine and of great value. It was to him therefore that I owed the best form of instruction I could get; at the end of six months however, M. Le Brun asked for my hand in marriage. Nothing could have been further from my thoughts than my marrying Le Brun, despite the fact that he was an attractive man with a pleasing countenance. I was then twenty years old; I had few worries about my future since I was already earning a substantial amount of money. In short, I had no inclination to wed at all. My mother, on the other hand, insisted that I should be foolish indeed to refuse such an advantageous offer. Finally, I accepted, goaded on by the desire to escape the torment of living with my stepfather, whose bad temper had grown steadily worse now that he had nothing to occupy his time. So little inclined was I to sacrifice my freedom, that even as I approached the church on my wedding day, I was still asking myself, "Shall I say yes or no?" Alas, I said yes and merely exchanged my old problems for new ones.[9] I do not wish to paint M. Le Brun as a wicked man; his character was a mixture of sweetness and gaiety. He was of an obliging nature, a kind man in fact; but his overwhelming passion for extravagant women, combined with a love of gambling, decimated both his fortune and my own, of which he made very free use. So, by the time I left France in 1789 I had less than twenty francs to my name, in spite of the fact that I had earned more than a million from my work: he had squandered the lot!

My marriage was kept secret for a while. M. Le Brun was officially engaged to the daughter of a Dutch art dealer with whom he was conducting some lucrative business; he begged me not to declare our union until the deal had been completed. I was only too happy to consent for I was most reluctant to lose my maiden name under which I was already quite well known. This secrecy, however, cast rather a gloomy shadow over my future. Several acquaintances who thought that I was simply about to marry Le Brun

sought me out, urging me not to go ahead with such an idiotic plan. First to arrive was Auber, the crown jeweller, who confided in the name of friendship, "You would do better to tie a stone around your neck and throw yourself in the river than marry Le Brun." Next came the Duchesse d'Aremburg, together with Canillac and Mme de Souza, the Portuguese ambassadress; all three were so young and pretty then! They came with belated advice, for I had married two weeks previously. "For Heaven's sake," said the Duchess, "don't marry Le Brun; he will make you so unhappy!" She proceeded to recite a great many stories which I did not really believe until later when I found it only too easy to confirm her words. My mother, who was present while all this was being said, could scarcely hold back her tears.

When I finally announced my marriage officially, these gloomy warnings ceased. I was not as downcast as I might have been, for I still had my beloved painting. I was overwhelmed with commissions from every quarter and although Le Brun took it upon himself to appropriate my earnings, this did not prevent him from insisting that I take pupils in order to increase our income even further. I consented to this demand without really taking time to consider the consequences and soon the house was full of young ladies learning how to paint "eyes, noses and faces." I was constantly correcting their efforts and was thus distracted from my own work, which I found very irritating indeed.

Among these pupils was a certain Mlle Emilie Roux de la Ville; she has since married M. Benoist, Directeur des Droits réunis and the man for whom Denoustiers wrote *Lettres sur la Mythologie*.[10] The talent which has since made her justly famous was already apparent in the pastel heads she painted for me. Mlle Emilie was the youngest of my pupils, for the greatest number were older than I. I felt this made it far more difficult for me to attain their awe and respect which is an essential feature of teaching. I had set up a studio for these young women in an old attic, a disused hayloft, and the old thick beams were still visible in the ceiling. One morning I climbed the stairs to the studio only to find that my pupils had attached a rope to one of the beams and were happily swinging back and forth, trying to balance as best they could. I adopted a "serious" manner and scolded them; I also gave a fine speech on the evils of time wasting. Then of course I wanted to try out the swing and soon I was enjoying myself even more than my pupils. It must be obvious to you that a personality such as mine found it difficult to assert authority. This problem, combined with the irritation of having to revert to the ABC of painting whilst correcting their work soon made me renounce the idea of teaching altogether.

I believe the strain of having to leave my precious brushes for several hours each day only increased my eagerness to paint. I refused to leave my easel until nightfall and the number of portraits I painted at this period is quite astonishing. As I had a horror of the current fashion, I did my best to make my models a little more picturesque. I was delighted when, having gained their trust, they allowed me to dress them after my fancy. No-one wore shawls then, but I liked to drape my models with large scarves, interlacing them around the body and through the arms, which was an attempt to imitate the beautiful style of draperies seen in the paintings of Raphael and Dominichino. Examples of this can be seen in several of the portraits I painted whilst in Russia; in

particular, one of my daughter playing the guitar. Above all I detested the powdering of hair and succeeded in persuading the beautiful Duchesse de Grammont-Caderousse not to wear any when she sat for me.[9] Her hair was as black as ebony and I parted it on the forehead, arranging it in irregular curls. After the sitting, which ended around dinner time, the Duchess did not alter her hair at all and left directly for the theatre; being such a pretty woman, she was quite influential and her hair style gradually insinuated itself into fashionable society and eventually became universal. This reminds me of the time when I painted the Queen in 1786: I begged her not to powder her hair but to part it on the brow. "I shall be the last to follow that fashion," said the Queen laughing. "I do not want people to say that I invented it to disguise my large forehead."

I tried as far as I was able to give the women I painted the exact expression and attitude of their physiognomy; those whose features were less than imposing, I painted dreaming, or in a languid, nonchalant pose. In the end they must have been pleased with the result, for I had difficulty in keeping up with the demand for my work and the list of potential customers grew longer and longer. In short, I was the fashion; fate seemed to be uniting everything in my favour. You will understand what I mean when I describe the following scene, which has left me the most satisfying memories. A little while after my marriage, I attended a meeting of the Académie Française; La Harpe was reading his discourse on talented women, when he came to this verse, full of exaggerated praise, which I heard for the first time

> Lebrun, of beauty both painter and model,
> The modern Rosalba, but more brilliant even than she,
> Unites the voice of Favart with the smile of Venus.

The author of *Warwick* looked across at me; whereupon everyone present, not excepting the Duchesse de Chartres and the King of Sweden, who were witnessing the meeting, rose to their feet, turned towards me and applauded so heartily that I was overcome with embarrassment.

The pleasures of vanity such as I am now recounting dear friend, and you did insist that I tell all, could not compare, however, with the joy I felt, when after two years of marriage, I discovered I was carrying a child. Now you will see how my devotion to art made me careless in the day to day details of life; for happy as I was at the idea of becoming a mother, after nine months of pregnancy, I was not in the least prepared for the birth of my baby. The day my daughter was born, I was still in the studio, trying to work on my *Venus Binding the Wings of Cupid* in the intervals between labour pains.

My oldest friend, Mme de Verdun, came to see me in the morning. She felt certain that the child would be born that same day and, since she was also acquainted with my stubborn nature, asked if I had everything I needed. I replied that I had no idea what it was I needed. "That's typical of you," she rejoined. "A tomboy to the last. I'm warning you, that baby will be born tonight." "Oh no," I said, "I have a sitting tomorrow, it can't be born today." Without saying another word, Mme de Verdun left and sent for the doctor. He came at once. I sent him back but he remained hidden in the house

until the evening and at ten o'clock my daughter was delivered into the world.[11] I shall not even attempt to describe the joy I felt on hearing her first cry. It is a feeling that all mothers will understand, increased by its coinciding with the relief following such atrocious pain. According to M. Dubuc, and he expresses it perfectly I think, happiness occurs when the mind is absorbed in an atmosphere of calm.

Queen Marie Antoinette

It was in the year 1779, my dear, that I first painted the Queen; she was then at the height of her youth and beauty. Marie Antoinette was tall, very statuesque and rather plump, though not excessively so. She had superb arms, small perfectly formed hands and dainty feet. Of all the women in France she had the most majestic gait, carrying her head so high that it was possible to recognise the sovereign in the middle of a crowded court. However, this dignified demeanour did nothing to detract from her sweet and kindly aspect. In short, it is very difficult to convey to anyone who has not seen her that perfect union of grace and nobility. Her features were not at all regular; she bore the long, narrow, oval face of her family, typical too of the Austrian race. Her eyes were not particularly large and a shade approaching blue. Her expression was intelligent and sweet, her nose fine and pretty, her mouth was not wide, although her lips were rather full. Her most outstanding feature, however, was the clarity of her complexion. I have never seen another glow in the same way, and glow is exactly the right word, for her skin was so transparent that it could not catch shadow. Indeed I was never satisfied with the way I painted it; no colour existed which could imitate that freshness or capture the subtle tones which were unique to this charming face. I never met another woman who could compete in this regard.

At the first sitting, I was very much in awe of Her Majesty's imposing air; but she spoke to me in such a kindly fashion that her warm sympathy soon dissolved any such impression. This sitting produced that painting of her holding a large basket, dressed in a gown of satin with a rose in one hand. It was destined for her brother, the Emperor, Joseph II, and the Queen ordered two copies, one for the Empress of Russia, the other for her apartments in Versailles or Fontainebleau. I painted a succession of portraits of the Queen on various occasions. . . . In one portrait, I painted her only to the knee, wearing an orange-red dress and sitting before a table upon which she was arranging some flowers in a vase. You can imagine how I preferred to paint her without any ostentatious dress and especially without the "obligatory" straw basket. These portraits were given to friends or ambassadors. One in particular showed her wearing a straw hat and a dress of white muslin with the sleeves pulled neatly back. When this painting was exhibited in the Salon, the evil tongues could not resist the temptation of saying that I had painted the Queen in her underwear; for it was then 1786 and the slander had already begun.

Nevertheless, this portrait was a success. Towards the end of the exhibition there was a small vaudeville play being performed entitled, I believe, *La Réunion des Arts.*

Brongniart the architect and his wife were in the author's confidence and they booked some first class seats before coming to fetch me on the opening night and driving me to the show. As I had absolutely no idea of the surprise they had prepared for me, you can imagine my feelings when *The Art of Painting* came onto the stage and the actress playing the role proceeded to copy me in the act of painting the Queen. At that very moment the entire audience, those in the stalls and those in the boxes, turned towards me and applauded heartily. I don't believe I was ever so moved or so grateful as I was that evening.

The shyness that I had felt on my first encounter with the Queen was soon dissipated by the gracious benevolence which she always showed toward me. As soon as Her Majesty heard that I had a pretty voice she often asked me to sing with her during the sittings, usually Grétry's duets, although her voice was not always perfectly pitched. As for her manner, it would be difficult to describe it in all its amiable grace. I don't think that Queen Marie Antoinette ever missed the opportunity of saying a kind remark to whoever had the honour of meeting her and the kindness that she bestowed upon me is one of my dearest memories.

One day I happened to miss an appointment which she had been gracious enough to grant me for a sitting. I was absent because, late into my second pregnancy,[12] I had been seized by a terrible pain. I rushed to Versailles the next day in order to make my apologies. The Queen was not expecting me and had ordered a carriage to go for a ride, and this carriage was the first thing I saw on entering the palace yard. I did not continue however without talking to the Queen's personal staff. One of them, M. Campan, received me in a cold, dry manner and addressed me in his stentorian tone: "The Queen was expecting you yesterday Madame. She is almost certainly about to go for her walk now and will not be able to sit for you today."

Upon my reply, that I had simply come to ask Her Majesty if she could sit for me another day, he went off to find the Queen. I was straightway invited to enter her chambers where Her Majesty was finishing her toilette. Holding a book in one hand, she was going over a lesson with her daughter. My heart was pounding, for my fear was more than equal to my error. The Queen turned towards me and said softly, "I waited all morning for you yesterday. What happened to you?" "Alas, Madame," I replied, "I was in such pain that I could not carry out Your Majesty's wishes. I have come today to receive fresh orders, and then I shall leave immediately." "No, no, don't go," continued the Queen. "I would hate to think that your journey had been a wasted one." She dismissed the barouche and sat for me. I remember being so eager to show my gratitude for her goodwill, that I seized my paintbox with great enthusiasm, causing it to overturn; my brushes and pencils were scattered all over the floor. I bent down in order to redress the consequences of my clumsiness. "Leave them, leave them," said the Queen, "your condition is too far advanced for you to bend safely." However much I tried to dissuade her, she went on to pick them all up herself.

I followed the Queen on her last trip to Fontainebleau, where, according to tradition, the court was supposed to be at its most splendid and I wanted to enjoy the spectacle. The Queen was dressed magnificently, her costume glittering with diamonds;

she appeared in glorious sunshine and so seemed a perfectly dazzling sight. The angle of her head sitting elegantly upon its handsome Grecian neck gave her such an air of majesty as she walked by that one was reminded of a goddess surrounded by nymphs. During the first sitting after this journey, I took the opportunity of describing to the Queen the impression she had made upon me that day and that the way she held her head added greatly to her noble aspect. She replied with more than a touch of humour in her voice: "But if I were not the Queen, people would say, 'What an arrogant manner that woman has!' Is that not so?"

The Queen was most assiduous in teaching her children those sweet ways which made her so dear to all who knew her. I have seen her showing her daughter, then aged about six, how to dine properly; her companion was a local country girl whom she was taking care of; the Queen insisted that the latter be served first, saying to her daughter, "It is you who ought to serve her."

The last sitting I obtained from Her Majesty was at Trianon, where I painted her head for the large canvas; I included her children in this painting. I remember that the Baron Breteuil, then a minister, was present and for the duration of the sitting he did nothing but criticise the other ladies of the court. He must have thought me either deaf or exceedingly good natured in order to trust me not to repeat his spiteful remarks to those concerned. The fact is I never spoke a word of what he said to anyone, although I have not forgotten it either.

Having finished the Queen's head as well as separate studies for the Premier Dauphin, the Madame Royale and the Duc de Normandie, I returned to this painting which had become so important to me and completed it in time for the Salon of 1788. The sight of the frame alone being carried in gave rise to scores of unpleasant remarks! "So that's where our money goes!" Several other comments of this nature were relayed to me, causing me to expect the most strident criticism. Finally I sent on the painting, but I no longer had the courage to follow it and discover its fate, so frightened was I of being abused by the public. My terror grew to such a size that I developed a temperature; I went and locked myself in my room. I was still there, praying to the good Lord for the success of "my" Royal Family, when my brother burst in with a crowd of friends to say that I had received universal acclaim.

After the Salon the King brought this painting to Versailles. However, it was M. D'Angevilliers, then Minister of Arts and Keeper of the Royal Palaces, who presented me to His Majesty. Louis XVI was kind enough to talk with me for some time and said that he was very pleased with my work; then he added, still looking at the picture, "I know nothing about painting; but I have grown to love it through you." My painting was hung in one of the rooms in Versailles, and the Queen always passed it on her way to mass. When the Dauphin died in the early part of 1789, the sight of the picture moved her greatly, refreshing the memory of the cruel loss she had recently sustained. Indeed, she was not able to pass through this room without bursting into tears. Finally she asked M. D'Angevilliers to take it down. The Queen, of course, with her usual grace, told me of her intention straight away and also the reason for her decision. In fact, the preservation of this painting is due almost entirely to the sensitivity of the

Queen; for the ruffians and bandits who came there shortly after to hunt out their Majesties, would have almost certainly destroyed it with their knives, just as they attacked the Queen's bed, tearing it to shreds!

I never had the pleasure of seeing Marie Antoinette after the last court ball at Versailles. The ball was held in the theatre and my box was close enough to that of the Queen for me to hear everything she said. I saw that she was perturbed by the fact that all the young men of the court spurned her invitation to dance; one of these young men was Monsieur de Lambeth whose family had been showered with kindness by Her Majesty. This happened so often that it became impossible to arrange many of the pair dances. I was struck by the indecorous behavior of these young men. I do not know why, but their refusals seemed to me to be a sort of revolt, a prelude to revolution, a foretaste of the more serious revolts to come. The Revolution was creeping closer; it would explode in the following year.

With the exception of the Comte d'Artois, I had now painted the whole of the Royal Family in succession; the royal children, Monsieur, the King's brother, later Louis XVIII, his wife, the Comtesse d'Artois and Princesse Elisabeth. The features of the latter were not regular but her face expressed the sweetest good nature and her fresh complexion was indeed worthy of note; in all, she had the sort of charm that one finds in a young shepherdess. However, do you not know, my dear friend, that Princesse Elisabeth was a veritable angel of goodness. How many times I witnessed her kind treatment of the unfortunate! Her heart harboured all the virtues; she was tolerant, humble, sensitive and devoted. The Revolution showed that she also possessed an heroic courage; this sweet princess was seen to walk in front of the butchers who had come to assassinate the Queen, saying, "Perhaps they will mistake me for her"!

The portrait I painted of the King's brother afforded me the opportunity of meeting a man whose wit and scholarship one could praise without recourse to flattery; it was impossible not to enjoy oneself in the company of Louis XVIII, who could talk on any subject with as much good taste as knowledge. However, there were occasions when, no doubt for the sake of variety, he would sing during our sittings; not indecent songs, but songs of such a basic nature that I was baffled to think by what means such silly ditties might appear at court. Also, he always sang terribly out of tune. One day he asked me, "How do I sing, Madame Le Brun?" "Like a prince, monsieur," I replied.

The Marquis de Montesquiou, the Prince's Equerry, sent a very pretty carriage with six horses to bring my mother, whom I had begged to accompany me, and myself to Versailles and to take us home again. All along the route, people stood at their windows to watch us pass; everyone lifted their hats. I laughed at the homage paid to six horses and the groom who rode at the front. On my return to Paris, I mounted a plain cab and henceforth nobody paid any attention to me whatsoever.

This Prince was a liberal, in the moderate sense of the word you understand. He and his courtiers formed a circle at court very distinct from that of the King. So I was not at all surprised to see that during the Revolution the Marquis de Montesquiou was named General in Chief of the Republican Army in Savoy. I had only to remember the singular conversations that I had heard personally, without mentioning his blatant criti-

cisms of the Queen and all those whom she loved. As for the Prince himself, the papers showed him presenting himself to the National Assembly, declaring that he did not want to take his seat as a prince, but as a 'citizen'. Even so, I doubt that such a declaration would have been sufficient to save his neck and he was very wise to leave France as he did shortly after.

During the same period I also painted a portrait of the Princesse de Lamballe. Without being pretty, she often appeared so from a distance. Her features were small, her complexion fresh and sparkling, her hair a superb blonde and as a whole she carried herself with extreme elegance. The horrible end that befell this Princess is well known; she perished a victim of her own devotion. In 1793 she was living in Turin, safe from all danger, but decided to return to France when she heard that the Queen was in danger.

I have wandered far from my original intention, my dear, of describing the year 1779, but I wished to explain in one letter my relationship as an artist to all these noble people of whom none survives today except the Comte d'Artois, Charles X, and the unfortunate daughter of Marie Antoinette.

A thousand tender thoughts go with this letter.

1783: Rubens's *Chapeau de Paille* and Admission to the Royal Academy

We returned to Flanders to see the great works of Rubens again. They were far better placed there than they are now in the Paris museum. The Flemish churches suited them perfectly and created a wonderful effect; other great works by the same master adorned the walls of smaller, private galleries. At Antwerp I came across the famous *Chapeau de Paille*,[13] which has just recently been sold to an English man for a considerable sum. This beautiful painting depicts one of Rubens' wives. Its great power lies in the subtle representation of two different light sources, simple daylight and the bright light of the sun. Thus the highlighted parts are those lit by the sun and what I must refer to as shadow, is, in fact, daylight. Perhaps one must be a painter to appreciate the brilliance of Rubens' technique here. I was so delighted and inspired by this painting that I completed a self portrait whilst in Brussels in an effort to achieve the same effect. I painted myself wearing a straw hat with a feather and a garland of wild flowers, and holding a palette in one hand. When this picture was exhibited at the Salon, I must say it did much to enhance my reputation. The celebrated Muller made an engraving from it; but you must feel as I do that the black shadows of an engraving take away all the particular effect of a painting such as this.

A little while after my return from Flanders in 1783, Joseph Vernet, on the strength of this painting and several others besides, decided to propose me as a member of the Académie Royale de Peinture. M. Pierre, the King's painter, strongly opposed the idea; he did not believe, he said, in the inclusion of women; and yet Mme Vallayer-Coster, a talented flower painter, was already a member; indeed I believe that Mme Vien was another. However talentless this M. Pierre might have been as an artist, for his

vision extended only as far as brush technique, he possessed a certain wit; what is more, he was rich and this enabled him to receive artists in a rather luxurious fashion, artists being rather more impecunious than they are now. His opposition to my entry should have proved fatal to me, had it not been for the fact that in those days all genuine lovers of art were associates of the Académie de Peinture and they formed a petition in my favour against M. Pierre, which gave rise to the following couplet.

For Madame Le Brun
Upon the tune, *Ardimer, do you not see?*

> *In the Salon your triumphant art*
> *Should be emblazoned.*
> *To rob you of your honour[3]*
> *One must have a heart*
> *Of stone, of stone, of stone[14]*

Eventually, I was admitted.[15] M. Pierre then started the rumour that I had been admitted only on the Court's command. In all honesty I believe that the King and Queen were pleased to see me received into the Academy but that was the limit of their goodwill. As my entry painting I gave *Peace Bringing Back Abundance*. This painting hangs today in the Ministry of the Interior. In fact they ought to have returned it, for I am no longer a member of the Academy.

I continued to paint at a furious pace and I often held three sittings in a single day. I found the evening sittings excessively tiring and this fatigue eventually led to a disorder of the stomach. I was unable to digest and became dangerously thin. My friends asked the doctor to recommend rest after lunch. I had great difficulty in acquiring this habit but I remained in my bedroom with the curtains drawn and little by little sleep came upon me. Now I am sure that I owe my life to this routine. You know, my dear, how I value this period I call "my calm." Continuous work combined with the fatigue from frequent travelling over long distances has now made it an absolute necessity; without this short simple rest which I have continued over the years, I would not be here writing to you. My only reservation is that this enforced siesta has deprived me of the pleasure of lunching in town; and as I used to devote my entire morning to painting, I was never able to see my friends until the late evening. Despite this I can still say that I was not deprived of social pleasure for I spent my evenings in the most amiable and talented company.

After my marriage I continued to live in Cléry Street where M. Le Brun possessed a large and richly furnished apartment; paintings by great masters hung on every wall. As for me, I was relegated to a small antechamber and a bedroom which had also to serve as a salon. The walls of this room were papered and the design was an echo of the Jouy cloth used in the curtains around the bed. The furniture was simple, basic even. However this did not prevent M. de Champcenetz from writing that "Madame Le Brun lived in gold panelled rooms, lit her fire with bank notes and burnt only aloe wood in

her grate''; all this because his mother-in-law was jealous of me. However I shall delay for as long as possible before telling you about the thousands of slanders that have plagued my life; we shall come to them later. One explanation for the bitterness of these remarks is the fact that I received grand guests from town and court nearly every evening in the self same apartment I have just described to you. Great ladies and noble lords, famous names in literature and the arts, all came to visit me in this very room. Sometimes the crowd was such that the Maréchaux de France had to sit on the floor for there were not enough chairs. I remember one evening in particular when the Maréchal de Noailles, who was very old and fat, had great difficulty in getting back onto this feet.

"Women Reigned Supreme Then; The Revolution Dethroned Them"

I dined several times at Saint-Ouen, home of the Duc de Nivernais: his house was so beautiful and the friends who met there were the most amiable set imaginable. The Duc de Nivernais who is always quoted as the model of a cultured, refined sensibility, was also dignified and gentle in his manner without being in the least bit affected. He was especially noted for the respect he showed to women, of whatever age. I would have considered him supreme in all these regards, if I had not known the Comte de Vaudreuil, who, though many years younger than M. de Nivernais, nevertheless combined an exquisite courtesy with a politeness that was even more touching since it came straight from the heart. Besides, it is so difficult today to explain the urbane charm, the easy grace, in short all those pleasing manners which, forty years ago, were the delight of Parisian society. The sort of gallantry I am describing has totally disappeared. Women reigned supreme then; the Revolution dethroned them. . . .

Life in Italy

I also climbed the steps to the Sistine chapel, to admire the dome with a fresco by Michelangelo as well as his painting of *The Last Supper*.[16] Despite all the criticisms of this painting, I thought it a masterpiece of the first order for the expression and the boldness of the foreshortened figures. There is a sublime quality in both the composition and in the execution. As for the general air of chaos, I believe it to be totally justified by the subject matter.

The following day I went to the Vatican Museum. There is really nothing to compare with the classical masterpieces either in shape, style or execution. The Greeks, in particular, created a complete and perfect unison between truth and beauty. Looking at their work, there is no doubt that they possessed exceptional models, or that the men and women of Greece discovered an ideal of beauty long, long ago. As yet I have made only a superficial study of the museum's contents, but the *Apollo, The Dying Gladiator, The Laocoön,* the magnificent altars, the splendid candelabras, indeed all the beautiful things that I saw have left a permanent impression on my memory.

Leaving the house for this particular visit to the museum, I was called upon by

members of the Academy of Painting, including Girodet. They brought me the palette of the young Drouais, and in exchange asked for a few of my paintbrushes. I cannot hide from you, my friend, the delight I felt at being distinguished for this honour, it was such a flattering request; I shall always be grateful for this sweet memory.

How I regret the absence of the young Drouais, whom death has so cruelly snatched from us! I knew him in Paris; he had even dined at my house with his friends the night before they all left for Rome. I am sure you have not forgotten his splendid *Marius.* I can still see it. A crowd arrived to see the painting exhibited at his mother's house. Alas! Death has little respect in these matters: did he not also strike down Raphael before his thirty-eighth year? Did he not rob the world of this genius at the height of his power and artistic force? . . .

I have seen Angelica Kaufmann; I was extremely keen to meet her. I found her most interesting; apart from her fine talent, she was intelligent and witty. A very delicate seeming woman, she might easily pass for fifty; her health became impaired after her first marriage for she had the misfortune to marry an adventurer who ruined her. She subsequently remarried, and her present husband, an architect, is also her financial advisor. We had some long and interesting conversations during the two evenings I spent with her. Her speech was genteel and well informed but due to her lack of enthusiasm and my own dearth of knowledge she did little to inspire me.

Angelica possesses a few paintings by the great artists, and I also saw several of her own works while in her home. I preferred her sketches to her paintings, for the colour of the former resembled that of Titian.

Yesterday I went out to dine with her at the home of our ambassador, Cardinal Bernis, whom I visited three days after my arrival in the city. . . .

As soon as I had returned to Parma, where I had spent so little time previously en route to Rome, I was welcomed as a member of their Academy and I donated a small portrait of my daughter which I had just completed. In the same week I had an equally gratifying experience in this town. I had brought with me the painting of Lady Hamilton as a sibyl: having finished the painting during my sojourn in Naples, my plan was to take it back to France, for I expected to return there shortly. As the paint was still quite fresh when I arrived in Parma, I hung the picture on its stretcher in one of my private rooms so that it would not yellow. One morning, whilst performing my toilette, I was told that there were seven or eight art students downstairs who wished to see me. They were ushered into the room where I had placed my *Sibyl* and a few minutes later I went to receive them. Having spoken of their desire to meet me, they continued by saying that they would very much like to see one of my paintings. "Here is one I have recently completed," I replied, pointing to the *Sibyl.* At first their surprise held them silent; I considered this far more flattering than the most fulsome praise; several then said that they had thought the painting the work of one of the masters of their school; one actually threw himself at my feet, his eyes full of tears. I was even more moved, even more delighted with their admiration since the *Sibyl* had always been one of my favourite works. If any among my readers should accuse me of vanity, I beg them to reflect that an artist works all his life to experience two or three moments such as the one I have just described.

The Portrait of Mme. Murat

One of the first people I saw on my return from London was Mme de Ségur, and I was a frequent visitor to her house. One day her husband led me to understand that my trip to England had somewhat displeased the Emperor who had said: "Madame Le Brun has gone to see *her friends.*"

Bonaparte's grudge against me could not have been very deep, for a few days after he was supposed to have said this, he sent M. Denon[17] to commission me to paint a portrait of his sister, Mme Murat. I did not think it proper to refuse, although I was only paid eighteen hundred francs for the painting, that is, less than half of my usual fee for a similar size portrait. In the end the price turned out to be even more moderate: for the sake of composition I included Mme Murat's daughter in the painting, a very pretty little girl, but I did not demand a larger fee because of this.

It would be impossible to describe all the vexations and torment I had to suffer while painting this portrait. First of all Mme Murat arrived with two ladies in waiting who proceeded to dress her hair as I tried to paint her. When I observed that it would be impossible to capture a likeness if I allowed them to continue, she eventually agreed to send the two women away. Added to this inconvenience, she almost always broke our appointments, which meant my staying in Paris for the whole summer waiting, usually in vain, for her to appear, for I was eager to finish the painting; I cannot tell you how this woman tried my patience. Moreover the gap between sittings was so long, that each time she did appear, her hair was dressed differently. At the beginning, for example, she had curls falling onto her cheek and I painted them accordingly; but a little later this style had gone out of fashion and she returned with a completely different one; I then had to rub out the curls as well as the pearls on her *bandeau* and replace them with cameos. The same thing happened with the dresses. The first dress I painted was rather open, as was the fashion then, and had a great deal of bold embroidery; when the fashion changed and the embroidery became more delicate, I had to enlarge the dress in order not to lose the detail. Eventually all these irritations reached a pitch, and I became very bad tempered as a result; one day she happened to be in my studio and I said to M. Denon, in a voice loud enough for her to overhear: "When I painted real princesses they never gave me any trouble and never kept me waiting." Of course Mme Murat did not know that punctuality is the politeness of kings, as Louis XIV quite rightly remarked and he, at least, was no upstart.

Pen Portrait of David

I was keen to seek out the company of all famous artists, especially those distinguished in my own particular field. David was a frequent visitor to my house, then suddenly he stopped appearing. I met him elsewhere in society and thought I would cajole him in a friendly way on the subject. "I do not like," he said, "to be part of a hierarchy." "What?" I replied. "Do you think I treat the people from the court better than the

rest? Don't you think I receive everyone with the same welcome?'' He continued to insist on his point, although jokingly. ''Ah,'' I said laughing. ''I believe you suffer from pride; it hurts you not to be a Duke or a Marquis. I am quite indifferent to title and am equally happy to receive all, provided they are amiable people.''

From then on David never came back. He even directed the hate that he bore some of my friends towards me. This came to light later, when he procured some heavy tome written against M. de Calonne, in which the author had not forgotten to drag up all the infamous slanders of which I was the object. This book sat permanently on a stool in David's studio, and was always open at the very page upon which I was mentioned. Such wickedness was both so insidious and so childish that I would have found it difficult to believe, had I not been informed of the fact by the Duke Edward Fitz-James and by the Comte Louis de Narbonne, as well as others of my acquaintance, who all remarked upon it, and on several occasions.

However it must be said that David loved art so much that no petty hatred could prevent him from appreciating talent wherever he saw it. After I left France, I sent the portrait of Paisiello, which I had just finished painting in Naples, to Paris. It was hung in the Salon beneath a portrait by David, who was evidently not satisfied with his work. Approaching my painting, he looked at it for a long time and then, turning towards some of his pupils and other companions said: ''One would think that my painting was done by a woman and the portrait of Paisello [sic] by a man.'' M. Le Brun overheard him say this and reported it back to me; moreover, I know that David always took the time to praise my work whenever the opportunity presented itself.

It might seem that such flattering praise for my work made me forget the personal attacks levelled at me by David, but one thing I could never forgive was his atrocious conduct during the Terror: he exercised a cowardly persecution against a large number of artists, including Robert,[18] the landscape painter, whom he had arrested and thrown into prison with a cruelty that touched on barbarity. It would have been impossible for me to renew my acquaintance with such a man. When I returned to France, one of our most famous painters[19] came to call upon me, and during the conversation said that David was eager to see me again. I did not reply, and as the painter was a very astute man, he understood that my silence was not of that type referred to in the saying ''we who say nothing mean yes.''

4

Rosa Bonheur (1822–1899)

Rosa Bonheur enjoyed enormous international popularity in the second half of the nineteenth century. Her paintings were exhibited in England and the United States as well as her native France. Her works, especially the wildly successful *Horse Fair* (Fig. 3), received wide distribution through engraved copies. She was the most famous woman artist during the years of the Second Empire (1855–70), and the first woman to receive the cross of the French Legion of Honor, presented to her personally in 1865 by the Empress Eugénie. And Bonheur's popularity was even more extensive and enduring in Britain than in France in the late Victorian era.[1]

As Albert Boime has so perceptively noted, her form of realism avoided the potentially volatile issue of urban or rural class conflicts and focused instead on the politically neutral world of animals.[2] Her art was therefore more acceptable to official tastes than that of her contemporary male colleagues, such as Courbet, Manet, or Millet.

Unlike the memoirs of Vigée-Lebrun and most of the other texts in this book written before 1945, Bonheur's autobiographical statements were recorded by someone else, Anna Klumpke, from conversations with the artist. Unlike contemporary interviewers, Anna Klumpke had no tape recorder to ensure accuracy. However, these transcribed statements are as close as we can come to a primary source for Bonheur's autobiography. Contemporary scholars have accepted this record as an accurate reflection of Bonheur's beliefs and perceptions about her own life.

The first half of *Rosa Bonheur: Sa Vie, Son Oeuvre,* (Her Life, Her Works) deals with Klumpke's initial meetings with Bonheur, the circumstances surrounding Klumpke's portrait of the much older and more famous artist, and the course of the two women's relationship.

Anna Elizabeth Klumpke (1856–1942), born in San Francisco, was an established artist by the time she first met Rosa Bonheur in 1889. Her strong mother, separated from her husband, took Anna and her three sisters to Europe. Klumpke enrolled in the Atelier Julian in the 1880s and won a medal in the Salon of 1885 for a portrait of her sister. (Her sisters would also distinguish themselves, in their chosen fields of medicine, music, and astronomy.)

The execution of the portrait of Bonheur by Klumpke, in 1898, deepened the

Figure 3. Rosa Bonheur, *The Horse Fair.* The Metropolitan Museum of Art, New York.

intimacy between the two women.[3] Anna Klumpke moved in with Bonheur and remained with her until her death in 1899, filling the void left by the death of Nathalie Micas, Bonheur's previous companion. The estate at By was left to Klumpke, indicating in a tangible way the strength of the attachment between these artists. Bonheur's faith in Klumpke was justified. In 1908, about a decade after Bonheur's death, the volume from which our excerpts are taken was published in French.[4]

Bonheur's family background was typical of the majority of pre-twentieth-century women artists. Like Gentileschi and Vigée-Lebrun, she was the daughter of an artist. She first learned to paint, along with her three siblings, from her father, Raymond Bonheur. Raymond was actively involved in the utopian movement of Saint-Simonianism, which questioned the prevailing social attitudes toward gender relations and political systems. Bonheur's critical attitude toward conventional gender stereotypes can be traced back to her early but influential home environment.

The first segment contains Bonheur's reminiscences about her early artistic training from her father. Her copying at the Louvre and drawing from plaster casts were standard practices for young artists. That Raymond Bonheur consciously spurred Rosa on, using the role model of Vigée-Lebrun, is of great interest; she would recall "being haunted night and day" by his words.

With the international success of *The Horse Fair* in 1855, Bonheur began to achieve financial independence. In 1860 she withdrew from Paris and lived with Nathalie Micas in a villa on the outskirts of the forest of Fontainebleau. Boime has persuasively argued that her exclusive concentration on animal subjects was consistent with her rejection of contemporary gender stereotypes. Bonheur believed in "metempsychosis," the transmigration of souls from humans to animals. Therefore, her intense identification with animals was based on a belief in an unbroken continuity between the human and animal realms.

Stylistically, her works remain faithful to an intensely observed realism. Her role in the selection of subject matter is active, but more humble in the effort to recreate naturalistic appearances as faithfully and "artlessly" as possible.

Boime has established that *The Horse Fair* was in fact an effort to glorify the Second Empire, in order to win favor with the new regime. The type of horse shown was the Percheron, native to Normandy; this breed was used to draw the imperial coaches and was the favorite of the imperial posting service. Her strategy proved most successful, since Bonheur came to be strongly supported by the Second Empire. The next excerpt includes Bonheur's account of Empress Eugénie's visit to her studio. Bonheur's political conservatism was paired with a highly unconventional lifestyle. Her attitude toward women's clothing as well as women's intellectual capabilities dominates the final excerpt. Even in this very late phase of her life, she remains defensive over her adoption of male dress. Since she had worn pants sporadically for over forty years, this seems remarkable. From the discussion of women's clothing she moves on to the attitudes toward women's superiority inculcated in her youth by her father, under the influence of Saint-Simonianism. Toward the end of this segment, we hear a self-defense based on the acceptance of social norms, characteristic of exceptional women: "I have always led an honorable life. I have remained pure" (that is, virginal). Bonheur's phenomenal success as an artist, her financial independence, and her fame were acquired through the rejection of a normative life-style. Homoerotic attachments, however, had to remain chaste to be acceptable. Breaking some rules was possible only while accepting certain other conventions.

On Her Early Training

In our little studio on Tournelles Street, where we had returned to live, I worked with unremitting effort, sketching with love the plaster statues that my father provided me, and not stopping even when friends came to see us. When he returned home, in the evening, it was to come immediately to look at my work of that day. He corrected it, more severely, I believe, than that of his students; but if I happened to do a passable design, I could see how happy he was to congratulate me on my progress.

One day, my father happened to leave this box of paints at the house; I seized them on the spot. Going down the stairs four by four, I bought some cherries for two cents, and returning to the studio, I set myself to painting my first still life on a small canvas buried in the corner. I still see my father's surprise: "That's very good," he said to me, embracing me, "Continue to work with perseverance, you will become a true artist." He caressed my hair and added in a more emotional tone: "Perhaps, my daughter, I'll find in you the realization of my artistic ambitions!"

Shortly afterwards, he wanted to enroll me at the Louvre Museum. My joy was so great in imagining that, from then on, I would be permitted to work in this sanctuary as much as I wished, that all during that first day my hand never stopped trembling like a leaf, such that I was incapable of a single pencil stroke. When I returned home in the evening, my father took notice of my distress. "What's the matter with you?" he

asked, "Are you ill?" I threw myself in his arms all in tears and cried, "I am so happy that I couldn't draw today, but you won't have to complain about such laziness anymore."

My father, you may well consider, had recommended that I retain the best bearing amongst the petty artists who worked as I did in the beautiful sculpture hall. I heeded well his advice, and it seems even that I walked with a military step that resounded marvelously on the paving stones. Because of this, the students of the Ecole des Beaux-Arts called me "the little soldier"; in this way at least, I managed to keep them at a distance.

If some of them made fun of me, I took my revenge by doing their caricature. I've kept some examples of my know-how in this period, when I was barely 14 years old: here's one. The old maid that you see was not among my persecutors; on the contrary, she was full of goodness for me and would have gladly defended me if need be.

My days were entirely spent at the museum. For lunch, at noon, a cent for fried potatoes, and two cents for bread took care of my business; I only drank water, which I supplied myself from the fountain with a little gourd which was 10 centimeters high. In the evening, my father didn't do much more cooking than that. He sent me to the neighborhood eating-house to have a milk bottle filled with bouillon; with some bread, this constituted our whole dinner.

Before going to bed, I learned the history of France from a book my father had bought for me and which had cost him twenty-nine cents. It was a synoptic tableau from the Gauls to the third year of the reign of Louis-Philippe. Not content with having me learn the great historic facts of my country, my father required me to choose essay topics from the events that struck my imagination the most.

I remember a certain afternoon when, by way of a promenade, my father took me on foot from Paris to Mont-Valerie, which during this period was dominated by a very old structure: a great monastery surrounded by an old cemetery. Once we arrived there, my father stopped amongst the graves, doubtless thinking of my mother, whom he had lost only a few years before.

Leaving the cemetery, he began walking without talking, completely absorbed in his thoughts; I followed him as a dog follows his master. And I was thinking that one day I would lose him too. I was completely moved by this; then my affection for him suggested to me the idea of placing my feet in the traces of his. Where did this thought come from, surprising in a child? Perhaps from my mother.

In the evening at home, to distract myself from the worries which we never lacked and from the obsessive thought of my absent mother, I sometimes happened to copy, by the glow of the lamp, plaster statues of animals. I soon discovered that this way of working had a serious advantage, such that the forms of the beef, sheep, horses imprinted themselves on my mind with surprising facility. Lots of these models were from the sculptor Mène, a man of great talent and a friend of my father. These marvelous castings so interested me that I soon tried myself to model animals to use in my paintings. I manipulated the trowel with as much facility as the brush. Thus I created a whole flock

of lambs, sheep, goats, beef, bulls, horses, and stags. These animals were all of a small size, you can well imagine. It was I who gave my brother, Isidore, his first lessons in sculpting.

"Find your way, my daughter," my father never ceased repeating to me, "Find your way, have the ambition to surpass Mme. Vigée-Lebrun, about whom everyone is talking at this time. She is, as you are, the daughter of a painter, and she did so well that at the age of twenty-eight years she was admitted to the Royal Academy, and she is now a member of the Academy of Rome, and of those of St. Petersburg and Berlin."

These words haunted me night and day. I meditated on them at length. To follow the same path as this woman seemed to me, however, to be folly.

"Can't I become famous," I said once to my father, "in limiting myself to animals?"

"Certainly," he answered, "and I will reply to you like the king of France: 'If God wants it, you can do it.' May this be your motto from now on."

A Visit from the Empress Eugénie

The petty painters who were making fun of me ceased their mockery from the day they saw that I was doing good paintings.

Finally, my first work was purchased. I received 100 francs. You can guess my joy. At once, I thought my fortune was made. Even so, this was how I managed little by little to fill my father's pocketbook.

Some critical articles, even some pamphlets, had been dedicated to my works. In one of them, which I've already had the occasion to discuss with you, Eugène de Mirecourt had requested for me the cross of the Legion of Honor from the imperial government since 1856. Now at this time you could have counted on your fingers the women who had been the object of a similar distinction since the establishment of the order [of the Legion of Honor], and then it was for services rendered to the army. Only Sister Rosalie had received the cross for her devotion to the poor and the sick. The fact alone that my name was designated for this honor gave me, up to a certain point, the right to be proud.

During the period when I lived on Rue d'Assas, my studio was frequented by a crowd of artists and society people. This made, in truth, a very flattering circle around me, but one which would have made it impossible for me to work if I hadn't abruptly resolved to exile myself to the forests of Fontainebleau. I saw many fewer visitors there; on the other hand, some were individuals of the highest importance. You are going to be the judge.

A few days after having received the letter from the Duke of Aumale which you have read, I was busy at work (June 14, 1864) on my painting *The Long Rocks*—you know it well: this stag with the great antlers followed by an entire family of does and fawns—when all at once I hear the rattling of carriages, the noise of bells, the crack of whips. This whole fracas ceases suddenly in front of my door. Almost immediately, I

see Nathalie burst like a torrent into my studio crying: "The Empress! It's the Empress who's coming here! . . . Take off your smock as fast as possible. You have only time to put on this skirt and jacket," she added, handing me the garments. In less time than it takes to tell, the transformation in my attire was accomplished and both sides of the double door to the studio opened. Already the Empress had reached the threshold and behind her came her ladies-in-waiting, some officers, and personages of the court in uniform. With the regal grace that makes her the queen of Parisian taste, Her Majesty approached. She offered me her hand, which I raised to my lips, and said that, led on a promenade in the neighborhood of my house, she had had the desire to meet me and to visit my studio. I affirmed to her, in turn, how sensitive I was to the honor of such a visit and I showed her the few paintings I had there and also some sketches on which she wished to compliment me. Nevertheless, what appeared to interest her the most was precisely the canvas on which I was working, the *Stags on the Long Rocks,* . . .

On Women's Clothing and the Role of Women in Society

I rebuke energetically women who renounce their customary clothing in the desire to pass themselves off as men. If I had found that pants suited my sex, I would have completely abandoned skirts, but this is not the case. Thus I have never counseled my sisters of the palette to wear men's clothes in the ordinary circumstances of life.

If, however, you see me dressed as I am, it is not in the least in order to make me into an original, but simply to facilitate my work. Consider that, at a certain period in my life, I spent whole days at the slaughterhouse. Oh! One must have the faith of one's art to live in the pools of blood, in the midst of killers of beasts. I also had the passion for horses. Now where better to study these animals than in the fairs, mingling among the horse dealers? I was forced to recognize that the clothing of my sex was a constant bother. That is why I decided to solicit the authorization to wear men's clothing from the prefect of police.

But the suit I wear is my work attire, and nothing else. The epithets of imbeciles have never bothered me; Nathalie laughed them off just as I did. It didn't bother her at all to see me dressed as a man; but if you are the least bit offended by it, I am ready to put on a skirt, inasmuch as I have only to open a closet in order to find a whole assortment of feminine clothing.

My trousers have been great protectors for me, . . . Many times I congratulated myself on having dared to break with traditions that would have condemned me, for lack of being able to drag my skirts everywhere, to refrain from certain types of work. As for my feminine attire, at the time when I was beginning to make my reputation, Nathalie gave me some very intelligent advice: "You cannot have the pretension of dressing in the latest fashion," she said to me. "Therefore, I urge you to compose a sort of costume which doesn't undergo any of the transformations to which elegant women subject themselves. You will retain it all your life, it will belong to you." Nathalie was right; I followed her advice and adopted the Breton style, modified to my

liking. It often happened, I readily admit it, that I appeared a little ridiculous with my straight sleeves, my vest, and my skirt with its ample pleats; but Nathalie consoled me by saying: "Never mind! Never mind! They will recognize Rosa Bonheur in the crowd by her petticoats, just as they recognized Napoleon by his little hat."

Since I have been at By, living constantly among my animals, I have scarcely had the time to play the great lady; it's absolutely necessary that visitors take me as they find me. If I go to a meeting, however, or if I engage in an official undertaking, I do not fail to wear my dress and my hat with feathers. Oh, the question of hairstyles. The hat in fashion has long been my pet peeve. None wanted to stay on my head, because I did not have a chignon in which to plunge some pins. A friend of Nathalie's was just at the right moment to prove to me in her way that I had to adopt the bonnet of elderly women. This headdress was all the rage at the time; even the elegant young women decked themselves out in it. It was a fatal piece of advice. I followed it, however, but regrettably so; and I owe to it at least one brilliant misadventure.

Two years ago (October 8, 1896) on the occasion of the reception of the Russian royalty in Paris, the minister of the fine arts had the desire to introduce to them the leading figures of French art, in the course of a visit to the Louvre Museum. Letters of invitation were sent, and I had the honor of receiving one.

Following my habit in similar circumstances, I wore my beautiful suit of black velvet and my little feathered bonnet, which, because of my short hair, could only be retained by a chin strap going from one ear to the other. You see here the effect.

From the moment I arrived at the Louvre, I would have given I do not know what to have had on my head my gray felt hat. I was the only woman, in the middle of a crowd of men each more decorated than the other, because they had taken care to invite only artists who belonged to the Legion of Honor. All the eyes turned toward me; I didn't know where to hide myself. This was a harsh test, and that day I really missed my masculine attire, I can assure you.[5] Seeing my embarrassment, M. Carolus-Duran had the courage to come toward me and offer me his arm, which I seized with gratitude, and I clung to it despairingly.

Such a support reassured me and I forgot a bit how ridiculous I was when I saw the welcome given me by most of my fellow artists. And yet, my test was not at its end. Several days later the illustrated magazines appeared; I was profoundly annoyed and angered to recognize myself in this silhouette that had all Paris laughing for a while.

In spite of my metamorphosis of costume, there is no daughter of Eve who appreciates more than I the nuances; my brusque and almost savage nature never prevented my heart from always remaining perfectly feminine. If I had loved jewels, I would certainly have worn them. Nathalie certainly did and I never reproached her for it.

Why wouldn't I be proud of being a woman? My father, that enthusiastic apostle of humanity, repeated to me many times that woman's mission was to uplift the human race, that she was the Messiah of future centuries. I owe to his doctrines the great and proud ambition that I conceived for the sex to which I take glory in belonging and whose independence I will uphold until my last day. Moreover, I am persuaded that the future belongs to us. I only wish to cite two proofs: If the Americans are leading modern

civilization, it is because of the admirable and intelligent way in which they raise their daughters and because of the respect they have for their wives. On the other hand, if the Orientals stagnate in a barbarism from which they cannot extricate themselves, it is because the husbands do not value sufficiently their spouses and consequently the children are not disposed to feel affection for their mothers.

Our timid beauties from old Europe permit themselves too easily to be led to the altar as lambs used to go in times past to sacrifice in pagan temples.

For a long time, I have understood that in putting on her head the crown of orange blossoms, the young woman subordinates herself; she is now only the pale reflection of what she was before. She becomes forever the companion of the head of the community, not in order to be his equal, but in order to help him in his work. No matter how great her worth, she will remain in the shadow.

The memory of my mother's silent devotion calls to mind that it is in the nature of man to manifest his opinions without worrying about the impression they produce on the mind of his companion.

I know well, of course, that spouses of a noble fiber do exist, who are the first to *highlight* the merits of their wives: You know some examples of them. As far as I am concerned, however, I have never dared take the risk and present myself before the Mayor. And nevertheless, contrary to the opinion of Saint-Simon, I consider marriage an indispensable sacrament for society. What a grand idea to give to human law the power to establish a contract so powerful, so noble, that even death cannot dissolve it.

While reading in the *Positive Philosophy* of Littré the illuminating exposition that this famous writer has given to the doctrines of Auguste Comte, I was struck by finding there a thought I have had for a long time. The institution of widowhood for men as well as women is admirable, because it is indispensable to the peace, the well-being, and the protection of the children. What happened in my family in the past? My father could not suffer his solitude—I recounted all that for you. A year before his death, the one who had replaced my mother in our home had given him a son, most of whose education I have paid for. Oh well, everyone said that it was I who was his mother and not his benefactress. That was something one can forgive, but forget, never! . . .

Like Rachel, like George Sand, and so many others, I could have assuredly benefited from the tolerance which women who distinguish themselves in the sciences and the arts have enjoyed as regards public opinion, and one would have been able to say of me everything one liked. Instead, I have always lived an honorable life, I have remained pure, and I have never had either lovers or children.

If my father criticized me sometimes for my free and boyish ways, I have also told you, he can at least rejoice on high, because during my whole life, the one whom he called his most precious possession has remained without stain.

5

Berthe Morisot (1841–1895)

With the revived interest in the careers of women artists, Berthe Morisot has easily joined the elite canon of previously neglected, exceptionally gifted artists. As the most talented woman painter in the founding circle of Impressionism, her modernist style of delicacy, verve, and originality has been the subject of recent intensive scholarly attention.

Morisot's literary activity consisted exclusively of correspondence. Her letters to intimate friends and family survive in the form codified by her grandson, Denis Rouart, and first published in 1957. In this volume, the letters of the artist are edited, excerpted, and interspersed with letters and reminiscences by other members of the family. The most historically interesting and intimate comments occur in her letters to her sister Edma. Since the two shared an intense interest in artistic affairs, Morisot's correspondence with her sister includes the most information about the progress of her own work and happenings in the art world. As sisters, the two also shared their feelings about marriage and motherhood. Unless otherwise noted, all of the letters reprinted here were addressed to Edma.

Berthe Morisot was born into an upper-middle-class family in 1841. Her father was a high-ranking government official. The family lived in a number of provincial cities until around 1852, when they settled in a suburb of Paris. Berthe and her sisters Edma and Yves received drawing lessons as part of their grooming to become wives and mothers. However, Berthe and Edma manifested an intense interest in art that went beyond the normal bounds of class expectations. Their brother, Tiburce, recalls the following words of warning from one of their first teachers, Joseph-Benôit Guichard:

Considering the character of your daughters . . . my teaching will not endow them with minor drawing-room accomplishments; they will become painters. Do you realize what this means? In the upper-class milieu to which you belong, this will be revolutionary, I might almost say catastrophic. Are you sure that you will not come to curse the day when art, having gained admission to your home, now so respectable and peaceful, will become the sole arbiter of the fate of two of your children?[1]

When the sisters expressed an interest in landscape painting, *en plein aire,* Guichard, a romantic portrait and history painter, introduced them to Achille Oudinot, who in turn introduced them around 1860 to Camille Corot, the most famous landscape painter in France. Some of Berthe's early landscapes, such as her first publically exhibited painting in the Salon of 1864, show the influence of this master. However, it is extremely difficult to precisely reconstruct the formative phase of Morisot's career since she destroyed most of her paintings dated before 1870.

Throughout the 1860s the Morisot sisters continued to paint. They became integrated into the avant-garde circle of Manet, associating frequently with Degas, Puvis de Chavannes, and Fantin-Latour, among other artists. They entertained regularly in their own home and attended the Thursday-evening gatherings at the Manets. Therefore, the new ideas about painting were accessible to them. However, as proper ladies of the *haute bourgeoisie,* they could not attend the café gatherings of their male colleagues. They were also subjected to sexist attitudes, as revealed by Manet's comment to Fantin-Latour, in August 1868: "I quite agree with you, the Mlles Morisot are charming. Too bad they're not men. All the same, women as they are, they could serve the cause of panting by each marrying an academician, and bring discord into the camp of the enemy."[2]

In 1869 Edma married and renounced her painting career. The first letters reprinted here date from this period, when Berthe, still searching for her mature style, struggled on alone. The sequence of letters from March 1869 to September 1870 reveals her integration into the artistic avant-garde circles of the time and her sense of proper behavior for a woman of the upper bourgeoisie.

The letter written sometime in March 1870 that discusses Morisot's submission to the Salon of 1870 is an especially fascinating document. The painting that Manet "retouched" is *Mother and Sister of the Artist* (Fig. 4). As Stuckey has noted, the composition was inspired by a double portrait by Fantin-Latour, although Morisot's light-filled interior and brighter palette is distinct from Fantin's Old Master tonality.[3] Manet's hand is visible mainly in the figure of Mme. Morisot: her face, hands, and dress. We can accept the rest of the image, composition, and surface as Morisot's. Edma had come to stay with her family during the winter of 1869–70 because she was pregnant; this was painted the week before the birth of Edma's first daughter. In this instance, the highly compressed space of the image certainly refers to the intimacy between painter and sitters; as Griselda Pollock has accurately observed, "proximity and compression" are characteristic of the "spaces of femininity."[4] Furthermore, the imminence of her delivery must also inform the expressive introspection of Edma. Light does flood the canvas, but as seen in the reflection in the mirror, curtains screen out all but a small segment of the exterior world. The literal "confinement" of Edma due to her pregnancy is given a tangible visual presence.

Recently, in a study of Berthe's imagery of Edma, Marni Riva Kessler suggests that this painting was an attempt to re-claim the intimacy of their relationship, disrupted by Edma's marriage. Pregnant Edma is a signifier of the domestic and maternal realm, not available to the still unmarried painter.[5]

Morisot's career remained uninterrupted by her marriage to Eugène Manet, Edou-

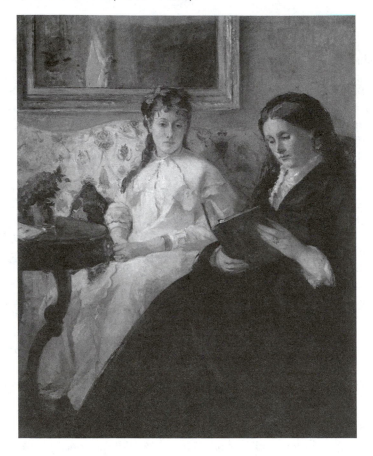

Figure 4. Berthe Morisot, *The Mother and Sister of the Artist*.
National Gallery of Art, Washington, D.C.

ard Manet's brother, in 1874. When writing the letter from Ryde, Morisot was with her husband. Her difficulties in painting are met with determination and dedication, which eventually produced an oeuvre now recognized as equivalent in artistic merit to those of her male Impressionist colleagues.

While Morisot's commitment to painting remains an unusual choice for a woman of her era and class background, her acceptance of her culture's definitions of gender roles and stereotypes is clear and apparently unconflicted. As her next letter reveals, she accepted her culture's emphasis on motherhood. She functioned as a professional avant-garde artist within the restrictions of movement appropriate for women of her class. Like Mary Cassatt and unlike Rosa Bonheur, she dressed and lived in a conventional manner.

By 1880 the prominent critic Gustave Geffroy could write: "No one represents

Impressionism with more refined talent or with more authority than Morisot.''[6] Not only is Morisot's dedication to an Impressionist style consistent but she was equally dedicated to bypassing the Salon system and exhibiting her work directly to the public through the newly invented exhibition mechanism of group shows. This may indicate a practical as well as ideological commitment. Access to the Salons, restricted by a conservative jury, was never overtly hospitable to new tendencies in painting. Furthermore, only a handful of works by any individual could be exhibited at one time. The Impressionist group shows permitted a broader sampling of works to be viewed. Morisot's correspondence reveals her interest in selling her works. Despite her class status and position as a married woman, she was not aloof from the financial demands of the professional artist. Morisot exhibited work in all the Impressionist group shows except the one held following the birth of her daughter, Julie, in 1879. Her response to Julie's birth is described in the next letter.

In general, most of Morisot's subjects reflect her world view as a Parisian woman of the *haute bourgeoisie*. Her paintings are focused on the domestic milieu of women, children, and the home. Most frequently, members of her family, her sisters and their children, her daughter, and her servants are the subjects of her works.[7] Women are viewed in the home, in private gardens, or in urban parks. She rarely depicted men, only occasionally using her husband (usually paired with her daughter) as a subject.

When she painted views of nature, she maintained her identity as a Parisienne, an urban dweller. She avoided scenes of peasant life in the countryside, preferring instead to focus on the tourist views of the towns in which she or her family members often vacationed, such as Ryde. The tourist towns, many of them located on the Normandy Coast, were accessible to the urban visitor through the recently expanded network of trains, a new phenomenon in Morisot's time.

In the later 1880s and the 1890s, Morisot's style developed into a synthetic idiom with longer brushstrokes and reworked canvases. She occasionally depicts subjects with symbolic or allegorical content. This development parallels the shift from Impressionism to post-Impressionist symbolism, as seen most obviously in her colleague Renoir's stylistic development. She often painted in Nice, where she wrote letters to her friend Sophie Canat and to Edma in the winter of 1888–89, reprinted in this volume.

While many critical appraisals of Morisot have fixed on her ''femininity,'' interpreting her talent as a natural delicacy and capriciousness appropriate to her sex, modern scholars understand that Morisot's self-conscious selection of style was not determined by her gender but by a deliberate choice of artistic means. The difficulties she encountered in capturing ''the spontaneous'' are revealed in her letters. Her works should be seen in context with the paintings of Renoir and Monet, for example, and distinguished from the art of other contemporary women such as Cecilia Beaux or Marie Bashkirtseff, whose diary she read in 1890 and discussed in one of the letters excerpted here. Being a woman did not automatically establish an instinctual affinity with Impressionism.

The last two letters deal with Morisot's sense of her own mortality. The first was written after recovery from an illness in 1890. The second was written on the eve of her death, to her daughter, then 16 years old.

In the light of recent scholarly attention, we can now better appreciate Morisot's Impressionism as equal in quality to that of her male contemporaries, yet distinctively different, as a result of her gendered and class-defined identity in late-nineteenth-century France.

Berthe Morisot's Letters to Her Sister Edma
March 19, 1869: ". . . This sort of thing is unhealthy"

If we go on in this way, my dear Edma, we shall no longer be good for anything. You cry on receiving my letters, and I did just the same thing this morning. Your letters are so affectionate, but so melancholy, and your husband's kind words made me burst into tears. But, I repeat, this sort of thing is unhealthy. It is making us lose whatever remains of our youth and beauty. For me this is of no importance, but for you it is different.

Yes, I find you are childish: this painting, this work that you mourn for, is the cause of many griefs and many troubles. You know it as well as I do, and yet, child that you are, you are already lamenting that which was depressing you only a little while ago.

Come now, the lot you have chosen is not the worst one. You have a serious attachment, and a man's heart utterly devoted to you. Do not revile your fate. Remember that it is sad to be alone; despite anything that may be said or done, a woman has an immense need of affection. For her to withdraw into herself is to attempt the impossible.

Oh, how I am lecturing you! I don't mean to. I am saying simply what I think, what seems to be true.

April 23, 1869: "Do not grieve about painting. I do not think it is worth a single regret"

I am not any more cheerful than you are, my dear Edma, and probably much less so. Here I am, trapped because of my eyes. I was not expecting this, and my patience is very limited. I count the days passed in inaction, and foresee many a calamity, as for example that I shall be spending May Day here with poultices on my eyes. But let us talk about you. I am happy to think that your wish may be fulfilled. I have no knowledge of these matters, but I believe in your premonitions. In any case, I desire it with all my heart, for I understand that one does not readily accustom oneself to life in the country and to domesticity. For that, one must have something to look forward to. Adolphe would certainly be surprised to hear me talking in this way. Men incline to believe that they fill all of one's life, but as for me, I think that no matter how much affection a woman has for her husband, it is not easy for her to break with a life of work. Affection is a very fine thing, on condition that there is something besides with which to fill one's days. This something I see for you in motherhood.

Do not grieve about painting. I do not think it is worth a single regret.

May 2, 1869: The Salon

The first thing we beheld as we went up the big staircase was Puvis' painting. It looked well. Jacquemard was standing in front of it and seemed to admire it greatly. What he seemed to admire less was my person. There is nothing worse than a former admirer. Consequently he forsook me very quickly. However, we next met Carolus Duran, who was with his wife, and who on seeing us blushed violently. I shook hands with him, but he did not have a word to say to me. His wife is a tall and handsome woman. He is showing a portrait of her, which, I think, is going to be a success, although it is quite vulgar. It isn't absolutely bad, but I find it mannered and flat. I don't have to tell you that one of the first things I did was to go to Room M. There I found Manet with his hat on in bright sunlight, looking dazed. He begged me to go and see his painting, as he did not dare move a step.

I have never seen such an expressive face as his; he was laughing, then had a worried look, assuring everybody that his picture was very bad, and adding in the same breath that it would be a great success. I think he has a decidedly charming temperament, I like it very much.

His paintings, as they always do, produce the impression of a wild or even a somewhat unripe fruit. I do not in the least dislike them, but I prefer his portrait of Zola. . . .

I am more strange than ugly.[8] It seems that the epithet of *femme fatale* has been circulating among the curious, but I realize that if I tell you about everything at once, the people and the paintings, I will use up all my writing paper, and so I think I had better tell you another time about my impressions of the paintings, all the more so because I could scarcely see them. However, I did look for our friend Fantin. His insignificant little sketch was hung incredibly high, and looked extremely forlorn. I finally found him, but he disappeared before I could say a word about his exhibit. I do not know whether he was avoiding me, or whether he was conscious of the worthlessness of his work.

I certainly think that his excessive visits to the Louvre and to Mademoiselle Dubourg[9] bring him no luck. Monsieur Degas seemed happy, but guess for whom he forsook me—for Mademoiselle Lille and Madame Loubens. I must admit that I was a little annoyed when a man whom I consider to be very intelligent deserted me to pay compliments to two silly women.

I was beginning to find all this rather dull. For about an hour Manet, in high spirits, was leading his wife, his mother, and me all over the place, when I bumped headlong into Puvis de Chavannes. He seemed delighted to see me, told me that he had come largely on my account as he was beginning to lose hope of seeing me again at the Stevenses, and he asked if he might accompany me for a few minutes. I wanted to see the pictures, but he implored me so eagerly: "I beg of you, let us just talk. We have plenty of time for looking at paintings." Such conversation might have appealed to me had I not found myself confronted at every step by familiar faces. What is more, I had completely lost sight of Manet and his wife, which further increased my embarrassment.

I did not think it proper to walk around all alone. When I finally found Manet again, I reproached him for his behaviour; he answered that I could count on all his devotion, but nevertheless he would never risk playing the part of a child's nurse.

You will ask what has become of my mother during all this time. She was afraid of getting a headache, and sat on a sofa, where I would join her from time to time. I brought Puvis to her while she was already engaged in conversation with *petit père* Riesener. We all went again to see Manet's picture, and there we found Monsieur Oudinot, orating. He pretended not to see us, but don't you think this encounter was rather strange? I've talked about everything now except paintings; but be patient, I shall review the Salon for you in my own way. I must go back Monday. I almost assented to a rendez-vous there with Puvis. We shook hands, and he promised to come to see me.

May 11, 1869: "The sight of all these daubs nauseates me"

I have missed my chance, dear Edma, and you may congratulate me on having got rid so quickly of all my agitations. I think that I should have fallen ill, if at that moment I had had to decide in favour of Monsieur D——. Fortunately this gentleman turned out to be completely ludicrous. I had not expected this, and was quite surprised, but by no means disappointed! Now that I am free of all anxiety, and am taking up again my plans for travel, which in truth I had never given up, I am counting definitely on my stay in Lorient to do something worthwhile. I have done absolutely nothing since you left, and this is beginning to distress me. My painting never seemed to me as bad as it has in recent days. I sit on my sofa, and the sight of all these daubs nauseates me. I am going to do my mother and Yves in the garden; you see I am reduced to doing the same things over and over again. Yesterday I arranged a bouquet of poppies and snowballs, and could not find the courage to begin it. On Wednesday we went to the Stevenses. Yves has certainly made a conquest of Monsieur Degas. He asked her to permit him to paint a portrait of her. He is always talking about you, asking about you, and is indignant at my keeping you posted about his new infatuations. If you think that I have given you a review of the exhibition, that is only kindness on your part. I see it so badly that it is difficult for me to judge it. Friday I looked with great interest at Mademoiselle Callart's two pictures. They did not seem as good as those of last year, though the subjects are about the same.

I have never once been to the Salon without meeting Oudinot in Room M. The other day, as we were passing him, Puvis asked me with astonishment if that was not my former teacher. I think he has heard some gossip in that connection. You are right in thinking that there is nothing remarkable in the Salon; personally I can see in it only mediocre work—or am I too severe? Every now and then I hear some praises that I cannot join in, nor even comprehend. Did you read Charles Blanc's long article on Chenavard? For myself, I shall forbear to give you a description of his picture. It is certainly the work of an intelligent man, but much too classical for my taste. Monsieur

Riesener admires greatly certain aspects of it. I am the only one at our house who likes Puvis' paintings. They are thought to be uninteresting, cold. Well, anyway, you will see them at Marseilles, and you will give me your opinion. What makes me think my taste is not entirely perverted is that I recall Fantin's admiring them a lot. I do not meet him anywhere, this dear Fantin! Yet I need to talk with him a little to recover my zest for life.

Late Spring 1869: On Degas

As for your friend Degas, I certainly do not find his personality attractive; he has wit, but nothing more. Manet said to me very comically yesterday, "He lacks spontaneity, he isn't capable of loving a woman, much less of telling her that he does or of doing anything about it." Poor Manet, he is sad; his exhibition, as usual, does not appeal to the public, which is for him always a source of wonder. Nevertheless he said that I had brought him luck and he had had an offer for *Le Balcon.* I wish for his sake that this were true, but I have grave fears that his hopes will once again be disappointed.

Monsieur Degas has made a sketch of Yves, that I find indifferent; he chattered all the time he was doing it, he made fun of his friend Fantin, saying that the latter would do well to seek new strength in the arms of love, because at present painting no longer suffices him. He was in a highly satirical mood; he talked to me about Puvis, and compared him to the condor in the Jardin des Plantes.

August 13, 1870: "I am not capable of anything"

Manet lectures me, and holds up that eternal Mademoiselle Gonzalès as an example; she has poise, perseverance, she is able to carry an undertaking to a successful issue, whereas I am not capable of anything. In the meantime he has begun her portrait over again for the twenty-fifth time. She poses every day, and every night the head is washed out with soft soap. This will scarcely encourage anyone to pose for him!

September 1870: "Without knowing it I produced masterpieces at Lorient"

During the day I received a visit from Puvis de Chavannes. He saw what I had done at Lorient and seemed to find it not too bad. Tell Adolphe[10] that when we examined the pier he complimented me on my knowledge of perspective, and that naturally I gave full credit where it was due. . . .

The Manets came to see us Tuesday evening, and we all went into the studio. To my great surprise and satisfaction, I received the highest praise; it seems that what I do is decidedly better than Eva Gonzalès. Manet is too candid, and there can be no mistake about it. I am sure that he liked these things a great deal; however, I remember what

Fantin says, namely, that Manet always approves of the painting of people whom he likes. Then he talked to me about finishing my work, and I must confess that I do not see what I can do . . . As he exaggerates everything, he predicted success for me in the next exhibition, though he has said many unpleasant things to me . . . Since I have been told that without knowing it I produced masterpieces at Lorient, I have stood gaping before them, and I feel myself no longer capable of anything. The little Delaroches came three times to pose. It is a nightmare. I have not heard anything more about them, hence I hope that they are at Houlgate, and that my attempt may end at this point. Decidedly, I am too nervous to make anyone sit for me, and then the opinions of this one and that one worry me, and make me disgusted with things before they are in place. . . .

Manet exhorted me so strongly to do a little retouching on my painting of you that when you come here I shall ask you to let me draw the head again and add some touches at the bottom of the dress, and that is all. He says that the success of my exhibition is assured and that I do not need to worry; the next instant he adds that I shall be rejected. I wish I were not concerned with all this.

September 28, 1870: "Everyone is deserting me"

I have wanted to write to you, my dear Edma, but then I feel myself overcome by an insurmountable laziness. I am reproached by everybody and I do not have the strength to react. And I understand perfectly the difficulties you have in painting; I have reached the point of wondering how I have ever in my life been able to do anything. . . .

Didn't you try to work by the river in that place at the water's edge that we thought was so pretty? It seems to me that the season ought to be most favorable, particularly if you have sun. . . .

Yves writes that she continues to be bored; as for me, I am sad, and what is worse, everyone is deserting me; I feel alone, disillusioned, and old into the bargain. . . .

March 1870: *The Portrait of Mme. Morisot and Her Daughter* (Fig. 4)

Mother wrote to you at the time Puvis told me that the head was not done and could not be done; whereupon great emotion; I took it out, I did it over again. Friday night I wrote him a note asking him to come to see me; he answered immediately that this was impossible for him and complimented me a great deal on all the rest of the picture, advising me only to put some accents on mother's head. So far no great misfortune. Tired, unnerved, I went to Manet's studio on Saturday. He asked me how I was getting on, and seeing that I felt dubious, he said to me enthusiastically: "Tomorrow, after I have sent off my pictures, I shall come to see yours, and you may put yourself in my hands. I shall tell you what needs to be done."

The next day, which was yesterday, he came at about one o'clock; he found it very good, except for the lower part of the dress. He took the brushes and put in a few

accents that looked very well; mother was in ecstasies. That is where my misfortunes began. Once started, nothing could stop him; from the skirt he went to the bust, from the bust to the head, from the head to the background. He cracked a thousand jokes, laughed like a madman, handed me the palette, took it back; finally by five o'clock in the afternoon we had made the prettiest caricature that was ever seen. The carter was waiting to take it away; he made me put it on the hand-cart, willy-nilly. And now I am left confounded. My only hope is that I shall be rejected. My mother thinks this episode funny, but I find it agonizing.

I put in with it the painting I did of you at Lorient. I hope they take only that. . . .

Manet has never done anything as good as his portrait of Mademoiselle Gonzalès; it is perhaps even more charming now than when you saw it. As for our friend Chavannes, everybody agrees that his picture is very good: this proves that I was right and mother wrong.

Good-bye—I embrace you, write to me, and tell me as much about yourself as I tell you about myself.

Autumn 1872: "This is an extraordinary opportunity"

I saw our friend Manet yesterday; he left today with his fat Suzanne for Holland, and in such a bad humour that I do not know how they will get there. He wrote to me this morning to inform me about his departure, and to tell me that he had given my address to a very rich gentleman who wants to have portraits of his children done in pastel. He advises me to make him pay handsomely if I want him to respect me. This is an extraordinary opportunity that I must not let slip. If I were actually sure that this gentleman was coming to see me, I should be somewhat worried. I know my nerves, and the trouble I should have if I undertook such a thing. Suppose that by chance he does come: tell me what I can ask—500 francs, that is to say, 1000 francs for the two? That seems to me enormous!

1873: "I am eager to earn a little money"

I sent my Cherbourg seascape to M——. He was to show it to Durand-Ruel.[11] I have not heard anything about it since. I am eager to earn a little money, and I am beginning to lose all hope. Have you worked this week? You are far more fortunate than I am: you work when you feel like it, and that is the only way in which one can do good work. As for me, I work hard without respite or rest, and it's pure waste. . . .

I am invited to go to the country, where I could ride horse-back, paint, etc., but all that scarcely tempts me. I am sad, sad as one can be. . . . I am reading Darwin; it is scarcely reading for a woman, even less for a girl. What I see most clearly is that my situation is impossible from every point of view.

Summer 1875: The Trip to Cowes and Ryde, England

It is not too expensive here, and it is the prettiest place for painting—if one had any talent. I have already made a start, but it is difficult. People come and go on the jetty, and it is impossible to catch them. It is the same with the boats. There is extraordinary life and movement, but how is one to render it? I began something in the sitting room, of Eugène. The poor man has taken your place. But he is a less obliging model; at once it becomes too much for him. . . .

Nothing is nicer than the children in the streets, bare-armed, in their English clothes. I should like to get some of them to pose for me, but all this is very difficult. My English is so horribly bad, and Eugène's is even worse. . . .

The little river here is full of boats, a little like the river at Dartmouth in the photographs Tiburce sent us. I am sure you would like all this very much, and that it would even give you a desire to start working again. The beach is like an English park plus the sea; I shall have to make a water-colour of it, for I shall never have the courage to set up my easel to do it in oil.

At Ryde, everything takes place on the pier, which is interminably long. It is the place for promenading, for bathing, and where the boats dock.

I found a superb Reynolds there, for a little less than two francs. My black hat with the lace bow made the sailors in the port burst out laughing.

You should really write me a little. Cowes is very pretty, but not gay; besides, we constantly miss our home life. Eugène is even more uncommunicative than I.

I have worked a little, but what rain we have had for a week! Today we have been to Ryde. I set out with my sack and portfolio, determined to make a water-colour on the spot, but when we got there I found the wind was frightful, my hat blew off, my hair got in my eyes. Eugène was in a bad humour as he always is when my hair is in disorder—and three hours after leaving we were back again at Globe Cottage. I nevertheless took the time to take a little walk through the big town of Ryde, which I decidedly find even drearier than Cowes. There are more people in the streets but fewer boats on the water; and the pretty little river adds a lot of charm to the place. Anyway I am happy with our choice, which is a rare thing.

At Ryde there are many shops, and even a picture dealer. I went in. He showed me water-colours by a painter who, I am told, is well known; they sell for no less than four hundred francs apiece—and they are frightful. No feeling for nature—these people who live on the water do not even see it. That has made me give up whatever illusions I had about the possibility of success in England. In the whole shop, the only thing that was possible and even pretty was by a Frenchman; but the dealer says that sort of thing does not sell.

Summer 1875: "My work is going badly"

I am horribly depressed tonight, tired, on edge, out of sorts, having once more the proof that the joys of motherhood are not meant for me. That is a misfortune to which you

would never resign yourself, and despite all my philosophy, there are days when I am inclined to complain bitterly over the injustice of fate.

My work is going badly, and this is no consolation. It is always the same story: I don't know where to start. I made an attempt in a field, but the moment I had set up my easel more than fifty boys and girls were swarming about me, shouting and gesticulating. All this ended in a pitched battle, and the owner of the field came to tell me rudely that I should have asked for permission to work there, and that my presence attracted the village children who caused a great deal of damage.

On a boat one has another kind of difficulty. Everything sways, there is an infernal lapping of water; one has the sun and the wind to cope with, the boats change position every minute, etc. . . . The view from my window is pretty to look at, but not to paint. Views from above are almost always incomprehensible; as a result of all this I am not doing much, and the little I am doing seems dreadful to me. . . . I miss the babies as models; one could make lovely pictures with them on the balcony. If Bébé Blanc were willing to come to see me with her Lize, I should gladly paint them.

1879: On the Birth of Her Daughter[12]

Well, I am just like everybody else! I regret that Bibi is not a boy. In the first place because she looks like a boy; then, she would perpetuate a famous name, and mostly for the simple reason that each and every one of us, men and women, are in love with the male sex. . . . Your Bibi is a darling; you'll find mine ugly in comparison, with her head as flat as a paving stone. Edma's photograph has dispelled all my illusions about her. . . . All poor Julie has to offer is her fat cheeks and her pretty complexion. . . . Another piece of news, less distressing: Eva Gonzalès is married. . . . Don't accuse me of being neglectful, my dear, I think of you and your children continually, but my life is becoming complicated, I have little time, and then I have my days of melancholy, my black days when I am afraid to take up a pen for fear of being dull. The death of the poor dear duchess made me pass through one of these bad phases. Mme Carré told me the other day, laughing at my looks: "I think you have lived too long." Well, this is true. Inasmuch as I see everything that I have known and loved disappear, I have lived too long. The loss of friends can no longer be replaced at my age, and the void is great.

Nice: To Sophie Canat, Winter 1888–89

Your picture of our life here is all wrong. We are never on the Promenade des Anglais; our villa with its beautiful shade trees is all that we need. I am busy with Julie's lessons and also with my painting; we often walk in the mountains following the goat paths, though they are a little beyond my strength—my hair is as white as snow, and my legs are a little stiff.

As for society and parties, none at all, or at least as little as possible. I am enjoying

my freedom thinking with some terror of the day when I shall have to take my daughter to dances.

Winter 1888–89

This place is delightful; I am working, I am doing aloes, orange trees, olive trees—in short, a whole exotic vegetation that it is quite difficult to draw. . . .

I have worked as much as I could; the result may seem meagre. . . . I should like to capture some of the charming effect of the surrounding vegetation. I am working myself to death trying to give the effect of the orange trees. I want it to be as delicate as it is in the Botticelli I saw in Florence, and this is a dream that I shall not realize. . . . I do not understand why this country here does not serve as a studio for all young landscapists: aside from its beauty one enjoys here an unchanging weather that makes possible the most careful studies. I won't say that work is easier here, for the landscape is fiendish, of an outline that does not permit of approximations and of colors that one never finds. It is extraordinary how much of Corot there is in the olive trees and the backgrounds. Now I can understand the title he loves—*Souvenir d'Italie.*

Autumn 1890: On Marie Bashkirtseff's Diary

My admiration is dampened because of her mediocre painting; the "Meeting" and the rest are awkward, commonplace, almost stupid, and very difficult to reconcile with her alert style, with so much intellectual boldness and grace. I associate in my mind two books by women: *Récits d'une soeur* and hers. The truth is that our value lies in feeling, in intention, in our vision that is subtler than that of men, and we can accomplish a great deal provided that affectation, pedantry, and sentimentalism do not come to spoil everything.

Winter 1890: "I am still a mere beginner"

I am well now but I have not yet got over the moral shock; I felt the embrace of death, and I am still terrified at the idea of all that might happen after I go, particularly to Julie. Have I ever told you that according to my will Mallarmé[13] would be her guardian? But, how many buts. . . . If Eugène too went, or if he fell seriously ill, would you undertake to care for the child?

You ask me what I am doing. My attempts at colour prints are disappointing, and that was all that interested me. I worked all summer with a view to publishing a series of drawings of Julie. Worst of all, I am approaching the end of my life, and yet I am still a mere beginner. I feel myself to be of little account, and this is not an encouraging thought.

March 1, 1895: To Her Daughter, Julie, Written
on the Eve of Her Death

My little Julie, I love you as I die; I shall still love you even when I am dead; I beg you not to cry, this parting was inevitable. I hoped to live until you were married. . . . Work and be good as you have always been; you have not caused me one sorrow in your little life. You have beauty, money; make good use of them. I think it would be best for you to live with your cousins, Rue de Villejust, but I do not wish to force you to do anything. Please give a remembrance from me to your aunt Edma and to your cousins; and to your cousin Gabriel give Monet's *Bateaux en réparation*. Tell M. Degas that if he founds a museum he should select a Manet. A souvenir to Monet, to Renoir, and one of my drawings to Bartholomé. Give something to the two concierges. Do not cry; I love you more than I can tell you. Jeannie, take care of Julie.[14]

6

Marie Bashkirtseff (1858–84)

Born into a family of minor Russian nobility, Marie Bashkirtseff spent much of her youth in France, first in Nice, then Paris. This emigré status was, no doubt, due to her parents' separation when she was 11. Precociously bright, she had taught herself Greek and Latin by the age of 13. A career as a singer was contemplated, but the idea was abandoned with the onset of tuberculosis, the disease that would eventually kill her at the age of 26. In 1877 she decided to become an artist, entering the Atelier Julian. At that time, the segregated class at Julian's provided the most complete training in the visual arts available to women, though inferior to the training available to men at the Ecole des Beaux-Arts. Between 1877 and her death in 1884, Bashkirtseff created several hundred paintings, drawings, and pastels. She exhibited paintings at the Salons of 1880, 1881, and 1883. In 1884 she received a medal for her most famous painting, *The Meeting* (Fig. 5). Bashkirtseff aligned herself with the Naturalist school led by Jules Bastien-Lepage. The similarities in theme and technique between *The Meeting* and Bastien-Lepage's work were obvious even to Bashkirtseff's contemporaries.[1] However, the painting does demonstrate her ability to organize a large-scale, multifigured composition of a psychologically engaged group, realistically delineated. Like that of Bastien-Lepage, her style treads a middle ground between the more detailed, linear, conservative academic style and the looser, more visibly painterly surfaces of Impressionists like Morisot and Monet.

As early as the summer of 1882, she expressed interest in using subjects derived from the working-class street life in urban Paris. In the lives of these young boys, Bashkirtseff perceived ''a liveliness and freedom from the artifices which she as a woman of the upper class experienced as restrictions on her life.''[2] Although *The Meeting* did not receive a medal, it was purchased by the French government and reproduced in engravings and lithographs.

Two paintings were shown posthumously at the Salon of 1885. That year the Union des femmes peintres et sculpteurs, the major organization of professional female artists in France, mounted an extensive retrospective of her works, which included over 200 paintings, drawings, and pastels, and five pieces of sculpture.

66

Figure 5. Marie Bashkirtseff, *The Meeting*. Musée d'Orsay, ©
photo R.M.N.

Bashkirtseff's fate might have been similar to May Alcott's. Both artists died be-
fore they could create a mature oeuvre. Bashkirtseff's fame resides, as she so accurately
surmised, in the posthumous publication of her journal. Her 84 handwritten notebooks
were edited by her mother and first published in France in 1887. Her voluminous, almost
daily writing puts the reader in touch with a young woman who, in the privacy of this
literary form, freely broke all the rules of the social construction of femininity of her
era. Her ambition and starkly vain self-obsessiveness represented an entirely new phenom-
enon to appear in print in her epoch. The diary was widely read and created a sensation.
Upon its translation and publication in English in 1890, one reviewer, Marion Hepworth
Dixon, wrote: "It is this Journal with which the world is now ringing, and which it
is hardly too much to say is likely to carry the fame of Marie Bashkirtseff over the face
of the civilized globe."[3] (Even in this volume we have references to the journal by Berthe
Morisot and Paula Modersohn-Becker.)
 Bashkirtseff anticipated the posthumous publication of her journal and wrote a

preface for it, dated May 1, 1884, the first excerpt. She died on October 31 of that year. In her preface, she realizes that the immortality she so longed for through her painting might not be realized and that the journal would provide a substitute means of recognition: "Should I not live long enough to become famous, this journal will be of interest to naturalists."

The fame of Bashkirtseff's journal derives from these passages where this young woman permits herself the freedom to transcend the expectations for women of her class and era.

Contemporary scholars have determined the extent to which the journal was excerpted and altered for publication by her family. Even her date of birth was a source of conflict. Her father told her that she was born on November 28, 1858, only seven months after her parents' marriage; her family adjusted this date to November 1860. References to family members living in the household were excised, as were references to her feminist activities. (Bashkirtseff was active in the suffragist movement known as Le Droit des Femmes and wrote articles for the feminist journal *La Citoyenne* under a pseudonym.)

The excerpts included here span the years from 1877 to 1884. They address the major themes that obsessed this artist during her brief life. She is extremely forthright in her egocentric vanity, something that was still shocking for her contemporary readers. Other excerpts focus on the process of acquiring artistic training and her determination to become a recognized painter. She defines this goal after her first week in the studio. Answering the question "And why draw?" she responds, "To get all that I have been crying for since the world began. To get all that I have wanted and still want. To get on by my talent, or in any way I can, but to get on."

Another theme is her awareness of the restrictions and limitations under which a woman of her class functioned. "What I long for is the freedom of going about alone. . . . it is this that makes me gnash my teeth to think I am a woman." Paired with this seemingly unstoppable drive and ambition are insecurity and doubts about her artistic capabilities. The persistent rivalry with Louise Breslau, stimulated by numerous in-house competitions at Julian's, are described in excruciating detail. The final two excerpts, written in the last month of her life, entwine her death with that of the artist she most admired, Bastien-Lepage.

The immediacy and relatively uncensored process of journal writing, as opposed to the retrospective, more self-conscious form of the autobiographies encountered so far, brings the reader into a more intimate relationship with the author. We are transformed into that sympathetic friend who Bashkirtseff imaginatively projects as her correspondent. The force of her personality is communicated vividly and directly to the reader.

May 1, 1884: "And I tell all, yes, all. . . . Else what were the use of it?"

When I am dead people will read my life, which to me seems very remarkable. Were it not so it would be the climax of misery. But I hate prefaces and editors' notes, and

have missed reading many excellent books on this account. That's why I've wished to write my own preface. It could have been dispensed with had the whole diary been published; but I think it best to begin with my thirteenth year, the preceding part being too long. The reader, however, will find sufficient data to go upon in the course of this narrative, for I frequently make references to the past, now for one reason, now for another. Suppose I were to die now quite suddenly, seized by some illness; perhaps I should not know of my danger; they would conceal it from me; and, after my death my drawers would be ransacked, and my family would discover my Journal, and, having read, would destroy it. Soon afterwards nothing would remain of me—nothing . . . nothing . . . nothing! . . . It is this which has always terrified me. To live, to have so much ambition, to suffer, weep, struggle—and then oblivion! . . . oblivion . . . as if I had never been. Should I not live long enough to become famous, this Journal will be of interest to naturalists; for the life of a woman must always be curious, told thus day by day, without any attempt at posing; as if no one in the world would ever read it, yet written with the intention of being read; for I feel quite sure the reader will find me sympathetic. . . . And I tell all, yes, all. . . . Else what were the use of it? In fact, it will be sufficiently apparent that I tell everything. . . .

May 8, 1877: "The finest actions are done for self"

Would you like to know the truth? Well, remember what I am going to tell you—I love nobody, and shall never love, but one person, who will gracefully pamper my self-love . . . my vanity.

When you feel yourself beloved, you do everything for *the other* one, and then there is no feeling of shame; on the contrary, it makes you feel heroic.

I know very well that I would never ask anything for myself; but for another I would do a hundred meannesses, for it is by mean actions that one rises.

This again proves clearly that the finest actions are done for self. . . . To ask for myself would be sublime, because it would cost me. . . . Oh! how horrid even to think of it! . . . But for another it is a pleasure, and it looks like self-sacrifice, like devotion, like charity personified.

And on such occasions you believe in your own merit. You really believe yourself to be charitable, devoted, and sublime.

October 6, 1877: The Atelier Julian

Every time he [Julian] corrects my drawing he asks with some distrust if I did it alone.

I should think so indeed. I have never asked for advice of any of the pupils, except how to commence the study of the nude.

I am getting rather used to their ways—their artistic ways.

In the studio all distinctions disappear: you have neither name nor family; you are

no longer the daughter of your mother; you are yourself; you are an individual with art before you—art and nothing else. One feels so happy, so free, so proud!

At last I am what I wished to be for so long. I wanted it so long that I cannot quite realize it.

October 10, 1877: "I should never be content to draw no better than they"

Don't suppose I am doing wonders because M. Julian is surprised. He is surprised because he expected to find the whims of a rich young girl and a beginner. I need experience but my work is correct and like the model. As for the execution, it is just what may be expected after a week's work.

All my fellow-students draw better than I do, but none of them can get it as like and true in proportion. What makes me think I shall do better than they, is that, although I see their merit, I should never be content to draw no better than they, whereas generally the beginners are continually saying, "Oh! if only I could draw as well as such or such a one!"

These women of forty have practice, work, and experience; but they will never do more than they are doing at present. As for the young ones, they draw well, and have time before them, but no future.

Perhaps I shall never do anything, but it will be from impatience. I could kill myself for not having begun four years ago, and it seems to me that it is too late.

We shall see.

October 11, 1877: "To get all that I have been crying for since the world began"

It's all very well to say it's useless to regret the past, but every minute I say to myself, "How good it would be if I had begun working three years ago. By this time I should be a great artist, and I might," &c. &c.

M. Julian told the studio servant that Schaeppi and I were the most promising ones.

You don't know who Schaeppi is. She is the Swiss girl. Goodness, what a dialect! And M. Julian added that I might become a great artist.

I know it from Rosalie.

It is so cold that I caught cold; but I *forgive* that, if I can only draw.

And why draw?

. . . to get all that I have been crying for since the world began. To get all that I have wanted, and still want. To get on by my talent, or in any way I can, but to get on. If I had *all that,* perhaps I should do nothing.

April 13, 1878: "I swear that I will become famous"

At twenty-two I shall be either famous or dead.

You think perhaps that one works only with the eyes and fingers?

You who are *bourgeois,* you will never know the amount of sustained attention, of unceasing comparison, of calculation, of feeling, of reflection, necessary to obtain any result.

Yes, yes, I know what you would say . . . but you say nothing at all, and I swear to you by Pincio's head (that seems stupid to you; it is not to me)—I swear that I will become famous; I swear solemnly—by the Gospels, by the passion of Christ; by myself—that in four years I will be famous.

January 2, 1879: "What I long for is the freedom of going about alone"

What I long for is the freedom of going about alone, of coming and going, of sitting on the seats in the Tuileries, and especially in the Luxembourg, of stopping and looking at the artistic shops, of entering the churches and museums, of walking about the old streets at night; that's what I long for; and that's the freedom without which one can't become a real artist. Do you imagine I can get much good from what I see, chaperoned as I am, and when, in order to go to the Louvre, I must wait for my carriage, my lady companion, or my family?

Curse it all, it is this that makes me gnash my teeth to think I am a woman!— I'll get myself a *bourgeois* dress and a wig, and make myself so ugly that I shall be as free as a man. It is this sort of liberty that I need, and without it I can never hope to do anything of note.

The mind is cramped by these stupid and depressing obstacles; even if I succeeded in making myself ugly by means of some disguise I should still be only half free, for a woman who rambles about alone commits an imprudence. And when it comes to Italy and Rome? The idea of going to see ruins in a landau!

"Marie, where are you going?"

"To the Coliseum."

"But you have already seen it! Let us go to the theatre or to the Promenade; we shall find plenty of people there."

And that is quite enough to make my wings droop.

This is one of the principal reasons why there are no female artists. O profound ignorance! O cruel routine! But what is the use of talking?

Even if we talked most reasonably we should be subject to the old, well-worn scoffs with which the apostles of women are overwhelmed. After all, there may be some cause for laughter. Women will always remain women! But still . . . supposing they were brought up in the way men are trained, the inequality which I regret would disappear, and there would remain only that which is inherent in nature itself. Ah, well,

no matter what I may say, we shall have to go on shrieking and making ourselves ridiculous (I will leave that to others) in order to gain this equality a hundred years hence. As for myself, I will try to set an example by showing Society a woman who shall have made her mark, in spite of all the disadvantages with which it hampered her.

January 10, 1879: "If I don't win fame quickly enough with my painting I will kill myself"

Robert Fleury[4] came to the studio in the evening.

We dine and breakfast at the Café Anglais, where the food is good; it is the best restaurant in the place.

The Bonapartist papers, and the *Pays* in particular, were so stupid about the elections that I feel a sort of shame for them, as I did yesterday for Massenet when his incantation was encored, for it lost its charm by repetition.

If I don't win fame quickly enough with my painting I will kill myself, that is all. I made up my mind to this several months ago. . . . In Russia once before I wanted to kill myself, but I was afraid of hell. I will kill myself when I am thirty years of age, for until thirty we are still young and can hope for some turn of luck—happiness, or success, or anything in short. There, now, that's settled; and if I were sensible, I should not worry myself, neither to-night, nor ever again.

I am speaking very seriously, and am quite pleased at having settled it so far.

January 11, 1879: "God is a very convenient institution"

At the studio it is thought that I go greatly into society; and this, together with my position, keeps me apart, and prevents me from asking them to do any of the little things for me that they are in the habit of doing for each other—to accompany me to some painter's, for instance, or to a studio.

I worked honestly all the week until ten o'clock on Saturday night, then I went home and began to cry. Until now I have always prayed to God, but as He never hears me at all, I almost begin to lose my faith.

Only those who have experienced this feeling can fully understand the horror of it. I do not wish to preach religion out of goodness, but God is a very convenient institution. When there is no one to have recourse to, when all other means fail, there still remains God. It commits us to nothing, disturbs nobody, while affording a supreme consolation. Whether He exists or no, we are *absolutely bound to believe in Him,* unless we are quite happy, and then we can do without Him. But in sorrow and misfortune—in fact, in discomforts of every kind—it were better to die than not to believe.

God is an invention which saves us from utter despair.

Only think then what a thing it is to call upon His name in one's last extremity, without believing in Him!

January 14, 1879: Winning a Prize at Julian's

I was unable to get up till half-past eleven after sitting up all night. The competition was judged this morning by the three masters—Lefebvre,[5] Robert Fleury, and Boulanger. I only reached the studio at one o'clock, and then only to learn the result. The elder girls had been examined this time, and the first words that greeted my ears as I entered were: "Well, Mlle. Marie, come along and receive your medal!"

And indeed there was my drawing fastened to the wall with a pin, and bearing the word: "Prize." I should have been less surprised had a mountain fallen on my head.

I must explain to you the importance and real meaning of these competitions. Like all other competitive examinations, they are useful, but the rewards are not always the proof of the tastes and natural ability of the individual. For it is unquestionable that Breslau, for instance, whose picture comes fifth in the list, is superior in every way to Bang, who comes first after the medal. Bang goes *piano e sano,* and her work is like good honest carpentering; but she always takes a high place, because women's work is in general rendered painful by its weakness and fancifulness, whenever it is not of a strictly elementary character.

The model was a lad of eighteen years, who, both in form and color, strikingly resembled a cat's head that one would make with a saucepan, or a saucepan in the form of a cat's head. Breslau has painted some figures which would easily win the medal; but this time she has not succeeded. And further, it is not execution nor beauty which is most appreciated down below, for beauty has nothing to do with study, you may have it in you or not, execution being only the complement of other more important qualities; but it's above all *correctness,* boldness and *perception* of truth. They don't consider the difficulties, and they are right; therefore a good drawing is preferred to an indifferent painting. What, after all, do we do here? We study; and these heads are judged solely from that point of view. Mine is a perfect swaggerer. These gentlemen despise us, and it is only when they come across a powerful, and even brutal, piece of work, that they are satisfied; this vice is very rare amongst women.

It is the work of a young man, they said of mine. It is powerful; it is true to nature.

"I told you that we had a stunner up there," said Robert Fleury to Lefebvre.

"You have won the medal, young lady," said Julian, "and it was awarded with honours; the gentlemen did not hesitate."

I ordered a bowl of punch, as is the custom down-stairs, and Julian was called. I received congratulations, for many present imagined that I had reached the height of my ambition, and that they should get rid of me.

Wick, who won the medal at the last examination but one, is this time the eighth; but I console her by repeating to her the words of Alexandre Dumas, who says so truly:—"A failure is not a proof that we have no talent, whereas one successful piece of work is a proof that we have." This definition is, after all, the one most exactly applicable to these matters.

A genius may do a bad thing, but a fool can't do a good one.

December 21, 1881: "I am nothing"

This girl [Breslau] is a power; she is not the only one I admit; but we come out of the same cage, not to say the same nest, and I foresaw and predicted her gifts, and announced them to you during my first days of study, ignorant as I then was, very ignorant. I despise, and have no faith in, myself. I don't understand why Julian and Tony say what they do. I am nothing; I have nothing in my vitals (Oh, Zola!). Compared to Breslau, I seem to myself like a thin and brittle cardboard box compared to a richly carved, massive oak chest. I am hopeless about myself, and am convinced that if I were to talk to the masters about it, they would come to the same conclusion.

But I mean to persist for all that, and to go on with closed eyes and arms stretched out, like one about to be engulfed in an abyss.

April 22, 1882: "If I had her talent I should be like no one else in Paris"

No, look you; what I should want in order to live would be the possession of great talent. I shall never be happy like the rest of the world; to be celebrated and to be loved, as Balzac says, that is happiness! . . . And yet to be loved is only an accessory, or rather the natural result, of being celebrated. Breslau is lean, crooked, and worn out; she has an interesting head, but no charm; she is masculine and solitary!

She will never be anything of a woman unless she has genius; but if I had her talent I should be like no one else in Paris. . . . That must come. . . . In the mad desire that it may come I seem to see a sort of hope that it will come.

This absence, this interrupted work . . . no longer to have advice and encouragement . . . it is bewildering! . . . You feel as though you had returned from China, you are no longer up to date. Ah! . . . I think I like nothing as I do painting, which, in my eyes, must give me all other kinds of happiness! False vocation, false disposition, false hope! This morning I went to the Louvre, and behold, I am slandering myself; one ought to be able to reproduce when one sees as I do. Formerly I used to have the confidence of ignorance, but my eyes have been opened for some time past. This morning it was Paul Veronese's turn to appear to me in all his splendour and magnificence—this unheard-of richness of tones! How shall I explain that these splendours have hitherto seemed to me great, dingy, grey and flat canvases? . . . What I did not see, I see now. . . . The celebrated pictures, which I looked at simply out of natural respect, charm and fascinate me; I feel the delicacies of colouring; in short, I appreciate *colour*.

One of Ruysdael's landscapes has made me return to it twice. Some months ago I saw nothing in it of what I see this morning—of real atmosphere . . . of space; in short, it is not painting, it is Nature itself. Well, that I now see all those beauties, which I did not see before, is owing to my trained eye; it may well be that the same phenomenon is produced in the hand.

I do not mean to say that until I went to Spain I was absolutely wooden, but that

journey certainly removed a veil from my eyes. . . . Well, then, I must now work at the studio—I have done enough independent things to render my hand supple for the moment; now my technique must become first-rate, and I will paint a picture. . . .

June 20, 1882: "How women are to be pitied"

Ah, well! nothing new. An interchange of visits and painting . . . and Spain. Ah! Spain, it is one of Théophile Gautier's books which has caused all that. Is it possible? What! I have been to Toledo, Burgos, Cordova, Seville, and Granada! Granada ! What! I have visited these countries whose very names it is an honour to utter; eh, well! it is delirium. To return there! To see those marvels again! To return alone or with some of one's fellow-comrades; have I not suffered enough through going there with my relatives! O poetry! O painting! O Spain! Ah! how short life is! Ah! how unfortunate one is to live so little! For to live in Paris is only the starting-point of everything. But to go on those sublime travels—travels of connoisseurs, of artists! Six months in Spain, in Italy! Italy, sacred land; divine, incomparable Rome! It makes my head swim.

Ah! how women are to be pitied; men are at least free. Absolute independence in every-day life, liberty to come and go, to go out, to dine at an inn or at home, to walk to the Bois or the café; this liberty is half the battle in acquiring talent, and three parts of every-day happiness.

But you will say, "Why don't you, superior woman as you are, seize this liberty?"

It is impossible, for the woman who emancipates herself thus, if young and pretty, is almost tabooed; she becomes singular, conspicuous, and cranky; she is censured, and is, consequently, less free than when respecting those absurd customs.

So there is nothing to be done but deplore my sex, and come back to dreams of Italy and Spain. Granada! Gigantic vegetation! pure sky, brooks, oleanders, sun, shade, peace, calm, harmony, poetry!

July 30–31, 1882: "I must produce something which will make them leap with astonishment"

Robert Fleury came this evening, and we had a discussion about the picture . . . and about work in general. I do not work in a satisfactory manner. For two years I have had no continuity of ideas, and so I am never able to pursue a study to the end. That is very true. . . . He says it in order to prove to me that I make as much progress as possible considering the manner in which I work, and that the other young people work longer and better. Nothing is so effectual as perseverance and continuity; whereas a good week now and then, followed by idleness, goes for little, and does not allow of progress. But, it's true, I was ill, travelling, and without a studio. . . . Now I have everything, and if I do not set to work I must be worthless.

The picture is a good one; I will do it well. This week my painting has been bold,

but . . . to rid me of my despair he would have to say something more exciting; in fact, that I am as powerful as . . . one of the most powerful; that I can do whatever I choose; that. . . . And he tells me, when I complain, that it is absurd, and that he has never seen any one do more in so short a time. Four years! then he tells me that the most gifted or the most fortunate do not succeed in less than seven, eight, or even ten years. Oh, it's too bad!

There are moments in which I could dash my brains out. Rhetoric is of no use. I must produce something which will make them leap with astonishment, nothing else will restore my peace. . . .

August 10, 1882: "My picture"

That poor Tony has rubbed out the left hand at the end of the sitting. Though one may be an Academician, and have received the medal of honour, one is none the less subject . . . and first of all he wanted to do something very excellent; he told me that he had almost a nightmare and a bad headache because it didn't seem to come right at first.

How I sympathise with these troubles that I know so thoroughly . . . and of which no one can form an idea who is not *of the fraternity.*

He writes a journal every evening just as I do; what do you think he can say in it about me? He thinks that Breslau's laurels prevent me from sleeping. . . . But he knows to what a degree I recognise my inferiority. . . . It is true that now I talk of *my picture,* and even that seems to me a presumption! It is only by hearing other nobodies say: "My sketch, my picture," &c., that I have dared . . . and if it appears ridiculous to me, it is because I should prize so highly the right of saying it openly, and do not want to see it debased or lowered by too familiar and disproportionate usage. You understand me, do you not?

March 30, 1883: On Marriage

Today I have worked until six o'clock; at six o'clock, as there is still daylight, I have opened the door of the balcony to hear the church bells and breathe the spring air while playing on the harp.

I am calm, I have worked well, then I washed, and dressed myself in white; I have played some music, and now I am writing; tranquil, satisfied, enjoying this interior arranged by myself, where I have everything to my hand it would be so lovely to live this life . . . awaiting fortune; and even if it came I would sacrifice two months a year to it, and for the other ten months I would remain shut up and working. . . . It is the only way, besides, to get the two months in question. What torments me is that I shall have to marry. Then there would no longer be any of these base disquietudes of vanity from which I do not escape.

Why does she not marry? They say I am taken for five-and-twenty, and that enrages me; whereas once married. . . . Yes, but to whom? If I were, as once, in health.

. . . But now it must be a man who is kind and delicate. He must love me, for I am not rich enough to marry one who would leave me quite to myself.

April 1, 1883: "It seems to me that I am ill"

I go to the Louvre this morning with Brisbane (Alice). Not that she is very interesting, as Breslau, for instance, would have been. There is no exchange of ideas; but she is good, and fairly intelligent; she listens to me, and I think aloud. It is an exercise. I talk of what interests me, and of what I should desire. Of Bastien, naturally, for he has taken an enormous place in my conversations with Julian and Alice. I like his painting extraordinarily, and I shall seem to you very blinded if I tell you that those old dusky paintings in the Louvre make me think with pleasure of the living pictures bathed in air, with speaking eyes, and with mouths just about to open.

Well, that is my impression this morning, I do not give it as final.

I cough, and though I do not get thinner it seems to me that I am ill, only I do not want to think of it. But why then have I such a healthy look, not only in colour, but in size?

I look for the cause of my sadness and I find nothing, unless it be that I have hardly done anything for a fortnight.

October 1, 1884: "My picture will not be done"

Such disgust and such sadness.

What is the good of writing?

My aunt has left for Russia on Monday; she will arrive at one o'clock in the morning.

Bastien grows from bad to worse.

And I can't work.

My picture will not be done.

There, there, there!

He is sinking, and suffers terribly. When I am there I feel detached from the earth, he floats above us already; there are days when I, too, feel like that. You see people, they speak to you, you answer them, but you are no longer of the earth; it is a tranquil but painless indifference, a little like an opium-eater's dream. In a word, he is dying. I only go there from habit; it is his shadow, I also am half a shadow; what's the use?

He does not particularly feel my presence, I am useless; I have not the gift to rekindle his eyes. He is glad to see me. That's all.

Yes, he is dying, and I don't care; I don't realise it; it is something which is passing away. Besides, all is over.

All is over.

I shall be buried in 1885.

October 16, 1884: "The picture of this year!"

I have a terrible amount of fever, which exhausts me. I spend all my time in the *salon,* changing from the easy-chair to the sofa.

Dina reads novels to me. Potain came yesterday, he will come again tomorrow. This man no longer needs money, and if he comes, it is because he takes some little interest in me.

I can no longer go out at all, but poor Bastien-Lepage comes to me; he is carried here, put in an easy-chair, and stretched out on cushions—I am in another chair drawn up close by, and so we sit until six o'clock.

I was dressed in a cloud of white lace and plush, all different shades of white; the eyes of Bastien-Lepage dilated with delight.

"Oh, if I could only paint!" said he.

And I—

Finis. And so ends the picture of this year!

VICTORIAN ENGLAND

Recent scholarly studies have provided a detailed picture of the artistic and literary activities of women in Victorian England. The excellent documentation of women's participation in the visual arts and analysis of the writing of the era present us with a newly clarified context for understanding the Victorian texts excerpted here.

During the second half of the nineteenth century there was an enormous increase in the absolute number of practicing professional women artists in England. In 1841 fewer than 300 women identified themselves as artists in the census; by 1871 there were 1,000 women artists. The middle third of the century saw this growing body of women artists become more vocal and visible. In 1856 the Society of Female Artists was established. According to Pamela Gerrish Nunn, the founding of this society was a key historical turning point: "The society's establishment can be seen as a reflection of the growing numbers of women anxious to show their work but dissatisfied with the conditions of exhibition which prevailed (which discriminated against them) and as a move to extend women's working (and therefore earning) possibilities."[1] Paula Gillett interprets the formation of this group as a reflection of the fact that, by the mid-1850s in England, the field of painting was viewed as a potentially profitable and still socially acceptable mode of employment for women.[2]

Painting then was taking its place, along with working as a governess, as permissible employment for the 800,000 unmarried middle-class women. Even by the 1870s those women, struggling to make their way in the field of painting, were confronted with a range of obstacles to full professionalism. They were not admitted into the Royal Academy, which provided crucial recognition in this culture. Elizabeth Thompson Butler was the only woman who came close to being elected, losing by a slim margin in 1879. Their education remained discriminatory since they could not study the nude. Women bore greater domestic responsibilities, whether as unmarried spinsters in the households of their parents or as wives and mothers. All such social roles were expected to take precedence over activities such as painting. Furthermore, a large number of amateur

artists created expectations of dilettantism, making things difficult for the woman painter committed to professional excellence.

As Gerrish Nunn notes, women were not supposed to earn money: financial dependence was expected of all but the lowest classes of women.[3] Furthermore, women artists operated in a cultural milieu with widespread beliefs in the innate inferiority of their creative powers, both intellectual and artistic. Patriarchal Victorian culture believed that women's limited achievements in the arts inevitably resulted from gender-linked deficiencies in artistic creativity and the higher powers of imagination.[4]

Despite these widespread cultural myths about women and art, educational opportunities did open up for women artists during the period under consideration. In 1842 the Female School of Art was founded to improve design components in manufactured goods and to provide an honorable means of employment for single women. The growing strength of the feminist movement in the 1850s was centered around a campaign for a Married Women's Property Bill. Fueled by an active art market for contemporary paintings, Laura Herford, submitting a work signed only with her initials, forced open the doors of the Royal Academy in 1860. However, between 1863 and 1868 no other women were admitted, and women continued to be excluded from the life class. The opening of the Slade School in 1871, with its stated policy of equal opportunity for men and women, was of great benefit to women. Well into the 1870s, careers in the arts, both fine and applied, were among the very few respectable occupations for those without independent income in the middle classes.[5]

With the growing population of women artists, more women exhibited their works in the 1880s and 1890s, although unbiased critical evaluation was still not possible. The founding of the Fine Art Society in 1876, the opening of the Grosvenor Gallery in 1877, and the continuing exhibitions of the Society of Lady Artists (known after 1899 as the Society of Women Artists) provided more varied opportunities for women to exhibit. The Royal Academy until 1900 remained dominated by male artists, never permitting more than 300 women to exhibit in any individual show.

Gerrish Nunn concludes that while the Victorian period witnessed the emergence of women as artists, those artists still suffered a full range of discriminatory attitudes and conditions: "Women working between 1880 and 1900 seem to have fared only cosmetically better than earlier generations examined here."[6]

Gillett notes a strengthened level of hostility toward women artists in the 1880s and 1890s. She connects this posture with a depressed art market, characterized by greater competition for sales as well as the increased practice of women painting the nude.[7]

Such cultural attitudes were not strong enough to discourage women painters, who were now benefiting from expanded opportunities for training and growing professional commitment. "Societal insistence on a refined dilettantism that would restrict women painters to small-scale work and to subjects deemed appropriate to their nature . . . was increasingly unacceptable to those women who had cast off Victorian roles and expectations."[8]

By the 1890s there were 56 separate institutions where women could study art,

and after 1893 the Academy School finally permitted women to study the partially draped male model. Access to totally nude live models was achieved a decade later in 1903, in a separate life class.

However courageous women artists have been in their professional goals, their acceptance of prevailing cultural stereotypes can be seen in the patterns of their artistic careers after marriage.[9] Most women artists accepted the fact that marriage would curtail or terminate their painting careers. Anna Mary Howitt stopped painting completely after her marriage. Paul Underwood has discussed the ways marriage affected the career of even the highly successful and well-established Elizabeth Thompson after she became Lady Butler.[10] A career in the visual arts remained a culturally conservative choice, and it is not surprising that Victorian women artists largely accepted the "separate sphere" as defined by hegemonic patriarchal social discourse.

Evidence for the acceptance of the "Cult of True Womanhood" and the differences between the sexes is found in the marked differences between men's and women's autobiographies during the Victorian period. Gail Twersky Reimer has defined male autobiography in the following manner:

The male Victorian autobiographer typically explored his own creative mind and imagination with the consciousness that he was a "hero" of the age, whose vocation could be best understood through analysis of past experience. Seeking to trace a continuity from early childhood to the defining idiom of his adult life, i.e., his work, he concerned himself less with the actual events in his life than with re-covering or dis-covering a unitary self by probing the life of the mind.[11]

Most Victorian women did not venture into "true Autobiographies"; only a few (Butler is an exception) even used the term. Unlike men of the epoch, Victorian women exhibited an unwillingness to examine their achievements in detail as stages in a career; their self-writing instead took the form of the diary, letter, and travel memoir. These types of writing are frequently found and in fact are more characteristic than other literary modes in the entries included in this book. "That few Victorian women felt at home with this [autobiographical] tradition is proved by their unwillingness to engage in long consistent examinations of all their achievements."[12]

Linda Petersen confirms the difference in men's and women's autobiographical writing in the Victorian era. She notes a marked absence of spiritual autobiographies by women, the type of developmental autobiography viewed as the primary tradition of such writing in Britain since the seventeenth century. "In general, they [women] did not compose retrospective accounts of spiritual or psychological progress, they did not use principles derived from biblical hermeneutics to interpret their lives, and they did not attempt to substitute another system of interpretation to create a secular variant of the form."[13] Peterson attributes this in part to the prevailing cultural attitudes about women's intellectual capabilities. Hannah More's *Strictures on the Modern System of Female Education* (1799), a volume addressed to aspiring women writers, is characteristic of the culture's beliefs about the limitations of the female mind. More assigns to women faculties of "fancy" and "memory" but denies that women have faculties of "comparing,

combining, analyzing and separating'' their ideas, and believes that they lack "deep and patient thinking" and "power of arrangement . . . to link a thousand connected ideas.''[14] The prevailing attitudes of the Church of England likewise excluded women from public use of biblical analogies for self-interpretation, an important component of the autobiographical literary tradition in England.

"For many nineteenth-century women, the illusion of writing letters to a sympathetic friend was the only enabling entry into autobiographical discourse.''[15] This is the appropriate context in which to understand the first text in this chapter—Anna Mary Howitt's *An Art Student in Munich*. In the preface, Howitt states that the book is based on letters home. From June 1850 through May 1852, most of the passages bear specific dates. However, without any designated correspondents, the volumes take on the character of a travel journal or diary. One of the earliest travel books is Anna Jameson's *Diary of an Ennuyée* (1826), a thinly disguised "fictional" account of her travels in France and Italy as a governess. This type of publication is another component of the appropriate context for Howitt's text.

The combination of diary and letter is common in women's self-writing during the Victorian period. All four of the writers excerpted here use this technique. Journal entry and letter are similar in that each posits the existence of an intimate, sympathetic reader and each is written for private communication. The importance of letter writing in the eighteenth century has been discussed in connection with Vigée-Lebrun's memoirs. Sanders makes the additional observation that actual letters inserted at crucial points were sometimes used to increase authenticity or record spontaneous praise for achievements by an indirect method. Both Jopling and Butler use this technique frequently.

The other three volumes also excerpted in this chapter were not published until the twentieth century; in fact, Anna Lea Merritt's remained unpublished until 1982. This is consistent with Sanders's generalizations: "Not until the final quarter of the nineteenth century did a significant number of women who enjoyed professional success in any field publish formal autobiography, and even then it often dwindles into chatty reminiscences of old friends, and extracts from their correspondence.''[16]

Most women's autobiographies are composed of "a collage of viewpoints and identities, mediated through selected diary entries and letter extracts, which instead of presenting a coherent picture of an individual life, stray off into eddies of gossip, incidental allusions to current affairs, and sketches of the great and famous. . . . Women autobiographers prefer to screen themselves behind a variety of poses.''[17] This description of literary strategies applies to Butler's and Jopling's books precisely.

Professionally successful women, in general, were "not consistently in conflict with the dominant culture: indeed, they actively contributed to its formation, frequently reinforcing images of the feminine ideal and upholding traditional notions of the domestic and dependent womanly stereotype. . . . Most women reveal their ambivalent commitment to autobiography in the rash of disclaimers, apologies and self-contradictory statements that mark their rhetorical strategy.''[18]

These conclusions are consistent with the theoretical position articulated in the introduction to this volume. Women occupied two spheres simultaneously, the male

and the female world. Most Victorian women artists accepted the terms of the discourse of gender in their culture.

Yet the very existence of the quantity of self-writing by nineteenth-century women testifies to a "preoccupation with individual experience and a desire to communicate it. . . . Increasingly women felt that what had happened to them . . . deserved retelling, especially to other women, who could find it 'useful.' "[19]

7

Anna Mary Howitt (1824–1884)

Anna Mary Howitt's brief, active career as a painter is, for our contemporary context, overshadowed by the publication of her account of her studies in Germany. Originally published in 1853, *An Art Student in Munich* was ahead of its time, and was republished in 1880. Recognizing the limitations of art education in England, Howitt courageously went to Munich accompanied by Jane Benham (Hay), (who appears in her book as "Clare") to study with Wilhelm Kaulbach (1805–1874) in May of 1850. She returned to England in 1852. The fruits of this period of apprenticeship may be determined from the ecstatic review of her painting in the *Atheneum* of 1854, whose reviewer wrote that Howitt's *Margaret Returning from the Fountain* was "the finest picture so far of the year."[1] Her mature activity as a painter was compressed between 1853 and 1858. The following year she married Alaric Watts. It is certainly possible that her marriage was the main reason for her withdrawal from professional art activities; as discussed earlier, marriage frequently interrupted the professional careers of Victorian women. However, her mother's diary records that "In the spring of 1856, a severe private censure of one of her oil paintings by a king amongst critics [John Ruskin] so crushed her sensitive nature as to make her yield to her bias for the supernatural, and withdraw from the ordinary arena of the fine arts."[2] Gerrish Nunn speculates that the marriage of her friend Barbara Leigh Smith (Bodichon) (who appears in our excerpt as "Justina") in 1857 may have also been a significant factor.

Howitt was raised in Nottingham and Esher, England, in a supportive but not specifically artistic environment. She was the eldest daughter of Quaker parents, and the sources of her early education in the visual arts are not certain. Between 1840 and 1843 the Howitt family lived in Germany, an experience that made Anna more ready to live in Munich seven years later. Beginning with the family's move to London in 1848, Howitt developed a circle of feminist artist friends such as Benham and Leigh Smith. After her return from Munich in 1852, her contacts included abolitionists (through her mother's interests) and Pre-Raphaelite artists. According to Gerrish Nunn, nearly all her exhibited paintings remain untraced.

In the preface to *An Art Student in Munich,* Howitt states that the volume is derived

from "gleanings from letters written home." Most of the pages do have specific dates, so the text takes on the character of a private journal or diary. However, it is divided into chapters and there are some brief connecting narrative passages between the dated texts, clearly the result of a later editing process.

The portions of *An Art Student in Munich* excerpted here focus on Howitt's dedication to the study of art. Her understanding of the differences between men and women are articulated. The feminist bonding between herself and her companions, also aspiring women artists, is described. Finally, the religious mission of art as she conceived it is revealed in these pages.

The first segment recounts her initial encounter with Kaulbach and her excitement over arrangements to work in his studio. The determination of these young women to acquire training, their projections of alternative plans if they can "find no really first-rate master," and their fervent prayers offered at the happy outcome convey some of their energy and excitement.

The visit of "Justina" provides insight into the comradeship and bonding among these aspiring women artists who are imbued with a feminist vision of an "inner sister-hood" of artists, living together in mutual support. Certainly it is this attitude which provided the impetus for the founding of the Society of Female Artists in 1857. Howitt's extreme content, her thorough joy in her condition, is summarized in her statement "what a beautiful state is that of the student, after all."

Our final excerpt encapsulates Howitt's perceptions about being a woman. Her firm belief in and acceptance of prevailing notions of a "separate sphere" in which women exist and the specific differences between the sexes are here clearly defined. As she articulates her perceptions of gender difference, so consistent with those of patriarchal Victorian discourse on gender, she also simultaneously asserts a faith in art as a religious mission. She defines art as "the interpreter to mankind at large of God's beauty."

Anna Mary Howitt is a characteristic example of the ways in which women of this era, even those dedicated to excellence as artists, accepted the Victorian definitions of "true womanhood." We can only regret that the energy which propelled her to Germany could not sustain her very long as a married woman in Victorian England.

June 1850: Entering the Studio of Kaulbach

Rejoice with us: on Monday we become pupils of——! Yes, next Monday we are to begin our studies in that identical little atelier where, seven years ago, when almost a child, I saw that group of young artists resting themselves at noon, and playing on the guitar,—a group which has haunted me ever since, like a glimpse into a new world of poetry, or the old world of Italian art. Yes! that little room, with its glorious cartoons, its figures sketched on the walls, its quaint window festooned with creepers,—*that* is to be our especial studio. There we stood this morning; there we showed——our sketches; there I talked to him in the German tongue, being the mouth-piece for us both, as though he had been a grand, benevolent angel.

I told him how earnestly we longed *really to study*; how we had long loved and revered his works; how we had come to him for his advice, believing that he would give us that, if not his instruction, which we heard was impossible. I know not how it was, but I felt no *fear*,—only a reverence, a faith in him unspeakable. And what did he do? He looked at us with his clear keen eyes, and his beautiful smile, and said,—"Come and draw here; this room is entirely at your disposal." "But," said we, "how often, and when?" He said, "Every day, and as early as you like, and stay as long as there is day-light."

We knew not how to thank him; we scarcely believed our ears: but he must have read our joy, our astonishment, in our countenances.

The amount of our joy may be estimated by considering what was exactly our position the evening before,—nay, indeed, at the very time when we entered the studio. The evening before, we were discouraged and disheartened to an extreme degree; our path in study seemed beset by obstacles on every hand: in fact, we asked ourselves for what had we come,—how were we better off here than in England? We talked and talked, and walked into that lovely English Garden, along the banks of the Isar; the trees rose up calmly in their rich summer foliage; all was silent in the approaching twilight; long gleams of pale flesh-colored sky gleamed through the clumps of trees in the distance; acres of rich summer grass and flowers stretched away from our feet. Behind us rose a gentle mound surmounted by a white marble pavilion, more like something on the stage than a reality; there was the scent of early mown grass, the distant hum of the city, the towers and spires of which, in the distance, rose abruptly into the evening sky, as if from a sea of wood; there was the near rush of the water, the gentle voice of a bird ever and anon. The peace of Nature sunk into our hearts: never had nature and life and art seemed so holy and beautiful to us, I believe. We talked of a thousand things; a certain cloud, a certain barrier which seemed to have existed between our hearts, melted away; for, after all, our hearts had been strangers to each other until this night.

On our return home, we still thought and thought what was to be done; we talked till it was morning, and by that time we had arranged a grand ideal plan of work, which, as far as it went, was good. We determined, if we could find no really first-rate master, to have models at our own rooms, and work from them most carefully with our anatomical books and studies beside us; that we would do all as thoroughly as we could, and help and criticise each other; that we would work out some designs in this way, studying the grand works around us, going daily to the Basilica, to the Glyptothek, to drink in strength, and inspiration, and knowledge; that we would draw also from the antique, and would take our drawings to be corrected by——, as he had already offered. This was the scheme of the night.

The first thing, therefore, this morning, was our setting off boldly to him with our sketches, to ask his advice. The rest is told.

As we left the studio, I could have fallen upon my knees, and returned fervent thanks to God, so mysterious was this fulfilment of my long-cherished poetical dream. It would have been a relief to one's heart so to have done; but though one often feels such impulses, one rarely gives way to them. As we walked through the streets home,

how wondrously proud did we feel! It seemed to us as though a sort of glory must surround us, as though every one ought to read instantly upon our brows—'the happy pupils of a great master!'

September 1850: Justina's Visit—A Group of Art-Sisters

How delicious was my meeting with Justina yesterday! At the moment when I was sitting at a solitary breakfast—for Clare was yet asleep—with my mind full of Justina, and after having arranged and dusted everything in our rooms, to be ready for her, I heard the outer door open. I said to myself, 'Justina!' The room door opened, and she entered.

Of course the first thing we did was to cry for joy, and then to gaze at each other, to see whether really she were Justina and I were Anna. It seemed strange, dream-like, impossible, that we two could be in Munich together. . . . Before long we set off to Kaulbach's studio—Justina, Clare, and I; but we could not resist going a little out of the way to walk down the beautiful Ludwig Strasse into the Ludwig Kirche. Many things struck her much: the rich coloring introduced into the architecture, the pervading presence of one great artistic thought throughout the city. She was more impressed than I expected her to be. I had always imagined the German school of art would not find a response in her soul; but she declared that an entirely new class of beauty, a fresh field of delight and thought, had been opened to her.

When we entered the Ludwig Kirche, I saw her form dilate with emotion. She seemed to grow taller and grander; a rich flush came over her face; and her eyes filled with tears.

"I do not feel this," said she, "to be the work of man, but of nature. The arched roof produces upon me the same thrill as the sky itself!". . .

Thoroughly did she enter into the spirit of Kaulbach's works; she is worthy to understand them. She thinks, with me, that for intellect, and dramatic power and poetry, he is superior to any living artist.

We three, as it happened, had the studio all to ourselves; and we stood and sat before those grand works, in the most perfect repose and silence, and drank in the whole spirit of the place.

Justina looked grandly beautiful, with that golden hair of hers crowning her as with a halo of glory, and her whole soul looking through her eyes, and quivering on her lips as she gazed at the pictures. I longed for Kaulbach to quietly enter, and see her standing before them like a creature worthy to be immortalized by him,—an exception to the puny prosaic race of modern days, who are unworthy to live in art,—who only deserve to pass away and be forgotten. . . .

Justina is gone! I am alone this evening, as Clare is out with some English friends.

Thank God that she has been here! We all agree that three such gay delightful days never before were spent by three such accordant spirits; days which we shall never forget, and out of which Justina declares that something great and good must come.

She, the very embodiment of health, soul, and body, without a morbid or mean emotion ever having sullied her spirit—with freshness as of the morning, and strength as of a young oak—has had the most beneficial influence on both of us through her intense love of nature and art, through the same aims in life, yet all three so different from each other. Clare, a thorough creature of genius, born to success whether she had devoted herself to music, the drama, or painting,—an artist in the true sense of the word, with a dramatic power of expression in everything she attempts, and of a self-absorbed character by nature. I, possessing an intense devotion and love of art, of a sensitive, poetical temperament, which at times becomes somewhat morbid, yet earnest, persevering, with a constant aspiration after the spiritual, and a firmer, much firmer faith in the Unseen than either of the others. Cannot you see how great must be our usefulness to each other,—our influence upon each other? We have been all three struck by this; we have felt our peculiar individualities come out in strongest contrast.

What schemes of life have not been worked out whilst we have been together! as though this, our meeting here, were to be the germ of a beautiful sisterhood in Art, of which we have all dreamed long, and by which association we might be enabled to do noble things.

Justina, with her expansive views, and her strong feelings in favor of associated homes, talked now of an Associated Home, at some future day, for such "sisters" as had no home of their own. She had a large scheme of what she calls the Outer and Inner Sisterhood. The Inner, to consist of the Art-sisters bound together by their one object, and which she fears may never number many in their band; the Outer Sisterhood to consist of women, all workers and all striving after a pure moral life, but belonging to any profession, any pursuit. All should be bound to help each other in such ways as were most accordant with their natures and characters. Among these would be needle-women—good Elizabeth——'s, whose real pleasure is needle-work, whose genius lies in shaping and sewing, and whose sewing never comes undone,—the good Elizabeth! how unspeakably useful would such as thou be to the poor Art-sisters, whose stockings must be mended! Perhaps, too, there would be some one sister whose turn was preserving, and pickling, and cooking; she, too, would be a treasure every day, and very ornamental and agreeable would be her preparation of cakes and good things for the evening meetings once or twice a month. And what beautiful meetings those were to be, as we pictured them in the different studios! In fact, all has been present so clearly to my imagination, that I can hardly believe them mere castles in the air.

November 14, 1851: "What a beautiful state is that of the student"

What a beautiful thing, what a beautiful state is that of the student, after all! the very aspiration, endurance, patient labor, and uncertainty of this phase of human life, engendering faith, and hope, and love, and humility, throw a peculiar halo of beauty around it. I have often felt this, but never more strongly than to-day. It seemed to me that the acquiring, the accomplishing, was, as far as the soul itself is concerned, really more than the acquisition,—than that which is accomplished.

April 1852: On the Nature of "Woman": "Different always, but not less noble"

Baron H., I recollect, once described to me an excursion which some students he knew had made to Vienna on a raft. In description, at all events, it sounded very delightful. The floating so dreamily along the solemn Danube—the peculiar life among the raftsmen—the pausing for the night with the raft at old-world villages upon the banks—villages far away from the beaten path of ordinary travellers—the glimpses of a quaint, fresh, peasant life, opening out before you in the talk of the raftsmen and of the villagers—all this, I well remember, most pleasantly affected by imagination. I remember, also, that a sort of little sigh for a moment heaved itself up in my heart as he described it,—'Oh, if I were but a man, then would I voyage with a raft!'

But, thank God! such silly sighs as this do not often heave themselves up in my heart; for the longer I live the less grows my sympathy with women who are always wishing themselves men. I cannot but believe that all in life that is truly noble, truly good, truly desirable, God bestows upon us women in as unsparing measure as upon men. He only desires us, in His great benevolence, to stretch forth our hands and to gather for ourselves the rich joys of intellect, of nature, of study, of action, of love, and of usefulness, which He has poured forth around us. Let us only cast aside the false, silly veils of prejudice and fashion, which ignorance has bound about our eyes; let us lay bare our souls to God's sunshine of truth and love; let us exercise the intelligence which He has bestowed on us upon worthy and noble objects, and this intelligence may become keen as that of men; and the paltry high heels and whalebone supports of mere drawing-room conventionality and young ladyhood withering up, we shall stand in humility before God, but proudly and rejoicingly at the side of man! Different always, but not less noble, less richly endowed!

And all this we may do, without losing one jot or one tittle of our womanly spirit, but rather attain solely to these good, these blessed gifts, through a prayerful and earnest development of those germs of peculiar purity, of tenderest delicacy and refinement, with which our Heavenly Father has so specially endowed the woman.

Let beauty and grace, spiritual and external, be the garments of our souls. Let love be the very essence of our being—love of God, of man, and of the meanest created thing—LOVE that is strong to endure, strong to renounce, strong to achieve! Alone through the strength of love, the noblest, the most refined of all strength—our blessed Lord Himself having lived and died teaching it to us—have great and good women hitherto wrought their noble deeds in the world; and alone through the strength of an all-embracing love will the noble women who have yet to arise work noble works or enact noble deeds.

Let us emulate, if you will, the strength of determination which we admire in men, their earnestness and fixedness of purpose, their unwearying energy, their largeness of vision; but let us never sigh after their lower so-called *privileges,* which when they are sifted with a thoughtful mind are found to be the mere husks and chaff of the rich grain belonging to *humanity,* and not alone to men.

The assumption of masculine airs or of masculine attire, or of the absence of tenderness and womanhood in a mistaken struggle after strength, can never sit more gracefully upon us than do the men's old hats, and great coats, and boots, upon the poor old gardeneressees of the English Garden. Let such of us as have devoted ourselves to the study of an art—the interpreter to mankind at large of God's beauty—especially remember this, that the highest ideal in life as well as in art has ever been the blending of the beautiful and the tender with the strong and the intellectual.

8

Louise Jopling (1843–1933)

Like Anna Mary Howitt, Louise Jopling is a Victorian woman known today more through her writing than by her surviving paintings. Published in 1925, Jopling's *Twenty Years of My Life: 1867–1887* is a discursive and rambling memoir that traces her beginnings as an artist through the most active period of her professional life.

Pamela Gerrish Nunn has described the majority of Jopling's paintings as characterized by "the gloss of prettiness, or sentimentality, fluent surface and ingratiating smile."[1]

Punctuated frequently by letters, the narrative flows along with the same ingratiating qualities which Nunn perceived in Jopling's paintings. Most of the letters are by Jopling herself, although a few from famous correspondents such as John Millais are reprinted. The letters lend documentary authenticity to the rather superficial narrative. The twenty-year period was already far back in the author's past, and her temporal distance from the events is underscored in her introductory remark "I have the feeling . . . that I am describing the life and adventure of somebody else." For Jopling, then, it was the passage of between thirty and fifty years between the actual living and the writing down of these events that enabled her to undertake her autobiographical project.

Married at the age of 17 to Frank Romer and a mother of two boys by the time she was 22, Louise moved to Paris with her family in 1865. The liberating effects of living in Paris and the opportunities, however discriminatory, to study art there are detailed in the first segment reprinted here, describing her lessons in the women's class at the Atelier Chaplin. "Only abroad can a working and a domestic life be carried on simultaneously with little effort." The supportive environment of this all-woman class finds a parallel in the last segment, in which Jopling discusses her own activity as a teacher.

Romer abandoned Louise in 1871, and died a few years later. In our second segment, Jopling reprints a letter she wrote to a friend, Albert Fleming, after hearing the news of her husband's death. In this letter she expresses her desire for independence, unless she is absolutely forced into another union strictly for financial reasons or ill-health; "I am perfectly happy with my work, my children and the love of my sisters."

Despite these professed sentiments, she married the painter Joseph Jopling in 1874.

91

She was again widowed when Jopling died in 1884. She was married yet a third time in 1887, to George Rowe, but that phase of her life is outside the scope of her autobiography.

Her responsiveness to the position of women artists is documented by the establishment of her own class, discussed in the last excerpt. Unlike Anna Lea Merritt, Jopling exhibited her works at the Society of Female Artists, despite her other, more prestigious options of exhibiting at the Royal Academy and the fashionable Grosvenor Gallery. She thus expressed a feminist solidarity with other women artists of her era.

Study at the Atelier Chaplin

Studio life was a strange experience to me. I had never been to a school of any sort, having always learnt with a governess at home.

I had not worked with other girls, save my own sisters, and it took me a little time to acclimatize myself. However, my companions were charming, and the fact of my being a foreigner, and the mother of the two pretty little boys who, with their nurse, used to fetch me from the Studio, made the other students take an affectionate interest in me.

It was glorious having so much opportunity for serious work. Only abroad can a working and a domestic life be carried on simultaneously with little effort.

In France one is expected to cultivate what little talent one possesses. How my relations in England would have stared, and thought me little less than mad, to entertain the idea of becoming a "professional"—I, a married woman! . . .

What a happy life it was! How different from that I should have led in London! At this time, I knew of no girl, much less a married woman, who had studied Art. There must have been some, though, because females had already made their way into the Academy Schools. The drawings sent up for approval are signed only with initials. Great must have been the surprise of the examiners when a girl first made her appearance amongst the youthful males! Brave pioneer! I wish I had been there to see her entry. Her name was Laura Herford. She was the aunt of the distinguished water-colour artist, Mrs. Allingham, R.W.S., who had previously been known as a clever black-and-white artist, under her maiden name of Emily Paterson. Restrictions, however, were made. A female student was not allowed to study from, what is euphoniously called, "the altogether." With such a handicap, is it surprising that for a time women lagged far behind men in the race for fame?

To a sane and healthy mind this prohibition savours of pruriency, and it was to this wrong way of looking at Nature that James Hinton, the philosopher, so strongly objected. It is no shock to a girl student to study from life. With youths it is, perhaps, different, owing to the survival of the monastic method of segregating them from girls of their own age.

When Sir Joshua Reynolds organized an Academy of painting and sculpture, two women were included: Mary Moser and Angelica Kauffmann. Zoffani, [sic] one of their

members, painted a portrait group of the "Forty." It is amusing to see that the two lady members are only represented by their portraits on the wall of the room in which the male members are seated.

Letter to Albert Fleming: "I shall stand or fall by my own making"

Indeed, yes; I have been feeling very much Frank's death. My thoughts travel very far backwards, and retrospection only shows me the good and the best of his nature. He was the lover of my youth; the father of my children; and, like the blood on Lady Macbeth's hand, these things are ineffaceable, even by any amount of wrongdoing. Of course we do not know yet, but I imagine, till quite the last, he was ignorant of his approaching end. I have seen three of his letters from America to a friend of his here, in Paris, and they are written in a thoroughly happy strain, and with unbounded confidence in his well-doing in the future. I should not like to think of his having died in want, away from his own people. It will, of course, be to me an unceasing regret that, after having lived together for ten years, our last parting should have been in enmity. But, long ago, I had borne him no malice, and I trust that his last thoughts of me were not unkind.

You say, "So you are free at last." Indeed, I had no wish to be. What difference does it make to me? I inherit no fortune, and, as I do not wish to marry again, it does me no good in that way.

I do not quite understand your ideas about Frank's death "putting an end to vile gossip, slander, and evil-speaking." My dear Albert, it would be another world if that were possible. Show me the happy mortal who can walk through it without experiencing one, if not all, of the three. You write, "And I know that you are too weary of it all ever to set the tongues wagging again." How did I set them going? Believe me, I do not consider myself so omnipotent as to make them speak, or be silent at my will. If I have been a fair mark for gossip, I shall be so just the same now, for I only recognize my own views of right or wrong, and not what the world chooses to say about what I do.

As to marrying again, I shall do so only when I have no longer the power, as I have now, of earning my own bread. I have tasted for too long a time, and have too keen a relish for the bread of independence ever to exchange it for the kickshaws of dependence.

What bad arguments you choose! "For your own peace' sake!" Peace has never reigned so thoroughly within our little home as in the last two years. It is the inner home one must study, and not the outside of its walls. Can you show me any household in which it has been better for the children when a second marriage has been entered upon?

If the mother and the children were on the verge of starvation, I grant you, yes. But, otherwise, is there not more jealousy, dissension, and unhappiness brought about by a second husband, and a second family, than any good that is done by it, or "peace"

won? Would my children love me any better, do you think? Do you know that I would sacrifice the whole of the world's opinion to my children's love?

Again; for my "position's sake." I do not care to owe it to another person. I shall stand or fall by my own making, or my own marring. And for my "Art's sake." Oh, what, in Heaven's name, can you adduce in support of that opinion? Do you know that I should, by marrying again, be simply cutting my own throat, as far as my profession goes?

I should be loading myself with extra duties, and all these duties would be as iron bars to my success. If I married a man, do you not think he would require some of my time, some of my thoughts? God knows I have enough to think of as it is. With children coming every second year, where would be my time or strength for work? You must, in your heart, think me incapable of any further success to give such counsel.

No; I am perfectly happy with my work, my children, and the love of my sisters. If all the world chose to turn its back upon me, and cast me out, I should still be happy with these three things.

No; I have no fear of the future, and my only *bête noire* is a second marriage. Ill-health is the one adversary that would prove too strong for me. I know of no other. Were I alone, and childless, it would be different perhaps; but with my boy and girl I can never be lonely. Gainsay me if you can, Monsieur!

Yes; if ever I want a friend I shall take you at your word.

The Role of the Teacher: "Every girl should have a vocation"

I had many inquiries as to whether I would take pupils into my Studio, so I set apart one morning a week, to give what I called a Demonstration lesson.

I consulted Millais one day when he came to see me, and, looking around at the work I had in hand, he exclaimed:

"Oh, you make me feel idle!"

I found painting before an audience a splendid tonic. One had to have one's wits about one. One didn't dare to make a mistake, with critical eyes watching every stroke.

My audience was not entirely composed of *bona fide* pupils, as friends, amateurs, and writers of the press came.

As is natural when one starts on a new phase of life, the newspaper world wishes to know all about it, in order to make "copy" for their paper.

I remember I was asked my opinions about an Art training. It amuses me, I said, when I hear people saying that they "could not draw a straight line." Neither could they have formed a letter, before learning to write.

Drawing to a child is actually easier than forming, apparently, unmeaning characters. In all savage races there is a pictorial language, long before their speech is translated into written words.

In my opinion, every girl should have a vocation, either artistic or otherwise, by which, if the necessity arose, she could earn her own bread, and be independent.

To master any subject requires patience, perseverance, observation, and a well-developed memory.

The study of Art should be exact. I have found that it disciplines mentally, much as the study of Mathematics does. It not only trains the hand, but the mind as well.

It is ridiculous that, in nearly all schools, this essential part of Education is charged as an extra. Teachers ought to take their pupils into the country, and make them sketch. It would interest them in many ways, in botany especially.

I make my pupils, however young they are, draw at once from "the life"—I can judge their capacity better in this way. The study of the antique ought to be taken up later, when the student understands enough to appreciate its beauties. . . .

1887: "I found teaching intensely interesting"

My School began to be much noticed in the daily papers, and "The Pall Mall Gazette" in November had an illustrated page.

The theme of my discourse to my interviewer was "That there is no sex in Art." The pupils used to be highly amused and interested when an interviewer accompanied me on a tour of inspection of the School, and there was quite an excitement when a photographer arrived, to take them all whilst they were at their work.

I found teaching intensely interesting. I learned so much myself. I was continually correcting faults, not only in my pupils' work, but in my own.

9

Elizabeth Thompson Butler (1846–1933)

Elizabeth Thompson Butler was the most famous woman artist of the 1870s in Victorian England. The phenomenal success of *The Roll Call* (Fig. 6), exhibited in 1874, catapulted her to fame. She was nominated as an Associate of the Royal Academy in 1879, but failed to be elected by a narrow margin. Although she lived well into the twentieth century, the peak of her career was quite brief. As Paul Usherwood notes, after 1881 "she seldom managed to sell her work and the scant reviews she received were generally unsympathetic."[1] Her marriage, in 1877, to an officer in the British army, Major William Butler (1838–1910), contributed to the early demise of an extraordinarily promising artistic career.

Thompson has been the subject of detailed scholarly attention in recent years. In 1987 the first major retrospective of her works was mounted by the National Army Museum in London. The catalogue by Paul Usherwood and Jenny Spencer-Smith adds significantly to our knowledge of this artist. These authors emphasize that Butler's paintings are not militaristic, wholehearted glorifications of war but rather should be interpreted as illustrations of the courage and endurance of the ordinary British soldier. They do not glorify privileged officers but generate empathy for the enlisted man.[2]

Elizabeth Thompson Butler's *An Autobiography* was published late in the artist's life, in 1922, long after the demise of the Victorian era. It was actually the third volume she had written. *Letters from the Holy Land* (1903), typical of mid-Victorian travel narratives in an epistolary mode, was her first book. *From Sketchbook and Diary* (1909) is written as a series of entries from her journal.

The volume from which these excerpts are reprinted is one of the few written by a woman which is called an "Autobiography." Despite the use of the term, it is heavily interspersed with journal entries and a few letters. Although organized in a strictly chronological manner, more than half of the text consists of diary entries, strung together by neutral, brief narrative passages. Predictably, the tone is discursive and modest.

Thompson was born into a family which nurtured her talents. Her mother was a landscape painter and her father personally tutored his two daughters. They lived abroad for much of their youth. Thompson's sister, the poet, essayist, and critic Alice Meynell,

Figure 6. Elizabeth Thompson Butler, *The Roll Call*. Copyright reserved to her Majesty Queen Elizabeth II. Photo: Rodney Todd-White and Son.

became famous in her own right. In 1866, aged 19, Elizabeth Thompson began her studies at the Female School of Art in South Kensington, where she remained until 1870.

The first excerpt records the creation and reception of *The Roll Call* (Fig. 6), her most famous painting. Her desire for realism and her thorough research are described. The financial rewards and popular response on Varnishing Day are told in an enthusiastic and refreshing manner.

Influenced by the contemporary French military paintings of artists such as Alphonse de Neuville, Edouard Detaille, and J. L. E. Meissonier, whose works Butler had seen in the Parisian Salon of 1870, her realistic, detailed image is a closeup view of the Crimean War from the point of view of the soldier. This subject was radically innovative. For the first time in British painting, a realistic, serious image from a past war is combined with the sensitive portrayal of individuals typical of Victorian genre paintings.[3]

Matthew Lalumia has convincingly argued that *The Roll Call* must be understood within the reformist climate of the early 1870s, specifically the "Cardwell Reforms" enacted following the election of the Gladstone ministry in 1868. In a series of bills, practices in effect in the British army for 200 years were abolished. The legislation introduced a merit system for promotions, reduced the enlistment period, and improved barracks life.[4]

Thompson's submission to the next Salon of 1875, *Quatre Bras,* enjoyed almost as extensive a reception. In fact, her successes encouraged a number of male artists to try to exploit the new market that Thompson's imagery had defined. Her preparation for *Quatre Bras,* also recorded in her diary, is reprinted in the next segment. Her text emphasizes her attention to detail and desire for authenticity. The painting was hung in a dark central room, the "Black Hole" of the Royal Academy galleries. Despite this, Thompson still writes: "They make a pet of me at the Academy." Usherwood suggests that the poor hanging of *Quatre Bras* was due to the fear that further concessions toward women artists, in particular Thompson's election to the Academy, might be expected. Although she barely lost her bid for election, the artist never stood for reelection. By the 1880s, the liberal, reformist climate and the Women's Movement itself had lost the zeal and momentum of the 1870s. Thompson's success within the Academy itself was a case of "tokenism" that failed to make any permanent changes in the bastion of patriarchal privilege which was the Royal Academy in Victorian England.[5]

After her marriage to William Butler in 1877, several factors influenced the course of her career: her change of name, her transient life as an officer's wife obliged to follow her husband to far-flung geographic locales, and the bearing and raising of six children. These circumstances interfered with her ability to paint as a professional. The artist also adopted many of Butler's liberal political views. However justified it may seem to us today, his mistrust of the motives of imperialist colonial policies was not popular in the conservative political climate of the 1880s. As Lady Butler selected topics consistent with her husband's unorthodox political positions, her reputation suffered.[6]

By the late 1880s when Butler painted *An Eviction in Ireland*—or more simply *Evicted,* as the painting is now known—the issue of her admission into the Academy was in her past. Her political sympathies had a more contemporary focus and were consistent

with the viewpoints of her husband. *Evicted* generates sympathy for the Irish tenant farmers who had been forced off the land in the 1880s. The painting was exhibited just as Parnell was about to appear in a divorce case and his fate, with that of Irish Home Rule, seemed to hang in the balance. Lord Salisbury, mentioned in Butler's narrative, was then the Prime Minister and "a leading advocate of the policy of coercion as a response to Irish agitation."[7] Implicit criticism of the British military presence in Ireland made this work politically volatile.

The last segment concerns Butler's response to the mustering of forces for World War I. With one of her sons directly involved in the fighting, this excerpt shows her sensitivity to the imminent death of these soldiers, but also her tacit support of the war. Unlike Käthe Kollwitz, Lady Butler, wife and mother to soldiers, was no pacifist. Yet even at this very late phase of her career, she brings a painter's eye to the appearance of these men.

More journal than autobiographical narrative, Elizabeth Thompson Butler, like Louise Jopling, required historical distance to justify the act of recording her life story.

1873–74: *The Roll Call*

I had quite a large number of commissions for military water-colours to get through on my return home, and an oil of French artillery on the march to paint, in my little glass studio under St. Boniface Down. But after my not inconsiderable success with *Missing*[8] at the Academy, I became more and more convinced that a London studio *must* be my destiny for the coming winter. Of course, my father demurred. He couldn't bear to part with me. Still, it must be done, and to London I went, with his sad consent. I had long been turning *The Roll Call* [Fig. 6] in my mind. My father shook his head; the Crimea was "forgotten." My mother rather shivered at the idea of the snow. It was no use; they saw I was bent on that subject. My dear mother and our devoted family doctor in London (Dr. Pollard), who would do anything in his power to help me, between them got me the studio, No. 76, Fulham Road, where I painted the picture which brought me such utterly unexpected celebrity.

Mr. Burchett, still headmaster at South Kensington, was delighted to see me with all the necessary facilities for carrying out my work, and he sent me the best models in London, nearly all ex-soldiers. One in particular, who had been in the Crimea, was invaluable. He stood for the sergeant who calls the roll. I engaged my models for five hours each day, but often asked them to give me an extra half-hour. Towards the end, as always happens, I had to put on pressure, and had them for six hours. My preliminary expeditions for the old uniforms of the Crimean epoch were directed by my kind Dr. Pollard, who rooted about Chelsea back streets to find what I required among the Jews. One, Mr. Abrahams, found me a good customer. I say in my Diary:

"Dr. Pollard and I had a delightful time at Mr. Abrahams' dingy little pawnshop in a hideous Chelsea slum, and, indeed, I enjoyed it *far* more than I should have enjoyed the same length of time at a West End milliner's. I got nearly all the old accoutrements

I had so much longed for, and in the evening my Jew turned up at Dr. Pollard's after a long tramp in the city for more accoutrements, helmets, coatees, haversacks, etc., and I sallied forth with the 'Ole Clo!' in the rain to my boarding house under our mutual umbrella, and he under his great bag as well. We chatted about the trade *'chemin faisant.'''*

I called Saturday, December 13th, 1873, a "red-letter day," for I then began my picture at the London studio. Having made a little water-colour sketch previously, very carefully, of every attitude of the figures, I had none of those alterations to make in the course of my work which waste so much time. Each figure was drawn in first without the great coat, my models posing in a tight "shell jacket," so as to get the figure well drawn first. How easily then could the thick, less shapely great coat be painted on the well-secured foundation. No matter how its heavy folds, the cross-belts, haversacks, water-bottles, and everything else broke the lines, they were there, safe and sound, underneath. An artist remarked, "What an absurdly easy picture!" Yes, no doubt it was, but it was all the more so owing to the care taken at the beginning. This may be useful to young painters, though, really, it seems to me just now that sound drawing is at a discount. It will come by its own again. Some people might say I was too anxious to be correct in minor military details, but I feared making the least mistake in these technical matters, and gave myself some unnecessary trouble. . . .

On March 29th and 30th, 1874, came my first "Studio Sunday" and Monday, and on the Tuesday the poor old "Roll Call" was sent in. I watched the men take it down my narrow stairs and said *"Au revoir,"* for I was disappointed with it, and apprehensive of its rejection and speedy return. So it always is with artists. We never feel we have fulfilled our hopes.

The two show days were very tiring. Somehow the studio, after church time on the Sunday, was crowded. Good Dr. Pollard hired a "Buttons" for me, to open the door, and busied himself with the people, and enjoyed it. So did I, though so tired. It was "the thing" in those days to make the round of the studios on the eve of "sending-in day."

Mr. Galloway's[9] agent came, and, to my intense relief, told me the picture went far beyond his expectations. He had been nervous about it, as it was through him the owner had bought it, without ever seeing it. On receiving the agent's report, Mr. Galloway sent me a cheque at once—£126—being more than the hundred agreed to. The copyright was mine.

"Varnishing Day," Tuesday, April 28th.—My real feelings as, laden like last year, with palette, brushes and paint box, I ascended the great staircase, all alone, though meeting and being overtaken by hurrying men similarly equipped to myself, were not happy ones. Before reaching the top stairs I sighed to myself, "After all your working extra hours through the winter, what has it been for? That you may have a cause of mortification in having an unsatisfactory picture on the Academy walls for people to stare at." I tried to feel indifferent, but had not to make the effort for long, for I soon espied my dark battalion in Room *II. on the line,* with a knot of artists before it. Then began my ovation (!) (which, meaning a second-class triumph, is *not* quite the word). I

never expected anything so perfectly satisfactory and so like the realisation of a castle in the air as the events of this day. It would be impossible to say all that was said to me by the swells. Millais, R.A., talked and talked, so did Calderon, R.A., and Val Prinsep, asking me questions as to where I studied, and praising this figure and that. Herbert, R.A., hung about me all day, and introduced me to his two sons. Du Maurier told me how highly Tom Taylor had spoken to him of the picture. Mr. S., our Roman friend, cleaned the picture for me beautifully, insisting on doing so lest I should spoil my new velveteen frock. At lunchtime I returned to the boarding house to fetch a sketch of a better Russian helmet I had done at Ventnor, to replace the bad one I had been obliged to put in the foreground from a Prussian one for want of a better. I sent a gleeful telegram home to say the picture was on the line. I could hardly do the little helmet alterations necessary, so crowded was I by congratulating and questioning artists and starers. I by no means disliked it all. Delightful is it to be an object of interest to so many people. I am sure I cannot have looked very glum that day. In the most distant rooms people steered towards me to felicitate me most cordially. "Only send as *good* a picture next year" was Millais' answer to my expressed hope that next year I should do better. This was after overhearing Mr. C. tell me I might be elected A.R.A. if I kept up to the mark next year. O'Neil, R.A., seemed rather to deprecate all the applause I had to-day and, shaking his head, warned me of the dangers of sudden popularity. I know all about *that,* I think.

Thursday, April 30th.—The Royalties' private view. The Prince of Wales wants "The Roll Call." It is not mine to let him have, and Galloway won't give it up.

1875: *Quatre Bras*

July 16th.—Mamma and I went to Henley-on-Thames in search of a rye field for my "Quatre Bras." Eagerly I looked at the harvest fields as we sped to our goal to see how advanced they were. We had a great difficulty in finding any rye at Henley, it having all been cut, except a little patch which we at length discovered by the direction of a farmer. I bought a piece of it, and then immediately trampled it down with the aid of a lot of children. Mamma and I then went to work, but, oh! horror, my oil brushes were missing. I had left them in the chaise, which had returned to Henley. So Mamma went frantically to work with two slimy water-colour brushes to get down tints whilst I drew down forms in pencil. We laughed a good deal and worked on into the darkness, two regular "Pre-Raphaelite Brethren," to all appearances, bending over a patch of trampled rye. . . ."

On "Studio Monday" the crowds came, so that I could do very little in the morning. The novelty, which amused me at first, had worn off, and I was vexed that such numbers arrived, and tried to put in a touch here and there whenever I could. Millais' visit, however, I record as "nice, for he was most sincerely pleased with the picture, going over it with great *gusto*. It is the drawing, character, and expression he most dwells on, which is a comfort. But I must now try to improve my *tone*, I know.

And what about *'quality'*? To-day, Sending-in Day, Mrs. Millais came, and told me what her husband had been saying. He considers me, she said, an even stronger artist than Rosa Bonheur, and is greatly pleased with my *drawing*. *That* (the 'drawing') pleased me more than anything. But I think it is a pity to make comparisons between artists. I *may* be equal to Rosa Bonheur in power, but how widely apart lie our courses! I was so put out in the morning, when I arrived early to get a little painting, to find the wretched photographers in possession. I showed my vexation most unmistakably, and at last bundled the men out. They were working for Messrs. Dickinson. So much of my time had been taken from me that I was actually dabbing at the picture when the men came to take it away; I dabbing in front and they tapping at the nails behind. How disagreeable!''

On Varnishing Day at the Academy I was evidently not enchanted with the position of my picture. ''It is in what is called 'the Black Hole'—the only dark room, the light of which looks quite blue by contrast with the golden sun-glow in the others. However, the artists seemed to think it a most enviable position. The big picture is conspicuous, forming the centre of the line on that wall. One academician told me that on account of the rush there would be to see it they felt they must put it there. This 'Lecture Room' I don't think was originally meant for pictures and acts on the principle of a lobster pot. You may go round and round the galleries and never find your way into it! I had the gratification of being told by R.A. after R.A. that my picture was in some respects an advance on last year's, and I was much congratulated on having done what was generally believed more than doubtful—that is, sending any important picture this year with the load and responsibility of my 'almost overwhelming success,' as they called it, of last year on my mind. And that I should send such a difficult one, with so much more in it than the other, they all consider 'very plucky.' I was not very happy myself, although I know 'Quatre Bras' to be to 'The Roll Call' as a mountain to a hill. However, it was all very gratifying, and I stayed there to the end. My picture was crowded, and I could see how it was being pulled to pieces and unmercifully criticised. I returned to the studio, where I found a champagne lunch spread and a family gathering awaiting me, all anxiety as to the position of my *magnum opus*. After that hilarious meal I sped back to the fascination of Burlington House. I don't think, though, that Mamma will ever forgive the R.A.'s for the 'Black Hole.' . . .''

April 30.—The private view, to which Papa and I went. It is very seldom that an 'outsider' gets invited, but they make a pet of me at the Academy. Again, this day contrasted very soberly with the dazzling P.V. of '74. There were fewer great guns, and I was not torn to pieces to be introduced there, and everywhere, most of the people being the same as last year, and knowing me already. The same *furore* cannot be repeated; the first time, as I said, can never be a second.

May 3rd.—To the Academy on this, the opening day. A dense, surging multitude before my picture. The whole place was crowded so that before ''Quatre Bras'' the jammed people numbered in dozens and the picture was most completely and satisfactorily rendered invisible. It was chaos, for there was no policeman, as last year, to make people move one way. They clashed in front of that canvas and, in struggling to wriggle out, lunged right against it. Dear little Mamma, who was there nearly all the time of

our visit, told me this, for I could not stay there as, to my regret, I find I get recognised (I suppose from my latest photos, which are more like me than the first horror) and the report soon spreads that I am present. So I wander about in other rooms. I don't know why I feel so irritated at starers. One can have a little too much popularity. Not one single thing in this world is without its drawbacks. I see I am in for minute and severe criticism in the papers, which actually give me their first notices of the R.A. The *Telegraph* gives me its entire article. *The Times* leads off with me because it says "Quatre Bras" will be the picture the public will want to hear about most. It seems to be discussed from every point of view in a way not usual with battle pieces. But that is as it should be, for I hope my military pictures will have moral and artistic qualities not generally thought necessary to military *genre*.

1888: *Evicted*

My husband was knighted—K.C.B.—in this interval, at Windsor. We went to live in Ireland from Dinan, in 1888, under the Wicklow Mountains, where the children continued their healthy country life in its fulness. The picture I had painted of the departing dragoons went to the Academy in 1889, and in 1890 I exhibited *An Eviction in Ireland,* which Lord Salisbury was pleased to be facetious about in his speech at the banquet, remarking on the "breezy beauty" of the landscape, which almost made him wish he could take part in an eviction himself. How like a Cecil!

The 'eighties had seen our Government do some dreadful things in the way of evictions in Ireland. Being at Glendalough at the end of that decade, and hearing one day that an eviction was to take place some nine miles distant from where we were staying for my husband's shooting, I got an outside car and drove off to the scene, armed with my paints. I met the police returning from their distasteful "job," armed to the teeth and very flushed. On getting there I found the ruins of the cabin smouldering, the ground quite hot under my feet, and I set up my easel there. The evicted woman came to search amongst the ashes of her home to try and find some of her belongings intact. She was very philosophical, and did not rise to the level of my indignation as an ardent English sympathiser. However, I studied her well, and on returning home at Delgany I set up the big picture which commemorates a typical eviction in the black 'eighties. I seldom can say I am pleased with my work when done, but I *am* complacent about this picture; it has the true Irish atmosphere, and I was glad to turn out that landscape successfully which I had made all my studies for, on the spot, at Glendalough. What storms of wind and rain, and what dazzling sunbursts I struggled in, one day the paints being blown out of my box and nearly whirled into the lake far below my mountain perch! My canvas, acting like a sail, once nearly sent me down there too. I did not see this picture at all at the Academy, but I am very certain it cannot have been very "popular" in England. Before it was finished my husband was appointed to the command at Alexandria, and as soon as I had packed off the "Eviction," I followed, on March 24th, and saw again the fascinating East.

1914: "They are going to look death straight in the face"

Lyndhurst, New Forest, September 22nd, 1914.—I must keep up the old Diary during this most eventful time, when the biggest war the world has ever been stricken with is raging. To think that I have lived to see it! It was always said a war would be too terrible now to run the risk of, and that nations would fear too much to hazard such a peril. Lo! here we are pouring soldiers into the great jaws of death in hundreds of thousands, and sending poor human flesh and blood to face the new "scientific" warfare—the same flesh and blood and nervous system of the days of bows and arrows. Patrick is off as A.D.C. to General Capper, commanding the 7th Division. Martin, who was the first to be ordered to the front, attached to the 2nd Royal Irish, has been transferred to the wireless military station at Valentia. That regiment has been utterly shattered in the Mons retreat, so I have reason to be thankful for the change. I am here, at Patrick's suggestion, that I may see an army under war conditions and have priceless opportunities of studying "the real thing." The 7th Division[10] is now nearly complete, and by October 3rd should be on the sea. I arrived at Southampton to-day, and my good old son in his new Staff uniform was at the station ready to motor me up to Lyndhurst where the Staff are, and all the division, under canvas. I was very proud of the red tabs on Patrick's collar, meaning so much. I saw at once, on arriving, the difference between this and my Aldershot impressions. This is *war,* and there is no doubt the bearing of the men is different. They were always smart, always cheery, *but not like this.* There is a quiet seriousness quite new to me. They are going to look death straight in the face.

September 23rd.—I had a most striking lesson in the appearance of men after a very long march, *plus* that look which is quite absent on peace manoeuvres, however hot and trying the conditions. What surprises and telling "bits" one sees which could never be imagined with such a convincing power. A team of eight mammoth shire horses drawing a great gun is a sight never to be forgotten; shapely, superb cart horses with coats as satiny as any thoroughbred's, in polished artillery harness, with the mild eyes of their breed—I must do that amongst many most *real* subjects. But I see the German shells ploughing through these teams of willing beasts. They will suffer terribly.

Anna Lea Merritt (1844–1930)

Anna Lea Merritt emerged from a nonartistic family background of wealthy Quakers to become a prominent and successful figure and portrait painter in late Victorian England. Like Mary Cassatt and Cecilia Beaux, she came from Philadelphia. Her professional life, however, was centered in England, and her style, subjects, and artistic creed are consistent with late-Victorian Academicism.

This artist's painting output was active and diversified. She earned her living, like so many other painters in this epoch, through commissioned portraits. Many of these portraits were of children, and one may speculate that some patrons supposed a woman artist would be especially responsive to children. Her allegorical works such as *War* (1883) and *Love Locked Out* (Fig. 7) were widely appreciated and reproduced in engravings and lithographs. Later in her life, after 1900, she painted landscapes inspired by the countryside around her home.

Her *Memoirs* are written in the form of a traditional autobiography, organized in a strictly chronological format. Anna Lea was the eldest of six sisters, born into a wealthy and prominent Quaker family. She attended the Eagleswood School in Pennsylvania and the Agassiz School in Massachusetts. This education was in an academic, humanistic, classical mode, similar to that of young men of her class, and included no training in the visual arts. In 1865, on the Leas' first trip abroad, she received a few critiques from a member of the Florence Academy. She was similarly instructed in 1869 in Dresden. With the outbreak of the Franco-Prussian War in 1870, the family dispersed, and Anna and her sister went to London.

The first excerpt concerns her introduction to the English art world. In London, she settled in the same building as Henry Merritt (1822–77), then an established painter, who became her first regular painting instructor. Under Merritt's supervision she developed her skills, and her works were first exhibited at the Royal Academy in 1871. With some brief interruptions, she continued to show there until 1917. As Gerrish Nunn notes, her Academic style was sufficiently "up-to-date to be invited, along with Jopling, Burne-Jones, and G. F. Watts to exhibit at the fashionable Grosvenor Gallery."[1]

Her attachment to Henry Merritt progressed from the professional to the emo-

Figure 7. Anna Lea Merritt, *Love
Locked Out* (1889). The Tate
Gallery. London Photo: Art
Resource, N.Y.

tional and romantic, and they were married in 1877. Merritt died only three months
after their wedding. In 1879 Anna Lea Merritt, as she was now known, published a
two-volume collection of her husband's writings prefaced by her own memoirs of their
relationship, *Henry Merritt: Art Criticism and Romance.* This is typical of one pattern
among women writers, defined by Mary G. Mason, in which the self-discovery of iden-
tity, especially a literary voice, is linked to the recognition of the consciousness of a
significant ''other.''[2] It was her husband's reputation that propelled her into print, while
her own autobiography, written late in her life, in 1926, remained unpublished during
her lifetime. Only in 1982 did it reach a wider audience, when it was published by the
Museum of Fine Arts, Boston.

After 1877 the artist exhibited her works under the name Anna Lea Merritt. Her
single most famous composition, *Love Locked Out* (Fig. 7), was shown in 1890. It has
the distinction of being the first work by a woman artist purchased by the British
government. This event provoked Sir Wyke Bayliss, then President of the Royal Society
of British Artists, to make the following comment in 1906:

One of the loveliest of the Landmarks in the realm of Art has been discovered within the lifetime of most of us. I mean the formal, authoritative recognition of the fact that women can paint pictures. . . . I can only be glad that the discovery has been made not too late for me to have seen the painting . . . 'Love Locked Out.' . . . the authorities, recognizing it as a work of genius, purchased it. . . . [3]

It is surely not coincidental that the positive reception of this work is connected with its subject matter, the nude. The relationship between women artists and the study of the nude from life was, as Gillett notes, one loaded with anxieties for the Victorian age.[4] Women were eventually and reluctantly permitted to study the nude at the Royal Academy schools as the last symbol of equality in artistic training. But into the early twentieth century, the practice required to master the nude remained the prerogative of male artists and women's failure to master it was seen as proof of women's inferiority.

Lea Merritt exhibited widely in the United States and England between 1875 and 1895. She was integrated socially into the elite circles of British art, counting as her friends James Whistler, Edward Burne-Jones, and Frederick Leighton, among others.

Anna Lea Merritt never remarried. In 1891 she withdrew from society and settled in a small English village where she resided for almost fifty years, until her death in 1930. She described this life in her second book, *A Hamlet in Old Hampshire* (1902). Like Cassatt, she painted for the Woman's Building of the World's Columbian Exposition in Chicago in 1893. Her contribution was three decorative panels: *Needlework, Benevolence,* and *Education.* Also like Cassatt, Anna Lea Merritt lived long enough to witness her stylistic idiom become supplanted by the full range of innovations of late-nineteenth- and early-twentieth-century modernism.

"A Letter to Artists: Especially Women Artists" has been reprinted nearly in its entirety because it is a rare and witty document that transcends the year 1900, when it was first published and seems to speak directly to us today with the same forthright practical sensibility.[5] This essay reiterates some of the main concerns voiced in the memoirs: the need for standards of excellence, and the desire to measure up to quality defined in male terms. Although it may seem naive of her to discount the institutional gender inequality of late-Victorian England, it is not unexpected. She only exhibited her works at the Royal Academy, disdaining the shows of the Society of Female Artists. Even so, her sensitivity to the social demands on women and the way they can affect a woman artist's ability to work is remarkably perceptive.

1870: "There were no art schools for women"

Mr. Marshall, the great surgeon who, as lecturer to the Royal Academy, knew the most distinguished artists, most kindly came to see my work and offered to introduce me to Millais[6] for his advice. At that time, there being no modern exhibition open and no picture of Millais in a public gallery, I had of course not seen his work, but eagerly accepted the great opportunity. He came! Was it not wonderful? He looked at my portrait productions with kind interest. There was one of my sister Fanny, and one of

Rose Hawthorne, which I had done in Dresden. The sitters were not there for comparison. I urged my desire to study, my hope to enter the Academy School, but that he did not consider possible for a woman. In fact he said, "Just keep on as you are doing—you can sometimes draw from a statue in the British Museum; you can look at the great pictures in the National Gallery, and paint portraits. Just keep on alone." He invited me to visit his studio which I found crowded with portraits in various stages, and on his easel one of his beautiful daughters. His eager energy and cordiality were delightful, but I couldn't intrude my insignificance again, nor did it seem that his kind encouragement was the hard criticism that I craved.

Just imagine that in 1870 and 1871 there were no art schools for women, no Slade, no Royal Academy, no Byam Shaw, or Spenlove, or St. John's Wood, or Bushey.[7] Heatherley's was the only one existing and not then so desirable as now. I am not sure that ladies were admitted. It was hard to have lost the great chance of studying in a Paris atelier—I must just continue my old way of scraping along as best I could—all by my lone, and this in crowded London.

How does one scrape along? I left Torrington Square immediately after breakfast, returning only in time for the late dinner. In my studio I lunched on a roll and some jam, if indeed I found time to think of it. I bought a reduced cast of the Venus of Milo and large busts of her and of Clytie and painted one of these, especially the full length, again and again. From an Italian model several portraits, and very often spent a morning at the National Gallery, not copying, but looking closely into the technique of Titian and Veronese, trying to discover their methods of handling, their ways of using brush and colours and endeavouring to experiment in the methods I imagined. What I longed for was Titian's method, but Veronese seemed direct and simple, perhaps easier. When one is trying to learn from the great, why not aspire to the best?

I never drew anything but with the brush, my only tool. I am inclined to think that charcoal drawing and stumping are injurious. Pencil line is useful, but if the ulterior object is to paint, learn from the beginning the qualities of paint, the touch of brushes.

Love Locked Out

In that year 1889, I was also at work upon Love Locked Out [Fig. 7]. The thought had been inspired years before as a monument to my husband. In my thought the closed door is the door of the tomb. Therefore I showed the dead leaves blowing against the doorway and the lamp shattered. "The light in the dust lies dead," another broken lute. I could not afford to have it done in bronze, as I desired for a monument, so it became only a painting and was bought for the Chantrey collection—the first woman's work so bought. For years I refused to have it copied, for which entreaties were innumerable. I feared people liked it as a symbol of forbidden love, while my Love was waiting for the door of death to open and the reunion of the lonely pair.

"A Letter to Artists, Especially Women Artists"

It is now twenty-seven years since I have lived by my brush. The great interest in art and the development of influential exhibitions and schools in America I have watched with keen interest and with the regret that I had not their aid in early life. Born in America, grafted on England, each country has a hand, and I would like to point out to my countrymen some defects that we see in the very special care with which art has been fostered in England. As a woman artist, I may consider it a little from the woman's point of view, but there has never been any great obstacle for women to overcome. Our work in England from the first has found its place in the general body of art work, and modern conditions affect men and women equally.

Here in England during the last fifteen years young women of the educated classes have increasingly been encouraged to earn their living. People who formerly felt it a dishonor not to provide for their womankind now let them do many things, but of all businesses *art* is the most popular and fashionable.

Therefore an excessive number of young ladies with very moderate ability come to art for a living.

In youth, of course, the prospect of independence and self-reliance is attractive. In later life we know the anxiety and ever-increasing responsibility, the strain of uncertainty inseparable from self-help, and feel that no young girl should lightly undertake such a career. Rather let us try to uphold the propriety, where possible, of letting others support them in return for their constant feminine helpfulness. What women can least endure is uncertainty about their means of living. They should know that there is no income so fluctuating as that of the artist, even of the fairly successful man. Expenses inseparable from good work are considerable. A young artist on leaving the schools cannot make any mark here in England unless sure of finding two hundred pounds a year for expenses of studio, models, and materials. Let girls consider this.

I speak on the practical, mercenary side of this subject because that is generally ignored and thousands of young people, with very mediocre ability and no means, study for this profession because they have read of fabulous sums given for a few of the greatest works and have no notion of their own qualifications for art or of the difficulties they must encounter, or of the outlay required to produce important work, even after attaining proficiency in technique.

The education of the art student both in England and in America is indeed made easy and inexpensive. It is the first launch into independent work that is difficult; of course, not for the few who have distinct gifts for art, but for the average student who can paint fairly well as he has been taught; or has learned (as one told me) well enough to teach!

If you lived in a rustic agricultural neighborhood in England it would surprise you to see how many of the farmers' daughters disdain interest in poultry or butter and ride miles on their bicycles to study "art" in one of the South Kensington branches. The fashionable character of the profession is the attraction to them. There may be successes among them; but alas for the trash which has been proudly showed me! . . .

A scheme for the development of art which gives first and chiefly unlimited instruction at a price accessible to the humblest, which even goes far afield into the hedges and fields and sows ambition by the wayside, as in England, begins at the wrong end. First teach the people of means so that they shall recognize the fine in art, know its mark in the young beginner, know the true germ unnamed by any dealer or before the newspapers have blown it, and care for it enough to buy it. It is possible to train connoisseurship, partly by instruction in the history of art, partly by observation of nature. It is on the observation of nature that Ruskin[8] based his criticism of modern painters, and the keenness of his vision and beauty of his word-painting remain a lesson ever open to all who read. True connoisseurship is a gift almost as much as the painter's, and it also may be trained and developed. Above all, let the man who wants a picture feel that he may make his own choice and not fear to buy directly from the artist. Indeed, to the artist the sympathy of his patron will be of no less value than his money. Art cannot flourish where the artist cannot live, so it must depend upon the rich men of America whether we shall have the glory of a name in art. "Corporations have no conscience" is an old saying; let us add that they can have no art knowledge. If they want decorations or historical pictures for public buildings, there is no way for them to choose the artist save by reference to acknowledged authority. In so rich a country there should always be found a few gentlemen of cultivated and natural taste, such, for instance, as Mr. H. J. Marquand and Mr. John G. Johnson, whose judgment in a committee would be wise and independent and ought to be recognized by those who need direction in important public commissions. . . .

In America the patronage of native art used to be so exceedingly timid, though enormous prices were given for French pictures, that formerly young American artists had either to live abroad, so as to enter their native land under foreign colors, or open a studio to teach amateurs—almost exclusively lady amateurs. Perhaps this may ultimately evolve an appreciative purchasing class, but at present, like other painters, the amateurs are mainly interested in their own efforts, with a remarkable predilection for looseness of handling and whatever may be the newest fashion in color. The misfortune is we flatter them by involuntarily adopting a different standard of criticism in regard to their work. An artist of European distinction travelling recently in America remarked that everywhere he was supposed to feel deep interest in the works of amateurs. On every hand it was said to him, "My daughter would like to show you her painting; she could be a great artist if she chose." Very seldom was it asked, "Where can we see your works nearer than the Luxembourg?" We should really take our amateur painters seriously and tell them painful truths, as though they were of ourselves.

Is it possible that women are differently from men affected by all these modern circumstances?

Women artists have been fairly treated in the exhibitions; there was never any exclusion.

Recent attempts to make separate exhibitions of women's work were in opposition to the views of the artists concerned, who knew that it would lower their standard and risk the place they already occupied. What we so strongly desire is a place in the large

field: the kind ladies who wish to distinguish us as women would unthinkingly work us harm.

The only complaint we have in England, and we never speak of it, is that no one of us has been elected to the Academy, even in an honorary degree, but when a lady comes whose art is unmistakably deserving of this distinction I do not believe it will be withheld. It would be a great encouragement that women often fall short of the expectations formed for them.

But the inequality observed in women's work is more probably the result of untoward domestic accidents. Some near relative may be ill, and a woman will give her care and thought where a man would not dream of so doing, where no one would expect it from him. By many smaller things a woman's thoughts are distracted when a man's more easily keep on the course. Women who work must harden their hearts, and not be at the beck and call of affections or duties or trivial domestic cares. And if they can make themselves so far unfeminine, their work will lose that charm which belongs to their nature, and which ought to be its distinction.

The chief obstacle to a woman's success is that she can never have a wife. Just reflect what a wife does for an artist:

Darns the stockings;
Keeps his house;
Writes his letters;
Visits for his benefit;
Wards off intruders;
Is personally suggestive of beautiful pictures;
Always an encouraging and partial critic.

It is exceedingly difficult to be an artist without this time-saving help. A husband would be quite useless. He would never do any of these disagreeable things.

Another feminine defect is a tendency to over-thriftiness and overindustry. For instance, in the spring, when our pictures are sent in, when the birds are singing, when "a young man's fancy (we are told) lightly turns to thoughts of love," to what does every true woman turn? To spring cleaning, of course. A man does not: he goes away.

We working women do not amuse ourselves, we are apt to be working always. Constant industry becomes plodding and monotonous. Some of us even make a dress occasionally. But this thriftiness is a great mistake, for ideas are begotten—and observation is acute in moments of leisure—far from the tools of craft. Only look how incessant industry has injured one class of little people whom it has been too much the habit to extol: I allude to the busy bee. When we were children we all learned that little hymn about the busy bee and how she improves the shining hours. What a mistake to improve it! Well, for hundreds of years, even thousands, the busy bee has been drudging all day long, buzzing with self-adulation over its virtuous business,—with what injury to its art? In all these years it has made no improvement in the architecture of its waxen house; every cell is made exactly as it was in the beginning. There is no novelty, no invention. If it would only loaf about sometimes it might get a new idea: but bees are governed by a matron with a profound belief in organizing industry for others. Save us from the

modern tendency to turn art into an organized industry. This is woman's tendency—to deny herself frivolity or rest, to work over-hard, to lose in consequence freshness and spontaneity, and to become like the miserable bee.

Art should be really all play—all recreation.

Re-creation is the truest description of art, which shares the joy of the universe and tries to re-create little portions of it, just to show her understanding of the Creator, and in this effort knows only joy and refreshment, never toil.

Not imitation but re-creation is genius.

Art in all its branches is a profession as open to women as to men. For women of exceptional ability there have always been interest and employment. In painting and in sculpture, in enamelling, in house decoration, bookbinding, and that most enchanting art, landscape gardening, many succeed and gain cordial recognition. There ought to be a lady member in every firm of domestic architects, for mere men have a way of forgetting coal cellars and linen cupboards. Doubtless women would think of many improvements in domestic convenience while not overlooking the beautiful. Home-making is their specialty.

The characteristic virtues of women are the greatest obstacles to their success. Thriftiness, industry, altruism—these qualities are not art qualities. While there is a field for the truly gifted in every branch of art, young people simply wanting a respectable business should look to something else where competition is less keen. Organization of art study and exhibitions tending to destroy individuality work great injury, and finally the needed reward of high attainment is the opportunity of designing sculpture or picture in association with architecture or for special places. Without such association art lapses from the epic and can only fling out her thousand lyrics to fly at random in a windy world.

AMERICA

American women were active creators, both as painters and sculptors, during the second half of the nineteenth century. The participation of women in the history of art in America in this epoch was fueled by the relatively early opening of art schools for women. In 1844 women were drawing from plaster casts at the Pennsylvania Academy of Fine Arts, founded in 1805. An anatomy class, segregated by sex, began there in 1860, and by 1868 women had their own life drawing class with a nude female model. In 1877, the male nude was introduced. Women could also learn painting skills by studying privately with an established artist, usually male. Also in 1844, the Philadelphia School of Design for Women (later Moore College of Art) was founded, to provide training in practical skills for the arts industries. A similar design curriculum was available at the Cooper Institute of Design for Women in New York.

American artists both male and female went to Europe throughout the nineteenth century. Every artist in this section spent lengthy periods of time abroad. The desire to study abroad may be gauged by the publication in 1879 of May Alcott's pamphlet *How to Study Abroad and Do It Cheaply,* excerpted below. By the 1870s, Julian's women's class was open in Paris. Although the Academy in Rome remained closed to women throughout the nineteenth century, Italy retained its attraction for neoclassical sculptors of both sexes, such as Harriet Hosmer.

Pamela Gerrish Nunn describes the continuing discriminatory policies toward women sculptors throughout the nineteenth century in Europe.[1] The authors of three of the next six texts are sculptors. The first, Harriet Hosmer, made her reputation in Rome; the others, Enid Yandell and Janet Scudder, developed their skills in the studio of Lorado Taft (1860–1936), helping to fulfill the huge demand for architectural sculpture for the World's Columbian Exposition in Chicago. These three sculptors are representative of a significant number of American women active in this medium in the second half of the century. We must assume that America was more responsive to the work of women sculptors than the countries of Europe.

The other three artists whose texts are included in this section were painters. Mary Cassatt was an expatriate living in Paris and associated with the avant-garde movement of Impressionism. Cecilia Beaux pursued a successful career as a portrait painter in the United States in the 1890s and early twentieth century. May Alcott died in Paris from complications of childbirth before she could create a mature oeuvre.

The self-writing of these artists falls into two major categories: private correspondence to family and close associates written mainly from Europe, and texts intended for publication.

The prevailing patriarchal configuration of the "Cult of True Womanhood" was developed by bourgeois men in America between the 1820s and 1840s. This discourse "prescribed a female role bounded by kitchen and nursery, overlaid with piety and purity, and crowned with subservience."[2] The women who rejected these constraints, who entered the labor force out of financial necessity, were viewed as unnatural. This perception of "unnaturalness" is certainly applicable to every one of the artists whose writings are excerpted in this chapter.

Placed on a pedestal of moral purity, women simultaneously began to be active in both the temperance and the abolitionist movements. When Susan B. Anthony, the Quaker teacher, abolitionist, and temperance leader, teamed up with Elizabeth Cady Stanton, the women's rights movement was born—in 1848, at the first women's-rights convention in Seneca Falls, New York. The integration of women artists into the broader political activities of American feminists may be gauged by the attention accorded the works of women artists in two key public displays in the final third of the nineteenth century: the Women's Pavilion at the Philadelphia Centennial Exposition of 1876, and the Woman's Building of the World's Columbian Exposition in Chicago of 1893.

Though they were temporary and their contents lost or dispersed, [these structures] were significant events in the history of women's art. In no other period, excepting our own, have community women taken such an interest in women artists. . . . All were founded as all-female or separatist exhibition spaces by public-spirited women who wanted to educate people as to the full range of women's talents and to inspire women to raise their sights.[3]

Supported by this type of recognition, American women painters and sculptors created a varied and artistically innovative body of works from 1850 on. The artists whose texts are excerpted here testify to the possibilities of women achieving fame in the visual arts in the decades preceding World War I.

Paralleling the options for art training were the expanded possibilities for academic education for women. Improved education for women was linked in America, as was the need for governesses in Victorian England, with the need for adequately trained teachers who were willing to work for less money than men. In 1821 Emma Willard opened the school that would bear her name in Troy, New York, the first school to provide a secondary education for women. Mount Holyoke College, founded by Mary Lyon (1791–1839) in 1837, was the first college intended specifically to train teachers. Catherine Beecher (1800–78), the author of a popular home-economics text, organized

a teacher-training school in the 1840s in Connecticut, the first state to develop a public school system.

With improved education, women began to write extensively in a private context, both letters and journals. Many examples of extensive correspondence, such as the texts reprinted in this chapter, have survived from this era. The importance of letter writing in the lives of nineteenth-century American women has been emphasized by the research of Carroll Smith-Rosenberg.[4]

All the letters included in this section were written from Europe to correspondents here in America. Harriet Hosmer resided in Rome for most of her adult life. She originally traveled to Italy to acquire her artistic training, but she remained there throughout her active career as an independent sculptor. Her correspondence to her patron, Wayman Crow, and his family documents her life in Italy. May Alcott was an active letter writer when separated from her family while living abroad to pursue her artistic training. Since Mary Cassatt lived in Paris most of her life, her correspondence was varied and voluminous throughout her active career as a painter.

Women writers in America, as in Victorian England, struggled under the burdens of hegemonic notions of intellectual inferiority tied to gender. In 1829 Sarah Hale advised aspiring poets in the *Lady's Magazine:* ''The path of poetry, like every other path in life, is to the tread of woman exceedingly circumscribed. She may not revel in the luxuriance of fancies, images and thoughts or indulge in the license of choosing themes at will, like the Lords of creation.''[5]

Despite such warnings, women authors did raise their voices publicly during this epoch, mainly as novelists. Nathaniel Hawthorne condescendingly referred to these authors as ''that mob of scribbling women.'' As Mary Kelley has shown, the twelve novelists who she collectively names the ''literary domestics'' came to dominate a significant portion of the recently developed national publishing marketplace from the 1820s through the 1850s. Despite their financial successes, the literary domestics remained ''private and domestic. . . . They never left the cloistered corridors of their domestic consciousness.''[6] While as a group the ''literary domestics'' accepted that women belonged in the home as wives and mothers, they also gave significance to the domestic realm by attributing to women ''a higher moral and spiritual sphere. . . . the literary domestics claimed superiority for her [woman] and imagined a reformation of society in her name.''[7]

Harriet Beecher Stowe's enormously popular *Uncle Tom's Cabin* (published in 1851) is the most famous example of the impact of these women writers in nineteenth-century America. Although not one of this group, Louisa May Alcott achieved financial independence, and sponsored her sister May's art studies abroad not from her poorly paid teaching job but with the income earned through her famous novel *Little Women*. Enid Yandell's text is a thinly disguised fictional account of her life with two roommates in Chicago in the early 1890s, documenting the unorthodox life-style of these young women.

But autobiography was not a popular form of writing for women in Victorian America. Estelle Jelinek notes that women's autobiographies were not published in sig-

nificant numbers before the end of the nineteenth century. Many autobiographies were published between 1890 and 1914, a peak period of public service for women.[8] The published autobiographies of Janet Scudder and Cecilia Beaux, excerpted here, date from even later, after 1925. These texts are retrospective and fairly reserved, published at the very end of the authors' public artistic careers. Alcott's *Studying Art Abroad* was a manual, intended as a ''guidebook'' to help other young women of limited means to acquire a European art education.

The varied forms of these texts reflect the diversity of types of writing by American women in this period. As a group, they provide multiple insights and perspectives on the lives and attitudes of women painters and sculptors active between 1850 and World War I.

Harriet Hosmer (1830–1908)

Harriet Hosmer was the first woman in the nineteenth century to forge a successful professional career as a sculptor. Between her arrival in Rome in 1852 and the creation of her most famous work *Zenobia* (Fig. 8) in 1859, Hosmer had developed an international clientele for her iconographically innovative if stylistically conservative, neoclassical works in marble.

Hosmer was raised in an indulgent and free-spirited manner by her physician father in Watertown, Massachusetts. Both mother and siblings had died from tuberculosis, so Harriet was permitted to follow her own inclinations, which resulted in her expulsion from school three times. At the age of 16, she attended the boarding school of Mrs. Charles Sedgewick, in the Berkshire Mountains of western Massachusetts. Here, Hosmer roomed with Cornelia Crow (later Carr), who would become Hosmer's biographer. The letters excerpted here are from Carr's biography, published after Hosmer's death, in 1912. The active patronage of Cornelia's family was crucial to Hosmer's career, and the role they played in her life is documented in the publication of these letters. Thus the correspondence reflects positively on the author as well as on Hosmer herself. All except one of the letters reprinted here are addressed to Cornelia, her mother, or her father, Wayman Crow.

In 1849 Hosmer returned to Boston, where she studied with Peter Stephenson (1823–1860). Seeking to improve her knowledge of anatomy, she traveled to St. Louis, since the Boston medical school would not permit her into anatomy classes. The first letter, written before her trip abroad, clarifies her determination to work in the medium of sculpture, a highly unusual choice for a woman. Back in Boston, Hosmer became acquainted with the famous actress Charlotte Cushman, who took Hosmer to Rome in 1852.

There Hosmer entered the studio of John Gibson (1790–1866), sculptor to Queen Victoria and the leader of the neoclassical artists in Rome. This choice of mentor was a shrewd professional decision. Gibson nurtured her talents and Hosmer's works progressed under his supervision. This relationship is described in her letter to Wayman Crow dated December 1, 1852.

Figure 8. Harriet Hosmer, *Zenobia in Chains*. Wadsworth Atheneum, Hartford. Gift of Mrs. Josephine M.J. Dodge.

The rest of the letters were written from Rome and present a vivid picture of the social and professional life of the young artist. When reading these letters, it should be remembered that the Crows were Hosmer's first patrons and their financial support was absolutely crucial to her ability to pursue her career. On October 12, 1854, Hosmer wrote: "Every successful artist in Rome, who is living, or who has ever lived, owes his success to *his* Mr. Crow." These letters contain valuable information about the life-style, studio procedures, and creative processes of the artist, and also discuss Hosmer's attitude toward marriage and women's rights.

Hosmer is the most famous member of a group of female neoclassical sculptors. Derogatorily named by Hawthorne the "White Marmorean Flock," the group included Edmonia Lewis (1843?–1909?), Anne Whitney (1821–1915), Vinnie Ream Hoxie (1847–1914), Emma Stebbins (1815–82), Louise Lander (1826–1923), and Margaret Foley (c. 1827–77).

By 1855 Hosmer had created her first full-length figure, *Oenone*. Two years later, she carved *Beatrice Cenci*, recognized today as one of her finest works. By 1859, with the establishment of her own studio and the creation of the seven-foot-tall version of *Zenobia*, the artist had reached maturity.

Zenobia was the first full-length figure Hosmer created without commissions. As Susan Waller has documented, *Zenobia* owes much to the influence of Anna Jameson, a recognized English authority on art and advocate of women's rights. It is a self-conscious feminist symbol of the nobility of women despite contemporary oppressive conditions. For Hosmer and Jameson, *Zenobia* "becomes the embodiment of a shared ideal, a shared confidence that women's underlying strength of character ultimately transcended the circumstances of defeat."[1] *Zenobia* was exhibited as a focal point of the London International Exposition and subsequently shown in Boston, New York, and Chicago, where it was highly praised.

In the 1860s Hosmer's most regular patrons were English noblewomen, and many of the works executed for this circle have disappeared. As tastes in the United States veered away from neoclassicism in the post–Civil War era, Hosmer's reputation in this country also declined. Like Cassatt and Lea Merritt, Hosmer was commissioned to create a work—in Hosmer's case, a statue of Queen Isabella—for the 1893 World's Columbian Exposition. Ultimately, it ended up in a corner of the California pavilion. A plaster version was sent to the San Francisco Exposition the following year, which led to her trip to that city for a series of lectures. After 1900 she lived in Watertown; the active years of her career were over.

To Cornelia Crow, November 1851: On Sculpture

Dear C:

You can't imagine how delightful are the musical rehearsals in Boston every Friday afternoon—once a week, at least, I am raised to a higher humanity. There is something in fine music that makes one feel nobler and certainly happier. Fridays are my Sabbaths, really my days of rest, for I go first to the Athenæum[2] and fill my eyes and mind with beauty, then to Tremont Temple[3] and fill my ears and soul with beauty of another kind, so am I not then literally "drunk with beauty"?

And now I am moved to say a word in favor of sculpture being a far higher art than painting. There is something in the purity of the marble, in the perfect calmness, if one may say so, of a beautiful statue, which cannot be found in painting. I mean if you have the same figure copied in marble and also on the canvas. People talk of the want of expression in marble, when it is capable of a thousand times more than canvas. If color is wanting, you have form, and there is dignity with its rigidity. One thing is certain, that it requires a longer practice and truer study, to be able to appreciate sculpture as well as one may painting. I grant that the painter must be as scientific as the sculptor, and in general must possess a greater variety of knowledge, and what he produces is more easily understood by the mass, because what they see on canvas is most frequently to be observed in nature. In high sculpture it is not so. A great thought must be embodied in a great manner, and such greatness is not to find its counterpart in everyday things. That is the reason why Michael Angelo is so little understood, and will account for a remark which I heard a lady make, a short time since, that "she wondered

they had those two awful looking things in the Athenæum, of 'Day' and 'Night'; why don't they take them away and put up something decent?'' Oh, shades of the departed!
. . .

Yours H.

To Wayman Crow, December 1, 1852:
Work with John Gibson and Life in Rome

Dear Mr. Crow:

Can you believe that this is indeed Rome, and more than all that I am in it? I wrote you from Liverpool, and after that delayed sending you any word till I could say I was in this delightful place which I now consider my home. I will say nothing of Italy or of what you already know, but tell you at once of the arrangements I have made for the present in the way of art. Of course you know that Mr. Gibson, the English sculptor, is the acknowledged head of artists here. He is my master, and I love him more every day. I work under his very eye, and nothing could be better for me in every way. He gives me engravings, books, casts, everything he thinks necessary for studies, and in so kindly, so fatherly a manner that I am convinced Heaven smiled most benignantly upon me when it sent me to him.

I saw Mr. Terry last night, There was quite an assembly of artists, Mr. Gibson, Crawford, Mosier, Spence, and others . . . I was a little disappointed in Rome when I first came, but now I feel how beautiful and grand the city is, and already look upon it with loving eyes. We are a jolly party in ourselves, Miss Cushman, Miss Hayes, Miss Smith (an English lady), Grace Greenwood, Dr. Hosmer, and myself. I am away all day, but try to make up for that at other hours, and doubly enjoy myself. We see Mrs. Sartoris frequently, and already I love her dearly. She is very like Mrs. Kemble, who, by the way, is to be here in January. She (Mrs. Kemble) went with us in London to the British Museum and various other places.

Remember me to the beloved old professor, whose instructions I value more highly every day, as I see how invaluable they are.

Yours, H.

To Cornelia Carr, April 22, 1853:
"I wouldn't live anywhere else but in Rome"

Dear C:

I have not the least idea that I shall see America for five years at the inside. I have determined that, unless recalled by accident, I will stay until I shall have accomplished

certain things, be that time, three, five, or ten years. My father will make me a visit in about three years, I suspect, or when he wants very much to see me, and then it will be my turn to visit him. As by that time you might forget how I look, I have caused to be taken a Daguerre of myself in daily costume, also one for the Pater. They are, like Gilpin's hat and wig, "upon the way."

You ask me what I am doing, and in reply I can say I am as busy as a hornet. First, I am working on your Daphne, and then making some designs for bassi-relievi. I reign like a queen in my little room in Mr. Gibson's studio, and I love my master dearly. He is as kind to me as it is possible for you to imagine, and he is, after Rauch, the first sculptor of the age.

Don't ask me if I was ever happy before, don't ask me if I am happy now, but ask me if my constant state of mind is felicitous, beatific, and I will reply "Yes." It never entered into my head that anybody could be so content on this earth, as I am here. I wouldn't live anywhere else but in Rome, if you would give me the Gates of Paradise and all the Apostles thrown in. I can learn more and do more here, in one year, than I could in America in ten. America is a grand and glorious country in some respects, but this is a better place for an artist.

I am looking forward to our summer in Sorrento, for they say it is the loveliest spot on earth. . . .

Yours H.

To Wayman Crow, August 1854: On Marriage

Dear Mr. Crow:

I have your letter of June 13th. I have been fancying you all in Lenox, and see that I was not wrong.

By this time Bessie S. is Mrs. R. You see, everybody is being married but myself. I am the only faithful worshipper of Celibacy, and her service becomes more fascinating the longer I remain in it. Even if so inclined, an artist has no business to marry. For a man, it may be well enough, but for a woman, on whom matrimonial duties and cares weigh more heavily, it is a moral wrong, I think, for she must either neglect her profession or her family, becoming neither a good wife and mother nor a good artist. My ambition is to become the latter, so I wage eternal feud with the consolidating knot. . . .

To Wayman Crow, October 12, 1854: "However successful I may become in my profession, it is to you that I owe all"

Dear Mr. Crow:

. . . Now, dear Mr. Crow, I dare say you will say, "What is the girl driving at?" Why, simply this, that you have understood my case well enough to lay me under an

obligation, so great that if I were to realize your fondest hopes of me, I could never repay you. One thing is past denial, that however successful I may become in my profession, it is to you that I owe all. The great thing in every profession, and most certainly so in art, is to get a good "start," as we Yankees say, and then all is right. But without this good start, I want to know what a young artist is to do? One may model till one is blind, and if one gets no commissions for one's works, what is the use of it, for a work can never be really finished till it is in marble. I need not complain. When I look around and see other artists who have been here for years and still are waiting for a "start" and then think what a friend I have in you, *sensa complimenti,* I wonder why I have been so much more blessed than my neighbors. Every successful artist in Rome, who is living, or who has ever lived, owes his success to *his* Mr. Crow. The Duke of Devonshire was Mr. Gibson's. Mr. Hope was Thorwaldsen's.[4] And I never read the life of any artist who did not date the rising of his lucky star from the hand of some beneficent friend or patron. You know the world pretty well, and therefore know that people in general wait for some one to lead the way, and then they are ready to follow, but the one to lead that way is not sent to every poor soul who wants it. It is very inspiring, too, to know that there is somebody who has great faith in you. You seem to work up to that faith and you do the very best you can, not to disappoint the one who hopes so much from you. I don't want to be "puffed up with my own conceit," as the Bible hath it, but at the same time I am determined that you shall not be wholly disappointed in me. I don't mean that you shall say, five or ten years hence, "Well, I expected that girl would do something, but she never has." If I have the use of my legs and arms, I will show you that I haven't arms in vain. I am not very easily cast down, but have great faith, too, as well as yourself, and I have received a lesson, which I shall not forget, and which will do me a vast deal of good. . . .

Yours, H.

To Cornelia Crow Carr, October 30, 1854: On Italy

Dear C:

. . . I am taken to task for being an alien to my country, but do you know when one has lived in Rome for some time there is no place afterwards. It is a moral, physical and intellectual impossibility to live elsewhere. Everything is so utterly different here that it would seem like going into another sphere, to go back to America. Everything looks homey and the dear Italian tongue sounds as natural as English and everything is beautiful, I glory in the Campagna, the art is divine, and I dearly love the soft climate. I should perish in the cold winters at home, besides, I shall be positively tied here after this. I hope to have a studio and workmen of my own, and how could I be absent, for *"quando il gatto e fuori,"*[5] etc? Ah, there is nothing like it! I admire America, but (and I hear your reproaches) my heart's best love is for Italy. I wonder if Daphne has yet reached you? I hope you will like her and look upon her as a near relation. I am making

a statue now that is to become yours one of these days. It makes me so happy to think that you will all have the very first things I send from Rome,—my first bust and first statue.[6] I know they are going into kind, good hands, and I feel tenderly for them. You can't guess how busy I am from morning till night, nor how an artist must study and work to produce anything worthy of the name of art. Here have I been pegging away for more than two years, and I have learned just enough to feel that I know nothing; but *pazienza, col tempo tutto—forse.*

Yours H.

To Mrs. Wayman Crow, February 1858: On *Zenobia*

Dear Mrs. Crow:

Before you get this I shall be as deep in Palmyrene soil as the old monks of the Cappucini are in the soil of Jerusalem. I have not yet begun the Zenobia, as I am waiting for a cast of the coin; not that, as a portrait, it will be of great value to me now, but the character of the head determines the character of the figure. When I was in Florence, I searched in the Pitti and the Magliabecchian Libraries for costume and hints, but found nothing at all satisfactory. I was bordering on a state of desperation, when Professor Nigliarini, who is the best of authorities in such matters, told me if I copied the dress and ornaments of the Madonna in the old mosaic of San Marco, it would be the very thing, as she is represented in Oriental regal costume. I went and found it. It is invaluable; requiring little change, except a large mantle thrown over all. The ornaments are quite the thing; very rich and very Eastern, with just such a girdle as is described in Vopiscus. . . .

Yours, H.

March 1861: On Women's Rights

Dear ——:

. . . I had a discussion yesterday with Mr. May, he is a great woman's rights man, I find, just as much so as it seems to me is reasonable, that is, he thinks every woman should have the power of educating herself for any profession and then practising it for her own benefit and the benefit of others. I don't approve of bloomerism and that view of woman's rights, but every woman should have the opportunity of cultivating her talents to the fullest extent, for they were not given her for nothing, and the domestic circle would not suffer thereby, because in proportion to the few who would prefer fighting their own way through the world, the number would be great who would

choose a partner to fight it for them; but give those few a chance, say I. And those chances will be given first in America. What fun it would be to come back to this earth after having been a wandering ghost for a hundred years or so and see what has been going on in flesh while we have been going on in spirit!

Yours, H.

12

May Alcott (1840–79)

May Alcott survives today exclusively through her writings rather than her paintings. She is vividly portrayed as Amy, the youngest, "artistic" sister in Louisa May Alcott's *Little Women.* Her letters to her family, preserved in the Alcott papers were first edited and published by Caroline Ticknor in 1928. Ticknor's volume sketches in the basic facts of May Alcott's brief life. Alcott's most vivid writing is a thin but lively volume pragmatically titled *Studying Art Abroad and How to Do It Cheaply,* published in 1879, the year of her death. Addressed primarily to young women exactly like herself, born into middle-class families with limited financial resources, *Studying Art Abroad* testifies to the growing number of American women who, following the example of Lea Merritt Hosmer, and Cassatt, left America to acquire artistic training in Europe. Living abroad freed Alcott from family obligations. She struggled to develop an acceptable level of painting skills and establish a professional career while maintaining a way of life consistent with socially approved norms. With her premature death from complications following childbirth, her artistic career was abruptly terminated, and no significant paintings have survived.

May Alcott was born into a family of great intellectual energy, if no specific inclination toward the visual arts. Her father, Bronson, ran an idealistic school where Margaret Fuller, one of the country's leading intellectuals, was employed. May's earliest artistic training was in the women's classes of William Hunt and Dr. William Rimmer in Boston.[1] The family's limited financial resources would not have permitted the luxury of travel abroad. It was only after the popular success of *Little Women* in 1868 that funds were available for such a venture. Accompanied by her sister Louisa May Alcott, ten years her senior, May traveled abroad for the first time in 1870, touring France and Italy. Louisa left May in London for her first extended studies abroad. This trip came to an end when Louisa recalled her home in November of 1871 "to share in household responsibilities."[2] Apparently their mother's ill health, the care of her sister Nan's sons, and Louisa's sense of being overwhelmed all contributed to this decision.

A year and a half later, the family situation had stabilized sufficiently to permit another European sojourn. In April 1873, May sailed for England. The first excerpt

reprinted here is from a letter written to her family two months after her arrival in London. From her last sentence, one can infer already a desire to speak to other young women in similar situations, encouraging their travels abroad; this interest would culminate in her book, published six years later. She returned to her family in November 1874.

The second excerpt is a portion of a letter to her mother, written from Paris during her third trip abroad. This paragraph reflects a shift in consciousness that must have been common among Americans in Europe.

That same November, she attended a gathering at the home of Mary Cassatt. The third excerpt is frequently quoted, since it provides a rare verbal picture of Cassatt in her home. It also testifies to Alcott's perceptive recognition of Cassatt's talents, even before Cassatt exhibited with the Impressionists.

In the next excerpt, from a letter to her family in January 1877, she is working in the studio of Edouard Krug (1829–1901). In it she details the criticism of the day and expresses her feelings of solidarity with young women students.

Following the acceptance of a still life into the Salon of 1877, May wrote another letter home describing her interest in leaving Paris to study nature. Here we can sense her growing seriousness in defining her individual artistic mode and subjects.

A letter written in October 1877 is in a more sober tone, in response to the news of her mother's failing health. Given her obvious pain, it is especially poignant to find May writing of her first sale. This context makes it quite clear that, along with the nonfinancial prestige of exhibiting at the Salon, this form of recognition was of vital importance as well.

Events in her personal life accelerated in 1878. In March she announced her engagement to a Swiss, Ernest Nieriker, who was living in the same boarding house, and several weeks later she was married. That spring she wrote the manifesto reprinted here as the last excerpt from her family letters.

In November 1879, a daughter was born to the young couple. Tragically, May Alcott Nieriker, having lived to see the publication of *Studying Art Abroad,* died on December 29 from complications following her pregnancy.

Three excerpts have been taken from *Studying Art Abroad.* The first segment comes from the introduction, in which Alcott advises her young women readers to organize their priorities seriously before embarking. The segment on London is of interest for her rating of the art schools as to their professionalism, in which she notes for example the rather low standards of excellence at a school in Bloomsbury. The final segment deals with the options available in Paris, beginning with her own selection of Krug's studio. However, she also notes availability of instruction at the Atelier Julian. This segment also contains a defense of the American woman abroad, arguing for a serious appreciation of her determination to acquire artistic training rather than the prevailing stereotyping as an "indiscreet, husband-hunting, title-seeking butterfly." Her spirited defense of women artists in general and American women painters in particular make her book a valuable document of the growing feminist awareness among women artists by the last decades of the nineteenth century.

Letters to Her Family
June 1873: "Art life abroad is very charming"

. . . Often in looking about me here, I feel ashamed and impatient that we, who give so generously to many good causes and spend so lavishly in many foolish ways, are so slow to move in the direction of art, for we need just the culture that alone gives. I want a really good collection of the best pictures which shall be open to all; not merely to artists, or those who can pay their fifty cents for an hour's lounge, but absolutely free, like great galleries abroad, where any beggar may solace himself with beauty, if so inclined. When we get this, and schools such as we find here, then we need not run away from home and roam about gathering up the advantages of the Old World.

Nevertheless art life abroad is very charming and after my day among the Turners, I heartily enjoy wandering through London, taking a trip to Hampton Court, Kew, or Richmond, a row on the river, a brisk canter in the park, or a ten-mile tramp to see the May-Pole Inn, So free, so busy, so happy am I that I envy no one, and find life infinitely rich and full. Such being the case, and this my second trial of the experiment succeeding even better than the first, I feel that I may venture to say to any other young woman of moderate means, and artist longings, "Take heart, come over and try art-life in London.

To Her Mother, November 1896: On Life in Europe

My Dear Marmee,

. . . As soon as I land on this side it always seems as if I were someone else, whose actions I followed with interest but took no actual part in, and in a measure I lose my identity and feel like a heroine in some novel more than anything else. At present there is nothing in the least like a romance going on, but still it is quite different from Concord and its surroundings. . . . my days are much alike, drawing and painting from eight o'clock A.M. until dark, and to bed early, unless callers come as they sometimes do.

November 1876: "Miss Cassatt was charming as usual"

The group ate fluffy cream and chocolate, with French cakes, while sitting in carved chairs, on Turkish rugs, with superb tapestries as a background, and fine pictures on the walls looking down from their splendid frames. . . .

Statues and articles of *vertu* filled the corners, the whole being lighted by a great antique hanging lamp. We sipped our *chocolat* from superior china, served on an India waiter, upon an embroidered cloth of heavy material. Miss Cassatt was charming as usual in two shades of brown satin and rep, being very lively and a woman of real genius, she will be a first-class light as soon as her pictures get a little circulated and known, for they are handled in a masterly way, with a touch of strength one seldom

finds coming from a woman's fingers. They wouldn't suffer if hung with the Thomas Lawrences.

January 1877: "I shall found a school for indigent artists"

. . . When he [M. Müller] came to my drawing, of a full-length negro, who is really the "Prince of Timbuctoo," and such a splendid specimen of a man that he looks very princely, Müller said, "With what passion and enthusiasm you draw this ensemble; it is very vigorous and shows your interest and not scorn of the race." I couldn't answer him, as this was all said in French, but it amused the class as I, among them, had pretty freely expressed my admiration for him, beside fighting the battle of the blacks versus the whites, whenever the question came up between the Southerners, of whom there are three in the class, and two of us Northerners. I am proud that he proves my part of the proposition, as most true, for he is the most gentlemanly, polite and delicate model that we have had. He was in the Crimean War and showed us four great scars on his legs where he was wounded, and Mr. Krug told us he was decorated for his courage, and considered one of the best models in Paris.

My drawings improve from week to week, and now I can draw the human figure without great difficulty, which is quite a triumph, it being the most difficult thing possible to put on paper, and have action in it, and the individuality of each model. . . .

When I become rich and great, I shall found a school for indigent artists and aspiring young students, as Rosa Bonheur has done in Paris, for girls under twenty years of age. I have still thirty more years to work in and think of, if I am spared, that I may do something in that time. Things certainly look most promising just now and I have painted a head of "Christ" (that is the model we have who has sat so much for Christ that he goes now by that name) which Miss Austin, who is the best painter in the studio, held it up for all to see, saying she considered "that luminous flesh," and all asked what colors I had used, which considering I was a beginner was flattering to say the least.

Late Spring 1877: "I long to get into the country"

I long to get into the country and try my hand at a bit of nature with the new ideas I have been simmering to help me along. I don't want to paint merely portraits, which for money is a dog's life, but old donkey-women with yellow handkerchiefs on their heads, pretty children on the queer stone steps of some of the quaint houses of Brittany, perhaps, and such things, where landscape and figures combine to make a pleasing whole, and if I find what I want I shall stay all winter perhaps, out of Paris making pictures, though probably I shall find it necessary to study drawing much longer. Sometimes it does seem such an endless task to try to learn all that a painter must know before he attempts pictures.

To Her Mother, October 1877: Her First Sale

My Dear Marmee,

—Your little note nearly broke my heart, not to be there with my arms round your neck when you are so ill, and your baby, if no other daughter, should be with you. I paint away and try not to get anxious but hope for the best, and take this minute before the mail closes to tell you the great news about my Dudley picture, for I know it will please you as much as the Salon success did. To begin, yesterday I asked Miss Warner to lunch with me and go to the Dudley. So we went as agreed upon and of course looked about for the owl-panel, which to our surprise we found in a corner, badly hung but with a great star on the frame showing it was already *sold,* and that at the *private view* where only invited guests were present. Wasn't that a triumph, and for $50. which was thought very little for it, but as it took me only one morning to paint it I considered it enough, don't you? Only a few other pictures were decorated with stars, so I felt particularly proud and know you will for me. The exhibition is exceedingly good even compared with Paris Art, and I was surprised that without favor, the owl should ever have been accepted, much less sold.

Spring 1878: Combining Marriage and Career

I mean to combine painting and family, and show that it is a possibility if *let alone.* But not if I am at the mercy of constant company, who have no real claim on me and my time, so let me have my own way and devote this year at least to carrying out my aims. In America this cannot be done, but foreign life is so simple and free, we can live for our own comfort not for company. I often wonder if I could step back into my old life and feel at home there, for I seem quite a different person from the woman who bade you good-bye so long ago, and you would find me greatly changed.

To be a happy wife with a good husband to love and care for me, and then go on with my art. This blessed lot is mine, and from my purpose I never intend to be diverted. . . . I am free to follow my profession, I have a strong arm to protect, a tender love to cherish me, and I have no fears for the future. Set your dear hearts at rest, for could you see me in my lovely home amid birds and blossoms, and know my happiness you would say "May has decided wisely."

On Studying Art Abroad: "En route"

Now that Boston, New York, and Philadelphia have their Fine Art Museums and life classes, there is no longer the same necessity for crossing the Atlantic for an education that existed some years ago. But while the feeling prevails that there is no art world like Paris, no painters like the French, and no incentive to good work equal to that found in a Parisian *atelier,* many will continue to seek in France what, in their estimation, cannot be found in America. To such, especially if women, a few notes, suggestions,

and addresses will prove useful in simplifying the *modus operandi* of settling in a foreign city.

Let me impress upon them at the outset the importance of considering well what is one's particular taste or talent, aim or ambition, and to have a definite notion before starting of what one wants to learn, so as to insure the greatest amount of profit and enjoyment in a given time. For I am supposing our particular artist to be no gay tourist, doing Europe according to guide-books, with perhaps a few lessons, here and there, taken only for the name of having been the pupil of some distinguished master, but a thoroughly earnest worker, a lady, and poor, like so many of the profession, wishing to make the most of all opportunities, and the little bag of gold last as long as possible.

London

Just as naturally will one who seeks instruction in water-color figures and landscapes turn toward London, though the Roman painters possess a fine, strong style in the former subject which cannot be overlooked. However, as every one knows, England's art speciality is water-colors, of which the summer exhibitions give sufficient proof.

Also china painting and decorative art in general flourish in the big city which is acknowledged the great picture-market of the world, and this last fact may be of some importance to an artist if reduced to making pot-boilers, as the saying. "*Live* in Paris, but *sell* in London," was long ago adopted by painters of all nations.

Let us conclude, then, that each of the foregoing considerations has been well thought of, and after due deliberation and all possible study accomplished before starting, that our lady artist decides on a year abroad, and begins preparations in good earnest.

After the Royal Academy School, where it is exceedingly difficult to gain admittance, if an applicant can pass the examination at the Slade School, Gower Street, the course of instruction will prove a most thorough one, with the advantage to those wishing to study the figure of having excellent life models. The rooms are large, well ventilated, and well lighted not only by day, but also at night, so that every facility necessary for improvement is supplied, though the terms make six months or a year of study rather expensive. A Frenchman is at the head of this institution, and under his supervision etching has been very successfully taken up by many of the pupils, at the same time with the other branches.

A circular stating requirements and all details can be obtained of the curator in the building.

There is also the Kensington Art School, connected with the Kensington Museum, about the merits of which one hears such different opinions from the best authorities that a student must visit it in person, and examine the general course pursued, in order to form an independent judgment.

A few ladies who remember the Boston School of Design some years ago, and were fortunate enough to belong to the class under the able and inspiring teaching of Mr. Salisbury Tuckerman, know the method to have been nearly the same as that pursued

at Kensington; and such saw with great regret that, for want of proper support at the right time, the school in Temple Place had to be given up, as it would have afforded Bostonians the best art advantages. For it was not, as the name would suggest, merely industrial in character, like the present system of Mr. Walter Smith, and was of far more breadth and earnestness than anything found at the Lowell Free School, where good work is almost an impossibility in the crowded, narrow rooms, that, spite of an ever-increasingly rich fund, are the only accommodation for the students. The School of Design seemed exactly the happy medium which best answered to the common need.

But to leave Boston and return to London, mention must be made of a class under the instruction of Mr. Heatherly in Newman Street, where excellent casts from the antique are provided, as well as the living draped model for oil or water colors, at an exceedingly moderate price. In Queen's Square, Bloomsbury, is a rather elementary school for women, under the patronage of the Princess of Wales, who offers certain prizes for the best work done in the various classes, and of this there is an annual exhibition, which, to confess the honest truth, does not strike the visitor, from its standard of merit, as surprisingly creditable to the royal patroness.

Paris

Firstly, then, is the well lighted and ventilated studio of Monsieur Krug, No. 11 Boulevard Clichy, devoted to female students in all branches of art, and where the much-discussed question of the propriety of women's studying from the nude is settled in a delicate and proper manner by the gentlemanly director. Here one has the great advantage of severe and discriminating criticism, two mornings in each week, from Monsieur Carl Müller, the painter of the well-known *Conciergerie During the Reign of Terror,* hanging in the Luxembourg, and the recipient of every honor France has to bestow on a man of genius. Monsieur Cott and the sculptor, Carrier-Belleuse, also visit the class to inspect the afternoon and evening drawings. Monsieur Krug's prices are moderate, being one hundred francs per month, for the two daily and one evening *séance,* with no extra charge for the excellent models provided, or for towels, soap, etc., as is often the custom.

This is, on some accounts, for an American lady, new to painting and Paris, the best *atelier* she could choose, for many are overcrowded, badly managed, expensive, or affording only objectionable companionship. Still the pupils or admirers of each leading painter sing his praises loud and long, and those who receive ladies are Messieurs Chaplin, Barrais, Duran, Cabanel, Jackson, Luminais, Bougereau, Robert Fleurry [sic], and Lefebvre.

Then there is Jullien's [sic] upper and lower school, in Passage Panorama, where a student receives criticism from the first leading authorities, and is surrounded by splendidly strong work on the easels of the many faithful French, who for years have crowded the dirty, close rooms, though I believe the lower school, as it is called, or male class, no longer opens its doors to women, for the price, being but one half that of the upper school, attracted too many. Also with better models, and a higher standard of work, it

was yet found to be an impossibility that women should paint from the living nude models of both sexes, side by side with Frenchmen.

This is a sad conclusion to arrive at, when one remembers the brave efforts made by a band of American ladies some years ago, who supported one another with such dignity and modesty, in a steadfast purpose under this ordeal, that even Parisians, to whom such a type of womanly character was unknown and almost incomprehensible, were forced into respect and admiration of the simple earnestness and purity which proved a sufficient protection from even their evil tongues; M. Jullien himself confessing that if all ladies exercised the beneficial influence of a certain Madonna-faced Miss N. among them, anything would be possible.

Something beside courage was needed for such a triumph; and young women of no other nationality could have accomplished it, though, it must be acknowledged, a like clique will not easily be met with again.

So, let those who commonly represent the indiscreet, husband-hunting, title-seeking butterfly as the typical American girl abroad, at least do her the justice to put this fact on record, to her credit. . . .

An unprejudiced judge of pictures, in Paris, making the tour through the studios of Americans of both sexes, and carefully examining the work found there and at the Salon consecutive seasons, cannot but admit that in many instances that of the women is far superior and, what is somewhat surprising, far stronger in style than most of that done by the men.

If Mr. John Sargent be excepted, whose portrait of M. Carolus Duran alone undoubtedly places him in the first rank of painters, there is no other male student from the United States in Paris to-day, exhibiting in his pictures the splendid coloring always found in the work of Miss Casatte [sic], from Philadelphia, or the strength and vigor of Miss Dodson's "Deborah," particularly remarked in this year's Salon.

It is something of a boast for America to possess even these women candidates for artistic honors whose work bears favorable comparison with so much that is excellent done by the men of the same nationality, and that of the French in the great exhibitions; for even among the latter, a nation of painters as it is, the names only of Rosa Bonheur, Nelie Jacquemart, Louise Abbema, and Sarah Bernhardt occur as having so far distinguished themselves in art. With the last named, too, it seems more the versatility of talent shown by the leading actress of the Théàtre Français, than real merit as sculptor or painter, which attracts the crowd about any production of hers. And what is notably striking in the pictures of Rosa Bonheur is her bold, almost masculine use of the brush, compared with the more delicate, even uncertain style of her brother, Jules Bonheur. A stranger, seeing the two canvases side by side, would unhesitatingly select hers as the work of the man.

13

Mary Cassatt (1844–1926)

Arguably the finest American artist, male or female, of her epoch, Mary Cassatt was, like Berthe Morisot, a loyal supporter of the Impressionist movement. Like Anna Lea Merritt and Cecilia Beaux she was raised in Philadelphia, but her professional life was rooted in France and she was prepared to forge her artistic identity with the French avant-garde. Cassatt had been exhibiting works at the Paris Salon since 1872. Degas asked her to show her paintings in the Fourth Impressionist exhibition of 1879. Her stylistic development during the 1880s and 1890s is consistent with the general trend in works by Degas, Renoir, and Pissarro toward less painterly, atmospheric effects and stronger definition of forms.

Cassatt's literary activity consisted exclusively of correspondence. We are indebted to the scholarship of Nancy Mowll Mathews for the recent edition of a selected group of her letters.[1] Having spent so much time abroad, Cassatt's correspondence is varied and informative. She wrote to friends such as Emily Sartain and Louisine Havemeyer, and to family members, especially her brothers, but professional correspondence has also been preserved, such as that concerning her mural for the Woman's Building of the World's Columbian Exposition and proposed exhibitions of her works.

The tone, language, and substance of the letters varies greatly according to the intended reader. Letters to her brothers, for example, tend to be filled with family matters; if art is mentioned, it is in a businesslike context of investment.

The group of letters selected for inclusion spans the full range of Cassatt's correspondence. They cover a period of over forty years, from 1872 to 1913.

Like Degas, Morisot, Manet, and Lea Merritt, Cassatt was born into an upper-middle-class household with little specific inclination toward the visual arts. She spent four years at the Pennsylvania Academy of Fine Arts (1861–65), where she first met Emily Sartain. Sartain was one of Cassatt's closest friends in the late 1860s and early 1870s. She came from a family of professional engravers. Cassatt spent nearly five years in Europe, from 1866 until late in 1870, when she was forced to return home by the Franco-Prussian War. Soon after her return to Philadelphia, she determined to return to Europe, now focusing her sights on Spain. In December 1871, Cassatt and Sartain trav-

eled together back to Europe. The two went directly to Parma. Sartain decided to return to Paris and her family in April, while Cassatt stayed through the summer. Hearing from Sartain that two American acquaintances were headed for Spain, Cassatt set off for Madrid. She ended up in Seville, where she remained until April 1873. The first letter reprinted here conveys Cassatt's enthusiasm for the artists she was just discovering. Cassatt's attraction to the Spanish masters, like that of Manet, indicates a resistance to accepting the styles of the Parisian academic painters. The more conservative Sartain would align herself with the styles of her father John, her teacher Evariste V. Luminais, and traditional Salon art, eventually causing the breakup of their friendship in 1875. Sartain would later return to Philadelphia and became director of the Philadelphia School of Design for Women (1886–1920).

Cassatt settled permanently in Paris in 1872. She never married. Her parents and her sister, Lydia, lived with her in Paris after 1877, often serving as models for her paintings. She maintained close ties with other family members through a voluminous correspondence. We are indebted to May Alcott for her prose description of Cassatt's comfortable, elegant home life in Paris (see p. 127).

In a number of Cassatt's own paintings from this time, the enclosed private world of women of the haute bourgeoisie is given a visual record. *A Cup of Tea* (Fig. 9) is set in the highly compressed, nearly claustrophobic "spaces of femininity" discussed in connection with Morisot's contemporary works.[2] The painting maintains a sophisticated

Figure 9. Mary Cassett, *Five O'Clock Tea*. Oil on canvas. M. Theresa B. Hopkins Fund. Courtesy of Museum of Fine Arts, Boston.

balance between painterly surface and textural definition of materials, such as china cups and silver tea set. The strong patterning of the vertical striped wallpaper is counterbalanced by the jutting diagonal of the table and the sloping form of the woman on the left. The daring asymmetry of the composition shows an artist in full possession of her skills. This painting remains fixed on surfaces rather than emotional expression. The profile view of the figure on the left combined with the hidden face of the frontal figure leaves the viewer with a sense of distance, perhaps characteristic of ''polite behavior'' in social interactions of this class.

The next two letters, to her Impressionist colleagues, Camille Pissarro and Berthe Morisot, are representative of her cordial, if professional, relationships with members of this circle. Unfortunately, later in her life she destroyed her correspondence with Degas. In 1892 Cassatt was immersed in work on her mural, commissioned by Mrs. Bertha Palmer, head of the Board of Lady Managers of the Woman's Building for the World's Columbian Exposition, which was scheduled to open in Chicago the following year. This was her first opportunity to create on a larger scale, and her struggles and the energy involved in this enterprise come through quite clearly in her two letters to Mrs. Palmer reprinted here.

The next letter is addressed to a recent friend, Theodate Pope, a professional architect and feminist activist whose parents were collectors of Impressionist art. Cassatt made their acquaintance on a trip to the United States in 1898–99. This letter contains Cassatt's justification for the advice and direction she provided throughout her years in Europe for a select group of American collectors such as the Havemeyers (whose collection is now in the Metropolitan Museum of Art in New York), the Palmers, and the Sears family, as well as the Popes. Many paintings of both Impressionists and Old Masters now hang on the walls of American museums because of Cassatt's efforts.

Cassatt's letter to Harrison Morris, then director of the Pennsylvania Academy of Fine Arts, is the clearest statement in her correspondence of her belief in a jury-free system of exhibition and her adherence, even at this late phase of her life, to the principles of exhibition embodied by the Impressionist shows of the 1870s and 1880s.

In 1893 Cassatt purchased the Chateau de Beaufresne, some distance from Paris, which remained her home until the end of her life. Her later years were increasingly isolated. She developed cataracts and diabetes. She did remain sufficiently connected with political developments to permit the funds raised from an exhibition of her works in New York to be donated to the cause of women's suffrage. She continued to paint until World War I, mainly portraits and mother-and-child images, but compared with the new tendencies of Fauvism and Cubism, her art, once so radical, began to look conservative.

The final letter in this book, addressed to her old friend Louisine Havemeyer, includes a statement on Cassatt's attitude toward early-twentieth-century women's rights and the suffrage movement. Though clearly a feminist, she had a pragmatic and realistic view of the nature of men and women.

Many aspects of Cassatt's personality over a period of several decades are richly illuminated through her correspondence.

To Emily Sartain, October 5, 1872:
"Velasquez oh! my but you knew how to paint!"

My Dear Emily,

Where oh Where are Mrs. Bryen [Birney] and sister? I am at the Hotel de Paris Madrid but have not yet heard anything of them, except on Thursday evening at Pau, when I was told that they had left that morning for Burgos. Emily Sartain if you and Mrs. Tolles don't wish to feel everlasting and eternal remorse for opportunities wasted, put yourselves into the train and come down, not to Madrid but to the "Academie Reale."

I got here this morning at 10 o'clock at 12 I had had a bath was dressed and on my way to the Academie Museo or whatever they call it.[3] Velasquez oh! my but you knew how to paint! Mr. Antonio Mor or Moro, whom you were introduced to at Parma has a word or two to say to you Emily. Titian also would like to introduce you to his daughter who is carrying the head of John the Baptist, holding it up on a platter with her beautiful bare arms. She says the one you saw in Dresden was a copy. Van Dyke's three children at Turin are beautiful, but he has a man in velvet and crimson satin that is a step beyond that in some respects. Oh dear to think that there is no one I can shriek to, beautiful! lovely, oh! painting what ar'nt you. I am getting wild I must eat some dinner if I can get any.

6 P.M. Just done dinner feel decidedly better, very tired though, & rather lonely. I dont see any women about, nothing but men.

Sunday 11 A.M. I have just seen Mrs. Burney and sister they arrived last night, they have just gone to breakfast afterwards we will go out. I suppose you will think I have written great stuff here, but I really never in my life experienced such delight in looking at pictures, no Titians in Italy are finer, nor Rafaelles either, the Madonna of the fish is most beautiful. I am going to try and find a boarding house, and get settled and then I will write you the prices. I started off from Parma without getting my letters and with very little money, if I run out I will write to Drexel and borrow. Mother wrote to me that Father did not wish to send me a large bill but little and often, as he was afraid, but when he hears that I came on without waiting for money I have no doubt he will be in an awful state of mind. My bill for the gloves weighs on my conscience but I am afraid just now to send any away, you see my journey lasted 4 days and two nights I spent on the cars.

If I can tell you of prices not too high do you think you and Mrs. Tolles can come down? I don't hesitate to tell you that although I think now that Correggio is perhaps the greatest painter that ever lived, these Spaniards make a much greater impression *at first*. The men and women have a reality about them which exceed anything I ever supposed possible, Velasquez Spinners good heavens, why you can walk into the picture. Such freedom of touch, to be sure he left plenty of things unfinished, as for Murillo he is a baby alongside of him, still the Conception is lovely most lovely. But Antonio Mor! and then Rubens! I won't go on, oh Emily *do do* come you will never regret it. Rather come now and go back to Luminais after you have seen these, indeed it is not because

I want you and Mrs. Tolles, it is for you both I wish it for your sakes. The Correggio here is beautiful but not nearly so fine as the St. Gerome. Delicacy, expression of nobility and sublimity are not striking in this school but it is the extraordinary painting. So simple such breadth.

Monday. Haven't been able to find an apartment yet, and am beginning to feel alarmed about my finances especially as the letters from home have not arrived. Regards to Mrs. Tolles.

<div align="right">

affec. yours
Mary S. Cassatt
</div>

My copy reached home in a horrid state!

To Camille Pissarro, November 27, 1889: On Etchings and Exhibitions

My Dear Mr. Pissarro,

Thanks so much for your kind letter, yes. I am quite well again & have almost forgotten my broken leg[4]— We had a very pleasant place this summer at Septeuil[,] the house of Chintreuil where, he is buried—& Lovely country—

I have heard nothing of an exhibition, but am working at my etchings, & have a printing press of my own which I find a great convenience, & a great pleasure, one ought to print all one's own plates only it is too hard work— The friends who were inquiring about etchings were Mr & Mrs Havemeyer who bought so many pictures, they had the misfortune to have a child fall ill with mucous fever & were so anxious about her that they did not have time to see anything before they left— However I spoke to Durand Ruel about it & told him to show them your etchings in New York— Durand is doing very well in America[5]— As to the Manet subscription I declined to contribute. M. Eugène Manet told me that an American had wished to buy the picture & it was to prevent its leaving France that the subscription was opened. I wish it had gone to America—[6]

Come & see me when you are in Paris & we will talk over an exhibition, it is time we were doing something again.

With kindest regards to Madam Pissarro & compliments from my Mother

<div align="right">

Very sincerely yours
Mary Cassatt
</div>

To Berthe Morisot, April 1890: The Japanese Prints at the Ecole des Beaux-Arts

Dear Madame Manet,

Thank you very much for your letter and for your offer to look for a retreat for us for this summer, but we have Septeuil. At any rate we will be neighbors and I promise

you I am not sorry to be returning there and to be spared the trouble of investigating other estates. We have rented it from the first of June and I hope that we will be able to move in on that day, I am eager to be in the country. A thousand thanks for your kind invitation. I haven't seen "la belle Louise" to deliver it for you but I know that for the moment she is making a dress for the wedding and she is completely absorbed in this occupation, and doesn't even have the time to see her friends; also I think she is vexed with me because Melle Germaine repeated to her that I believed she would *never marry!*

I think that for the time being I am not able to go and have lunch at Mezy, but if you would like, you could come and dine here with us and afterwards we could go to see the Japanese prints at the Beaux-Arts.[7] Seriously, *you must not* miss that. You who want to make color prints you couldn't dream of anything more beautiful. I dream of it and don't think of anything else but color on copper. Fantin[8] was there the 1st day I went and was in ecstasy. I saw Tissot there who also is occupied with the problem of making color prints.[9] Couldn't you come the day of the wedding, Monday, and then afterwards we could go to the Beaux-Arts? If not that day then another and just drop me a line beforehand. My mother sends her compliments and I send a kiss to Julie and my best regards to Monsieur Manet.

Yours affectionately
Mary Cassatt

P.S. You *must* see the Japanese—*come as soon as you can.*

To Bertha Palmer, October 11, 1892: "If I have not been absolutely feminine, then I have failed"

My dear Mrs. Palmer,
Your letter of Sept. 27th only arrived this morning, so unfortunately this will not reach you by the 18th as you desired. Notwithstanding that my letter will be too late for the ladies of the committee, I should like very much to give you some account of the manner I have tried to carry out my idea of the decoration.

Mr. Avery sent me an article from one of the New York papers this summer, in which the writer, referring to the order given to me, said my subject was to be the "The Modern Woman as glorified by Worth"![10] That would hardly describe my idea, of course I have tried to express the modern woman in the fashions of our day and have tried to represent those fashions as accurately & as much in detail as possible. I took for the subject of the central & largest composition Young women plucking the fruits of knowledge or science &—that enabled me to place my figures out of doors & allowed of brilliancy of color. I have tried to make the general effect as bright, as gay, as amusing as possible. The occassion is one of rejoicing, a great national fête. I reserved all the seriousness for the execution, for the drawing & painting. My ideal would have been

one of those admirable old tapestries brilliant yet soft. My figures are rather under life size although they seem as large as life. I could not imagine women in modern dress eight or nine feet high. An American friend asked me in rather a huffy tone the other day "Then this is woman apart from her relations to man?" I told him it was. Men I have no doubt, are painted in all their vigour on the walls of the other buildings; to us the sweetness of childhood, the charm of womanhood, if I have not conveyed some sense of that charm, in one word if I have not been absolutely feminine, then I have failed. My central canvass I hope to finish in a few days, I shall have some photographs taken & sent to you. I will still have place on the side panels for two compositions, one, which I shall begin immediately is, young girls pursuing fame. This seems to me very modern & besides will give me an opportunity for some figures in clinging draperies. The other panel will represent the Arts, Music (nothing of St. Cecelia) Dancing & all treated in the most modern way. The whole is surrounded by a border, wide below, narrower above, bands of color, the lower cut with circles containing naked babies tossing fruit, &&c. I think, my dear Mrs. Palmer, that if you were here & I could take you out to my studio & show you what I have done that you would be pleased indeed without too much vanity I may say I am almost sure you would.

When the work reaches Chicago, when it is dragged up 48 feet & you will have to stretch your neck to get sight of it all, whether you will like it then, is another question. Stillman, in a recent article, declares his belief that in the evolution of the race painting is no longer needed, the architects evidently are of that opinion. Painting was never intended to be put out of sight. This idea however has not troubled me too much, for I have passed a most enjoyable summer of hard work. If painting is no longer needed, it seems a pity that some of us are born into the world with such a passion for line and color. Better painters than I am have been put out of sight, Baudry spent years on *his* decorations. The only time we saw them was when they were exhibited in the Beaux-Arts, then they were buried in the ceiling of the Grand Opera.—After this grumbling I must get back to my work knowing that the sooner we get to Chicago the better.

You will be pleased, believe me, my dear Mrs. Palmer

Most sincerely yours
Mary Cassatt

To Bertha Palmer, December 1, 1892:
"I am beginning to feel the strain a little"

My Dear Mrs. Palmer,

Your telegram received today gave me the greatest pleasure. I am infinitely obliged to you for the kind thought which prompted you to send it.

The fact is I am beginning to feel the strain a little & am apt to get a little blue & despondent. Your cable came just at the right moment to act as a stimulant. I have been shut up here so long now with one idea, that I am no longer capable of judging

what I have done. I have been half a dozen times on the point of asking Degas and come and see my work, but if he happens to be in the mood he would demolish me so completely that I could never pick myself up in time to finish for the exposition. Still he is the only man I know whose judgment would be a help to me. M. Durand-Ruel, poor man, was here with his daughters a week ago, it was most kind of him to come, they are all broken-hearted over the death of poor Charles. M. Durand was very kind & encouraging, said he would buy it if it were for sale, & of course from his point of view that was very complimentary but it was not what I wanted. He seemed to be amazed at my thinking it necessary to strive for a high degree of finish; but I found that he had never seen the frescoes of the early Italian masters, in fact he has never been to Italy except to Florence for a day or two on business. I asked him if the border shocked him, he said not at all, so it may not look eccentric &, at the height it is to be placed, vivid coloring seems to me necessary.

I have one of the sides well under way & I hope to have the whole finished in time for you to have it up & out of the way by the end of February.

You must be feeling the strain too, with all the responsibility on your shoulders, I hope you will have strength & health to bear you through. With kindest regards & renewed thanks my dear Mrs. Palmer

Sincerely yours,
Mary Cassatt

To Theodate Pope, September 1903:
On the Private Ownership of Paintings

Dear Miss Pope,

I ought to have answered your letter before this, but I have been very busy & I waited knowing you would soon be again in this part of the world— I had such a delightful letter from Miss Hillard & quite counted on answering it in person in Paris. I am very much disapponted to think I shall not see her again, & that she will be so busy with the new school she will not, probably, be able to come over to Europe very soon again—

You must not discourage her about Art, I am sure she will derive great enjoyment from the effects in her surroundings, & also for herself. I am quite sure she will begin to feel pictures in a different way, you must remember that art is a great intellectual stimulus, & not reduce everything to a decorative plane— What you say about pictures being things alone, & standing for so much, & therefore the wickedness of private individuals owning them, is I assure you a very false way of seeing things, surely you would not have museums crowded with *undigested* efforts of everyone? Only in years after an artists death are his pictures admitted to the Louvre, I wish to goodness we had some sensible rule of that kind at home, instead of that everything can be crowded into public Museums, & no standard is possible in such a mess. I think it is very exhilirating

to a painter to know he touches some individual enough for that person to want to own his work, & surely there is nothing wrong in a hard working lawyer or business man putting some of his earnings in a work of art which appeals to him, when we must all work for the state may I no longer inhabit this planet— I assure you when I was in Boston & they took me to the Library & pointed with pride to all the young ones devouring books, & that without guidance, taking up all sorts of ideas of other people; I thought how much more stimulating a fine Museum would be, it would teach all those little boys who have to work for their living to admire good work, & give them the desire to be perfect in some one thing— I used to protest that all the wisdom of the World is not between the pages of books; & never did I meet any one in the Boston Museum, where the state the pictures are in is a disgrace to the Directors— As to the Havemeyer collection about which you feel so strongly, I consider they are doing a great work for the country in spending so much *time* & money in bringing together such works of art, all the great public collections were formed by private individuals— You say ''no collection can be interesting as a whole''— There again you are thinking of decoration, but I know two Frenchmen who are thinking of a journey to New York, *solely* to see the Havemeyer collection because *only there* can they see what they consider the finest modern pictures in contact with the finest old Masters, pictures which time has consecrated & only there can they study the influences which went to form the Modern School, or at least only there see the result— You see how others look on collections.

Enough of this we can talk of art when we meet, I do hope you will come down here I shall be so happy to see you, come on a Saturday evening—spend Tuesday or if the weather does not tempt you I will go up & see you; at any rate we must meet, I had a young couple today to see the place who were enchanted. Kindest regards to all the party & hope you are all well ever yours most cordially

Mary Cassatt

To Harrison Morris, Managing Director of the Pennsylvania Academy of Fine Arts, March 15, 1904: On Unjuried Exhibitions

My Dear Mr. Morris,

I have received your very kind letter of Feb. 16th with the enclosed list of the different prizes awarded in the Exhibition. Of course it is very gratifying to know that a picture of mine was selected for a special honor and I hope the fact of my not accepting the award will not be misunderstood. I was not aware that Messrs Durand Ruel had sent a picture of mine to the Exhibition. The picture being their property they were at liberty to do as they pleased with it. I, however, who belong to the founders of the Independent Exhibition must stick to my principles, our principles, which were, no jury, no medals, no awards. Our first exhibition was held in 1879 and was a protest against official exhibitions and not a grouping of artists with the same art tendencies. We have

been since dubbed "Impressionists" a name which might apply to Monet but can have no meaning when attached to Degas' name.

Liberty is the first good in this world and to escape the tyranny of a jury is worth fighting for, surely no profession is so enslaved as ours. Gérôme who all his life was on the Jury of every official exhibition said only a short time before his death that if Millet were then alive, he, Gérôme would refuse his pictures, that the world has consecrated Millet's genius made no difference to him. I think this is a good comment on the system. I have no hopes of converting any one, I even failed in getting the women students club here to try the effect of freedom for one year, I mean of course the American Students Club. When I was at home a few years ago it was one of the things that disheartened me the most to see that we were slavishly copying all the evils of the French system, evils which they deplore and are trying to remove. I will say though that if awards are given it is more sensible and practical to give them in money than in medals and to young and struggling artists such help would often be welcome, and personally I should feel wicked in depriving any one of such help, as in the present case.

I hope you will excuse this long letter, but it was necessary for me to explain.

Thanking you again for your letter believe me, my dear Mr. Morris

Very sincerely yours
Mary Cassatt

To Louisine Havemeyer, January 11, 1913: On Women's Rights

. . . To go back to your letter, I don't see why women should pay taxes, except on their earnings, mostly they are living on their incomes made by the husbands therefore they are represented. I believe that the vote will be given freely, when women want it, the trouble is that so many don't want it for themselves and never think of others. American women have been spoiled, treated and indulged like children they must wake up to their duties. It seems that Mr S says, so Joseph D. R.,[11] tells me as he told him, that women and men have different spheres and each must stay in their own. I would like him to define these spheres. Nothing he enjoys more than ordering clothes for his daughter, I should say that was their sphere. Most men think they could dress women better than women can.

Sunday. I don't feel as excited over questions as I used to, it is age, and having been so near the border here for so long, of course in those long sleepless nights and idle days, full of pain I thought so much of what might be beyond. Then living so much alone, and having so many gone before. You who see all these young lives expanding around you must be so interested in their future. It is hard for me to keep up with people and work. Americans have a way of thinking work is nothing. Come out and play they say. Mrs Warren could not see why I did not throw over a days work and

go to her. I can understand how hard Mrs Sears[12] finds it. Here I am scribbling on. Heaps of love and many thanks for the nuts and the nice warm shawl. We will have it over our knees when you come.

<div style="text-align: right;">

ever yours affectionately
Mary Cassatt

</div>

14

Enid Yandell (1870–1934)

The flurry of artistic activity surrounding the Chicago World's Columbian Exposition in 1893, created unprecedented demands for large-scaled works of art. This was a fortunate event for that neglected category, the woman sculptor. We have already seen that, even for a mature painter like Mary Cassatt, the Woman's Building at the fair provided new opportunities to work on a large scale for a public purpose. For the virtually unknown sculptor, Enid Yandell, the Exposition was the event that propelled her into national prominence.

Born in Kentucky of a distinguished if impoverished family, Yandell was forced to earn her own living after her father's death. From 1887 to 1889 she studied at the Cincinnati Art Academy, where she developed an expertise in carving marble in a neoclassical style. Through family connections, Mrs. Palmer awarded her the commission for 24 nine-foot caryatids to adorn the roof garden of the Woman's Building. Like Janet Scudder, Yandell also worked for Lorado Taft. Moving beyond the now "old-fashioned" style of neoclassicism, Yandell also designed a realistic life-sized statue of Daniel Boone for the fair, which in 1906 was finally cast into bronze.

The literary excerpt included here is very different from the other types of writing in this volume. It is "fiction," but closely based on the experiences of Yandell and her two roommates and colleagues Laura Hayes and Jean Loughborough. Coauthored by all three artists, *Three Girls in a Flat* is based on the experiences of these young women while living in Chicago and working on sculpture intended for the Exposition. In the book, Yandell is "Duke Wendell." The exceptional freedom that these young, unmarried women enjoyed must have stimulated them to write this text. As Charlotte Rubenstein notes, contemporary reviews also considered this life-style quite daring.[1] One may assume that fiction provided a more comfortable mask from which the authors could speak in a more honest or forthright manner about their experiences.

Three Girls in a Flat is not a unified novel. Parts of it are written in epistolary form, other segments are inserted as diary entries, and still other chapters are straight narrative. The segment reprinted here is a conversation between Mrs. Julia Grant, the wife of Ulysses S. Grant, and "Duke Wendell" concerning women sculptors.[2] This

144

meeting took place at the home of the same Mrs. Palmer with whom Cassatt corresponded. The only persuasive argument that Yandell can muster for the need for women to work involves sparing brothers or fathers the burden of their support.

In 1895 Yandell was living in Paris and working in the studio of Frederic MacMonnies. There she executed a colossal, 42-foot figure of Pallas Athena (now lost) intended for the Nashville Parthenon.

Like so many other sculptors of this generation, she also absorbed the influence of Rodin's figural style. Many of her later commissioned pieces, were, like Scudder's, garden sculpture for wealthy American patrons.

Although she is virtually unknown today, Yandell's works numbered over 70 and she pursued an active career in both small-scaled and monumental sculpture until World War I, when her production tapered off.

Conversation with Mrs. Grant: On Women Sculptors

. . . As we entered the large double glass door, Mrs Palmer came toward us, welcoming her guests in the high, vaulted hall. Marjorie and I saw friends in the library and went to meet them, leaving the Duke alone for a moment. What followed can best be told in her own language, as she related the incident to us that night at the dinner-table.

I was crossing the hall when Mrs. Palmer, taking my hand, said: "I want to introduce you to Mrs. Grant," and as she turned toward us, "let me present to you Miss Wendell, the young sculptor; she is at work on the Woman's Building and we are very proud of her and think we have conferred on her an honor." "A sculptor! You cut marble?" I assented. "I met one before," she said, describing Vinnie Ream.[3] "She was a great deal about the General, but I don't approve of women sculptors as a rule." Just then we were separated and I departed for the balcony to see the parade. A few minutes later, as I pushed back the black satin curtain, with its heavy gold dragons, and entered the Japanese room, I saw Mrs. Grant for an instant alone, during which I seated myself on the window ledge and took up the cudgels on behalf of working women. "So you do not approve of me, Mrs. Grant?" "I don't disapprove of *you*, Miss Wendell," she replied gently, "but I think every woman is better off at home taking care of husband and children. The battle with the world hardens a woman and makes her unwomanly." "And if one has no husband?" I asked. "Get one," she answered laconically. "But if every woman were to choose a husband the men would not go round; there are more women than men in the world." "Then let them take care of brothers and fathers," she returned. "I don't approve of these women who play on the piano and let the children roll about on the floor, or who paint and write and embroider in a soiled gown and are all cross and tired when the men come home and don't attend to the house or table. Can you make any better housewife for your cutting marble?" "Yes," I answered, "I am developing muscle to beat biscuit when I keep house."

"But, Mrs. Grant, are there no circumstances under which a woman may go to work?" "I may be old-fashioned; I don't like this modern movement," she said, "but

I don't think so; and yet, there are certain sorts of work a woman may well do; teaching, being governess, or any taking care of children.'' ''But,'' I replied, ''suppose a case: A young brother and two strong sisters; the young man makes a good salary but can't get ahead because all his earnings are consumed in taking care of the girls. Hadn't they better go to work and give him a chance to get ahead and have a house of his own, they being as able to work as he? Are they being unwomanly in so doing? Or, the case of the father with a large family of girls and a small income—are they less gentlewomen for helping earn a living, lessening the providing of food for care of so many mouths by adding to the family funds?''

For a moment Mrs. Grant thought, and then, looking far over my head, across the shining summer sea, answered: ''You may be right; in that case,'' slowly, ''they ought to go into the world.''

Janet Scudder (1869–1940)

Janet Scudder's key formative experience for her active career as a sculptor was her work with Lorado Taft. For her, as for Enid Yandell, the Chicago World's Columbian Exposition was the beginning of a professional career in the still-novel field of sculpture for women. Known mainly for her garden sculpture, Scudder "had one of the most successful careers of any woman artist in the early 20th century."[1]

Unlike Yandell, Scudder's literary activity is told not in fiction but in true autobiography. Organized chronologically, *Modeling My Life* was published in 1925, late in the artist's life, when her active career as a sculptor was largely finished.

Modeling My Life begins with the artist's recollections of her childhood in Terre Haute, Indiana. Like Yandell, Scudder was born into an unartistic home of limited means. The volume terminates with her experiences living in France during World War I. There are no letters or diary entries. The narrative flows across the years. Her text does display the predictable restraint and modesty we have come to expect from the memoirs of famous women, as when she writes of her conversation with the secretary of Stanford White: "I have no intention of repeating the things said to me that day."[2] As we have seen, such circumspection, motivated by sensitivity to accusations of vanity, is characteristic of the retrospective writings of women artists since Vigée-Lebrun.

The precocious talent she exhibited at the local drawing school in Terre Haute led to her admission to the Cincinnati Academy of Art. After her graduation, and with the death of her father, Scudder was forced to earn her own living. Her first professional job was with Lorado Taft in Chicago. It is at this point in her life that our first excerpt begins. One can share the euphoria of financial independence described here.

Accompanied by Zulh Taft, her friend and fellow artist and Lorado Taft's sister, Scudder traveled to Paris and forced her way into MacMonnies's studio. Two years later she returned to New York to establish herself. Through a fortunate friendship with Matilda Auchincloss Brownell, Scudder received a commission to design a seal in relief for the New York State Bar Association. This led in turn to a number of profile portrait plaques, also in relief. She earned her living doing funerary urns and monuments, but remained uncertain of her personal style. This period is described in the second excerpt.

On a trip to Italy (1899–1900), she discovered Donatello's works in the Bargello of Florence. This experience, described in the third excerpt, would become the key inspiration for her personal sculptural aesthetic. From her contact with Quattrocento sculpture, emerged the *Frog Fountain* (Fig. 10). Its endorsement by Stanford White, as recounted by Scudder in the next excerpt, was an immense stroke of good fortune and established her reputation in New York. Other commissions followed, including *Pan* (1911) for the estate of John D. Rockefeller in Pocantico Hills.

The final excerpt concerns Scudder's modest, self-deprecating remarks on her activities for the American Woman's Suffrage Association. After 1913 Scudder purchased a home in the French countryside, where she lived and worked until the last year of her life. During World War I she turned her home over to the YMCA and worked as a Red Cross volunteer.

Figure 10. Janet Scudder, *Frog Fountain*. The Metropolitan Museum of Art, New York.

The Studio of Lorado Taft: "The white rabbits"

I worked there [in Taft's studio] many weeks and earned the reputation of being the most industrious and hard-working assistant in the studio. My willingness to do anything and everything was sometimes imposed upon by Mr. Mulligan, who began to call me constantly away from my regular and absorbing work—the covering of those armatures—to help him with his plaster casting, mix plaster for him, wash out molds and fetch him pails of water when he could find no one else to do it. Once, when I was at the top of a ladder and lost to the world in seeing an arm develop itself, he called out to me to fetch him a pail of water immediately. It was no moment to be commanded and without stopping work or turning my head, I called down to him: "Get your own pail of water. I'll not be a scullion to a Mulligan." He took the roar of laughter from the rest of the studio good-naturedly; and after that we became great friends; he even went to the extent of now and then fetching *me* piles of clay unasked.

I soon became friends with the three other young women working in the studio, especially Mr. Taft's sister, Zulh Taft. The companionship of working at the same thing always develops friendship and we four students lunched together and had great fun helping each other at our various tasks.

When Mr. Taft's personal work for the Fair was finished and ready to be cast for the façade of the Horticultural Building, he was asked to take charge of the pointing up of a great number of statues and groups which had been contracted for with various sculptors and which had been sent to Chicago in models one-quarter the final size for enlargement in plaster.

In the midst of this work he called us all together one day and said he had something important to tell us. My heart sank. I felt sure that he was about to say that his own studio was to be closed and that I was again to find myself without work—losing a job that was exactly what I had been longing for.

He began very solemnly to tell us that he had just had a talk with the architect-in-chief of the Fair, Mr. Burnham, who wished him to take charge of all the sculpture enlargements for the exposition buildings. The Horticultural Building, now completed, would be turned over to him for a studio. He was authorized to engage as many people as he could find capable of doing the work. The important thing was to get the work done within a year; nothing else mattered.

"When I told Mr. Burnham that I had several young women whom I would like to employ," he went on, a twinkle now in his eyes, "he said that was all right, to employ any one who could do the work—white rabbits, if they would help out. So you might begin right now calling yourself white rabbits—the kind that will receive five dollars for every week day and seven-fifty on Sundays. What do you all think of it?"

What did we all think of it! I don't know what the others thought, but when I realized that I was going to have a job that would last a whole year I left the studio with the feeling that I was either dreaming or had gone entirely out of my head.

That wonderful year! Filled with work, filled with accomplishment and filled with

what was considered in those days a very fat salary! Taft's studio was moved out en bloc to the Horticultural Building and the white rabbits moved in. We were ten by this time, including the men assistants, and we all took up residence in a small hotel near the Fair grounds. My best friend among them was always Zulh Taft—now Mrs. Hamlin Garland; then there was Bessie Potter Vonnoh,[3] who later became one of Chicago's best known artists on account of her very lovely portrait statuettes; Enid Yandell, who is now Kentucky's representative sculptor; Caroline Brooks,[4] afterwards the wife of the New York sculptor, Hermon MacNeil; and Miss Bracken,[5] who has carried off the laurels in our profession for California. We brought our lunch in paper bags and remained from eight in the morning until six in the afternoon; and when we got back to the hotel there was no question of what we could do with the evening; dinner and bed were the only things that appealed to us.

When the first month's work was finished and we took our place in line with hundreds of workmen to receive our pay envelopes, we were about the happiest white rabbits that ever existed. We rushed back to our rooms at the hotel, opened the envelopes and poured out the five-dollar bills—for some reason we were paid our hundred and fifty dollars in five-dollar bills—and carpeted the floor with them. We wanted to see what it felt like to walk on money.

On Portrait Sculpture as Public Monuments: "This obsession of male egotism that is ruining every city in the United States"

The Academy of Art in Cincinnati, the work at the World's Fair in Chicago, my year with MacMonnies in Paris and my two years of struggle in New York were all steps in the process of learning to be a sculptor. By the time I arrived in Paris for the second time I had reached the point where I was beginning to wonder what *kind* of sculpture I was going to do. I knew I could make a living; that was most satisfactorily demonstrated by having made enough money to return to Paris and not be worried for a long time about expenses. But beyond that—what could I do? Did I have a flair for any special branch of sculpture? Did I have ideas of making literature of sculpture, as a woman I knew did—every piece of her work was so cluttered up with symbolism that she had very little strength left, after she had composed her message to the world, to do the modeling? Did I believe that sculpture should teach lessons as those paintings that are supposed to tell stories do? Did I feel that art should be grave or gay—pagan or Christian—spiritual or sensual? But why go on with the endless questions that faced me! I didn't know at all what I wanted to do—and it took me three whole years to find out.

I did know, though, some of the things I did not want to do—and at the head of this list came equestrian statues; and this, too, in spite of a fleeting ambition while in Cincinnati to make this my life work. I think it was that winter in Washington, while I was doing two portrait medallions, when I realized that equestrian statues could come very near to ruining a beautiful city. It seems quite impossible to avoid running bang

into one of these monster-pieces everywhere you turn in Washington. Thank Heaven I resisted adding to the number! And I think I deserve credit for being brave enough to refuse to do a portrait statue at a time when I was sadly in need of a commission.

While in Washington a distinguished old senator asked me how I would like to do a portrait statue of Longfellow to be put up in the Capitol. Of course I thrilled at the idea of having a work of mine, an important work, in so conspicuous a place; then came a dampening of all enthusiasm as I thought of the hundreds of stuffy old bronze gentlemen in Prince Alberts and generals' uniforms already standing in every square of the city.

"It would be a crime to put up another portrait statue in Washington!" I exclaimed impulsively.

"What do you mean?" asked the senator. "We have the money and the site and it is now only a question of finding the sculptor."

I tried to explain my point of view. I asked the senator if he had ever seen the plan for the city which had been made over a century ago by a Frenchman, Major L'Enfant—a plan made at George Washington's special request. I grew enthusiastic over what our capital would be if that plan were finished with its suggested esplanades and magnificent vistas. I went further and said that the completing of that plan would furnish a chance to assemble all the bronze equestrian statues and place them on either side of the great avenue that would lead from the Capitol to the Monument, thus creating a historic pageant. I cited the circle of queens that surrounds the fountains in the Luxembourg gardens as an example. Then I ended by asking the senator if the committee wouldn't consider a fountain to Longfellow's memory, surrounded by flowers and plants and marble benches, a place where people might come at their leisure for a breathing spell, for a moment of rest—all this instead of a bronze figure that one person in a thousand might accidentally glance at, shudder and hurry away from as fast as possible.

"I'd love to do a memorial garden for Longfellow!" I ended with a glow of enthusiasm.

The senator looked at me through slightly offended and surely very critical eyes. "You've got entirely off the track, young lady! What we want is the statue of the MAN."

By this time I was getting tired of not having even my point of view admitted and became impatient.

"Well—I won't do it!" I burst out. "I won't add to this obsession of male egotism that is ruining every city in the United States with rows of hideous statues of men—men—men—each one uglier than the other—standing, sitting, riding horseback—every one of them pompously convinced that he is decorating the landscape!" Then, seeing a mild alarm in the old senator's eyes, I added more calmly: "Of course there are many good portrait statues. The point I am trying to make is that too much of anything is ruinous; and Washington already has too many portrait monuments."

The senator moved away to what he considered a safe distance, fully convinced by this time that he had encountered a particularly dangerous species of suffragette. Years later, when I was sitting beside him at dinner, he turned to me with a delightful twinkle in his eyes and said:

"If I'm not very much mistaken, you are the young lady who was once so violent about statues of men."

I nodded and met his smile. "I still am," I answered.

"I've never yet done a bronze figure of a man in a Prince Albert—and I hope to heaven I never will."

With this decision taken early in my career, I looked about and thought a great deal of what I should make my particular kind of sculpture. Of course, while doing this thinking and searching, I had to go ahead with the commissions I had brought away from New York with me; and for a long time my work consisted entirely of doing monuments for the dead. Sometimes I would become rather alarmed over this; it was so tremendously depressing; I hated the idea of devoting all my time to those who had passed away. But the experience left me with a very deep conviction that the dead are always with us. Surely they were continuously with me during those days; and in a most comforting way, too, for they kept me from worrying about expenses; without them, I might never have had those quiet years in which to find myself.

Florence and Donatello: "My work should please and amuse the world"

. . . Returning to the pension with the intention of spending the rest of the day in bed with a hot water bottle and frequent hot toddies, I happened to pass the Bargello and suddenly remembered I had not yet seen anything of Donatello's. Judging from the way I felt at that moment, I decided this would be my last chance to look at any sort of sculpture. I gathered together my rapidly failing forces, struggled up the famous staircase and at last reached the bas-reliefs of the singing boys. Suddenly I experienced a tremendous thrill. I forgot I was in a dying condition, I forgot I held the bottle of cognac in my hand, I forgot everything but the amazing realization that I had found the sort of sculpture that appealed to me in a way nothing else had ever done. But my exaltation was short-lived. It was completely dispelled by a furious guard who came up, spoke to me in a far from reassuring way and pointed accusingly at the broken bottle on the stone floor and the compromising streams of cognac which by this time were filling the whole room with strong fumes.

I always look back on that incident as being my first libation to Donatello and to the inspiration that later pointed out my way to me. And the second libation—if I had had any cognac left—would have been poured before Verrocchio's Boy and Fish which I discovered a day or two later in the Palazzo Vecchio. Somehow, the work of these two artists seemed to me to be exactly what I had been waiting for; they explained to me in a flash why I had so long felt a horror and aversion to bronze gentlemen in Prince Alberts.

I knew now what I wanted to do; and a visit the next week to the Naples Museum and to Pompeii settled the matter. The Pompeians understood perfectly the real personal use of sculpture. Their houses were built round a bronze statuette and the house was

given its name from the name of that statuette—the House of Narcissus, the House of the Faun, etc. I filled my brain and my sketch book to overflowing with all those gay pagan figures and then and there decided never to do stupid, solemn, self-righteous sculpture—even if I had to die in a poorhouse. My work should please and amuse the world. Banish the thought that I should ever try to teach any one anything! My work was going to decorate spots, make people feel cheerful and gay—nothing more!

Stanford White and the *Frog Fountain* (Fig. 10)

One day I sat down and wrote a letter to Stanford White. I told him I had had the pleasure of meeting him in MacMonnies' studio in Paris—that threadbare form of beginning such a letter; then I went on to say that I had come to New York to get something to do in the way of sculpture, that my studio was only a few blocks from his office and that I would appreciate it very much if he would come and see the things I had with me.

I didn't have to wait very long for his reply. As a matter of fact it came the very next day, a short and curt reply, in which he said that he was far too busy a man to go round visiting studios, that he was rushed to death, had a thousand calls in every direction and hadn't a free moment.

This indifference hurt me very deeply and then made me furious. I worked up a very strong case against Mr. White and wrote it out to him in a letter I sent off in reply to his. I told him I didn't think my request was nearly so extraordinary as he had found it; and that furthermore I did not think the most important architect in New York had the moral right to refuse to investigate the work of young sculptors about him—no matter how busy he might be. It was a relief when I finished this letter, read it over, sealed it and sent it off.

Of course I got no reply to it; I didn't expect one; and more than that I felt that I had definitely wiped out any further chances of ever interesting Stanford White in my work.

A month later I was trying to cross Forty-second Street at that congested hour between noon and one o'clock. Receiving a signal from the policeman to make a dash, I hurried out into the middle of the street and crashed straight into a very large man coming my way. After the first sensation of concussion had passed I looked up and found myself staring at a very red, vexed face that was in some way familiar to me. I continued to stare, trying all the time to recall who it was, and finally heard my name spoken.

"Oh—you are Miss Scudder!"

I nodded and suddenly remembered. "Yes—Mr. White," I answered a bit breathlessly.

At this point in the adventure that policeman called to us to move on and explained that the middle of Forty-second Street and Fifth Avenue had not yet been arranged for lengthy conversations. Stanford White smiled indulgently at the master of traffic and then turned back to me.

"I saw that little figure of yours the other day in the Emmetts' studio. What do you call it?"

"Frog Fountain," I murmured.

"I like it. How much do you want for it?"

Again the policeman interrupted, this time with raised club; but it would have taken the whole force and all the clubs in New York to make me budge at that moment; besides, I was talking to a man much bigger than the one who was trying to make us get out of the way.

"A thousand dollars," I answered with a calm that took so much nervous energy to produce that I was a wreck for days afterwards.

"All right," said Stanford White. "I'll take it. Send it to my office. Good-by."

He disappeared in the crowd and I barely escaped being crushed at that crucial moment of my career by a Fifth Avenue bus.

You may be sure I lost no time in getting my Frog Fountain out of the Emmetts' studio and into Mr. White's office. I even went to the extravagance of hiring a hansom cab—how I regret their disappearance!—and carried it there myself that same afternoon and waited an interminably long time for him to appear. In the end I had to leave without seeing him; but the next morning a check for one thousand dollars was in the post.

If I were making a diagram of my career with marks to indicate the most important points—milestones—I should certainly indicate in red letters the day on which Stanford White bought my Frog Fountain. In order to appreciate how important this was to a young sculptor you must know that at that time he was the one man every one was seeking, demanding, imploring to build not only magnificent edifices and churches and public buildings but elaborate country houses as well. He was being sought all over the United States by those who wanted to build something exceptionally beautiful and cared nothing for the expense involved. To have him buy my first really important piece of work meant much more to me than I even realized myself. It was months later that the effect of this purchase began to loom up as the dominating factor in my career.

It is really wonderful what a difference in one's outlook on the world a thousand dollars can make. With that check in hand I immediately gave up that horribly unsympathetic office-building-imitation-studio and moved into one I had been looking at with longing eyes for some time—the Gibson Studios on Thirty-third Street.

Activities for Women's Suffrage

During that visit to New York I had a little excursion into political life, due to the fact that Mrs. Norman Whitehouse asked me one night across her dinner table what I was doing for woman's rights.

"Well, Vera," I said, slightly embarrassed for an answer, "you know I am a sculptor and haven't much time to think about my own or any one else's rights."

Her scorn was scathing and after a fiery grilling from her I felt entirely crushed—

which was only the beginning of what she intended to do to me. The next morning she drove me down to Macdougal Alley to a meeting of the Art Committee Section of the "Woman's Rights Organization" and stood over me while I was made a member and given certain duties to perform. After this her interest never flagged. If she saw signs of slackness or lessening of attention, she immediately carried me off to luncheon or dinner and began hammering at me again. Through her influence I became a fairly active suffragette. During one of the great parades given at that time, I had charge of the art group, which of course interested me particularly, in spite of the fact that walking up Fifth Avenue in white clothes on a bitterly cold day was calculated to lessen any one's belief in any sort of rights—except those of a warm and snug hearth.

16

Cecilia Beaux (1855–1942)

The third Philadelphian among the artists in this book is Cecilia Beaux, who like Anna Lea Merritt came from a Quaker family. By the 1890s she with John Singer Sargent, one of the most prominent and well-respected American portrait painters. In 1974 Beaux was honored with a major retrospective exhibition at the Pennsylvania Academy, the site of her first success. She developed an individual style based on a synthesis of American realistic trends and European influences.

Published late in her life, in 1930, *Background with Figures* is a true autobiography, written contemporaneously with Lea Merritt's and Scudder's. Like those other texts, Beaux's is organized in a strictly chronological manner with a smoothly flowing narrative. Uninterrupted by letters or journal entries, this volume is a detailed reminiscence of the artist's life, with emphasis on the key elements that affected her professional career. References to a personal, emotional existence, however, are rigorously censored.

Beaux was raised in a predominantly female household by her grandmother and two unmarried aunts, none of whom had any special sensitivity or inclination toward the visual arts. Her talent for drawing was identified when she was enrolled in Miss Lyman's private school for upper-middle-class girls, where drawing was offered as a regular component of a "proper" female education. Her talents were encouraged, and she studied briefly with Catherine Drinker (1841–1922), a family relation who was the first woman lecturer at the Pennsylvania Academy. Although that institution was admitting women to some of its classes, Beaux attended a private school under the direction of a Dutch artist named Van der Whelen.

Unlike Cassatt, Beaux studied privately. Additional training was provided by William Sartain, Emily's brother. In the first segment Beaux coyly describes her memories of these years. She characterizes the attitude of her influential uncle toward the Pennsylvania Academy as, "Why should I be thrown into a rabble of untidy and indiscriminate art students and no one knew what influence?"

Out of this rather irregular and spotty professional training, Beaux created her first major painting, *Les derniers jours d'enfance* (Fig. 11). Influenced by Whistler's famous portrait of his mother, it was very well received at the Pennsylvania Academy, winning

Figure 11. Cecilia Beaux, *Les Dernier Jours d'Enfance*. Oil on canvas. Courtesy of the Pennsylvania Academy of the Fine Arts, Philadelphia. Anonymous partial gift.

the Mary Smith Award. The work was prominently displayed at the Paris Salon of 1887. Like *The Roll Call* for Elizabeth Thompson Butler, this painting was a turning point for Beaux's career, and her account of its creation is of special interest.

Beaux's experiences in Paris, like those of Jopling, Alcott, and Cassatt, were of special importance to her. The next excerpt concerns her second sojourn in Paris, when she studied mainly at the Atelier Julian. From the rather removed perspective of her later years, her insights into the value of being a student are fascinating.

In the 1890s, sufficiently established as a mature artist and now well into her thirties, Beaux opened a studio in New York. Here she produced many of her finest portraits over the next decade. She remained informed concerning contemporary trends in Europe. In 1896, accompanied by the painter Lilla Cabot Perry (1848–1933), she visited Monet, the subject of the next segment. Although Beaux's style was always more indebted to Whistler and Sargent than to Impressionism, her respect for Monet's rejection of ''Pointillism'' as well as her critique of his Impressionism come through clearly.

Between 1895 and 1915 Beaux was an instructor at the Pennsylvania Academy. After World War I Beaux's stature as a portrait painter remained high, and she executed a series of works for the United States Portraits Commission, including a portrait of Georges Clemenceau.

Beaux's painting career ended in 1924 when she broke her hip. A few years later she published *Background with Figures.* She lived out her remaining years at her home in Gloucester, outside Boston.

Studying with Mr. Sartain

Long before this, I would have turned toward the classrooms of the P.A.F.A., but my uncle, to whom I owed everything that my grandmother had not done for me, was steadfastly opposed to this. There was no reason to suppose that my trend was to be serious or lasting. Certainly I had done well and was a good copyist. I was a seemly girl and would probably marry. Why should I be thrown into a rabble of untidy and indiscriminate art students and no one knew what influence? So reasoned his chivalrous and also Quaker soul, which revolted against the life-class and everything pertaining to it. He put a strong and quiet arm between me and what he judged to be a more than doubtful adventure, and before long an opportunity came of which he entirely approved.

I had one acquaintance—a schoolmate, indeed, at Miss Lyman's—who, after a year or two of social gaiety as a débutante, began seriously to turn toward painting. She organized a class and took a studio. She had none of my limitations in the way of "ways and means." She asked me to join the class. We were to work from a model three mornings in the week, and Mr. Sartain had consented to come over from New York once every fortnight to criticise us. My uncle entered at once into this arrangement, and with his usual generosity paid my share in the cost.

Across all the intervening years it now seems that the record of this adventure, for so it now appears to me, should be written with a pen of fire. Time and experience have given it a poignancy, a significance, only dimly felt at the moment.

There were a few, only, in the class, all young, but all respectful toward what we were undertaking. It was my first conscious contact with the high and ancient demands of Art. No kind of Art, music or other, had ever been shown to me as a toy or plaything to be taken up, trifled with, and perhaps abandoned. I already possessed the materials for oil painting, and had used them quite a little, but without advice.

But the unbroken morning hours, the companionship, and, of course above all, the model, static, silent, separated, so that the lighting and values could be seen and compared in their beautiful sequence and order, all this was the farther side of a very sharp corner I had turned, into a new world which was to be continuously mine.

Les Derniers Jours d'Enfance (Fig. 11)

The seasons of the class were short, the criticisms infrequent, though to one view, at least, sufficient. For two years they continued, and it then became inconvenient for Mr.

Sartain to come to us regularly from New York. By that time, as I had been doing some portraits on the side, I was able to take a studio and the class painted there, with a model on certain days, without instruction. At this time I did a study of a friend which resulted in my making my first entrance into the doubtful field of the Exhibitions. It was well hung at the Pennsylvania Academy and was considerably noticed.

Finding myself in a large barren studio, for I soon wished to have the whole place to myself, I began to think of a picture. . . .

The picture I saw to do was a large picture, and I saw it complete in composition, the figures, lighting, and accessories. I took an old piece of sketching-board and did the composition small, but containing all the important masses, lines, and color. The subject was to be my sister, seated, full-length, with her first-born son in her lap. The picture was to be "landscape" in form, and the figures were to be seen as if one stood over them. The mother in black sat in a low chair, the brown-eyed boy of three almost reclining in her arms. He was to wear a short blue-and-white cotton garment, his bare legs trailing over his mother's knees. Her head was bent over him, and his hands lay upon her very white ones, which were clasped around him.

The whole picture was to be warm in tone and in an interior which did not exist, except in the mind of the designer.

Strangely enough, the presiding *dæmon* spoke French in whispering the name of the proposed work. "Les derniers jours d'enfance." And this title never seemed translatable or to be spoken in English.

The family allowed me to have one of the best of our rugs for the floor, and my sister lent me one of the Drinker heirlooms, a small and charming table, which was to stand near her with a few objects to be chosen later. It took some time to place the figures in precisely the right position on the canvas and to find precisely the right size and proportion for it.

The "less than life" conception of the figures, as they sat, back in the picture, with no absolute foreground to "place" them, would have usually required more experience than I possessed. But I had never heard of discouragement. Even after the picture was started, I changed the canvas and stretcher twice, and of course leaned heavily upon the original sketch, which contained every essential mass.

In the background, I followed the tones the sketch suggested. I felt the need of a strong horizontal mass across the canvas behind the group, and lower in value than the section above it, against which my sister's head and a little of the chair were to show.

I found a piece of panelling in a carpenter's shop—only a small piece, but I dyed it to look like mahogany, and it posed, by moving on, for a low wainscotting, uniting floor and wall. The labor, the difficulties, I remember perhaps as little as a mother does her hours of travail. My sister bore her part with her usual gallantry. The boy was extremely amused by the novelty of the scene in which he found himself. His mother's lap was comfortable, his head leaned upon her breast and her voice was close to his ear, and in the rests he enjoyed running out into the hall with me to get a distant view of the canvas through the open door.

To me, nearly the highest point of interest lay in the group of four hands which

occupied the very centre of the composition, the boy's fingers showing a little dark upon the back of the mother's white hand. The arm and back of the steamer chair I had to ignore and forget, as nothing was to be found that in the main would 'fit,' and I was obliged to invent a chair "to taste.". . .

It was first seen at the Pennsylvania Academy, where it had the luck to capture one of the corner panels in the big room, the North Gallery. I do not remember its going elsewhere at that time, but oddly enough it got to France before its author did.

After some time had elapsed, it was seen by one of my girl friends, Margaret Lesley, who had been a student in France. She was bent on returning, and was filled with determination to take the picture back with her to Paris. She would take it herself, generous soul, and send it to the Salon.

"The Salon!" I screamed. What insanity it was! But she persisted. After all, the issue was not serious. She would take it by hand, rolled up, in her stateroom. I gave in, of course, but without hope.

Her letter brought me the news of her stretching it and carrying it on top of a cab to the studio of Jean Paul Laurens, to get his criticism and advice as to entering it for the Spring Salon. Alas, I have no record of the words of the actual interview, but the great man strongly favored her sending it, so she got an impromptu frame and offered it to Fate.

It had no allies; I was no one's pupil, or protégée; it was the work of an unheard-of American. It was accepted, and well hung on a centre wall. No flattering press notices were sent me, and I have no recorded news of it. After months it came back to me, bearing the French labels and number, in the French manner, so fraught with emotion to many hearts. I sat endlessly before it, longing for some revelation of the scenes through which it had passed; the drive under the sky of Paris, the studio of the great French artist, where his eye had actually rested on it, and observed it. The handling by employés; their French voices and speech; the *propos* of those who decided its placing; the Gallery, the French crowd, which later I was to know so well; but there were not many Americans in France then, and we were not setting the idol of our wealth before them, for worship.

But there was no voice, no imprint. The prodigal would never reveal the fiercely longed-for mysteries. Perhaps it was better so, and it is probable that before the canvas, dumb as a granite door, was formed the purpose to go myself as soon as possible.

1889: The Atelier Julian

My persistence at the Julien Cours during my second winter in Paris was owing to its general, non-specific nature. I might have delivered myself, of course, to an individual master. There were several of high repute who admitted disciples. By an instinct I could not resist, I shrank from the committal, although there would have been contacts resulting from it of high value and interest. I saw no special direction in any exhibited work (I fear to say it), among the living, that I felt like joining. At Julien's one had not to

think of adherence, and I held in abhorrence the habit of floating about from one *atelier* to another, by which procedure many had the hope of stumbling upon the precious "key."

The criticism, as such, was small, and, as in the rue de Berri, there was no theory. What came to me from overhearing did not apply to me, and what I got was chiefly encouragement to keep on as I was going. I am not sure that there is not a good deal to be said for silent treatment in Art. All special direction and theory are liable—almost certain—to be in error, sooner or later. In Art as in Religion, Faith is necessary—indispensable, in fact. What the student above all needs is to have his resources increased by the presence of a master whom he believes in, not perhaps as a prophet or adopted divinity, but one who is in unison with a living world, of various views, all of whose roots are deep, tried, and nourished by the truth, or rather the truths that Nature will reveal to the seeker. He is the present embodiment of performance in art, better called the one sent, representing all. He is serious, quiet, a personality that has striven. Nothing breaks the sobriety of his visit. There is never the least social or offhand intercourse. His thoughtful consideration of your drawing will be impartial. He will do you justice and will be gracious toward your earnestness, but it will be a simple matter for him to probe your weakness. He is a Parisian, though probably of provincial origin. He is one of the esteemed of his day and generation in the world of French Art. How much he has seen! How great is his experience! How great his reverence! If his interest is slight, you suffer. If he seems to recognize in you some evidence of power to come, you will feel it in his few concise words as he passes on. Courage and persistence to perceive the truth flame up and stronger, quicker pulses feed subconscious force.

The men who criticised at Julien's were not great, but they had beliefs. Their work was personal and unmistakable, but they laid down no laws of their own invention. Never did the least sign of a desire to teach their personal view impinge upon their delivery of the "message" to students. The great effect of this large general method, if method it was, was in the faith one had in it, or it might be said in the High Priest who served it. I venerated his consecration, his office, and this veneration opened the breach toward those, however small, creeping conquests I might achieve, in power to express the truth which renewed vision could directly pursue. The "message" was the incoming tide upon which any species of seaworthy craft could be lifted over the bar.

Fortunate is the pupil whose master brings with him far more than he personally contains or is aware of, as something communicated. A student's first conceptions of Art should not be delivered to him in small packages. He should find in his masters more than is given to him. Or, let him feel only a sense of his relation to Art, to the Subject, his preceptors only liberating him upon the road, warming his desire toward what he is attempting to do, not showing him the overmuch and the myriad possibilities of it, but the simplest solution. He must find out the secrets for himself later, if ever.

The immense value to the student, in Paris, lies in the place itself. He cannot step out of the *cours* without having his crass judgments in regard to art developed, adjusted, poised. Everything is there. It is his own fault if he does not perceive. The rapid, constant invention of the World Magician is always going on; she eventually casts away many

of her experiments, and is perfectly aware that she *may* do so even when in the very heat of creation. But she is loyal; she preserves; she has thousands of pigeon-holes where are kept fragments of changes and novelties, never despised by *l'histoire de l'art français,* and of the rest of the world. She will show you, if you take the trouble to look, the long series in which your decade will take part, a brick of more or less value, as will be proved by time. The student may get, once for all, in Paris, an inescapable sense of relation, not to be found elsewhere, and Idealism has never been less sentimental, except perhaps in Greece.

1896: A Visit with Monet at Giverny

I did not linger long on this visit. It was midsummer, the least characteristic period of the year in Paris. But before I left, one, to me, highly memorable event had occurred. Mrs. Tom Perry (Lilla Cabot Perry) was painting at Giverney, to be near Monet, and would take me to see him. No sun and weather could have been more fortunate for a visit to the specialist in light than we were blessed with. We found him in the very centre of "a Monet," indeed: that is, in his garden at high noon, under a blazing sky, among his poppies and delphiniums. He was in every way part of the picture, or the beginning and end of it, in his striped blue overalls, buttoned at wrists and ankles, big hat casting luminous shadow over his eyes, but "finding," in full volume, the strong nose and great grey beard. Geniality, welcome, health, and power radiated from his whole person. There was a sleepy river, lost in summer haze not far away. The studio, which was a barn opening on the garden, we were invited to enter, and found the large space filled with stacked canvases, many with only their backs visible. Monet pulled out his latest series, views, at differing hours and weather, of the river, announcing the full significance of summer, sun, heat, and quiet on the reedy shore. The pictures were flowing in treatment, pointillism was in abeyance, at least for these subjects. Mrs. Perry did not fear to question the change of surface, which was also a change of *donné.* "Oh," said the *Maître,* nonchalantly, "la Nature n'a pas de pointes." This at a moment when the *haute nouveauté* seekers of that summer had just learned "how to do it," and were covering all their canvases with small lumps of white paint touched with blue, yellow, and pink. But they had not reckoned on the non-static quality of a discoverer's mind, which, in his desire for more light, would be always moving. For Monet was never satisfied. Even the science of Clemenceau, and his zeal for his friend, did not get to the bottom of the difficulty, which was purely physical. One could push the sorry pigment far, but not where Monet's dream would have it go, imagining that by sheer force of desire and *volonté,* the *nature* of the *material* he thought to dominate would be overcome. For the moment, when actual light gleamed upon it, fresh from the tube, it had the desired effulgence, but it could not withstand time and exposure, and maintain the integral urge of Monet's idea.

GERMANY

Germany in the nineteenth century presents some unique circumstances as compared with America, France, or England. Distinctions concerning feminist movements, attitudes toward women artists, and self-writing need to be viewed with national specificity. Both before and after unification in 1871, Germany was strongly authoritarian politically, and patriarchal in its cultural attitudes toward women. Jean Quataert has summarized the position of German women in the following way:

One feature most clearly dominated the social world of German women: dependency. The reality of dependency rested on assumptions about women's social inferiority and served to reinforce low concepts of self-worth. . . . [Women] had to prove their worth, their brain size, their capabilities, talents, and contributions to the national community. . . . Not socialization but biology determined women's roles.[1]

Historians have documented the history of two independent women's movements from the mid-nineteenth century up to World War I.[2] The bourgeois women's movement was intertwined both historically and ideologically with the political movement of Liberalism. The socialist women's movement was associated with the political party of the Social Democrats.

In Germany, middle-class women first began to organize into groups to champion their own interests in the 1860s. They were especially concerned with better educational and employment opportunities. The National German Women's Association was founded in 1865. Amy Hackett builds a convincing case for the acceptance of traditional concepts of "femininity" in the behavior and history of bourgeois German feminism, observing that "[The leaders of the movement] wished to maintain, even to cultivate and exalt, traditional 'feminine' qualities—especially women's maternal, nurturing 'instincts'—as unique and valuable additions to culture."[3] Such attitudes are consistent with the feminism of Käthe Kollwitz and Paula Modersohn-Becker, as we shall see.

Unlike American feminists, German feminists were reluctant to assert their "rights" and subordinated their own political priorities to those of the Liberal party. Since most male Liberals were opposed to women's suffrage, German women, practicing the feminine virtue of "self-sacrifice," thus compromised their own interests.

In fact, German women were only enfranchised by the socialist revolutionary government in the immediate aftermath of World War I, not through the political efforts of the bourgeois feminists. Richard Evans connects the "failures" of German bourgeois feminism to the politically repressive society of Wilhelmine Germany, dominated by the ideology of the army and the feudal aristocracy. Women's attempts to organize for any form of equality or suffrage were strongly hampered by the fact that before 1908 it was illegal for women to engage publicly in any form of political activity in Prussia and most other regions of Germany. Evans characterizes the suffrage movement in Germany as gripped by tactical paralysis and internal dissension.

Education for girls was inferior to that available to young men of a similar class background. One historian has characterized educational opportunities for middle-class girls in the following way:

The education they received was unmethodical, often of poor quality and not especially broad. The main emphasis was always literature, religion, foreign languages and history. Science, mathematics, and ancient languages, the core of higher education for boys in the nineteenth century, were never included.[4]

Most women employed outside the home were teachers. In 1878 there were about 1,500 women teachers in Prussian elementary schools; by 1900 that number had increased to 22,000. It is not surprising that Paula Becker was sent to the seminary for women teachers to obtain her credentials in her hometown of Bremen before being permitted to study art. Women also managed to break into the field of medicine. By 1900 there were increasing numbers of women employed in sales and clerical positions, social work, and postal and railway administration.[5]

Women wishing to pursue a career in the visual arts could attend applied- and decorative-arts schools in Germany. But the official government schools for "fine arts" were closed to them. In response, the Verein der Künstlerinnen, the official women's art organization, ran independent schools in Berlin, Munich, and Karlsruhe, organized around a traditional academic curriculum.

This reflected the broader educational climate of Germany, since all German schools were sexually segregated. This situation differed from that of the women's art organizations of England and France, which sought to integrate women students into the male educational establishments, the Royal Academy in England or the Ecole des Beaux-Arts in France.

The Berlin school was opened sometime before 1885, when Käthe Kollwitz was enrolled. According to Diane Radycki, this school cost six times the tuition of the Prussian Royal Academy and offered a shorter, less rigorous course of study.[6]

If the goal was to prepare women artists for the Prussian Academy of Art, the

difficulties of achieving full status were virtually insurmountable. The Prussian Academy conveyed only "honorary"—not regular—membership to women artists, the same category of membership available to males who were not artists but helped promote the arts in some manner. It was only in 1919, after the collapse of the Wilhelmine government, that Kollwitz became the first woman member of the Prussian Academy of Fine Arts. She held the directorship of the Graphic Arts department from 1928 until her resignation under Nazi pressure in 1933.

By the time Becker arrived at the Berlin school of the Verein der Künstlerinnen in 1896, there were separate departments of drawing, painting, and graphics. Four of the six male teachers were affiliated with the Prussian Academy. A few women also taught there. Käthe Kollwitz joined the faculty and taught figure drawing and graphics from 1897 to 1902.

As Radycki notes, when Becker studied at the St. John's Wood School in London, a private drawing school but one with the best reputation of preparing students for the Royal Academy, she was in a serious, coeducational environment aimed at conferring professional status and expertise. This situation contrasted markedly with the Berlin school of the Verein der Künstlerinnen. In fact, it was only when Becker left school and began living and working in the artist's colony of Worpswede under Fritz Mackensen's supervision that her talents and personal style first emerged. And it was not until she arrived in Paris after 1900 and studied the works of Cézanne, Gauguin, and Van Gogh that her mature individual painting style developed. Becker studied at the Ateliers Julian and Colarossi and even took advantage of the anatomy course recently opened to women at the Ecole des Beaux-Arts.

Women formed a significant proportion of writers in Germany in the nineteenth century. About 4,000 women writers are documented, constituting between one-fourth and one-third of the total number of writers in this period.[7] As in America, these writers were identified mainly with the literary form of the novel. Patricia Herminghouse says that this group of mostly middle- and upper-class women wrote for money, although they were not necessarily self-supporting. Writing was a sort of "cottage industry," an activity that, like painting, was appropriate for women of this class, since it could be done in the home.

Autobiography as a literary form in nineteenth-century Germany remained firmly identified with middle-class men.[8] Only about 500 women, as opposed to thousands of men, published autobiographies in the nineteenth century.

Given this much more limited context of autobiographical writing by women in Germany, as compared with Victorian England, it is not surprising that the two artists whose works are excerpted here confined their literary activities to the strictly private realms of letter and journal.

One reason for a self-imposed restriction to private letter-writing was expressed by Rahel Levin (Varnhagen) in a diary entry from 1826:

It seems to me to be in the nature of this reprehensible flattery when a woman writes for publication—that is, intends to write down something consciously thought out—that she always

places herself in a position of subordination to one or several men and disfigures herself at the same time.[9]

The widespread use of pseudonyms by German women in the eighteenth and nineteenth centuries was another means to overcome the contradications between self-protection and self-expression.[10]

Gudrun Wedel notes that literary criticism of women's writing during this period seemed to focus on the "unimportant and redundant details . . . being characteristics specifically tied to the woman's sphere. And this contempt for the woman's world is typical of prevailing contemporary opinion. It is thus not surprising that women find it difficult to report on their own lives, especially when extraordinary events are missing."[11]

Most women authors came from the middle class, and the next largest group from the aristocratic class. Over 75 percent of these authors had a job in what Wedel characterizes as "feminine" professions: as teachers, social workers, writers, or artists. By the end of the nineteenth century, appropriate professional activity, especially if it could be done in the home, was now acceptable for women. Marriage and motherhood were no longer perceived to be the sole focus of middle-class women's existence.

It is predictable that the important art of Kollwitz and Modersohn-Becker developed historically later than the English and American artists in this section. The weak, divided feminist movement and extremely conservative patriarchal cultural climate in Germany delayed the emergence of major women artists until the very end of the nineteenth century.

Paula Modersohn-Becker (1876–1907)

Like May Alcott, Paula Modersohn-Becker's life was tragically cut short by complications following the birth of a child. Unlike Alcott, however, this artist had already developed by the early age of 31 a historically significant body of paintings that reveals a personal and unique synthesis of Worpswede naturalism and the French Post-Impressionist influences of Van Gogh, Cézanne, and Gauguin. Recognized as one of the most important German artists of her generation, the works of Modersohn-Becker have been extensively studied and documented by scholars. Over a period of about ten years, she created 560 paintings (many are oil sketches), more than 700 drawings, and 13 etchings, which found no commercial audience during her lifetime.

This extensive oeuvre is matched by a voluminous literary output which has also survived. Modersohn-Becker was an active correspondent to friends and family, stimulated, naturally, by geographical separations. She also maintained a private journal. Like Marie Bashkirtseff, she first achieved fame through her writings. The first edition of her selected letters and journals was published in German in 1917. This volume was revised in 1920 and went through many reprintings before World War II. In 1979 the complete edition of her writings, containing every surviving word written by the artist, was published.[1] Over 400 pages of letters and journal entries provide us with detailed literary documentation of the life of this sensitive, talented, and fascinating artist.

Becker was born into an upper-middle-class home in Dresden. Like so many other women artists, her family was a nurturing one, if not specifically inclined toward the visual arts. Her first regular art instruction took place in England, where she had been sent in 1892 to stay with relatives and acquire some "womanly" skills appropriate for girls of her class. Her father insisted that she acquire a teaching degree so that she could maintain financial independence if necessary, so from 1893 to 1895 she was enrolled at the Bremen seminary for women teachers. Only after that objective had been achieved was she permitted to enroll in the drawing and painting school run by the Verein der Künstlerinnen, offering the best artistic training available to German women in this era. Given these delays in the course of her art instruction, one can appreciate the euphoria evident in the first letter reprinted here, addressed to her father. Both her appreciation for his support and her joy at this opportunity to study art are vividly communicated.

During the summer of 1897, Paula Becker discovered the artist's colony of Worpswede. She returned there for an extended stay in 1898–99, studying informally with Fritz Mackensen. There she met the sculptor Clara Westhoff, who would become her closest friend, and the painter Otto Modersohn, her future husband. The series of journal entries from this period reprinted here refer to Mackensen, the subjects selected for her art, and her impressions of Marie Bashkirtseff's journal.

On New Year's Eve of 1900, Becker left Worpswede for Paris, and her life thereafter was significantly altered. Before her death seven years later, she would make four visits to Paris, the last stretching from February 1906 to April 1907. The next letter was written to the Modersohns after about two weeks in Paris, describing her first impressions of the city and its art collections. A letter written the next day to her father has a predictably different tone and quality, but reveals her inner determination to pursue her goals. The next journal entry, from Worpswede after her return from Paris, contains her poignant premonition of her premature death.

In a letter to Westhoff, now married to the poet Rainer Maria Rilke, she discusses her current ideas about her art. This letter was written about two weeks before her marriage to Otto Modersohn, who had been widowed in 1900.

The next two journal entries and the following letter to her husband were written during her second stay in Paris in early 1903. These texts reveal her growing artistic security and her responses to the art available in France. Her visit to Rodin's studio is described, as is her awareness of the irony of Rilke's identification of her as "the wife of a very distinguished painter."

Her third trip to Paris, in 1905, lasted about three months. In February of 1906, she left her husband, his daughter Elspeth, and her old life, for Paris. The next sequence of letters to Otto documents her estrangement from him and her growing ambivalence about her marriage.

By May her work was going well and she was painting constantly. Her *Self-Portrait with Amber Necklace* (Fig. 12) was created during this prolonged stay in Paris. It is a fascinating work, both formally and iconographically. The painting clearly reveals the impact of contemporary avant-garde French painting. The densely painted surface and saturated colors are indebted to Van Gogh, while the smoothly flowing synthetic contours and frontal nudity relate the work to Gauguin's Tahitian imagery, exhibited at the Salon d'Automne, 1906. The generalized form and darkened contours also show her knowledge of Cézanne's late bather paintings, although Modersohn-Becker was back in Worpswede by the time of the major retrospective of Cézanne's works at the Salon d'Automne in 1907, mentioned in the last letter to Clara Rilke-Westhoff. As in Artemisia Gentileschi's *Self-Portrait as La Pittura,* the artist here compresses two traditions: the active male realm of artistic creation with the female world of the instinctual, the natural, the fertile and vegetal. She is both passive receptacle of nature's processes and active formulator of her own self-image. Remarkably, she is both present, in the features of her face and her treasured amber necklace, and distanced from her own image, in the simplified forms and generalized features of the abstracted nude body.

This was one of hundreds of works labeled as "degenerate" by the Nazis and

Figure 12. Paula Modersohn-Becker, *Self Portrait* (1906). 61 × 50 cm. Oeffentliche Kunst-sammlung Basel, Kunstmuseum.

confiscated in 1937. It was shipped to Switzerland and auctioned in 1939; it survived the war there and today hangs in the Basel Kunstmuseum.

Otto joined Paula in Paris, and by November 1906, as documented in her letters to Clara Rilke-Westhoff and her sister, they had reconciled. They remained together in Paris until their return to Worpswede in March 1907. In the last letter reprinted, written a few weeks before the birth of her daughter on November 2, she is thinking about Cézanne. On November 20, she died from an embolism at the age of 31.

To Her Father, ca. February 27, 1897:
"That I am able to live totally in my art!"

Dear Father, after a morning of hard work it is such a pleasure to sit down and thank you for that beautiful box of pastels. I keep looking at the rows of magnificent crayons and can hardly wait to begin using them.

My model right now is a little Hungarian boy, a mousetrapper, who cannot under-

stand a single word of German, so that it is impossible to scold him when he comes every morning half an hour late. But it is such fun drawing him.

Last Thursday after class I went to see the Kupferstichkabinett [Print Room] for the first time. I had stood at the glass entrance several times before, but the solemn gloom behind it always frightened me away. Yesterday I took heart and went in, feeling like an intruder in the sanctum sanctorum. An attendant came up to me and silently handed me a slip of paper on which I had to write down what I wanted to look at; "Michelangelo, drawings by". . . . He brought me a gigantic folio. I could hardly wait to look inside. At the same time, being the only woman in the midst of this overpowering masculinity, I would have given anything to make myself invisible. But as soon as I opened the folio and could study Michelangelo's powerful draftsmanship, I could forget the whole rest of the world. What limbs that man could draw!

We had the most amazing model that evening in life-drawing class. At first, the way he stood there, I was shocked at how ugly and thin he seemed. But as soon as he began to pose and when he tensed all his muscles so that they rippled down his back, I became very excited. How strange and wonderful, my dears, that I can react this way! That I am able to live totally in my art! It is so wonderful. Now if I can only turn this into something good. But I won't even think about that now—it just makes me uneasy.

Let me tell you something funny that happened to me. Do you remember, Mother, the drawing of the nude woman with the beautiful black hair which you took back to Bremen? Well, I drew her [again] in Fräulein Bauck's[2] class. She was wearing a black dress with a white collar, and so was I; only the style of her dress was a good deal more chic. And she stuck out a beautifully shod foot so smartly that I felt obliged to modestly hide my rather clumsy feet. And later when this young lady with her gentle dove's eyes appeared for a second time, it turned out that in place of her black mane her hair was now a beautiful chestnut brown. She told us some sort of story about washing her hair and having gotten hold of the wrong bottle. But I thought to myself quietly, Oh, yes, c'est la vie!

Journal, October 29, 1898: A Worpswede Mother

Mackensen was at the Rembrandt exhibition in Amsterdam. He is filled with a holy ardor for "this giant, this Rembrandt." He loves what is healthy, the old Germanic strain, with all his body and soul.

He saw the sea for the first time in his life. He and some others saw a horseback rider in the distance who rode up to them, stopped, dismounted, and adjusted something on his saddle. And they asked him, "Where is the sea?" And he raised his hand and said, "You can hear it roaring."

He saw a man sitting in the evening twilight, sitting on white birch chips and carving little white wooden shoes. He said that if someone could paint that, he would be greater than all the others.

He is often hard and egotistical. But confronted with nature, he is like a child,

soft as a child. At such times he is touching to me. He seems like an old proud warrior on bended knee before the Almighty.

I sketched a young mother with her child at her breast, sitting in a smoky hut. If only I could someday paint what I felt then! A sweet woman, an image of charity. She was nursing her big, year-old bambino, when with defiant eyes her four-year-old daughter snatched for her breast until she was given it. And the woman gave her life and her youth and her power to the child in utter simplicity, unaware that she was a heroine.

Mackensen saw a man chopping down a birch tree that was golden with autumn. And he walked closer. The man shouted, "Watch out!" And the tree fell. All the gold lay there at his feet. It was beautiful.

Journal, Early November, 1898

I have drawn my young mother again. This time outside in the open. She is a joy no matter how she poses. I should like to paint a hundred pictures of her. If only I could! This time her brown hair stands out against a red-brick wall. Later I must paint her once with the white clay hut as a background, the one built by old Renken himself. She will stand out dark and warm against it. And then once with the dark pines as a background. Oh!

Journal, November 11, 1898: The Diary of Marie Bashkirtseff

I'm drawing nudes in the evening now, life-size, beginning with little Meta Fijol and her pious Saint Cecilia face. When I told her that she should take all her clothes off, this spirited little person said, "Oh, no, I ain't doin' none of that." So at first she got only half undressed. But yesterday I bribed her with a mark and she complied. I blushed inside, hating the seducer in me. She is a small, crooked-legged creature. But I'm still happy to have a chance to study the human figure at my leisure again.

I am now reading the diary of Marie Bashkirtsev. It is very interesting. I am completely carried away when I read it. Such an incredible observer of her own life. And me? I have squandered my first twenty years. Or is it possible that they form the quiet foundation on which my next twenty years are to be built?

To Otto and Helene Modersohn, January 17, 1900: "The Louvre has me in its clutches"

Whenever I have felt most helpless here in Paris, I always let my thoughts wander back to Worpswede. That is always a splendid remedy. It disperses the chaos in me and brings a kind of gentle repose. Of course, Paris is wonderful, but one needs nerves, nerves, and more nerves—strong, fresh, and receptive nerves. To keep them under control in the face of these overpowering impressions here is not easy. That's why the people here are

mostly so blasé, or at least look as if they are. For the moment they can be witty or lively, but that simple, deep, and great feeling that we have, that's something that they know little about. I have noticed that in their art, too. There they have no trouble producing fireworks, and have more esprit than they know what to do with and that tingling in their fingertips; but what they don't have is simplicity and depth. I don't think Paris allows one to really get to the very bottom of feelings. It is always offering new and beautiful things with full hands. Or am I to blame? I wonder if I am too slow and awkward in working out my separate impressions? I still don't know the answer myself. You probably think that I don't like it here? On the contrary, if Mammon has nothing against it, then I plan to stay here until long after spring, for it seems to me that one can learn wherever one goes and whatever one does here. The Louvre! The Louvre has me in its clutches. Every time I'm there rich blessings rain down upon me. I am coming to understand Titian more and more and learning to love him. And then there is Boticelli's sweet Madonna, with red roses behind her, standing against a blue-green sky. And Fiesole with his poignant little biblical stories, so simply told, often so glorious in their colors. I feel so well in this society of saints—and then the Corots, Rousseaus, Millets that you told me about. There are wonderful pictures by Millet to be seen now at the art dealers'. The most beautiful one to me was of a man in a field who is putting on his jacket, painted against a brilliant evening sky. Well—and the Luxembourg—and then the air here! I have so often wished that you were here, Herr Modersohn, and really felt it to be an injustice for me to be seeing all of this, and not you. The air, when one walks across the bridges over the Seine! There seems to be a shimmering and mixing of subtle gray, yellow, and silver tones which completely shroud the branches of the trees. And the beautiful buildings are set off with a wonderful depth against this atmosphere. The gardens of the Luxembourg at twilight—oh, just twilight here! Once I was in Joinville on the outskirts of the city. The Marne flows nearby. It was a dreary day. The air grayish yellow, the water even more so, gloomy meadows and tall leafless poplars. The scene had a special charm about it—

And the street life! Every moment there is something new to see. Over there a fellow sits down on the ground and writes something in chalk on the pavement. Soon a crowd has gathered around him and he begins to pull their leg in a friendly way. Another time an acrobat performs his feats on the open street. And then almost every laborer digs into his pocket and throws him a sou. In the *crémerie* where I was eating today with all kinds of happy, friendly riffraff, an old man was singing *chansons* and accompanying himself on the guitar to the great delight of his audience who would join him in the refrain with laughing voices. Mornings I go to an academy (Cola Rossi). I have had some very fine critiques there, especially by Courtois, who has a fine feeling for *valeurs*. Collin, who does the more practical criticism at the start of each week, is more concerned with accuracy—

For two weeks I put up with the dirty housekeeping in a dirty atelier. But since last Sunday I have been living in a dollhouse atelier with my own furniture, i.e., one bench, one table, one chair. Everything else is made of boxes covered with cretonne. It must be grand to have money and to be able to furnish one's home here. There are so

many fine secondhand shops here, and thousands of fine things. Often I get into a rage and then I go into the shops and ask what the things cost. After I've taken a good look around then I calm down and saunter away—

There are as many painters here as there are grains of sand on the beach. And among them one sees some fairly eccentric phenomena. When one is in a good mood, one can be amused by it all. But when one feels weak, one is easily overcome by the creeping malaise. "All humanity's misery lays hold of me." One sees so frightfully much misery here, much that is corrupt and degenerate. I do think that we Germans are better people.

And with this thought I close. Do excuse me if I run on so frightfully like this to you. You already are familiar with this weakness of mine. If you have the time it would make me *extremely* happy to receive a few lines from you. And so good-bye until spring, or fall or next spring.

Your Paula Becker

Clara Westhoff lives in the same house with me; she is doing over-lifesize sculpture here in Paris and sends her best regards.
If you have any plans at all to write to me sometime, then please do it on February 8. That, you see, is my birthday.

To Her Father, January 18, 1900: "I must calmly follow my path"

My dear Father,
Many thanks for your two long letters. Don't look at the world and me so darkly. You will feel far better, and so will the two of us poor abused people, if only we could be left with that little bit of rosy hue which does, in fact, exist. In the end, though, it doesn't make that much difference to us.

So you are upset by my recent move? As far as order is concerned, it's a step forward. The old *hôtel* furniture and carpets were worn and filthy beyond redemption. Where I am now everything is clean. Fairly empty, but pleasant. As to expense, both places are about the same.

It's almost like spring here now. I am sitting at an open window. Outside a friendly sun is shining. I am happy that we are being spared your cold weather, because the fireplaces here tend to tease much more than they actually warm us.

A few words about the Académie. Today I had my critique from Courtois. He hits the nail on the head, short and to the point. He has an eye for what I want and doesn't want to push me in another direction. I learned much from him today and am very happy. I have registered for a morning course in life drawing. At the beginning of each week Girardot and Collin come and criticize the accuracy of our work. Toward the end of the week, Courtois comes and criticizes primarily the more picturesque aspects of what we have done, our tonal values, etc. This double-teacher method here has proved

to be successful; the Académie Julian also has this arrangement. And it's very agreeable to me, too.

In the afternoon there is a course in *croquis* also from the nude in which for two hours we draw models in four different poses. This is very instructive for understanding movement. Each of us pays a fee for this course every afternoon. That way we are not bound to it, and every so often can take a trip to the Louvre instead. The Old Masters there also do their part in helping me along.

I am taking different courses than Clara Westhoff is. In fact, my style of living is totally different from hers. Enough for today. Your two letters did depress me a little. They made you sound so thoroughly dissatisfied with me. I, too, can see no end to the whole thing. I must calmly follow my path, and when I get to where I can accomplish something, things will be better. None of you, to be sure, seems to have much faith in me. But I do.

Journal, July 26, 1900: "I know that I shall not live very long"

As I was painting today, some thoughts came to me and I want to write them down for the people I love. I know that I shall not live very long. But I wonder, is that sad? Is a celebration more beautiful because it lasts longer? And my life is a celebration, a short, intense celebration. My powers of perception are becoming finer, as if I were supposed to absorb everything in the few years that are still to be offered me, everything. My sense of smell is unbelievably keen at present. With almost every breath I take, I get a new sense and understanding of the linden tree, of ripened wheat, of hay, and of mignonette. I suck everything up into me. And if only now love would blossom for me, before I depart, and if I can paint three good pictures, then I shall go gladly, with flowers in my hair. It makes me happy again as it did when I was a child, to weave wreathes of flowers. When it's warm and I'm tired, I sit down and weave a yellow garland, a blue one, and one of thyme.

I was thinking today about a picture of girls playing music under a cloud-covered sky, in gray and green tones, the girls white, gray, and muted red.

A reaper in a blue smock. He mows down all the little flowers in front of my door. I think that perhaps I, too, will not last much longer. I know now of two other pictures with Death in them; I wonder if perhaps I shall still get to paint them?

To Clara Rilke-Westhoff, May 13, 1901: "I believe that things are progressing for me"

Dear, dear Clara Westhoff,
It's a hot and summerlike day. I have just come home from the Tiebrucks' with my sketchbook. It's just fine there now. In among the shining yellow dandelions and the touching little blue gill-over-the-ground, little children and little goats and Voge's little geese are sitting and kneeling and lying and standing and tumbling. And in the distance

blossoming trees and young birches are laughing. It was good being there. In the last few days I have again been thinking very intensively about my art and I believe that things are progressing for me. I even think that I'm beginning to have a liaison with the sun. Not with the sun that divides everything up and puts shadows in everywhere and plucks the image into a thousand pieces, but with the sun that broods and makes things gray and heavy and combines them all in this gray heaviness so that they become one. I'm thinking about all of that very much and it lives within me beside my great love. A time has come when I think that I shall again be able to say something [in my painting] one day; I am again devout and full of expectation. There is also so much that is new in Otto Modersohn during this time. I am so amazed at the way things emerge from him. For six weeks he will just walk around with his little pipe in his mouth and on the forty-third day it suddenly appears. Right now he rejects nearly all of his newest pictures. I don't know if he is right to do it. But what hovers before him is a deeper and deeper penetration into nature. And with a shout of joy I understand these revolutions, because even if I have no idea where they might be leading, it's enough for me just to see that so very, very much is going on in my dear man. And everything in such a calm way, everything as if in nature itself. *Dear* Clara Westhoff, I'm almost beginning to get used to not seeing you and being able to talk about all these things with you. But not yet completely, and I feel how much remains unspoken within me because you are not here. Your letter was a big part of you. It was lovely to read.

Journal, February 20, 1903: "I must strive for the utmost simplicity united with the most intimate power of observation"

I must learn how to express the gentle vibration of things, their roughened textures, their intricacies. I have to find an expression for that in my drawing, too, in the way I sketch my nudes here in Paris, only more original, more subtly observed. The strange quality of expectation that hovers over muted things (skin, Otto's forehead, fabrics, flowers); I must try to get hold of the great and simple beauty of all that. In general, I must strive for the utmost simplicity united with the most intimate power of observation. That's where greatness lies. In looking at the life-size nude of Frau M., the simplicity of the body called my attention to the simplicity of the head. It made me feel how much it's in my blood to want to overdo things.

To get back again to that "roughened intricacy of things": that's the quality that I find so pleasing in old marble or sandstone sculptures that have been out in the open, exposed to the weather. I like it, this roughened alive surface. . . .

When I'm out in the street I sometimes feel the same mood I felt three years ago. I feel like a queen hidden behind veils, with everything rushing and roaring past me.

Journal, February 25, 1903: On Ancient Sculpture

I am constantly observing things and believe that I am coming closer to beauty. In the last few days I have discovered form and have been thinking much about it. Until now

I've had no real feeling for the antique. I could find it very beautiful by itself. But I could never find any thread leading from it to modern art. Now I've found it, and that is what I believe is called progress. I feel an inner relationship which leads from the antique to the Gothic, especially from the early ancient art, and from the Gothic to my own feeling for form.

A great simplicity of form is something marvelous. As far back as I can remember, I have tried to put the simplicity of nature into the heads that I was painting or drawing. Now I have a real sense of being able to learn from the heads of ancient sculpture. What grand and simple insight went into their creation! Brow, eyes, mouth, nose, cheeks, chin, that is all. It sounds so simple and yet it's so very, very much. How simply the planes of such an antique mouth are realized. I feel I must look for all the many remarkable forms and overlapping planes when drawing nature. I have a feeling for the way things slide into and over each other. I must carefully develop and refine this feeling. I want to draw much more in Worpswede. I want to draw groups of children at the poorhouse or the A. family or the N. family. I look forward to work so much. I believe my stay here will have been very good for me.

To Otto Modersohn, March 2, 1903: Visit to Rodin's Studio

My dear Spouse,
Just listen, I'm getting the feeling more and more that you must come here, too. There are so many reasons why you should. But I'll tell you only one, a great reason, the greatest: Rodin. You must get an impression of this man and of his life's work, which he has gathered together in castings all around him. I have the feeling that we shall probably never experience anything like this again in our lifetime. This great art came into full blossom with incredible determination, silently, and almost hidden from view. The impression Rodin makes is a very great one. It is hard for me to talk about any single work of his because one must keep coming back to it often, and in all one's various moods, in order to completely absorb it. He has done the work almost in spite of the rest of the world, and it exudes such a wonderful feeling—he doesn't care whether the world approves or not. Instead he has one conviction, firm as a rock: that it is beauty itself which he means to bring into the world. There are many who pay him some heed, although most of the French put him into the same pot with Boucher and Injalbert and whatever the names of all those other dim lights are.

But I want to tell you everything chronologically.

Armed with a little calling card from Rilke, which referred to me as *"femme d'un peintre très distingué"*[3] I went to Rodin's studio last Saturday afternoon, his usual day for receiving people. There were all sorts of people there already. He didn't even look at the card, just nodded and let me wander freely among his marble sculpture. So many wonderful things there. But some I cannot understand. Nevertheless, I don't dare judge those too quickly. As I was leaving, I asked him if it would be possible to visit his *pavillon* in Meudon, and he said that it would be at my disposal on Sunday. And so I

was permitted to wander about the *pavillon* undisturbed. What wealth of work is there and such worship of nature; that's really beautiful. He always starts from nature. And all his drawings, all his compositions, he does from life. The remarkable dreams of form which he quickly tosses onto paper are to me the most original aspect of all his art. He uses the most simple and sparse means. He draws with pencil and then shades in with strange, almost passionate, watercolors. It is a passion and a genius which dominate in these drawings, and a total lack of concern for convention. The first thing that comes into my mind to compare them with are those old Japanese works which I saw during my first week here, and perhaps also ancient frescoes or those figures on antique vases. *You simply must see them.* Their colors are a remarkable inspiration, especially for a painter. He showed them to me himself and was so charming and friendly to me. Yes, whatever it is that makes art extraordinary is what he has. In addition there is his piercing conviction that all beauty is in nature. He used to make up these compositions in his head but found that he was still being too conventional. Now he draws only from models. When he is in fresh form he does twenty of them in an hour and a half. His *pavillon* and his two other ateliers lie in the midst of strangely intersecting hills which are covered with a growth of stubbly grass. There is a wonderful view down to the Seine and the villages along it, and even as far as the domes of Paris. The building where he lives is small and confined and gives one the feeling that the act of living itself plays hardly any role for him. "La travaille [*sic*], c'est mon bonheur,"[4] he says.

Letter to Otto Modersohn, March 9, 1906: "You must try to grasp the thought that our paths will separate"

Dear Otto,
Your many long letters lie here before me. They make me sad. Over and over again there is the same cry in them, and I simply cannot give you the answer you would like to have. Dear Otto, please let some time pass peacefully and let us both just wait and see how I feel later. Only, dear, you must try to grasp the thought that our paths will separate.

I wish so much that my decision hadn't made you and my family suffer so. But what else can I do? The only remedy is time, which slowly and surely heals all wounds—

I am happy for you that you have sold two paintings; that ought to bring at least a little cheer to these difficult times.

I wonder if you have been good enough to mail my drawings to me? I should like to have them here for admission to the École des Beaux-Arts. Even with them it is far from being a sure thing. Everyone says it is a fine place to work and that it is also cheaper. However, in case you haven't sent them off, please don't bother now. They would arrive too late, and I can still enroll in one of the private schools.

I am beginning to settle in here. This past week the weather has been wonderful, warm enough to make one walk on the shady side of the street. It is very beautiful stepping outside in the evening after the drawing lessons and seeing the great city spread out in the blue twilight, punctuated with the lighted streetlamps—

Last Sunday, Herma and I went to a very beautiful concert.[5] They played three Beethoven symphonies. After that I paid her a visit in her "convent." She has a cozy little nunlike cell where she has all the peace and calm she needs for her studying. The meal was very good. The company, naturally, was fairly mixed. On the whole though, I don't get together with Herma very much. She has much to learn on her own, and aside from that I seem to have a depressing effect on her, which is my fault. Next Sunday, however, we are taking a trip to the country.

Dear Otto, I squeeze your hand and send you heartfelt greetings.

Your Paula

To Otto Modersohn, September 3, 1906: "Let me go, Otto"

Dear Otto,

The time is getting closer for you to be coming. Now I must ask you for your sake and mine, please spare both of us this time of trial. Let me go, Otto. I do not want you as my husband. I do not want it. Accept this fact. Don't torture yourself any longer. Try to let go of the past—I ask you to arrange all other things according to your wishes and desires. If you still enjoy having my paintings, then pick out those you wish to keep. Please do not take any further steps to bring us back together. It would only prolong the torment.

I must still ask you to send money, one final time. I ask you for the sum of five hundred marks. I am going to the country for a while now, so please send it to B. Hoetger,[6] 108, rue Vaugirard. During this time I intend to take steps to secure my livelihood.

I thank you for all the goodness that I have had from you. There is nothing else I can do.

Your Paula Modersohn

To Otto Modersohn, September 9, 1906: "Come here soon so that we can try to find one another again"

Dear Otto,

My harsh letter was written during a time when I was terribly upset.[. . .] Also my wish not have a child by you was only for the moment, and stood on weak legs.[. . .] I am sorry now for having written it. If you have not completely given up on me, then come here soon so that we can try to find one another again.

The sudden shift in the way I feel will seem strange to you.

Poor little creature that I am, I can't tell which path is the right one for me.

All these things have overtaken me, and yet I still do not feel guilty.

I don't want to cause pain to any of you.

Your Paula

To Clara Rilke-Westhoff, November 17, 1906: "I realized that I am not the sort of woman to stand alone in life"

Dear Clara Rilke,

I shall be returning to my former life but with a few differences. I, too, am different now, somewhat more independent, no longer so full of illusions. This past summer I realized that I am not the sort of woman to stand alone in life. Apart from the eternal worries about money, it is precisely the freedom I have had which was able to lure me away from myself. I would so much like to get to the point where I can create something that is me.

It is up to the future to determine for us whether I'm acting bravely or not. The main thing now is peace and quiet for my work, and I have that most of all when I am at Otto Modersohn's side.

I thank you for your friendly help. My birthday wish for you is that the two of us will become fine women.

Please give my greetings to your husband when you write him. With affectionate greetings to you.

Your Paula Modersohn

I certainly hope that the misunderstanding between you and Otto Modersohn will turn into an understanding again.

Well, it seems that Ruth did not get the famous doll's bed after all.

To Milly Rohland-Becker, November 18, 1906: "If only I have a place where I can work in peace"

My dear Sister,

You really seem to love me as a sister, and I thank you for it. I love you in my own way, with much reserve, but very deeply. If you feel a little cheated by me, heaven will see to it that you are compensated for that in some other way. I'm convinced that we are rewarded or punished one way or another for everything we do while we are still on this earth. The review was more a satisfaction to me than a joy. Joy, overpoweringly beautiful moments, comes to an artist without others noticing. The same is true for moments of sadness. That is why it's true that artists live mostly in solitude. But for all of that, the review will be good for my reappearance in Bremen. And it will perhaps also cast a different light on my reasons for leaving Worpswede.

Otto and I shall be coming home again in the spring. That man is touching in his love. We are going to try to buy the Brünjes place in order to make our lives together freer and more open. We will also have all kinds of animals around us. My thoughts run like this just now: if the dear Lord will allow me once again to create something beautiful, then I shall be happy and satisfied; if only I have a place where I can work in

peace. I will be grateful for the portion of love I've received. If one can only remain healthy and not die too young.

I'm so happy, my dear, that things are going well for you! I think about you and your little one very often. Just learn to be patient, and the happy event will soon come. And please make up your mind now that it is not important whether it's a boy or a girl. Do you think it mattered in our case; aren't we fine girls?

Right now Otto is at Hoetger's atelier. Hoetger is doing a plaster bust of him. I am to get a cast of it. The two of them have gradually come to understand each other very well. Otto has great hopes for his own art this winter. He has many new ideas, which is a great comfort to me.

I naturally indulged myself with the money you sent. I bought myself silly trinkets, something for the head, something for the feet. A pair of beautiful old combs, a pair of old shoe buckles.

Farewell, my dear. Be happy, be good, be careful.

To Clara Rilke-Westhoff, October 21, 1907: On Cézanne and the Salon d'Automne

Dear Clara Rilke,

My mind has been so much occupied these days by the thought of Cézanne, of how he has been one of the three or four powerful artists who have affected me like a thunderstorm, like some great event. Do you still remember what we saw at Vollard in 1900? And then, during the final days of my last stay in Paris, those truly astonishing early paintings of his at the Galerie Pellerin. Tell your husband he should try to see the things there. Pellerin has a hundred and fifty Cézannes. I saw only a small part of them, but they are magnificent—My urge to know everything about the Salon d'Automne was so great that a few days ago I asked him to send me at least the catalogue. Please come soon and bring the letters [about Cézanne]. Come right away, Monday if you can possibly make it, for I hope soon, finally, to be otherwise occupied. If it were not absolutely necessary for me to be here right now, nothing could keep me away from Paris.

I look forward to seeing you and to your news.

I also send two lovely greetings to Ruth.

Your Paula Modersohn

18

Käthe Kollwitz (1867–1945)

Although she was born ten years before Paula Modersohn-Becker, Käthe Kollwitz's active professional life spanned a much longer period, extending through World War I, the disruptions of the twenties, and the rise of Nazism. Her works became a target—along with the greatest expressionist artists of her generation, such as Ernst Barlach, Wilhelm Lehmbruck, Franz Marc, Ernst Kirchner, and Paula Modersohn-Becker—for the label of "Degenerate Art."[1] The Nazis expelled Kollwitz from the Prussian Academy in January 1933. She survived the most tumultuous periods in modern European history, sacrificing one son to World War I and his namesake, her grandson, to World War II.

Her compassion for the lower classes, the urban proletariat; the strength of her liberal, pacifist political beliefs; and her extraordinary dignity as a woman, mother, and wife make this artist a powerful model for contemporary consciousness.

Kollwitz's literary output consists of letters to friends and family, a brief autobiographical statement written around 1922, and journal entries. In 1948 her writings were edited by her son, Hans; they were published in an English translation in 1955, a decade after Kollwitz's death. (This volume has recently been reprinted.)

The excerpts included here are mainly from the journal, but also include a segment from her autobiographical statement of 1922 and a few letters. Taken together, they provide documentation of Kollwitz's positions on art, politics, and family matters that are extremely revealing of a complex, highly intelligent personality.

Käthe Schmidt was born into a nonartistic but politically active family in the small provincial seaport town of Königsberg (now Kaliningrad). Her father was a socialist, and her own lifelong activism and responsiveness to the needs of the impoverished working classes may be traced to this home environment.

The first excerpt from her autobiographical essay, deals retrospectively with her parents' response to evidence of her early artistic talent and her rivalry with her sister, Lise.

Her formal artistic training was acquired in two schools run by the German women artists' professional association, the Verein der Künstlerinnen. She studied for one academic year, 1885–86, in Berlin and another year, 1888–89, in Munich.

181

She became engaged to Karl Kollwitz, then a medical student, in 1884, but they did not marry until 1891, when he was a doctor in Berlin, practicing in a working-class neighborhood.

The decade of the 1890s was productive for Kollwitz. She bore two sons and completed a six-part series of prints, *The Revolt of the Weavers,* inspired by an 1844 rebellion of destitute linen workers. When exhibited, these works were widely praised and recommended for a gold medal, which the Kaiser refused because of their volatile socialist subject matter. The series established Kollwitz's reputation as one of Germany's leading graphic artists.

For two years she was a teacher at the women's school in Berlin. Between 1902 and 1908 Kollwitz worked on her next major print cycle, *The Peasant War,* devoted to a sixteenth-century uprising led by "Black Anna." This subject was attractive to her since she could express both her sympathies with the impoverished proletariat and her feminist beliefs. During this period she spent a year in Florence, recipient of the Villa Romana Prize sponsored by Max Klinger.

The published journal entries begin in 1909 and continue to the end of her life in 1945. They are intensely honest, reflecting vacillations in her confidence, her responses to the art-exhibition mechanisms of her day, the problems of sexism, and political issues. Like that of Anne Truitt, Kollwitz's diary reflects on her roles as wife and mother as well as her own aging. The journal entries document her continuing struggle to find appropriate, powerful, and original visual form for her values. From her early series, in which she mixed the media of etching, aquatint, and various intaglio processes, through her powerful woodcut series from the early twenties to her later, highly simplified lithographs, Kollwitz's search for a graphic medium is paralleled by her search for themes that address the core issues, from a woman's perspective, of her era. The anguish over losing her own son in World War I led her to create a series of images based on the natural, protective instincts of a mother restraining her children and a commemorative sculptural monument.

A letter to her close friend from art school, Beate Bonus Jeep,[2] reveals her pragmatic attitude toward the oppression of the Nazi bureaucracy towards her works. Her ability to endure, to continue no matter what, is inspirational.

"The Early Years," ca. 1922: Early Training with Her Sister Lise

I turn now from discussion of my physical development to my nonphysical development. By now my father had long since realized that I was gifted at drawing. The fact gave him great pleasure and he wanted me to have all the training I needed to become an artist. Unfortunately I was a girl, but nevertheless he was ready to risk it. He assumed that I would not be much distracted by love affairs, since I was not a pretty girl; and he was all the more disappointed and angry later on when at the age of only seventeen I became engaged to Karl Kollwitz.

My first artistic instruction came from Mauer, the engraver. There were usually

one or two other girls in the class. We drew heads from plaster casts or copied other drawings. It was summer, and we sat in the front room. From the street below I could hear the rhythmic tramping of men laying paving stones. Above the tall trees of the garden across the way hung the dense, motionless city air. I can feel it to this day.

I was hard-working and conscientious, and my parents took pleasure in each new drawing I turned out. That was a particularly happy time for my father, in respect to us. All of us children were developing rapidly. Konrad was writing, and we gave performances of his tragedies; I was showing unmistakable talent for drawing, and so was Lise. I still remember overhearing my father in the next room saying happily to my mother that all of us were gifted, but Konrad probably most of all. Another time he said something that bothered me for a long time afterwards. He had been astonished by one of Lise's drawings, and said to Mother: "Lise will soon be catching up to Kaethe."

When I heard this I felt envy and jealousy for probably the first time in my life. I loved Lise dearly. We were very close to one another and I was happy to see her progress up to the point where I began; but everything in me protested against her going beyond that point. I always had to be ahead of her. This jealousy of Lise lasted for years. When I was studying in Munich there was talk of Lise's coming out there to study too. I experienced the most contradictory feelings: joy at the prospect of her coming and at the same time fear that her talent and personality would overshadow mine. As it turned out, nothing came of this proposal. She became engaged at this time and did not go on studying art.

Now when I ask myself why Lise, for all her talent, did not become a real artist, but only a highly gifted dilettante, the reason is clear to me. I was keenly ambitious and Lise was not. I wanted to and Lise did not. I had a clear aim and direction. In addition, of course, there was the fact that I was three years older than she. Therefore my talent came to light sooner than hers and my father, who was not yet disappointed in us, was only too happy to open opportunities for me. If Lise had been harder and more egotistic than she was, she would unquestionably have prevailed on Father to let her also have thorough training in the arts. But she was gentle and unselfish. ("Lise will always sacrifice herself," Father used to say.) And so her talent was not developed. As far as talent in itself goes—if talent could possibly be weighed and measured—Lise had at least as much as I. But she lacked total concentration upon it. I wanted my education to be in art alone. If I could, I would have saved all my intellectual powers and turned them exclusively to use in my art, so that this flame alone would burn brightly.

From Her Journal December 30, 1909: "All the essentials are strongly stressed and the inessentials almost omitted"

On Saturday the Secession show was opened. I went there with Hans. My things were hung well, although the etchings were separate. Nevertheless I am no longer so satisfied. There are too many good things there that seem fresher than mine. Brandenburg is excellent this time. I wish I had done his dance, his orgy. In my own work I find that

I must try to keep everything to a more and more abbreviated form. The execution seems to be too complete. I should like to do the new etching so that all the essentials are strongly stressed and the inessentials almost omitted.

September 1913: "All I lack is moral courage"

I am working on the group of lovers, with the girl sitting in the man's lap. My deep depression after the summer vacation has dissipated, but I still do not have any real faith. Sometimes it seems to me that all I lack is moral courage. I do not fly because I do not dare to throw myself into the air like Pégoud. Actually, with my technique—even in sculpture—I should trust myself more. Is my lack of courage a token of age? All the ifs and buts that older people are aware of. Pechstein exhibits his talented sculptural sketches without any scruples. He doesn't give a hoot that they are nothing but sketches.

August 27, 1914: "The task is to bear it . . . for a long time"

In the heroic stiffness of these times of war, when our feelings are screwed to an unnatural pitch, it is like a touch of heavenly music, like sweet, lamenting murmurs of peace, to read that French soldiers spare and actually help wounded Germans, that in the franc-tireur villages German soldiers write on the walls of houses such notices as: Be considerate! An old woman lives here.—These people were kind to me.—Old people only.—Woman in childbed.—And so on.

A piece by Gabriele Reuter in the *Tag* on the tasks of women today. She spoke of the joy of sacrificing—a phrase that struck me hard. Where do all the women who have watched so carefully over the lives of their beloved ones get the heroism to send them to face the cannon? I am afraid that this soaring of the spirit will be followed by the blackest despair and dejection. The task is to bear it not only during these few weeks, but for a long time—in dreary November as well, and also when spring comes again, in March, the month of young men who wanted to live and are dead. That will be much harder.

Those who now have only small children, like Lise her Maria, seem to me so fortunate. For us, whose sons are going, the vital thread is snapped.

September 30, 1914: "Down with all the youth!"

Cold, cloudy autumnal weather. The grave mood that comes over one when one knows: there is war, and one cannot hold on to any illusions any more. Nothing is real but the frightfulness of this state, which we almost grow used to. In such times it seems so stupid that the boys must go to war. The whole thing is so ghastly and insane. Occasionally there comes the foolish thought: how can they possibly take part in such madness?

And at once the cold shower: they *must, must!* All is leveled by death; down with all the youth! Then one is ready to despair.

Only one state of mind makes it at all bearable: to receive the sacrifice into one's will. But how can one maintain such a state?

December 1914: The Memorial for Peter

Conceived the plan for a memorial for Peter tonight, but abandoned it again because it seemed to me impossible of execution.[3] In the morning I suddenly thought of having Reike ask the city to give me a place for the memorial. There would have to be a collection taken for it. It must stand on the heights of Schildhorn, looking out over the Havel. To be finished and dedicated on a glorious summer day. Schoolchildren of the community singing, "On the way to pray." The monument would have Peter's form, lying stretched out, the father at the head, the mother at the feet. It would be to commemorate the sacrifice of all the young volunteers.

It is a wonderful goal, and no one has more right than I to make this memorial. . .

My boy! On your memorial I want to have your figure on top, *above* the parents. You will lie outstretched, holding out your hands in answer to the call for sacrifice: "Here I am." Your eyes—perhaps—open wide, so that you see the blue sky above you, and the clouds and birds. Your mouth smiling. And at your breast the pink I gave you.

January 17, 1916: "Where are my children now?"

. . . Where are my children now? What is left to their mother? One boy to the right and one to the left, my right son and my left son, as they called themselves. One dead and one so far away, and I cannot help him, cannot give to him out of myself. All has changed forever. Changed, and I am impoverished. My whole life as a mother is really behind me now. I often have a terrible longing to have it back again—to have children, my boys, one to the right and one to the left; to dance with them as formerly when spring arrived and Peter came with flowers and we danced a springtide dance.

January 1916: On the Jury for the Secession Exhibition

All day devoted to hanging pictures in the Secession. Acting on the jury and hanging too is very instructive.

A show ought to have a face, and the pictures exhibited must fit into this face. From that it follows that mediocre pictures may possess the features which are fitting for the face and often must be accepted, while better pictures which have unsuitable features must sometimes, and justly, be rejected. Necessary injustice in all exhibitions. . .

My unpleasant position on the jury. I always find myself forced to defend the cause of a woman. But because I can never really do that with conviction, since most of the

work in question is mediocre (if the works are better than that the other jury members will agree), I always become involved in equivocations.

February 21, 1916: "There must be understanding between the artist and the people"

Read an article by E. von Keyserling on the future of art. He opposes expressionism and says that after the war the German people will need eccentric studio art less than ever before. What they need is realistic art.

I quite agree—if by realistic art Keyserling means the same thing I do. Which refers back to a talk I had recently with Karl about my small sculptures.

It is true that my sculptural work is rejected by the public. Why? It is not at all popular. The average spectator does not understand it. Art for the average spectator need not be shallow. Of course he has no objection to the trite—but it is also true that he would accept true art if it were simple enough. I thoroughly agree that there must be understanding between the artist and the people. In the best ages of art that has always been the case.

Genius can probably run on ahead and seek out new ways. But the good artists who follow after genius—and I count myself among these—have to restore the lost connection once more. A pure studio art is unfruitful and frail, for anything that does not form living roots—why should it exist at all?

Now as for myself. The fact that I am getting too far away from the average spectator is a danger to me. I am losing touch with him. I am groping in my art, and who knows, I may find what I seek. When I thought about my work at New Year's 1914, I vowed to myself and to Peter that I would be more scrupulous than ever in "giving the honor to God, that is, in being wholly genuine and sincere." Not that I felt myself drifting away from sincerity. But in groping for the precious truth one falls easily into artistic oversubtleties and ingenuities—into preciosity. I suddenly see that very clearly, and I must watch out. Perhaps the work on the memorial will bring me back to simplicity.

March 31, 1916: "Go on with my work to its end"

I am overcome by a terrible depression. Gradually I am realizing the extent to which I already belong among the old fogies, and my future lies behind me. Now I am looked upon more or less kindly as a dignitary. If I had less of a name I would be treated like Loewenstein and Siewart; I would be rejected.

What can be done? Return, without illusions, to what there is in me and go on working very quietly. Go on with my work to its end. Show seasons are naturally always disturbing because I see all the strange, youthful and new things passing before me, and they excite me. I compare them with myself and see with disgusting clarity what is feeble and reactionary in my own work.

When I am at the Secession, in the midst of artists who are all thinking about their own art, I also think of mine. Once I am back home this horrible and difficult life weighs down upon me again with all its might. Then only one thing matters: the war.

April 18, 1916: "I would not have to give it away"

Last night I dreamed once more that I had a baby. There was much in the dream that was painful, but I recall one sensation distinctly. I was holding the tiny infant in my arms and I had a feeling of great bliss as I thought that I could go on always holding it in my arms. It would be one year old and then only two, and I would not have to give it away.

To Her Son, Hans, April 16, 1917: "I have never done any work cold . . ."

My dear Hans!
The show is open. There was a preview from three until five. Two minutes before three I pasted labels on the pictures in insane haste. Then I fled. I have already heard some reactions from those who were there. This show *must* mean something, for all these prints are the distillation of my life. I have never done any work cold (except for a few trivial things which I am not showing here). I have always worked with my blood, so to speak. Those who see the things must feel that.

May 1917: On Her Solo Exhibition: "It was a great success"

After Easter worked concentratedly on the show. On the afternoon of Sunday, the 15th, I had the porter open the building and showed Karl the exhibition. Monday, the 16th, it was opened. It was a great success. From many sides I heard that it made a strong and integrated impression. Stahl's review, Deri's prefatory notes, Lise's review in the *Monatsheft,* Wertheimer's comments. Their praise is such that I almost think the last two at least would not be so affected by an artist who was a stranger to them. Fondness for me is also involved. For I can scarcely think that I have been *so* able to communicate myself or—more than that—to have been the direct mediator between people and something they are not conscious of, something transcendent, primal. Suggestion must play some part here. If my works *continue* to make such an impression—even after decades— then I will have achieved a great deal. Then men will have been enriched by me. Then I shall have helped in the ascent of man. For that matter everyone does so, but it would then have fallen to me to do so to a greater degree than others.

July 1917: "My work has value"

My fiftieth birthday has passed. Different from the way I used to imagine it. Where are my boys?

And yet the day was good, this whole period is good. From so many sides I am being told that my work has value, that I have accomplished something, wielded influence. This echo of one's life work is *very* good; it is satisfying and produces a feeling of gratitude. And of self-assurance as well. But at the age of fifty this kind of self-assurance is not as excessive and arrogant as it is at thirty. It is based upon self-knowledge. One knows best oneself where one's own upper and lower limits are. The word fame is no longer intoxicating.

But it might have turned out differently. In spite of all the work I have done, success might have been denied me. There was an element of luck in it, too. And certainly I am grateful that it has turned out this way.

July 1917: Peter's Gravestone

When I told Karl that Wertheimer may visit Peter's grave, Karl said he would like Peter to have a gravestone. I said, then I should like to make it. Today I thought about it again. I thought that the relief of the parents might be set upon his grave. Then I realized that this relief would be more appropriate for the whole cemetery. It belongs up front at the entrance. A square stone, the relief cut into the face. Life size. Below or above it: Here lies German youth. Or: Here lie Germany's finest young men. Or: Here lie the youthful dead. Or simply: Here lie the young.

It seems to me *I must carry this out*. God grant I keep my health until it is all done for Peter and the others.

January 4, 1920: On Making a Poster for Aid to Vienna: "It is my duty to voice the sufferings of men"

I have again agreed to make a poster for a large-scale aid program for Vienna. I hope I can make it, but I do not know whether I can carry it out because it has to be done quickly and I feel an attack of grippe coming on.

I want to show Death. Death swings the lash of famine—people, men, women and children, bowed low, screaming and groaning, file past him.

While I drew, and wept along with the terrified children I was drawing, I really felt the burden I am bearing. I felt that I have no right to withdraw from the responsibility of being an advocate. It is my duty to voice the sufferings of men, the never-ending sufferings heaped mountain-high. This is my task, but it is not an easy one to fulfil. Work is supposed to relieve you. But is it any relief when in spite of my poster people in Vienna die of hunger every day? And when I know that? Did I feel relieved when I made the prints on war and knew that the war would go on raging? Certainly not. Tranquillity and relief have come to me only when I was engaged on one thing: the big memorial for Peter. Then I had peace and was with him.

February 26, 1920: "The man who sees the suffering of the world"

I want to do a drawing of a man *who sees the suffering of the world.* That can be only Jesus, I suppose. In the drawing where Death seizes the children there is also a woman in the background who sees the suffering of the world. The children being seized by Death are not hers; she is too old for that. Nor is she looking; she does not stir, but she knows about the world's suffering.

Sometimes it seems to me that the curtain is about to lift which separates me from my work, from the way my work now must be. I have a sense of something imminent coming closer. But then I lose it again, become ordinary and inadequate. I feel like someone who is trying to guess an object being described by music. The sound grows steadily louder; he thinks he is on the point of grasping it, and then the sound becomes weaker again and he has to look for another answer.

June 25, 1920: On Barlach's Woodcuts

Yesterday I went with Professor Kern to the Secession shows and to the big exhibition in order to choose a print for the Kunstverein. Then I saw something that knocked me over: Barlach's[4] woodcuts.

Today I've looked at my lithographs again and seen that almost all of them are no good. Barlach has found his path and I have not yet found mine.

I can no longer etch; I'm through with that for good. And in lithography there are the inadequacies of the transfer paper. Nowadays lithographic stones can only be got to the studio by begging and pleading, and cost a lot of money, and even on stones I don't manage to make it come out right. But why can't I do it any more? The prerequisites for artistic works have been there—for example in the war series. First of all the strong feeling—these things come from the heart—and secondly they rest on the basis of my previous works, that is, upon a fairly good foundation of technique.

And yet the prints lack real quality. What is the reason? Ought I do as Barlach has done and make a fresh start with woodcuts? When I considered that up to now, I always told myself that lithography was the right method for me for clear and apparent reasons.

In woodcuts I would not want to go along with the present fashion of spotty effect. Expression is all that I want, and therefore I told myself that the simple line of the lithograph was best suited to my purposes. But the results of my work, except for the print *Mothers,* never have satisfied me.

For years I have been tormenting myself. Not to speak of sculpture.

I first began the war series as etchings. Came to nothing. Dropped everything. Then I tried it with transfers. There too the results were almost never satisfying.

Will woodcutting do it? If that too fails, then I have proof that the fault lies only within myself. Then I am just no longer able to do it. In all the years of torment these small oases of joys and successes.

October 1920: The Rights of the Artist

. . . I simply should have been left alone, in tranquillity. An artist who moreover is also a woman cannot be expected to unravel these crazily complicated relationships. As an artist I have the right to extract the emotional content out of everything, to let things work upon me and then give them outward form. And so I also have the right to portray the working class's farewell to Liebknecht, and even to dedicate it to the workers, without following Liebknecht politically. Or isn't that so?

April 1921: "Now my work disgusts me"

Low. Low. Touching bottom.

I hope to get through it anyhow. Finish the woodcuts by the time of the Jury. Then the Jury; then a week's rest in Neuruppin, and then it may go better. But no. Poor work right along recently and no longer able to see things right. Then I was ripe for illness and fell ill, and at the same time everything slid and dropped and collapsed with a thoroughness I have not experienced for a long time. Now my work disgusts me so that I cannot look at it. At the same time total failure as a human being. I no longer love Karl, nor Mother, scarcely even the children. I am stupid and without any thoughts. I see only unpleasant things. The spring days pass and I do not respond. A weariness in my whole body, a churlishness that paralyzes all the others. You don't notice how bad you get when in such a state until you are beginning to rise out of it. One horrid symptom is this: not only do you not think a single matter through to the end, but you don't even feel a feeling to the end. As soon as one arises, it is as though you threw a handful of ashes on it and it promptly goes out. Feelings which once touched you closely seem to be behind thick, opaque window panes; the weary soul does not even try to feel because feeling is too strenuous. So that there is *nothingness* in me, neither thoughts nor feelings, no challenge to action, no participation. Karl feels that I am strange—and nothing matters at all to me.

In the theater yesterday. Saw Barlach's *Die echten Sedemunds*. A deep sense of envy that Barlach is so much more powerful and profound than I am.

However, I did have one fine experience in these dull, dead weeks. That was before I fell ill. At the Tiergarten I saw a nurse with two children. The older boy, about two and a half, was the most sensitive child I have ever seen. As the nurse put it, like a little bird. For this reason she did not like him. But the boy was utterly charming. On his little face and in his thin body impressions from outside were constantly reflected. A great deal of fear, oppression, hope, almost blissful joy; then again anxiety, etc. Like a butterfly whose wings are constantly quivering. Never have I seen a baby more moving, more affecting, more helpless and in need of protection and love.

June 28, 1921: "I am no revolutionist"

Went to the theater with Karl; saw *The Weavers*[5] at the Grosse Schauspielhaus. The inflammatory effect of the mass scenes, "Let Jaeger come out, let Jaeger come out! Let Hoelz come out!"

I was overcome by something of the same feeling I had when I saw *The Weavers* for the first few times. Of the feeling that animates the weavers, the desire for eye for eye, tooth for tooth, the feeling I had when I did the weavers. My weavers.

In the meantime I have been through a revolution, and I am convinced that I am no revolutionist. My childhood dream of dying on the barricades will hardly be fulfilled, because I should hardly mount a barricade now that I know what they are like in reality. And so I know now what an illusion I lived in for so many years. I thought I was a revolutionary and was only an evolutionary. Yes, sometimes I do not know whether I am a socialist at all, whether I am not rather a democrat instead. How good it is when reality tests you to the guts and pins you relentlessly to the very position you always thought, so long as you clung to your illusion, was unspeakably wrong. I think something of the sort has happened to Konrad. Yes, he—and I too—would probably have been capable of acting in a revolutionary manner if the real revolution had had the aspect we expected. But since its reality was highly un-ideal and full of earthly dross—as probably every revolution must be—we have had enough of it. But when an artist like Hauptmann comes along and shows us revolution transfigured by art, we again feel ourselves revolutionaries, again fall for the old deception.

To Jeep, 1933: On the Nazi Policy toward the Academy Show

Dear Jeep!

. . . The Academy show has opened here meanwhile. That is, it has not opened, rather it has been ready to open for two weeks. But Goering, the second man in the State, has no time to open it right now. I was admitted after all and was delighted with the exhibition. You will see it in the winter. It is only sculpture—one hundred and fifty years of sculpture, down to the present. You know I wanted to have my group there, but they refused it. Instead they wanted the Mother figure that is in the Kronprinzenpalais museum, and the small bronze gravestone relief. At first I was angry that they did not want my new work; but it is just as well after all. It could not possibly have been ready in stone, and in the cement cast, as it is now, it would not have done at all. It is far from dry yet and looks horribly mottled.—

Yesterday, when I came into the old rooms and saw my own works among the many others, and that they held up, I was very glad after all. Participation is good and vital, and it is sad to be excluded. For one is after all a leaf on the twig and the twig belongs to the whole tree. When the tree sways back and forth, the leaf is content to sway with it.

The day before the opening of the show my two works, the Mother from the Kronprinzenpalais museum and the gravestone relief, were taken out. So were three works by Barlach. From this and from Rust's speech I could not help concluding that both pieces were going to be put away in the warehouse of the National Gallery. That is for outdated trash. In fact, I began to fear worse things. I was afraid they would remove my figures from the cemetery in Belgium. But with a curious lack of consistency, although the works were removed from the Academy show, they are to be on exhibition

in the Kronprinzenpalais again. A sequence of decisions which is hard to understand. If only the sculptures may remain in Belgium in the place for which they were made.

November 1936: "There is really nothing more to say"

I am gradually realizing now that I have come to the end of my working life. Now that I have had the group cast in cement, I do not know how to go on. There is really nothing more to say. I thought of doing another small sculpture, *Age,* and I had some vague ideas about a relief. But whether I do them or not is no longer important. Not for the others and not for myself. Also there is this curious silence surrounding the expulsion of my work from the Academy show, and in connection with the Kronprinzenpalais. Scarcely anyone had anything to say to me about it. I thought people would come, or at least write—but no. Such a silence all around us.—That too has to be experienced. Well, Karl is still here. I see him every day and we talk and show one another our love. But how will it be when he too is gone?

One turns more and more to silence. All is still. I sit in Mother's chair by the stove, evenings, when I am alone.

PART III

World War I to World War II: 1914 - 1945

World War I provided different experiences for men and women coming to maturity in the second decade of the twentieth century. While most men were actively involved in fighting, women had to fill in the vacant jobs abandoned by the mass conscription needed for the war effort. In England, for example, 1,345,000 women entered the job market during the war.[1] At war's end, women workers in England, France, and Germany were encouraged to leave their jobs to provide employment for the returning war veterans. One acknowledgment of women's efforts on the home front during the war years was the granting of suffrage. Nineteen countries gave women the right to vote between 1915 and 1922.

Despite these political gains, the decade of the 1920s witnessed antifeminist reactions in many countries, including Germany and Russia. Population losses during the war, combined with the desire of avoiding competition with veterans, helped reinforce traditional gender ideologies and put women back in the home, devoted to childbearing. As Alice Kessler-Harris notes, protective legislation that limited work hours and established minimum wages for women, combined with the social ideology that women's place was in the home, resulted in limiting the participation of women in the labor force.[2] Between 1900 and 1940 the percentage of women in the work force rose only slightly.

For women artists, this period witnessed the dissolution of the most serious institutional barriers that had been erected to either eliminate or marginalize women in the profession. However, like the granting of the right to vote, admission into art academies, especially when their power and influence were waning, did not guarantee full equality in terms of either art history or critical appraisal.

The four women whose writings are excerpted in this section are all exceptional and, to some extent, isolated individuals. They are generally seen as operating creatively outside the cultural "mainstream" of their times.

However much they might be "independent" from more conservative artistic activities, three of these artists were closely connected with the nationalism of their geographical region. Emily Carr, Georgia O'Keeffe, and Frida Kahlo were all highly

sensitive to their identities, as a Canadian, American, and Mexican respectively. Barbara Hepworth, who was British, viewed her abstract vocabulary as less tied to nationalistic roots.

The texts excerpted here vary widely in nature. Carr was the most prolific writer of this group. In fact, her stories of her contacts with the Northwest Coast Indians, when published late in her life, established her fame before there was any general public awareness of her paintings. She wrote her autobiography and, in the last decade of her life, kept a journal. Hepworth's writing is also autobiographical, written mostly after her reputation was firmly established.

Both Kahlo and O'Keeffe maintained contact with intimate friends through letters. In addition, O'Keeffe wrote a brief autobiographical statement, first published in 1976 when the artist was nearly 90. In that same volume she reprinted the terse yet informative statements written for a few of her solo exhibitions between 1923 and 1944. These statements are also extremely helpful for our understanding of her art.

Barbara Hepworth (1903–1975)

Widely recognized as one of England's most important avant-garde sculptors of the twentieth century, Barbara Hepworth's works are well known, fully documented, and widely accessible in many museum collections. Hepworth, her second husband Ben Nicholson, and her fellow student Henry Moore are three key creative talents from the 1930s that moved British sculpture into the mainstream of the international avant-garde. After the birth of triplets in 1934, her totally abstract vocabulary, based mainly on direct carving, earned her widespread recognition. Her most prominently displayed public monument is the enormous, 21-foot-tall bronze *Single Form,* the memorial to Dag Hammarskjöld positioned in front of the United Nations Building in New York City. In 1968 she was honored with a major retrospective exhibition at the Tate Gallery in London.

In 1959 Hepworth published *A Pictorial Autobiography.* Heavily illustrated, as the title indicates, Hepworth's laconic but informative comments are interspersed with photos of friends and family and illustrations of her sculpture. All the following excerpts are from this volume, which has gone through numerous reprintings.

Most fascinating is her frequently quoted statement, in the first excerpt, of her earliest memories of a physical sense of bonding with the earth: "I, the sculptor, *am* the landscape. I am the form and I am the hollow, the thrust and the contour." It is impossible to appreciate Hepworth's artistic vocabulary without these references to landscape. The next excerpt is her very terse account of the breakup of her first marriage to the artist John Skeaping, whom she had married in 1925.

Hepworth benefited from women's broadened opportunities for professional artistic training in the early twentieth century. She won a scholarship to the Leeds School of Art when she was only 16, and the following year, with her fellow classmate Henry Moore, moved on to the Royal College of Art in London. Both Hepworth and Moore were awarded travel scholarships, and Hepworth went to Italy to develop her skills in carving marble. After her second marriage, to Ben Nicholson in 1931, and an extremely productive trip to France, recounted in the third excerpt, Hepworth began to struggle for a personal vision in her imagery. It was the break in her work necessitated by the birth of the triplets that reoriented her art toward the totally abstract vocabulary she

would employ for the rest of her life. The last two excerpts include a statement of the nature of her personal conceptions of abstract form and the circumstances surrounding the creation of *Single Form*.

Hepworth breaks with the prevailing conservative stylistic preferences of earlier women sculptors. She positioned herself in the forefront of the European avant-garde. By being receptive to the directions set by Jean Arp and Constantin Brancusi, she forged a highly innovative personal oeuvre.

"I, the sculptor, *am* the landscape"

All my early memories are of forms and shapes and textures. Moving through and over the West Riding landscape with my father in his car, the hills were sculptures; the roads defined the form. Above all, there was the sensation of moving physically over the contours of fulnesses and concavities, through hollows and over peaks—feeling, touching, seeing, through mind and hand and eye. This sensation has never left me. I, the sculptor, *am* the landscape. I am the form and I am the hollow, the thrust and the contour.

Feelings about ideas and people and the world all about us struggle inside me to find the evocative symbol affirming these early and secure sensations—the feeling of the magic of man in a landscape, whether it be a pastoral image or a miner squatting in the rectangle of his door or the "Single form" of a millgirl moving against the wind, with her shawl wrapped round her head and body. On the lonely hills a human figure has the vitality and the poignancy of all man's struggles in this universe.

On Marriage and Children

This was a wonderfully happy time. My son Paul was born, and, with him in his cot, or on a rug at my feet, my carving developed and strengthened.

I did not see what was happening to us after our second show together at Tooths in New Bond Street. Quite suddenly we were out of orbit. I had an obsession for my work and my child and my home. John wanted to go free, and he bought a horse which used to breathe through my kitchen window!

There was no ill-feeling—we fell apart, then finally John remarried and had a country estate and three wonderful sons. John was always kind to me and still is; we keep in touch from time to time.

Friends and relations always said to me that it was impossible to be dedicated to any art and enjoy marriage and children. This is untrue, as I had nearly thirty years of wonderful family life; but I will confess that the dictates of work are as compelling for a woman as for a man. Not competitively, but as complementary, and this is only just being realised. . . .

. . . These "working holidays" at Happisburgh were wonderful. We talked and walked, we bathed and played cricket, then we worked and danced. I think this idea of

a working holiday was established in my mind very early indeed. My father took us each year to Robin Hood's Bay to stay in a house on the lovely beach. At high tide the waves thumped on the house and spray fell all around us on the balconies. I was always in a state of great excitement. My room was the right hand attic and here I laid out my paints and general paraphernalia and crept out at dawn to collect stones, seaweeds and paint, and draw by myself before somebody organised me! This pattern was repeated in Norfolk, and later in Greece, and several times in the Isles of Scilly.

It made a firm foundation for my working life—and it formed my idea that a woman artist is not deprived by cooking and having children, nor by nursing children with measles (even in triplicate)—one is in fact nourished by this rich life, provided one always does some work each day; even a single half hour, so that the images grow in one's mind.

I detest a day of no work, no music, no poetry.

Visit to the Studios of Arp and Picasso

We visited Meudon to see Jean Arp and though, to our disappointment, he was not there his wife, Sophie Tauber-Arp,[1] showed us his studio. It was very quiet in the room so that one was aware of the movement in the forms. All the sculptures appeared to be in plaster, dead white, except for some early reliefs in wood painted white with sharp accents of black, and the next day, as we travelled on the train to Avignon, I thought about the poetic idea in Arp's sculptures. I had never had any first-hand knowledge of the Dadaist movement, so that seeing his work for the first time freed me of many inhibitions and this helped me to see the figure in landscape with new eyes. I stood in the corridor almost all the way looking out on the superb Rhone valley and thinking of the way Arp had fused landscape with the human form in so extraordinary a manner. Perhaps in freeing himself from material demands his idea transcended all possible limitations. I began to imagine the earth rising and becoming human. I speculated as to how I was to find my own identification, as a human being and a sculptor, with the landscape around me.

It was my first visit to the South of France, and out of the three days at Avignon the most important time for me was spent at St. Remy. It was Easter; and after a bus ride we walked up the hill and encountered at the top a sea of olive trees receding behind the ancient arch on the plateau, and human figures sitting, reclining, walking, and embracing at the foot of the arch, grouped in rhythmic relation to the far distant undulating hills and mountain rocks. There was the sound of dance music—and we discovered a gay café Robinson hidden by trees. I made several drawings. These were the last I ever made of actual landscape, because since then, as soon as I sit down to draw the land or sea in front of me, I begin to draw ideas and forms for sculptures.

On the way back from Avignon after Easter we saw Picasso in his studio. I shall never forget the afternoon light streaming over roofs and chimneypots through the window, on to a miraculous succession of large canvases which Picasso brought out to show us and from which emanated a blaze of energy in form and colour.

"The experience of the children seemed to intensify our sense of direction and purpose"

It seemed as though it might be impossible to provide for such a family by the sale of abstract paintings and white reliefs, which Ben Nicholson was then doing, and by my sculptures; but the experience of the children seemed to intensify our sense of direction and purpose, and gave us both an even greater unity of idea and aim.

When I started carving again in November 1934, my work seemed to have changed direction, although the only fresh influence had been the arrival of the children. The work was more formal, and all traces of naturalism had disappeared, and for some years I was absorbed in the relationships in space, in size and texture and weight, as well as in the tensions between the forms. This formality initiated the exploration with which I have been preoccupied continuously since then, and in which I hope to discover some absolute essence in sculptural terms, giving the quality of human relationships.

"All landscape needs a figure"

All landscape needs a figure—and when a sculptor is the spectator he is aware that every landscape evokes a special image. In creating this image the artist tries to find a synthesis of his human experience and the quality of the landscape. The forms and piercings, the weight and poise of the concrete image also become evocative—a fusion of experience and myth.

Working in the abstract way seems to release one's personality and sharpen the perceptions so that in the observation of humanity or landscape it is the wholeness of inner intention which moves one so profoundly. The components fall into place and one is no longer aware of the detail except as the necessary significance of wholeness and unity . . . a rhythm of form which has its roots in earth but reaches outwards towards the unknown experiences of the future. The thought underlying this form is, for me, the delicate balance the spirit of man maintains between his knowledge and the laws of the universe.

Single Form

Before Dag Hammarskjöld's death we had discussed together the kind of form he had envisaged to go in front of the Secretariat. When I heard of his death, and in order to assuage my grief, I immediately made a large new version of Single Form just for myself. It was 10 ft. 6 in. high.

Later, when the Secretary General heard of this, he asked me if I would go to New York and discuss the project as Dag Hammarskjöld had envisaged it.

Between us all we arrived at the right scale and position; and I met with the

utmost kindness and help. Then for some months I had to work to the scale of 21 feet and bring into my mind everything my father had taught me about stress and strain and gravity and windforce. Finally, all the many parts were got out of St. Ives safely, and when assembled in a big London studio they stood up in perfect balance. This was a magic moment. Finally the whole work was complete, and went to New York.

20

Emily Carr (1871–1945)

Like O'Keeffe's New Mexico imagery, Emily Carr's painting is identifiable with a specific region, the rain forests of the Canadian Northwest Pacific coast. Unlike O'Keeffe, whose works were regularly exhibited in New York, Carr worked in nearly total isolation from serious critical scrutiny throughout most of her life. Her national identity as a Canadian surely has something to do with this obscurity. However, beginning in the mid-1970s, through the efforts of Canadian women writers such as the art historian Doris Shadbolt, the outline of her artistic development is now more clearly understood. Carr emerges with a truly original artistic style after 1929, an artist who obsessively focused on the art of the Native Americans in the Pacific Northwest, especially their impressive totem poles, and the geographic environment which nurtured that art, the densely beautiful rain forests of the same region.

Carr was a prolific writer as well as a painter. During her lifetime, she published five books of stories and reminiscenses including her autobiography, *Growing Pains*. Beginning in 1930, she wrote regularly in a journal that was intended eventually for publication and titled *Hundreds and Thousands*. (The title refers to a type of English candy that comes in tiny bits, intended to be eaten by the handful.) By this time, the artist was almost 60. Although her memories in *Growing Pains* are recorded many years after the event, when "self-mythologizing had become habit,"[1] the entries from *Hundreds and Thousands* form a "personal and passionate manifesto."[2]

Carr was born in the extremely remote town of Victoria on Vancouver Island. Not only was her family not in the least artistically inclined but the region was notably limited in its capacity to appreciate native artists. Following the death of both parents, Carr convinced her legal guardian to send her to San Francisco for art training. Between 1890 and 1893, Carr attended the California School of Design, progressing through its academic curriculum from the drawing of plaster casts to the still-life class. Realizing she needed further instruction, she earned money giving art lessons in Victoria and waited for an opportunity to study abroad. From the summer of 1899 until 1904, Carr lived in England. She first studied at the conservative Westminster School of Art and then painted in the English countryside. Carr's health broke down and she spent the

last eighteen months of this sojourn in a sanitorium. The first excerpt deals with her return from this time abroad and her activities in Vancouver. Her desire to depict the totem poles of the Indians dates from this period. Carr sees these images as a sort of antidote for the academic art instruction she had endured up to this point.

Realizing that she had still not found her stylistic mode, she was determined to study in Paris. She left Canada for France accompanied by one of her three sisters in July 1910.

She returned to Victoria from Paris late in 1911 with a new, more painterly and coloristic style inspired by Fauvism. It is this new style, so unappreciated in Vancouver, that Carr discusses in her chapter "Rejected." Without any financial network to sustain her artistically, she ran a boardinghouse to support herself and entered a fifteen-year period of artistic dormancy.

Carr was motivated out of this fallow period by an invitation from the director of the National Gallery of Canada to participate in an exhibition of works by Indians and contemporary art of the Canadian west coast. On this trip east, she met the "Group of Seven," seven painters who had exhibited together in the 1920s. Like the *Mexicanidad* nationalism of the same period which inspired Frida Kahlo, the spirit of the "Group of Seven" was fervently nationalistic. Carr became closely associated with Lawren Harris, a member of this circle, and his spiritual involvement with theosophy had a strong impact on her over the next few years. Her paintings from 1928 to 1931 reflect her interest both in Harris's paintings and in theosophical doctrines. This is the period when she began to record her ideas in a journal. The entries excerpted here span the years 1930 to 1937. The first entry, written in 1930 discusses her first encounter with Harris. The second entry concerns Mark Tobey, with whom Carr spent three weeks in the fall of 1928. Her struggles to absorb these influences and translate them into a personal artistic vocabulary are clearly expressed.

The next series of entries in the journal concerns Carr's attempt to define her own spirituality and integrate those religious beliefs with her artistic goals. Shadbolt believes that this spiritual renewal is essential to her successful mature style of painting. "When she finally was able to identify the primal energy she found in nature with the spiritual energy she was seeking as the manifestation of God, the elements in her art became integrated at a higher level. . . . At this point her art reached its full range of effectiveness."[3] The excerpt dated November 12, 1932, expresses this religious pantheism quite clearly. Part of this leap was achieved through a new sketching technique, described in the journal entry of January 27, 1933.

One of her most powerful works, painted quite late in her career, is *A Skidegate Pole* (1941–42). (See Fig. 13.) This painting integrates Carr's two most consistent motifs, the totems of the Indians and the rhythmic contours of the landscape that nurtured their culture. The section of the pole depicted here seems to be embedded in the rolling contours of the earth, rather than sitting upon the ground isolated from nature. Carr had painted these poles as early as 1912, but her later works reveal a density and condensation in the shapes of the pole, infused with the saturation of color that is typical of her mature style.

Figure 13. Emily Carr, *A Skidegate Pole*. Collection: Vancouver Art Gallery, Emily Carr Trust.

Other journal entries deal with her ambivalent feelings toward any sort of recognition for her art, whether through criticism or sales.

The entry of April 4, 1934, is of interest since she recognizes here an affinity between her painting style and Van Gogh's. However, she perceives her own development as parallel to Van Gogh's, not directly influenced by his works.

The entry for April 16, 1937, contains one of the few references that Carr makes to her self-consciousness of being a "woman artist."

Carr suffered a heart attack in January 1937; after that her painting production diminished, and she began to devote more time to writing. The publication of *Klee Wyck* in 1941 was honored with a Governor-General's Medal and brought her the type of popular fame that had eluded her through painting. She died in 1945, just before the award of an honorary doctorate from the University of British Columbia and the opening of major solo exhibitions at the National Gallery of Ottawa and the Art Gallery of Toronto.

As Shadbolt notes, it is only since the 1970s that Carr's achievements have been fully documented and better appreciated. This may be explained by the weakening hold of formalist criticism and a heightened interest in preserving the environment, coupled with increased respect for indigenous art forms.[4] Today the Carr literature is extensive, and a detailed biography by Paula Blanchard has recently been published.[5]

Growing Pains: The Autobiography of Emily Carr
Home from London: The Vancouver Ladies' Art Club

There were no artists in Victoria. I do not remember if the Island Arts and Crafts Club had begun its addled existence. When it did, it was a very select band of elderly persons, very prehistoric in their ideas on Art.

It was nice to be home, but I was not there for long because the Ladies' Art Club of Vancouver asked me to accept the post of Art teacher to their Club. So I went to live in Vancouver. The Vancouver Art Club was a cluster of society women who intermittently packed themselves and their admirers into a small rented studio to drink tea and jabber art jargon.

Once a week I was to pose a model for them and criticize their work. I had been recommended by one of their members who was an old Victorian and who had known me all my life. She was abroad when I accepted the post.

The Art Club, knowing I was just back from several years of study in London, expected I would be smart and swagger a bit. When they saw an unimportant, rather shy girl they were angry and snubbed me viciously, humiliating me in every possible way. Their President was a wealthy society woman. Floating into the studio an hour or more late for class, she would swagger across the room, ignoring me entirely and change the model's pose. Then she would paint the background of her study an entirely different colour to the one I had arranged. If I said anything, she replied, "I prefer it so!"

Other members of the class, following her lead, and tossing their heads, would say with mock graciousness, "You may look at my work if you would like to, but I wish no criticism from you." At the end of my first month they dismissed me. Perhaps I did look horribly young for the post.

On her return to Vancouver my sponsor sent for me.

"I hear the Ladies' Club have dismissed you, my dear."

"Yes. I am glad!"

"All were unanimous in their complaint."

"What was it?"

"Millie, Millie!" she smiled. "You tried to make them take their work seriously! Society ladies serious! My dear, how could you?" she laughed.

"They are vulgar, lazy old beasts," I spluttered. "I am glad they dismissed me and I am proud of the reason. I hate their kind. I'd rather starve."

"What shall you do now?"

"I have taken a studio in Granville Street. The only woman in the Art Club who was decent to me (an American) has sent her little daughter to me for lessons. The child has interested her schoolmates. Already I have a class of nice little girls."

"Good, with them you will be more successful. The Club's former teacher was 'society'. She understood the Club ladies, complimented and erased simultaneously, substituting some prettiness of her own in the place of their daubs, something which they could exhibit. They liked that. She was older, too."

The snubbing by the Vancouver Ladies' Art Club starched me. My pride stiffened, my energy crisped. I fetched my sheep-dog and cage of bullfinches from Victoria, added a bunch of white rats, a bowl of goldfish, a cockatoo and a parrot to my studio equipment and fell into vigorous, hard, happy work, finding that I had learned more during those frustrated years in England than I had supposed—narrow, conservative, dull-seeing, perhaps rather mechanical, but nevertheless honest.

Because I did not teach in the way I had been taught, parents were sceptical, but my young pupils were eager, enthusiastic. Every stroke was done from objects or direct from life-casts, live-models, still life, animals.

Young Vancouver had before been taught only from flat copy. I took my classes into the woods and along Vancouver's waterfront to sketch. A merry group we were, shepherded by a big dog, each pupil carrying a campstool and an easel, someone carrying a basket from which the cockatoo, Sally, screeched, "Sally is a Sally." That was Sally's entire vocabulary. If she was left in the studio when the class went sketching she raised such a turmoil that the neighbours objected. Out with the class, joining in the fun, Sally was too happy even to shout that Sally was a Sally.

We sat on beaches over which great docks and stations are now built, we clambered up and down wooded banks solid now with Vancouver's commercial buildings. . . .

"Indian art taught me directness"

We passed many Indian villages on our way down the coast. The Indian people and their Art touched me deeply. Perhaps that was what had given my sketch the "Indian flavour". By the time I reached home my mind was made up. I was going to picture totem poles in their own village settings, as complete a collection of them as I could.

With this objective I again went up north next summer and each successive summer during the time I taught in Vancouver. The best material lay off the beaten track. To reach the villages was difficult and accommodation a serious problem. I slept in tents, in roadmakers' toolsheds, in missions, and in Indian houses. I travelled in anything that floated in water or crawled over land. I was always accompanied by my big sheep-dog.

Indian Art broadened my seeing, loosened the formal tightness I had learned in England's schools. Its bigness and stark reality baffled my white man's understanding. I was as Canadian-born as the Indian but behind me were Old World heredity and ancestry as well as Canadian environment. The new West called me, but my Old World

heredity, the flavour of my upbringing, pulled me back. I had been schooled to see outsides only, not struggle to pierce.

The Indian caught first at the inner intensity of his subject, worked outward to the surfaces. His spiritual conception he buried deep in the wood he was about to carve. Then—chip! chip! his crude tools released the symbols that were to clothe his thought— no sham, no mannerism. The lean, neat Indian hands carved what the Indian mind comprehended.

Indian Art taught me directness and quick, precise decisions. When paying ten dollars a day for hire of boat and guide, one cannot afford to dawdle and haver this vantage point against that.

I learned a lot from the Indians, but who except Canada herself could help me comprehend her great woods and spaces? San Francisco had not, London had not. What about this New Art Paris talked of? It claimed bigger, broader seeing.

My Vancouver classes were doing well. I wrote home, "Saving up to go to Paris."

Rejected: "My pictures . . . were jeered at, insulted"

I came home from France stronger in body, in thinking, and in work than I had returned from England. My seeing had broadened. I was better equipped both for teaching and study because of my year and a half in France, but still mystified, baffled as to how to tackle our big West.

I visited in Victoria, saw that it was an impossible field for work; then I went to Vancouver and opened a studio, first giving an exhibition of the work I had done in France.

People came, lifted their eyes to the walls—laughed!

"You always were one for joking—this is small children's work! Where is your own?" they said.

"This is my own work—the new way."

Perplexed, angry, they turned away, missing the old detail by which they had been able to find their way in painting. They couldn't see the forest for looking at the trees.

"The good old camera cannot lie. That's what we like, it shows everything," said the critics. This bigger, freer seeing now seemed so ordinary and sensible to me, so entirely sane! It could not have hurt me more had they thrown stones. My painting was not outlandish. It was not even ultra.

The Vancouver schools in which I had taught refused to employ me again. A few of my old pupils came to my classes out of pity,—their money burnt me. Friends I had thought sincere floated into my studio for idle chatter; they did not mention painting, kept their eyes averted from the walls, while talking to me.

In spite of all the insult and scorn shown to my new work I was not ashamed of it. It was neither monstrous, disgusting nor indecent; it had brighter, cleaner colour, simpler form, more intensity. What would Westerners have said of some of the things exhibited in Paris—nudes, monstrosities, a striving after the extraordinary, the bizarre,

to arrest attention. Why should simplification to express depth, breadth and volume appear to the West as indecent, as nakedness? People did not want to see beneath surfaces. The West was ultraconservative. They had transported their ideas at the time of their migration, a generation or two back. They forgot that England, even conservative England, had crept forward since then; but these Western settlers had firmly adhered to their old, old, outworn methods and, seeing beloved England as it had been, they held to their old ideals.

That rootless organization, the Vancouver Ladies's Art Club, withered, died. It was succeeded by The Fine Arts Society, an organization holding yearly exhibitions in which I was invited to show.

My pictures were hung either on the ceiling or on the floor and were jeered at, insulted; members of the "Fine Arts" joked at my work, laughing with reporters. Press notices were humiliating. Nevertheless, I was glad I had been to France. More than ever was I convinced that the old way of seeing was inadequate to express this big country of ours, her depth, her height, her unbounded wideness, silences too strong to be broken—nor could ten million cameras, through their mechanical boxes, ever show real Canada. It had to be sensed, passed through live minds, sensed and loved.

I went to the Indian Village on the North Shore of Burrard Inlet often. Here was dawdling calm; no totem poles were in this village. The people were basket-weavers, beautiful, simple-shaped baskets, woven from split cedar roots, very strong, Indian designs veneered over the cedar-root base in brown and black cherry bark.

Indian Sophie was my friend. We sat long whiles upon the wide church steps, talking little, watching the ferry ply between the city and the North Shore, Indian canoes fishing the waters of the Inlet, papooses playing on the beach. . . .

Having so few pupils, I had much time for study. When I got out my Northern sketches and worked on them I found that I had grown. Many of these old Indian sketches I made into large canvases. Nobody bought my pictures; I had no pupils; therefore I could not afford to keep on the studio. I decided to give it up and to go back to Victoria. My sisters disliked my new work intensely. One was noisy in her condemnation, one sulkily silent, one indifferent to every kind of Art.

The noisy sister said, "It is crazy to persist in this way,—no pupils, no sales, you'll starve! Go back to the old painting."

"I'd rather starve! I could not paint in the old way—it is dead—meaningless—empty."

One sister painted china. Beyond mention of that, Art was taboo in the family. My kind was considered a family disgrace.

Hundreds and Thousands: The Journals of Emily Carr ### November 23, 1930: "It seems to me it helps to write things and thoughts down"

Yesterday I went to town and bought this book to enter scraps in, not a diary of statistics and dates and decency of spelling and happenings but just to jot me down in, unvarnished

me, old me at fifty-eight—old, old, old, in most ways and in others just a baby with so much to learn and not much time left here but maybe somewhere else. It seems to me it helps to write things and thoughts down. It makes the unworthy ones look more shamefaced and helps to place the better ones for sure in our minds. It sorts out jumbled up thoughts and helps to clarify them, and I want my thoughts clear and straight for my work.

I used to write diaries when I was young but if I put anything down that was under the skin I was in terror that someone would read it and ridicule me, so I always burnt them up before long. Once my big sister found and read something I wrote at the midnight of a new year. I was sorry about the old year, I had seemed to have failed so, and I had hopes for the new. But when she hurled my written thoughts at me I was angry and humbled and hurt and I burst smarting into the New Year and broke all my resolutions and didn't care. I burnt the diary and buried the thoughts and felt the world was a mean, sneaking place. I wonder why we are always sort of ashamed of our best parts and try to hide them. We don't mind ridicule of our "sillinesses" but of our "sobers," oh! Indians are the same, and even dogs. They'll enjoy a joke with you, but ridicule of their "reals" is torment.

When I returned from the East in 1927, Lawren Harris and I exchanged a few letters about work. They were the first real exchanges of thought in regard to work I had ever experienced. They helped wonderfully. He made many things clear, and the unaccustomed putting down of my own thoughts in black and white helped me to clarify them and to find out my own aims and beliefs. Later, when I went East this Spring, I found he had shown some of my letters to others. That upset me. After that I could not write so freely. Perhaps it was silly, but I could not write my innermost thoughts if *anybody* was to read them, and the innermost thoughts are the only things that count in painting. I asked him not to. He saw my point and said he wouldn't. I trust him and can now gabble freely. Still, even so, I can't write too often, hence this jotting book for odd thoughts and feelings.

I've had a good Sunday in the blessed quiet studio. Pulled out my summer sketches and tried to get busy. It wouldn't come. I got to the typewriter and described Fort Rupert minutely, its looks and feeling and thoughts. Then I got to some charcoal drawing and commenced to *feel* it but got nothing very definite. At night I heard a sermon where the Children of Israel said their enemies regarded them as "grasshoppers" and they felt they were. How they lacked faith and failed, he said. Everyone needed faith in God and faith in himself. The good of the sermon was all undone by the beastly streetcars. Took me till after ten to get home. I was chilled to the bone waiting on corners in fog and got very ratty and rasped. Went to bed with nerves jangling.

November 24, 1930: "I must pep up"

This morning I've tried the thing on canvas. It's poor. I got a letter from Tobey. He is clever but his work has no soul. It's clever and beautiful. He knows a lot and talks

well but it lacks something. He knows perhaps more than Lawren, but how different. He told me to pep my work up and get off the monotone, even exaggerate light and shade, to watch rhythmic relations and reversals of detail, to make my canvas two thirds half-tone, one third black and white. Well, it sounds good but it's rather painting to recipe, isn't it? I know I am in a monotone. My forests are too monotonous. I must pep them up with higher contrasts. But what is it all without soul? It's dead. It's the hole you put the thing into, the space that wraps it round, and the God in the thing that counts above everything. Still, he's right too. I must pep up. I wonder if he had seen my stuff in Seattle. I thought perhaps Hatch would write but no word, only a printed invitation to preview some Japanese prints and temporary shows, so I suppose I'm lumped with the "temporary shows." It's a bit of a kick and goes to show I am conceited and thought my show was to be the main item of the galleries in Seattle for the month, but I'm only lumped in "temporary."

June 17, 1931: "What is it you are struggling for?"

I am always asking myself the question, What is it you are struggling for? What is that vital thing the woods contain, possess, that you want? Why do you go back and back to the woods unsatisfied, longing to express something that is there and not able to find it? This I know, I shall not find it until it comes out of my inner self, until the God quality in me is in tune with the God in it. Only by right living and a right attitude towards my fellow man, only by intense striving to get in touch, in tune with, the Infinite, shall I find that deep thing hidden there, and that will not be until my vision is clear enough to see, until I have learned and fully realize my relationship to the Infinite.

November 12, 1932: "See God in it all"

Go out there into the glory of the woods. See God in every particle of them expressing glory and strength and power, tenderness and protection. Know that they are God expressing God made manifest. Feel their protecting spread, their uplifting rise, their solid immovable strength. Regard the warm red earth beneath them nurtured by their myriads of fallen needles, softly fallen, slowly disintegrating through long processes, always living, changing, expanding round and round. It is a continuous process of life, eternally changing yet eternally the same. See God in it all, enter into the life of the trees. Know your relationship and understand their language, unspoken, unwritten talk. Answer back to them with their own dumb magnificence, soul words, earth words, the God in you responding to the God in them. Let the spoken words remain unspoken, but the secret internal yearnings, wonderings, seekings, findings—in them is the communion of the myriad voices of God shouting in one great voice, "I am one God. In all the universe there is no other but *me*. I fill all space. I am all time. I am heaven. I am earth. I am all in all."

Listen, this perhaps is the way to find that thing I long for: go into the woods alone and look at the earth crowded with growth, new and old bursting from their strong roots hidden in the silent, live ground, each seed according to its own kind expanding, bursting, pushing its way upward towards the light and air, each one knowing what to do, each one demanding its own rights on the earth. Feel this growth, the surging upward, this expansion, the pulsing life, all working with the same idea, the same urge to express the God in themselves—life, life, life, which *is* God, for without Him there is no life. So, artist, you too from the deeps of your soul, down among dark and silence, let your roots creep forth, gaining strength. Drive them in deep, take firm hold of the beloved Earth Mother. Push, push towards the light. Draw deeply from the good nourishment of the earth but rise into the glory of the light and air and sunshine. Rejoice in your own soil, the place that nurtured you when a helpless seed. Fill it with glory—be glad.

December 2, 1932: "Stick to the one central idea"

Half of painting is listening for the "eloquent dumb great Mother" (nature) to speak. The other half is having clear enough consciousness to see God in all.

Do not try to do extraordinary things but do ordinary things with intensity. Push your idea to the limit, distorting if necessary to drive the point home and intensify it, but stick to the one central idea, getting it across at all costs. Have a central idea in any picture and let all else in the picture lead up to that one thought or idea. Find the leading rhythm and the dominant style or predominating form. Watch negative and positive colour.

January 27, 1933: "The sketches should convey the essence of the idea"

The sunset was grand after a wet day. The dogs and I walked on the shore. Your eye ran across level green expanse of water fretted and foaming on the beach and rocks. Serene. Far out it ended mistily in pale space line, then rose to a sky full of low soft clouds with the domed blue above.

The People's Gallery scheme is over for the present. It was a good idea and I am convinced put for some purpose into my mind. I went ahead as far as I could; then it came to a *cul de sac:* no money, no help, no nothing but to let her lie by and sleep and some day she may revive. I don't know now. My energies are centred on the cliffs and sea. Have made six paper sketches. Looked them over today—too stodgy, just paint, not inspiration. I must go out and feel more.

In working out canvas from sketches, the sketches should convey the essence of the idea though they lack the detail. The thing that decided you to attempt that particular subject should be shown, more or less. Take that small sketch home and play with it on paper with cheap material so that you may not feel hampered but dabble away

gaily. Extravagantly play with your idea, keep it fluid, toss it hither and thither, but always let the *idea* be there at the core. When certainty has been arrived at in your mind, leave the sketch alone. Forget it and put your whole thought to developing the idea.

Empty yourself, come to the day's work free, open, with no preconceived ideas, no set rule of action, open and willing to be led, receptive and obedient, calm and still, unhurried and unworried over the outcome, only sincere and alert for promptings. Cast out the personal, strive for the spiritual in your painting. Think only of the objective. Desire only that the consciousness of the presence of God may show and speak, not as accomplished by you, not as your work, not as having anything to do with you, but being only a reminder and an explainer of the manifested Father, the Christ. You yourself are nothing, only a channel for the pouring through of that which *is* something, which is all. Your job is to keep that channel clear and clean and pure so that which passes through may be unobstructed, unsullied, undiluted and thus show forth its clear purity and intention. Strive for this thing, for the stillness that should make it possible. Do not let it be a worried obsession causing your life to become a struggle and turmoil but let go that the spirit may work in calm and peace. Learn by listening attentively, be aware of your aliveness, alert to promptings.

January 16, 1934: "Nothing hurts like nothingness"

Here I am, little book, having neglected you for some time. I have written to Lawren twice, so that does you out of your little spiel for I work it off on him instead of on you. It's all the same as long as you can get it off your chest, only it's easier when there is flesh and blood at the other end and, more than that, an answering spirit. . . .

My six pictures came home from Ottawa yesterday, returned without thanks, no praise, no blame. Wish Brown had said something even if it had been bad that would have put my back up. Nothing hurts like nothingness. A flat, blunt weapon gives the deepest, most incurable wound. I look at the pictures and wonder are they better than my present-day ones—this year's? I don't know but I do not *think* they are. I think they have better colour and perhaps more strength but any shapely or fine-coloured object can be pleasing. (Not that Mr. Brown did find my pictures pleasing; apparently the reverse.) But as I look at my big forest I find a lack of life—the essence. If manufactured materials were heaped together in a good light and pleasing folds wouldn't they do just as well? That is not what I want—the thing I search for. They lack that vital understanding thing, which must grow and develop and unfold in you yourself before it can come out.

March 18, 1934: "Three women from the Business and Professional Women's Club"

Ah, little book, I owe you an apology. I've got to like you despite how silly you seemed to me when Lawren suggested I start you. You help me to sort and formulate thoughts

and you amuse me, which is more than housecleaning does, and that is what I have been doing for the week. Well, it's all in the day's march, but the housecleaning march is bad, uphill going, stony, grim, and grimy, and nothing so unflinchingly and brutally tells you your exact age.

Three women from the Business and Professional Women's Club came out to select the picture I told them they could have to hang in their clubroom. Two stiff-backs came, just. I could feel them bristle as they entered the studio. I asked what space they had and what sort they wanted. One of them said, "I like your Indian" (an old, old man). Well, I brought out some. Nothing suited. They sniffed and stared and stared and sniffed while I felt helpless, irritated. A third dame of selection was to come later. Well, I fumbled round the canvases trying to see things with their eyes, and couldn't. My stature simply isn't business profession. However, No. 3 came duly and pretty quickly sorted out her likes and the others' dislikes. They took the despised "Mountain" which the Easterners saw nothing in. Gee! I wrestled with that mountain and I'm not through with "it" (the subject) yet.

Yesterday Phil took me on a van location hunt. We found one I like greatly, the Esquimalt Lagoon. Wide sweeps of sea and sky, drift galore, and hillside and trees, and great veteran pines. It will be some time yet before I can go. We looked in *en route* to see the Elephant and jacked her up higher. The dear beast looked O.K. It was the lovely time of day and the Lagoon and woods were at their best—mysterious, the material dormant, the spiritual awake. I *think* I could paint there.

April 4, 1934: On Van Gogh

I work this morning with "unity of movement" in a picture strong in my mind. I believe Van Gogh had that idea. I did not realize he had striven for that till quite recently so I did not come by the idea through him. It seems to me that clears up a lot. I see it very strongly out on the beach and cliffs. I felt it in the woods but did not quite realize what I was feeling. Now it seems to me the first thing to seize on in your layout is the direction of your main movement, the sweep of the whole thing as a unit. One must be very careful about the transition of one curve of direction into the next, vary the length of the wave of space but *keep it going,* a pathway for the eye and the mind to travel through and into the thought. For long I have been trying to get these movements of the parts. Now I see there is only *one* movement. It sways and ripples. It may be slow or fast but it is only one movement sweeping out into space but always keeping going—rocks, sea, sky, one continuous movement.

April 16, 1937: "I have been forgetting Canada and forgetting women painters"

I heard yesterday about my one-man show in Toronto. There were about twenty canvases collected from Toronto and Ottawa. I got two good write-ups from different papers and two letters, also a cheque for $50 from a Miss Lyle for a canvas.

I have been thinking that I am a shirker. I had dodged publicity, hated write-ups and all that splutter. Well, that's all selfish conceit that embarrassed me. I have been forgetting Canada and forgetting women painters. It's them I ought to be upholding, nothing to do with puny me at all. Perhaps what brought it home was the last two lines of a crit in a Toronto paper: "Miss Carr is essentially Canadian, not by reason of her subject matter alone, but by her approach to it." I am glad of that. I am also glad that I am showing these men that women can hold up their end. The men resent a woman getting any honour in what they consider is essentially their field. Men painters mostly despise women painters. So I have decided to stop squirming, to throw any honour in with Canada and women. It is wonderful to feel the grandness of Canada in the raw, not because she is Canada but because she's something sublime that you were born into, some great rugged power that you are a part of.

April 17, 1937: "I must never think of sales while I am painting"

Today another cheque came, for $225. It's almost unbelievable. Mr. McLean of Toronto bought one little old canvas and one brand new. Everyone is tickled. One thing I must guard against, I must never think of sales while I am painting. Sure as I do, my painting will roll downhill. Mr Band writes, "I am considering 'Grey.' Do you like it? I do." Yes and no. I did like it and many people have liked it, but since painting it my seeing has perhaps become more fluid. I was more static then, and was thinking more of effect than spirit. It is like the difference between a play and real life. No matter how splendid the acting is you can sit there with your heart right in your mouth but way down inside you know that it is different to the same thing in life itself.

Georgia O'Keeffe (1887–1986)

Georgia O'Keeffe's position in the history of twentieth-century American art is secured. She "excites an interest exceeding that of any other pre–World War II American artist and rivaling that of most postwar artists as well."[1] Self-consciously rejecting Cubism and other modernist forms of abstraction, O'Keeffe's images of the southwestern plains, of flowers, of dried bones found in the desert are haunting and powerful images. In a traveling exhibition that toured the country from 1987 to 1989, her works were widely viewed. However, as Anna Chave has noted, her popular success has not been accompanied by serious critical and art-historical inquiry. Like Berthe Morisot, her painting has been seen as an instinctual feminine product, located outside of any clearly defined American movements.

O'Keeffe's writing survives in several forms. She wrote a brief autobiographical statement about her early life, which was published in 1976; two excerpts are reprinted here, dealing with her early sense of vocation as an artist and the life class at the Art Institute of Chicago. In that volume, statements written for three solo exhibitions—in 1923, 1939, and 1944—were reprinted. These three statements contain important evidence of her attitudes toward her work, its critical reception, and her most characteristic subjects of these years. One other statement, concerning the "Great American Painting," reveals her nationalism and integration into the literary circles of New York in the 1930s.

The volume published in conjunction with her recent retrospective printed a large number of previously unpublished letters.[2] These letters, written over a period of sixty-five years to a wide range of correspondents, contain a more authentic and richly textured voice than the self-conscious statements crafted by the artist for publication. For this reason, several letters were selected for inclusion in this volume as well.

O'Keeffe was born on the plains of Wisconsin, and throughout her life the open spaces of the American landscape would attract her physically and imaginatively. She recalls wanting to be an artist by the time she was about 13. As early as 1901, O'Keeffe was receiving formal academic training, first in a convent school in Madison, then at the Art Institute of Chicago. Her experience in the "life class" there is described in the

second excerpt. Eventually she went to the Art Students League in New York. During the summer of 1912, she was introduced to the ideas of Arthur Wesley Dow by Alon Bement.[3] O'Keeffe responded to Dow's rejection of Western academic traditions, and she taught these principles over the next four years in Virginia, South Carolina, and Texas. It was from South Carolina that O'Keeffe wrote to her best friend, Anita Pollitzer, about the struggle to find a personal style and her desire for Alfred Stieglitz, more than anyone else, to validate her work. As an art student in New York, O'Keeffe was well aware of his 291 Gallery and its role in setting avant-garde taste in America.

O'Keeffe states the attitude of "Let them all be damned—I'll do as I please" that she was striving for in 1915. At the very end of that year, O'Keeffe packaged a group of her drawings and mailed them to Pollitzer, who in response to O'Keeffe's previous letter, showed them to Stieglitz. Thus began the most important and enduring personal and professional relationship of O'Keeffe's life. Between 1916 and Stieglitz's death in 1946, O'Keeffe's works were shown to the public in roughly annual exhibitions in Stieglitz's galleries. The second letter reprinted here is a response to one Stieglitz had mailed to her, and dates from the very beginning of their relationship. Courtship and marriage, in 1924, would eventually bond the couple.

Midway through that academic year of teaching, O'Keeffe wrote Pollitzer a letter, dated January 17, 1917, about a lecture she presented at the local Faculty Club, which documents her wide-ranging reading in theories of modern art. This information helps counteract the myth of the naive, instinctual artist. Also in the letter is a humorous account of a thwarted relationship with a local lawyer in this small, isolated Texas town. She was preparing another batch of her work; still lacking confidence, she tells Pollitzer, "You or Stieglitz will get it—I don't know which—won't know till I address it." This was to be her final year of teaching. With Stieglitz's financial support, she moved to New York and began creating the body of work for which she is so famous. During the twenties, she began painting her remarkable series of close-up flower images as well as some original views of Manhattan.

The next letter reprinted here is O'Keeffe's response to the review that Henry McBride wrote about her first major New York exhibition, in 1923. McBride was one contemporary reviewer who recognized the sexual implications of O'Keeffe's imagery. In a recent article, Chave characterizes O'Keeffe's art in the following terms:

O'Keeffe portrayed abstractly, but unmistakably, her experience of her own body, not what it looked like to others. The parts of the body she engaged were mainly invisible (and unrepresented) due to interiority, but she offered viewers an ever-expanding catalogue of visual metaphors for those areas, and for the experience of space and penetrability generally.[4]

Chave connects this awareness with the contemporary political campaign for reproductive freedom through access to contraception, and one might add the feminist euphoria in the aftermath of the successful battle for female suffrage. Such an interpretation, however persuasively argued, still remains speculative. In fact, O'Keeffe made numerous disclaimers of all sexual metaphor in her works. However, in her next letter she appeals

to Mabel Dodge Luhan, as a woman, to interpret her works differently from male critics. This correspondent was the catalyst for O'Keeffe's introduction to the landscape of Taos, New Mexico. Between 1929 and the settling of the Stieglitz estate in 1949, O'Keeffe spent most of her summers in New Mexico and her winters in New York. After 1949 she settled permanently in the remote town of Abiquiu, New Mexico, where she resided until her death. Her next letter to McBride, written during this first summer in New Mexico, conveys vividly her sense of "feeling in the right place again," her general euphoria when in contact with this region. On her way back to New York, she wrote Ettie Stettheimer another interesting account of her first New Mexico experience.

The next reprinted letter is addressed to the director of the Cleveland Art Museum, which had just purchased her *White Flower* (Fig. 14). We have an example of O'Keeffe's attempt to explain, in her own words, one of her famous images.

In her letter to Vernon Hunter,[5] she articulates her feelings about living most of the year with Stieglitz and the lure of New Mexico. In a poignant way, she speaks of her "divided self." In the next letter to a friend, the writer Jean Toomer, she reveals a powerful metaphor of her core essence as a "center," "a plot of warm moist well-tilled earth . . . starkly empty." This letter is exceptional in its intimate tone. The following letter, her response to her recent visit to the noted architect Frank Lloyd Wright, is of

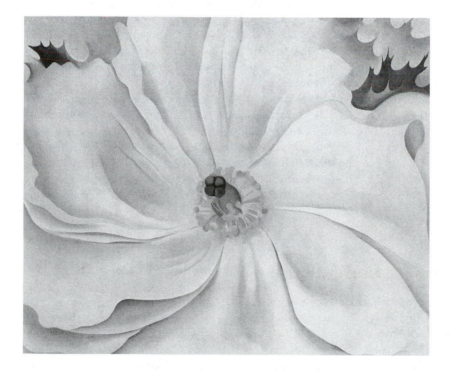

Figure 14. Georgia O'Keefe, *White Flower*. The Cleveland Museum of Art.

interest for its revealing comments about the way Stieglitz controlled the dissemination of her works. The letter to Eleanor Roosevelt clarifies O'Keeffe's political feminism in the 1940s, including her support for an Equal Rights Amendment.

The last letter selected for inclusion is addressed to James Johnson Sweeney, the curator of the Museum of Modern Art, who organized an exhibition of her works in 1946. The letter expresses ambivalent attitudes toward the public display of her paintings; her modesty, like Artemisia Gentileschi's, is coupled with pride in her achievements: "I am one of the few who gives our country any voice of its own."

O'Keeffe lived out the rest of her life, almost thirty years, in the splendid isolation of the New Mexico desert. Her divided self was now unified, although her years of greatest artistic activity were finished.

She was honored with major retrospective exhibitions at the Art Institute of Chicago in 1943, the Museum of Modern Art in 1946, and the Whitney Museum in 1970. That year, O'Keeffe was awarded the Gold Medal for Painting by the National Institute of Arts and Letters. Her paintings are found in most major museums. It is certainly a testimony to the power of her imagery that their interpretation continues to fascinate the public as well as art historians and critics, whether avowedly feminist or not.

"I am going to be an artist"

The year I was finishing the eighth grade, I asked our washwoman's daughter what she was going to do when she grew up. She said she didn't know. I said very definitely— as if I had thought it all out and my mind was made up—"I am going to be an artist."

I don't really know where I got my artist idea. The scraps of what I remember do not explain to me where it came from. I only know that by that time it was definitely settled in my mind. I hadn't seen many pictures and I hadn't a desire to make anything like the pictures I had seen. But in one of my mother's books I had found a drawing of a girl that I thought very beautiful. The title under it was "Maid of Athens." It was a very ordinary pen-and-ink drawing about two inches high. For me, it just happened to be something special—so beautiful. Maybe I could make something beautiful . . . I think my feeling wasn't as articulate as that, but I believe that picture started something moving in me that kept on going and has had to do with the everlasting urge that makes me keep on painting.

The Life Class at the Art Institute of Chicago

I have never understood why we had such dark olive green rooms for art schools. The Anatomy Class was in one of those dark-colored half-lighted dismal rooms. When I went in, the room was full. Most of the students were much older than I was. I was a little girl with a big black ribbon bow on my braid of hair. The man teaching had a soft light-brown beard and an easy way of moving and speaking. After talking a while he ⁀d, "Come out," to a curtain I hadn't noticed. Out walked a very handsome, lean,

dark-skinned, well-made man—finely cut face, dark shining hair, dark moustache—naked except for a small loincloth. I was surprised—I was shocked—blushed a hot and uncomfortable blush—didn't look around in my embarrassment and don't remember anything about the anatomy lesson. It was a suffering. The class only came once a week and I had to make up my mind what I was going to do about it before time for the next lesson. I still had the idea that I wanted to be an artist. I thought that meant I had to go to art school. Drawing casts in the upstairs gallery wouldn't go on forever. If I was any good at all I'd be promoted to the Life Class where there would be nude models. It was something I hadn't counted on but had to face if I was going to be an artist. I don't know why it seemed so difficult. In the summer when we went swimming down on the river a boy my age wore the least little piece of a bathing suit and I don't remember thinking anything about it except that he was blond and beautiful and laughing. The bare figure in that dismal dark classroom with everybody else dressed was different—he was definitely there to be looked at. Maybe if I had had a passionate interest in anatomy I wouldn't have been shocked. But I had no interest at all in anatomy and the long names of things—the teacher did not connect it in any way with my drawing upstairs. When the next lesson came and everyone else drifted in the direction of the Anatomy Class, I drifted in, too. I don't remember learning anything except that I finally became accustomed to the idea of the nude model.

To Anita Pollitzer, October 11, 1915:
"I would rather have Stieglitz like something . . .
than anyone else I know of"

Anita

——arent you funny to wonder if I like your letters. I was walking up from the little bandbox post office with the mail under my arm—reading your letter this afternoon—and when I came to the part telling what Stieglitz said about "its worth going to Hell to get there"—I laughed aloud—and dropped all the things under my arm

I had gone for the mail because I had worked till—what I thought didnt count—so it wasn't any use to keep on—I read your letter twice then went for a walk with about eight of the girls—it was supposed to be a run—and they were all very much astonished that none of them could keep up with me——I can run at a jog trot almost as easily as I can walk—and most girls cant you know.

We explored much woods and country and found the quaintest little deserted house imaginable with wonderful big pink and white and yellow roses climbing on it—and funny little garden effects——all surrounded by great tall pines

It would have been too cold to go without a coat if we hadn't run most of the way——whenever they had breath——so you know how great it felt

I came back and read your letter again

Anita——do you know——I believe I would rather have Stieglitz like something——anything I had done——than anyone else I know of——I have always thought

that——If I ever make anything that satisfies me ever ever so little—I am going to show it to him to find out if its any good—Don't you often wish you could make something he might like?

Still Anita—I dont see why we ever think of what others think of what we do—no matter who they are—isn't it enough just to express yourself——If it were to a particular person as music often is—of course we would like them to understand—at least a little——but why should we care about the rest of the crowd—If I make a picture to you why should I care if anyone else likes it or is interested in it or not I am getting a lot of fun out of slaving by myself—The disgusting part is that I so often find myself saying——what would you—or Dorothy—or Mr. Martin or Mr. Dow—or Mr. Bement—or somebody—most anybody——say if they saw it—It is curious—how one works for flattery——

Rather it is curious how hard it seems to be for me right now not to cater to someone when I work——rather than just to express myself.

During the summer—I didn't work for anyone—I just sort of went mad usually—I wanted to say "Let them all be damned—I'll do as I please"——It was vacation after the winter—but—now——remember Ive only been working a week——I find myself catering to opinion again—and I think I'll just stop it.

Anita—I just want to tell you lots of things—we all stood still and listened to the wind way up in the tops of the pines this afternoon——and I wished you could hear it—I just imagined how your eyes would shine and how you would love it—I haven't found anyone yet who likes to live like we do—

<div align="right">Pat.</div>

Saturday night.

To Alfred Stieglitz, September 4, 1916:
"How great it would be to be near you and talk to you"

Your letter this morning is the biggest letter I ever got——Some way or other it seems as if it is the biggest thing anyone ever said to me—and that it should come this morning when I am wondering—no I'm not exactly wondering but what I have been thinking in words—is—*I'll be damned* and I want to damn every other person in this little spot—like a nasty petty little sore of some kind—on the wonderful plains. The plains—the wonderful great big sky—makes me want to breathe so deep that I'll break—There is so much of it—I want to get outside of it all—I would if I could—even if it killed me—

I have been here less than 12 hours—slept eight of them—have talked to possibly 10 people—mostly educators—*think* quick for me—of a bad word to apply to them—the *little* things they forced on me——they are so just like folks get the depraved notion they ought to be——that I feel its a pity to disfigure such wonderful country with people of any kind—I wonder if I am going to allow myself to be paid 1800 dollars a year to get like that—I never felt so much like kicking holes in the world in my life—still there

is something great about wading into this particular kind of slime that I've never tried before—alone—wondering—if I can keep my head up above these little houses and know more of the plains and the big country than the little people

Previous contacts make some of them not like my coming here

So—you see it was nice to get a big letter this morning—I needed it—

I walked and heard the wind—the trees are mostly locust bushes 20 feet high or less—mostly less—and a prairie wind in the locust has a sound all its own——like your pines have a sound all their own—I opened my eyes and simply saw the wallpaper——It was so hideously ugly—I remembered where I was and shut my eyes right tight so I couldn't see it—with my eyes shut I remembered the wind sounding just like this before—

I didn't want to see the room—it's so ugly—it's awful and I didn't want to look out the window for fear of seeing ugly little frame houses—so I felt for my watch—looked at it—decided I needn't open my eyes again for 15 minutes—The sound of the wind is great——but the pink roses on my rugs! And the little squares with three pink roses in each one—dark lined squares—I have half a notion to count them so you will know how many are hitting me—give me flies and mosquitoes and ticks——even fleas——every time in preference to three pink roses in a square with another rose on top of it

Then you mentioned me in purple—I'd be about as apt to be naked——don't worry——! don't you hate pink roses!

As I read the first part of your letter—saying you hadn't looked at the stuff I left for my sister to send you—I immediately thought—I'd like to run right down and telegraph you not to open them—then—that would be such a foolish thing to do

Not foolish to me—or for me—but the other queer folks who think I'm queer

There is dinner—and how I hate it—You know—I——

I waited till later to finish the above sentence thinking that maybe I must stop somewhere with the things I want to say——but I want to say it and I'll trust to luck that you'll understand

Your letter makes me feel like Lafferty's paintings——they made me want to go right to him quick—your letter makes me want to just shake all this place off—and go to you and the lake—but—there is really more exhilaration in the fight here than there could possibly be in leaving it before it's begun—like I want to—

After mailing my last letter to you I wanted to grab it out of the box and tell you more—I wanted to tell you of the way the outdoors just gets me—

Some way I felt as if I hadn't told you at all—how big and fine and wonderful it all was—

It seems so funny that a week ago it was the mountains I thought the most wonderful—and today it's the plains—I guess it's the feeling of bigness in both that just carries me away—and Katherine,—I wish I could tell you how beautiful she is

Living? Maybe so—When one lives one doesn't think about it, I guess—I don't know. The plains send you greetings——Big as what comes after living—if there is anything it must be big——and these plains are the biggest thing I know.

My putting you with Lafferty is really wrong—his things made me feel that *he* needed.

Your letter coming this morning made me think how great it would be to be near you and talk to you——you are more the size of the plains than most folks—and if I could go with my letter to you and the lake—I could tell you better—how fine they are—and more about all the things I've been liking so much but I seem to feel that you know without as much telling as other folks need.

To Anita Pollitzer, January 17, 1917:
Talk on "Modern Art" at the Faculty Circle

Dear Anita:

Guess I havent written you for a long time but you know——sometimes the Devil just gets me by the ears and this time he pulled them out of joint and I've been so surprised and amused that I've just been looking on laughing—so of course didn't do anything else.

I had to give a talk at the Faculty Circle last Monday night——a week ago yesterday—so I had been laboring on Aesthetics—Wright—Bell—DeZayas—Eddy—All I could find—everywhere—have been slaving on it since in November——even read a lot of Caffin[6]——lots of stupid stuff—and other stuff too——Having to get my material into shape——Modern Art——to give it in an interesting 3/4 of an hour to folks who know nothing about any kind of Art——Well—I worked like the devil—and it was a great success——You see—I hadn't talked to the faculty at all and I was determined to get them going——They kept me going all through the time allotted to the man who was to come after me and an hour after it was time to go home—and some of them wanted me to talk again next time——It was funny—I planned to say things that would make them ask questions—Really——I had a circus It was so funny to see them get so excited over something they had doubts about the value of——

But that isn't all—You know that kind of reading and thinking takes one very much off the earth

——So imagine my astonishment to have a mere—ordinary—everyday man pull me out of the clouds with two or three good yanks and knock me down on the earth so hard that I waked up. I met him at a party Xmas time——next time I went to town he followed me around till I was alone then asked if he could come up—I said—No—— thinking we had absolutely no interests in common——but he looked so queer—I changed my mind right quick and said he could——then held up my hands in holy horror wondering what I'd do—So—The first time he came because I didn't want to hurt his feelings—and the next time because I wanted to explain something I had said the first time——And then my landlady informed me that she objected to my having anyone come to see me at all——and I nearly died laughing because—I had begun to enjoy the problem of trying to talk to him—It was so impossible that it was funny— He is prosecuting attorney in the court here——Yale—etc—but you see I am almost

hopelessly specialized—and had been thinking and reading and working so specially hard on a specialized line that there wasnt much else in my brain——so I practiced on him— he was a fair sample of the mind Id have to tackle in Faculty Circle——and he seemed interested—but I couldn't imagine why—

The night the old lady said she didn't want anyone to come any more—he was coming——and Anita——I had written Arthur such a funny letter day before—and Stieglitz that morning

When he came—I had to tell him right away about the old lady and that he couldn't come anymore—it was so funny——And you know I cant move Anita because there isnt any place to move to—I have had rooms engaged for over a month in a house that's being built

Well——he said——lets not stay here lets ride so I got my coat and hat——and off we went—

We rode a long time——it was a wonderful lavender sort of moonlight night—— Went out to some hills in a canyon draw that I wanted to see at night and stopped facing the hills

It was really wonderful—only someway he isn't the kind you enjoy outdoors with——he spoils it——I was in a wildly hilarious humor——We got out and walked a long way—It was warm—almost like summer—When we got back in the car we sat there talking a long time——I was leaning forward—looking over toward the hills telling some yarn—and bless you——when I sat back straight—his arm was around me—— Jingles—it was funny—we argued—we talked—we all but fought——and he couldn't understand because it amused me so——I almost died laughing—Of all the people in the world to find themselves out at the end of the earth——The barest hills you ever saw in front—nothing but plains behind——beautiful lavender moonlight—and that well fed piece of human meat wanting to put his arms round me——I wonder that the car didn't scream with laughter——and still I wouldn't get mad because he was so darned human and it was so funny——

—Anyway—it tumbled me out of the clouds—sort of stupefied me—it was two weeks ago tonight—I have been thinking more than I've been doing——Then too there has been the problem of Summer School to decide—9 weeks work $340 or $450 looks very good——so does 3½ months doing as I please—Va wrote and asked me back and I answered but know they won't give me what I want——I don't want to go back anyway.

——Many things to make me think——or try to think——and very little doing—

Tonight I'm doing up all my work——am going to send it off in the morning—— You or Stieglitz will get it——I dont know which—wont know till I address it

Im going to start all new——

It has snowed for almost three days—is great out——

I looked at the moon many times the night of the eclipse—it was wonderful here too.

Goodnight

I read this over——Have been walking in the snow——its wonderful out——cold dark.

——When I had read it over I said to myself——hardly worth sending its so stupid
It doesn't sound funny when I write it——but in reality was so funny when it
happened——I had almost forgotten about it till I thought of writing you——curious
the way things that happen start you thinking of other things——made me restless——
want people—I've talked more than usual with the girls and boys——Have been teaching
in the first and second grades—training school—just because I want to— . . . cracked I
guess

Statement from the Exhibition Catalogue, Anderson Galleries, 1923

I grew up pretty much as everybody else grows up and one day seven years ago found
myself saying to myself—I can't live where I want to—I can't go where I want to—I
can't do what I want to—I can't even say what I want to. School and things that
painters have taught me even keep me from painting as I want to. I decided I was a
very stupid fool not to at least paint as I wanted to and say what I wanted to when I
painted as that seemed to be the only thing I could do that didn't concern anybody but
myself—that was nobody's business but my own. So these paintings and drawings hap-
pened and many others that are not here. I found that I could say things with color and
shapes that I couldn't say in any other way—things that I had no words for. Some of
the wise men say it is not painting, some of them say it is. Art or not Art—they
disagree. Some of them do not care. Some of the first drawings done to please myself I
sent to a girl friend requesting her not to show them to anyone. She took them to
"291" and showed them to Alfred Stieglitz and he insisted on showing them to others.
He is responsible for the present exhibition.

I say that I do not want to have this exhibition because, among other reasons,
there are so many exhibitions that it seems ridiculous for me to add to the mess, but I
guess I'm lying. I probably want to see my things hang on a wall as other things hang
so as to be able to place them in my mind in relation to other things I have seen done.
And I presume, if I must be honest, that I am also interested in what anybody else has
to say about them and also in what they don't say because that means something to me,
too.

To Henry McBride, February 1923:
"Your notice pleased me immensely"

My dear Henry McBride:
After a week of my exhibition I took myself to bed with the grippe—it was the day
before your advice about the nunnery came out in the Sunday paper—or I might have
chosen the nunnery instead
——However—six days in bed with the grippe is a fair substitution for a nunnery—
and I had plenty of time to think about my sins—.
Your notice pleased me immensely—and made me laugh—. I thought it very

funny—. I was particularly pleased—that with three women to write about you put me first——My particular kind of vanity—doesn't mind not being noticed at all . . . and I dont even mind being called names——but I dont like to be second or third or fourth— I like being first—if Im noticed at all—thats why I get on with Stieglitz—with him I feel first—and when he is around—and there are others——he is the center and I dont count at all

Now these are secrets—and dont you tell all New York about it or everyone will know how to hurt my feelings—and I'll have to get a new set—

—One more thing I must tell you—Marin brought his new work over last week— and the first day I was out of bed Stieglitz brought it to me to look at (first) I spent the whole day with it—

I think it by far the best he has ever done—Several wonderful sail boats—I feel like going out and robbing someone for him—So he wont have to worry about money—. I wanted to spend all that I got from my show on them—Stieglitz laughs at me—but he is quite as excited himself——

You must see them soon—I'd like to send one of the sail boats to get you—but you will probably have to come up some other way—

There are wonderful houses too—and a great sea—You must see them soon

Sincerely—and thanks again for the notice

<div align="right">Georgia O'Keeffe</div>

I must add that I dont mind if Marin comes first—because he is a man—its a different class—

To Mabel Dodge Luhan, ca. 1925: "There is something unexplored about woman that only a woman can explore"

Mabel Luhan:

About the only thing I know about you—from meeting you—is that I know I dont know anything.—That I like—because everybody else knows—So when they say— "Dont you think so?" I dont think so—I dont think at all because I cant.—No clue to think from—except that I have never felt a more feminine person——and what that is I do not know—so I let it go at that till something else crystalizes

Last summer when I read what you wrote about Katherine Cornell I told Stieglitz I wished you had seen my work—that I thought you could write something about me that the men cant—

What I want written—I do not know—I have no definite idea of what it should be—but a woman who has lived many things and who sees lines and colors as an expression of living—might say something that a man cant—I feel there is something unexplored about woman that only a woman can explore—Men have done all they can do about it.—Does that mean anything to you—or doesn't it?

Do you think maybe that is just a notion I have picked up—or made up—or just like to imagine? Greetings from us both—And kiss the sky for me—

You laugh—But I loved the sky out there

Georgia O'Keeffe—

To Henry McBride, Summer 1929: "I feel like myself—and I like it"

My best greetings to you Henry McBride—and I hope this finds you very fine and fit. Stieglitz wrote me yesterday that he had a letter from you yesterday—and I—wanting one too—decided the only way to get it would be to write for it.

I am having a wonderful time—such a wonderful time that I dont care if Europe falls off the map or out of the world—or where it goes to

You know I never feel at home in the East like I do out here—and finally feeling in the right place again—I feel like myself—and I like it—and I like what Mabel has dug up out of the Earth here with her Indian Tony crown—No one who hasn't seen it and who hasn't seen her at it can know much about this Taos Myth—It is just unbelievable——One perfect day after another—everyone going like mad after something—even if it is only sitting in the sun

I have the most beautiful adobe studio—never had such a nice place all to myself—Out the very large window to a rich green alfalfa field—then the sage brush and beyond—a most perfect mountain—it makes me feel like flying—and I don't care what becomes of Art—

We wired Marin to come out—and he came—He is having a great time too. Stieglitz says we are being ruined for home—and I feel like saying I am glad of it—.

When you say you like Mabel—I must tell you—you really dont even imagine half of what you are liking—Just the life she keeps going around her would be a great deal—but that along with this country is almost too much for anyone to have in this life—However I am standing it well—never felt better—I often think how much it would all entertain you—Do write me that you are having a good summer—and if you are not—just get up and leave it—and go where you will have a good time—or like something or other—Have I painted? I dont know—I hope to—but I really dont care

There are four nice careful paintings—and two—Others—

No—there are five careful ones So thats that.

Write to me—I'll have lots to tell you next winter—Yours till the Mountain out yonder sinks——

Georgia O'Keeffe—

To Ettie Stettheimer, August 24, 1929: "If it were not for the Stieglitz call I would probably never go"

Dear Ettie:

A week ago today I took this paper at this funny little hotel to write you because it seemed amusing. I have carried it so long that it isn't amusing any more—However—the paper having lost its flavor isn't going to stop me.

I am on the train going back to Stieglitz—and in a hurry to get there—I have had four months west and it seems to be all that I needed—It has been like the wind and the sun—there doesnt seem to have been a crack of the waking day or night that wasnt full——I haven't gained an ounce in weight but I feel so alive that I am apt to crack at any moment—

I have frozen in the mountains in rain and hail—and slept out under the stars—and cooked and burned on the desert so that riding through Kansas on the train when everyone is wilting about me seems nothing at all for heat—my nose has peeled and all my bones have been sore from riding—I drove with friends through Arizona—Utah—Colorado—New Mexico till the thought of a wheel under me makes me want to hold my head

—I got a new Ford and learned to drive it—I even painted—and I laughed a great deal—I went every place that I had time to go—and Im ready to go back East as long as I have to go sometime—If it were not for the Stieglitz call I would probably never go—but that is strong—so I am on the way He has had a bad summer but the summers at Lake George are always bad—that is why I had to spend one away—I had to have one more good one before I got too old and decrepit—Well—I have had it—and I feel like the top of the World about it—I hope a little of it stays with me till I see you—

It is my old way of life—you wouldn't like it—it would seem impossible to you as it does to Stieglitz probably—but it is mine—and I like it—I would just go dead if I couldn't have it—When I saw my exhibition last year I knew I must get back to some of my own ways or quit—it was mostly all dead for me—Maybe painting will not come out of this—I dont know——but at any rate I feel alive—and that is something I enjoy.

Tell me what the summer has been for you—I hope it has been good for all of you—

I will be in Lake George by the time you get this
My greetings to Carrie and Florine
With Love

Georgia—

"The Great American Painting"

That first summer I spent in New Mexico I was a little surprised that there were so few flowers. There was no rain so the flowers didn't come. Bones were easy to find so I began collecting bones. When I was returning East I was bothered about my work—the country had been so wonderful that by comparison what I had done with it looked very poor to me—although I knew it had been one of my best painting years. I had to go home—what could I take with me of the country to keep me working on it? I had collected many bones and finally decided that the best thing I could do was to take with me a barrel of bones—so I took a barrel of bones.

When I arrived at Lake George I painted a horse's skull—then another horse's skull and then another horse's skull. After that came a cow's skull on blue. In my

Amarillo days cows had been so much a part of the country I couldn't think of it without them. As I was working I thought of the city men I had been seeing in the East. They talked so often of writing the Great American Novel—the Great American Play—the Great American Poetry. I am not sure that they aspired to the Great American Painting. Cézanne was so much in the air that I think the Great American Painting didn't even seem a possible dream. I knew the middle of the country—knew quite a bit of the South—I knew the cattle country—and I knew that our country was lush and rich. I had driven across the country many times. I was quite excited over our country and I knew that at that time almost any one of those great minds would have been living in Europe if it had been possible for them. They didn't even want to live in New York—how was the Great American Thing going to happen? So as I painted along on my cow's skull on blue I though to myself, "I'll make it an American painting. They will not think it great with the red stripes down the sides—Red, White and Blue—but they will notice it."

William M. Millikin, November 1, 1930: *The White Flower* (Fig. 14)

Mr. Milliken
Director—Cleveland Art Museum
Cleveland—Ohio
Dear Mr. Milliken:
I have been hoping that you would forget that you asked me to write you of the White Flower [Fig. 14] but I see that you do not.

It is easier for me to paint it than to write about it and I would so much rather people would look at it than read about it. I see no reason for painting anything that can be put into any other form as well—.

At the time I made this painting—outside my door that opened on a wide stretch of desert these flowers bloomed all summer in the daytime—.

The large White Flower with the golden heart is something I have to say about White—quite different from what White has been meaning to me. Whether the flower or the color is the focus I do not know. I do know that the flower is painted large to convey to you my experience of the flower——and what is my experience of the flower if it is not color.

I know I can not paint a flower. I can not paint the sun on the desert on a bright summer morning but maybe in terms of paint color I can convey to you my experience of the flower or the experience that makes the flower of significance to me at that particular time.

Color is one of the great things in the world that makes life worth living to me and as I have come to think of painting it is my effort to create an equivalent with paint color for the world—life as I see it

Yours very truly
Georgia O'Keeffe—.

To Vernon Hunter, Spring 1932: "I have to get along with my divided self the best way I can."

My dear Vernon Hunter
Your letter gives me such a vivid picture of some thing I love in space—love almost as passionately as I can love a person—that I am almost tempted to pack my little bag and go——but I will not go to it right this morning—No matter how much I love it— There is some thing in me that must finish jobs once started—when I can—.

So I am here—and what you write me of is there

The cockscomb is here too—I put it in much cold water and it all came to life from a kind of flatness it had in the box when I opened it——tho it was very beautiful as it lay in the box a bit wilted when I opened it—. I love it—Thank you.

I must confess to you—that I even have the desire to go into old Mexico—that I would have gone—undoubtedly—if it were only myself that I considered—You are wise—so wise—in staying in your own country that you know and love—I am divided between my man and a life with him—and some thing of the outdoors—of your world— that is in my blood—and that I know I will never get rid of—I have to get along with my divided self the best way I can—.

So give my greetings to the sun and the sky—and the wind—and the dry never ending land

—Sincerely
Georgia O'Keeffe

To Jean Toomer, January 10, 1934: "A plot of warm moist well tilled earth with the sun shining hot on it"

I waked this morning with a dream about you just disappearing—As I seemed to be waking you were leaning over me as you sat on the side of my bed the way you did the night I went to sleep and slept all evening in the dining room—I was warm and just rousing myself with the feeling of you bending over me—when someone came for you— I wasnt quite awake yet—seemed to be in my room upstairs—doors opening and closing in the hall and to the bathroom—whispers—a womans slight laugh—a space of time— then I seemed to wake and realize that you had gone out and that the noises I had heard in my half sleep undoubtedly meant that you had been in bed with her—and in my half sleep it seemed that she had come for you as tho it was her right—I was neither surprised no[r] hurt that you were gone or that I heard you with her

And you will laugh when I tell you who the woman was—It is so funny—it was Dorothy Kreymborg

And I waked to my room here—down stairs with a sharp consciousness of the difference between us

The center of you seems to me to be built with your mind—clear—beautiful—

relentless—with a deep warm humanness that I think I can see and understand but *have not*—so maybe I neither see nor understand even tho I think I do—I understand enough to feel I do not wish to touch it unless I can accept it completely because it is so humanly beautiful and beyond me at the moment I dread touching it in any way but with complete acceptance My center does not come from my mind—it feels in me like a plot of warm moist well tilled earth with the sun shining hot on it—nothing with a spark of possibility of growth seems seeded in it at the moment—

It seems I would rather feel it starkly empty than let anything be planted that can not be tended to the fullest possibility of its growth and what that means I do not know

but I do know that the demands of my plot of earth are relentless if anything is to grow in it—worthy of its quality

Maybe the quality that we have in common is relentlessness—maybe the thing that attracts me to you separates me from you—a kind of beauty that circumstance has developed in you—and that I have not felt the need of till now. I can not reach it in a minute

If the past year or two or three has taught me anything it is that my plot of earth must be tended with absurd care—By myself first—and if second by someone else it must be with absolute trust—their thinking carefully and knowing what they do—It seems it would be very difficult for me to live if it were wrecked again just now—

The morning you left I only told you half of my difficulties of the night before. We can not really meet without a real battle with one another and each one within the self if I see at all.

You have other things to think of now—this asks nothing of you.

I[t] is simply as I see—I write it—though I think I have said most of it—

My beautiful white Kitten Cat is in a bad way for three days—she seems to have a distressing need for a grown real male—and these two little Kitten Cats seem quite puzzled and frequently quite excited—and they are all running me wild—I feel like digging a hole in the back yard and burying the whole outfit

I never saw such a performance before—and right at this moment I dont need it—troubles enough with myself—

I do have to laugh when I think of your possible remarks if it had happened when you were here

I like you much.

I like knowing the feel of your maleness and your laugh—

Statement from the Exhibition Catalogue, An American Place 1939

A flower is relatively small. Everyone has many associations with a flower—the idea of flowers. You put out your hand to touch the flower—lean forward to smell it—maybe touch it with your lips almost without thinking—or give it to someone to please them. Still—in a way—nobody sees a flower—really—it is so small—we haven't time—and to see takes time, like to have a friend takes time. If I could paint the flower exactly as I see it no one would see what I see because I would paint it small like the flower is small.

So I said to myself—I'll paint what I see—what the flower is to me but I'll paint it big and they will be surprised into taking time to look at it—I will make even busy New Yorkers take time to see what I see of flowers.

Well—I made you take time to look at what I saw and when you took time to really notice my flower you hung all your own associations with flowers on my flower and you write about my flower as if I think and see what you think and see of the flower—and I don't.

Then when I paint a red hill, because a red hill has no particular association for you like the flower has, you say it is too bad that I don't always paint flowers. A flower touches almost everyone's heart. A red hill doesn't touch everyone's heart as it touches mine and I suppose there is no reason why it should. The red hill is a piece of the badlands where even the grass is gone. Badlands roll away outside my door—hill after hill—red hills of apparently the same sort of earth that you mix with oil to make paint. All the earth colors of the painter's palette are out there in the many miles of badlands. The light Naples yellow through the ochres—orange and red and purple earth—even the soft earth greens. You have no associations with those hills—our waste land—I think our most beautiful country. You must not have seen it, so you want me always to paint flowers. . . .

To Frank Lloyd Wright, May 1942:
"I felt that I should offer you my best"

Dear Frank Lloyd Wright,
I wish that I could tell you how much the hours with you mean to me—I've thought of you most of my waking hours since I left your house and I assure you that I left with a keen feeling of regret

Last night in the hotel in Chicago—my sister gone on to Cleveland to meet her husband—I got out your book.[7] I read the part marked with the red line at the end— then started at the beginning and read to the end of the first evening—stopping often to think about it—always relating what you give me to painting—to what I want to do—and you may smile when I say to you that I thought seriously of taking the train back to Madison to visit you again—I thought too——if I had offered you one of my best paintings years ago—maybe you would have taken it—I remember that even then— so long ago—that was what I wanted to do even tho I did not know you as I do now— I felt that I should offer you my best but I knew Alfred would make a great stir if I started doing things like that—[8]

I have always said to him that I think I should give things away—that it would be alright—and he always says—"Yes—it would be if you were alone—but it wouldn't be while I'm around"

Since I visited you I know that my feeling was right for *me*. Two together aren't the same as one alone—

As I think over this whole trip—the hours with you are the only part of it that I feel really add to my life—

I salute you and go on to the second evening of your book with very real thanks Will you give a very quiet greeting and thanks to the beautiful wife

Sincerely
Georgia O'Keeffe.

To Eleanor Roosevelt, February 10, 1944: The Equal Rights Amendment

Mrs. Franklin Roosevelt
29 Wash. Sq. W.
N.Y.
Having noticed in the N.Y. Times of Feb. 1st that you are against the Equal Rights Amendment may I say to you that it is the women who have studied the idea of Equal Rights and worked for Equal Rights that make it possible for you, today, to be the power that you are in our country, to work as you work and to have the kind of public life that you have.

The Equal Rights Amendment would write into the highest law of our country, legal equality for all. At present women do not have it and I believe we are considered—half the people.

Equal Rights and Responsibilities is a basic idea that would have very important psychological effects on women and men from the time they are born. It could very much change the girl child's idea of her place in the world. I would like each child to feel responsible for the country and that no door for any activity they may choose is closed on account of sex.

It seems to me very important to the idea of true democracy—to my country—and to the world eventually—that all men and women stand equal under the sky—

I wish that you could be with us in this fight—You could be a real help to this change that must come.[9]

Sincerely
Georgia O'Keeffe

Statement from the Exhibition Catalogue, An American Place, 1944

I have picked flowers where I found them—have picked up sea shells and rocks and pieces of wood where there were sea shells and rocks and pieces of wood that I liked. . . . When I found the beautiful white bones on the desert I picked them up and took them home too. . . . I have used these things to say what is to me the wideness and wonder of the world as I live in it.

A pelvis bone has always been useful to any animal that has it—quite as useful as a head, I suppose. For years in the country the pelvis bones lay about the house indoors

and out seen and not seen as such things can be—seen in many different ways. I do not remember picking up the first one but I remember from when I first noticed them always knowing I would one day be painting them.

I was the sort of child that ate around the raisin on the cookie and ate around the hole in the doughnut saving either the raisin or the hole for the last and best.

So probably—not having changed much—when I started painting the pelvis bones I was most interested in the holes in the bones—what I saw through them—particularly the blue from holding them up in the sun against the sky as one is apt to do when one seems to have more sky than earth in one's world. . . . They were most wonderful against the Blue—that Blue that will always be there as it is now after all man's destruction is finished.

To James Johnson Sweeney, June 11, 1945: "I am one of the few who gives our country any voice of its own"

. . . I must say to you again that I am very pleased and flattered that you wish to do the show for me.[10] It makes me feel rather inadequate and wish that I were better. Stieglitz efforts for me have often made me feel that way too—The annoying thing about it is that I can not honestly say to myself that I could not have been better.

However—we need not go into that. But I do wish to say that if for any reason you wish to change your mind feel assured that it will be alright with me—For myself I feel no need of the showing. As I sit out here in my dry lonely country I feel even less need for all those things that go with the city. And while I am in the city I am always waiting to come back here.

Since I left New York and since seeing you I have had a girl who did some secretarial work for me last winter—collect clippings and put them together for you. I dont know how well she will have done it but she will have done something—It will be odd reading for you I am afraid—

When I say that for myself I do not need what showing at the Museum shows means—I should add that I think that what I have done is something rather unique in my time and that I am one of the few who gives our country any voice of its own—I claim no credit—it is only that I have seen with my own eye and that I couldnt help seeing with my own eye—. It may not be painting but it is something—and even if it is not something I do not feel bothered—I do not know why I am so indifferent—

I wonder if by any chance the Museum sent me a check for that painting of the window. I received the returned Red Hills[11] but I received no check for the exchange. The Red Hills were sold again last week and I thought I had better be sure of what the Museum was doing about it. If the check was sent me it has gone astray in the mail as I have not received it—

Will you let me know because I haven't said anything to Stieglitz about not receiving the check and he has sold the painting—

Oh—isn't it a nuisance—all these things we have to bother about—I'd rather just look at the sage out my window and I rather imagine you would too.

22

Frida Kahlo (1907–1954)

Frida Kahlo's art and life are more thoroughly entwined than in practically any other artist in history. Born into a racially mixed family in Mexico City, her life was permanently altered when a public bus on which she was riding was rammed by a streetcar. Kahlo was literally impaled on a piece of metal debris, her pelvis and backbone shattered. The rest of her intense, tumultuous life was punctuated by recurrent pain and 32 operations. Following her marriage to Diego Rivera, Mexico's most noted muralist, in 1929, she endured a series of miscarriages and necessary abortions. Kahlo's highly precise, almost miniaturist style and self-obsessive imagery have recently become widely popular.

Several paintings by Kahlo were included in the exhibition *Mexico: Splendors of Thirty Centuries,* which toured this country from 1990 to 1991. This sparked at least two articles concerning the perceived obsession with Kahlo, which verges on a popular cult. An article published by her biographer, Hayden Herrera, in the *New York Times* is subtitled "Why Frida Kahlo Is the Perfect Woman for the '90s."[1] Peter Schjeldahl confirms the pervasive interest in Kahlo in his article for the popular magazine *Mirabella* (November 1990), stating "Frida Kahlo has our complete attention."[2] Herrera notes that there are three separate film projects in preparation (one by another media star, Madonna, who owns two Kahlo paintings). Kahlo's self-embellishment, narcissism, and bisexuality are all seen as positive traits in the current cultural climate. She is a role model for all women artists and for Chicano artists of both sexes.

Kahlo has been treated in a detailed and sensitive manner by Herrera. Unfortunately, until very recently her life, like O'Keeffe's, has overshadowed serious art-historical analysis and criticism.

The first excerpt here concerns the beginnings of Kahlo's activity as a painter; she recounted this story to her friend, the art historian Antonio Rodríguez many years later. Kahlo painted sporadically and without any public attention until the mid-1930s. The letter to her friend Lucienne Block tells of her initial contact with Julien Levy, who owned a small gallery oriented toward Surrealism in Manhattan.

An exhibition took place at Levy's gallery in 1938; André Breton, who along with Leon Trotsky had been her houseguest in Mexico City, wrote the introduction. In the

letter to her friend Alejandro Gómez Arias, she wrote about the reception of her works and her enthusiasm for this public response.

The following year, 1939, Kahlo went to Paris, where Breton was supposed to have organized a show of her works. Writing to her lover Nickolas Muray from Paris, she recounts the frustrating events in two letters.

In the final excerpt, written late in her life to Antonio Rodríguez, she distances herself from the movement of Surrealism, emphasizing her political connections with Mexican nationalism, *Mexicanidad.* Janice Helland has defined this movement as a ''romantic nationalism that focused upon traditional art and artifacts uniting all *indigenistas* . . . [which] revered Aztec tradition above and beyond other pre-Spanish native cultures.''[3] The Aztec sources of her imagery are visible in one of her most powerful self-portraits, *Self-Portrait with Thorn Necklace and Hummingbird* (Fig. 15). Against a characteristically shallow background, Kahlo wears a dead hummingbird. Sacred to the chief

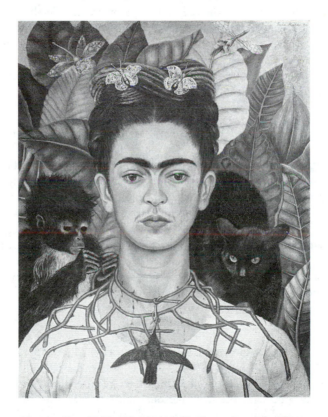

Figure 15. Frida Kahlo, *Self Portrait with Thorn Necklace and Hummingbird.* The Harry Ransom Humanities Research Center, the University of Texas at Austin.

god of Tenochtitlán, Huitzilopochtli, the god of sun and war, it represents the soul of a warrior who has died, whether in battle or as a sacrifice. Helland believes that the thorn necklace is related to the practice of Aztec priests' mutilating themselves with agave thorns and stingray spines.

Kahlo was also inspired by popular Catholic imagery.[4] She was a collector of indigenous small-scale *ex-voto* paintings on tin. She imitated the inscription and the tin support in many of her paintings. This subcategory of picture is an offering of thanks to a divine agent of intervention for survival. Traditional *ex-votos* depict the actual event from which the person was saved and bear an inscription documenting the disaster. Other paintings by Kahlo, such as *Henry Ford Hospital,* fit this category precisely. The effectiveness of the ex-voto is perceived as deriving from the greatest possible realism in the imagery. In the context of the ex-voto, one can understand her famous statement, ''I never painted dreams. I painted my own reality.''[5] Painting therefore becomes not an aesthetic act but a religious event, intended to ensure the continued survival of the subject. Painting her own image is not narcissism but literally a matter of life and death.

In April 1953, desperately ill, Kahlo was carried on a bed to the opening of her first major retrospective exhibition in the Gallery of Contemporary Art in Mexico City. After her death in July 1954, Rivera donated her house to the state as the Frida Kahlo Museum. In 1984 Kahlo's paintings were declared to be part of the National Patrimony, a rare honor and mark of esteem by the Mexican government.

Statement to Antonio Rodríguez: "In this way I began to paint."

My father had had for many years a box of oil colors and some paintbrushes in an old vase and a palette in a corner of his little photography workshop. Purely for pleasure he would go to paint at the river in Coyoacán, landscapes and figures and sometimes he copied chromos. Ever since I was a little girl, as the saying goes, I had been casting an eye in the direction of the box of colors. I could not explain why. Being so long in bed, I took advantage of the occasion and I asked my father for it. Like a little boy whose toy is taken away from him and given to a sick brother, he ''lent'' it to me. My mother asked a carpenter to make an easel, if that's what you would call a special apparatus that could be attached to my bed where I lay, because the plaster cast did not allow me to sit up. In this way I began to paint.

To Lucienne Bloch, February 14, 1935

Since I came back from New York [in 1935] I have painted about twelve paintings, all small and unimportant, with the same personal subjects that only appeal to myself and nobody else. . . . I send four of them to a gallery, which is a small and rotten place, but the only one which admits any kind of stuff, so I send them there without any enthusiasm, four or five people told me they were swell, the rest think they are too crazy.

. . . ''To my surprise, Julian [*sic*] Levy wrote me a letter, saying that somebody

talked to him about my paintings, and that he was very much interested in having an exhibition in his gallery, I answered sending few photographs of my last things, and he sent another letter very enthusiastic about the photos, and asking me for an exhibition of thirty things on October of this year.

To Alejandro Gómez Arias, November 1, 1938

On the very day of my exhibition I want to chat with you even if only this little bit.

Everything was arranged *a las mil maravillas* [marvelously] and I really have terrific luck. The crowd here treats me with great affection and they are all very kind. Levy did not want to translate A. Breton's preface and that is the only thing that seems to me to be a little unfortunate since it seems rather pretentious, but now there is nothing to be done about it! How does it seem to you? The gallery is terrific, and they arranged the paintings very well. Did you see *Vogue*? There are three reproductions, one in color—the one that seemed the best. Write to me if you remember me sometime. I will be here two or three weeks more. I love you very much.

To Nickolas Muray, February 16, 1939

The question of the exhibition is all a damn mess. . . . Until I came the paintings were still in the custom house, because the s. of a b. of Breton didn't take the trouble to get them out. The photographs which you sent *ages ago, he never received*—so he says—the gallery was not arranged for the exhibit *at all* and Breton has no gallery of his own long ago. So I had to wait days and days just like an idiot till I met Marcel Duchamp (marvelous painter) who is the only one who has his feet on the earth, among all this bunch of coocoo lunatic sons of bitches of the surrealists. He immediately got my paintings out and tried to find a gallery. Finally there was a gallery called "Pierre Colle" which accepted the damn exhibition. Now Breton wants to exhibit together with my paintings, 14 portraits of the XIX century (Mexican), about 32 photographs of Alvarez Bravo, and lots of popular objects which he bought on the markets of Mexico—*all this junk,* can you beat that? For the 15th of March the gallery suppose to be ready. But . . . the 14 oils of the XIX century must be *restored* and the damn restoration takes a whole month. I had to lend to Breton 200 bucks (Dlls) for the restoration because he doesn't have a penny. (I sent a cable to Diego telling him the situation and telling that I lended to Breton that money—he was furious, but now is *done* and I have nothing to do about it.) I still have money to stay here till the beginning of March so I don't have to worry so much.

Well, after things were more or less settled as I told you, few days ago Breton told me that the associated of Pierre Colle, an old bastard and son of a bitch, saw my paintings and found that only *two* were possible to be shown, because the rest are too "*shocking*" for the public!! I could of kill that guy and eat it afterwards, but I am so sick and tired of the whole affair that I have decided to send every thing to hell, and

scram from this rotten Paris before I get nuts myself. . . . You have no idea the kind of bitches these people are. They make me vomit. They are so damn "intellectual" and rotten that I can't stand them any more. It is really too much for my character. I rather sit on the floor in the market of Toluca and sell tortillas, than to have any thing to do with those "artistic" bitches of Paris. They sit for hours on the "cafes" warming their precious behinds, and talk without stopping about "culture" "art" "revolution" and so on and so forth, thinking themselves the gods of the world, dreaming the most fantastic nonsenses, and poisoning the air with theories and theories that never come true. Next morning—they don't have any thing to eat in their houses because *none of them work* and they live as parasites of the bunch of rich bitches who admire their "genius" of "artists." *shit* and only *shit* is what they are. I never seen Diego or you, wasting their time on stupid gossip and "intellectual" discussions. that is why you are real *men* and not lousy "artists."—Gee weez! It was worthwhile to come here only to see why Europe is rottening, why all this people—good for nothing—are the cause of all the Hitlers and Mussolinis. I bet you my life I will hate this place and its people as long as I live. There is something so false and unreal about them that they drive me nuts.

To Nickolas Muray, February 27, 1939

Marcel Duchamp has help me a lot and he is the only one among this rotten people who is a real guy. The show will open *the 10th of March* in a gallery called "Pierre Colle." They say its one of the best here. That guy Colle is the dealer of Dali and some other big shots of the surrealism. It will last two weeks—but I already made arrangements to take out my paintings on the 23rd in order to have time to packed them and take them with me on the 25th. The catalogues are already in the printing shop, so it seems that everything is going on alright. I wanted to leave on the "Isle de France" the 8th of March, but I cable Diego and he wants me to wait till my things are shown, because he doesn't trust any of this guys to ship them back. He is right in a way because after all I came here *only* for the damn exhibition and would be stupid to leave two days before it opens. Don't you think so?

To Antonio Rodríguez, ca. 1952: On Surrealism

Some critics have tried to classify me as a Surrealist; but I do not consider myself to be a Surrealist. . . . Really I do not know whether my paintings are Surrealist or not, but I do know that they are the frankest expression of myself. . . . I detest Surrealism. To me it seems to be a decadent manifestation of bourgeois art. A deviation from the true art that the people hope for from the artist. . . . I wish to be worthy, with my painting, of the people to whom I belong and to the ideas that strengthen me. . . . I want my work to be a contribution to the struggle of the people for peace and liberty.

The United States:
1945 - 1970

Any discussion of the contributions and activities of American women artists in the period 1945–70 must first focus on the 1930s. The federal government subsidized many artists during the Depression, and generated accurate census information. By this time, women were no longer a small minority in the profession; a survey of professional artists in 1935 revealed that 41 percent of artists receiving assistance were women.[1] Some women were also employed as upper-level administrators supervising these programs. Since works were submitted unsigned, women finally had the opportunity to be judged "gender-blind" against their male colleagues. Three of the artists whose statements are excerpted here—Lee Krasner, Louise Nevelson, and Alice Neel—received assistance during the 1930s from one of the federally funded welfare programs. The fourth artist, Eva Hesse, belongs to another generation; she was formally trained at Yale University, benefiting from the greater equality of education open to women by the 1950s and 1960s.

In the preceding sections of this book, the texts were actually written by the authors. In this part, every single text is a record of an oral exchange. But although all four are interviews, in Nevelson's and Neel's the presence of the interviewer is so unobtrusive that those texts are more similar to written autobiography from earlier periods.

Since these excerpts were not actually written by the artists, the context of literary activity by contemporary women writers is less relevant to our understanding of their form.

Collectively, the four artists illustrate the broad diversity of imagery, media, and techniques utilized by women artists in the twentieth century. The two painters, Krasner and Neel, have widely divergent oeuvres. Krasner's adherence to abstraction does position her within the modernist aesthetic; however, her gender and her personality, both abrasive and self-deprecating, reinforced her relative anonymity in the history of the first-generation Abstract Expressionism of the "New York School."[2] Until quite recently, Krasner has been viewed more frequently as the "wife of Jackson Pollock" than as a major painter.

Neel's painting, focused on portraiture, served to exclude her from modernist discourse by its subject matter. Only when the primacy of abstraction had lessened in

the more responsive "pluralism" of the 1970s and 1980s did she begin to receive some measure of recognition.

Both Nevelson and Hesse worked in sculpture. Although both artists were highly innovative, their works are dramatically different. Nevelson constructed large wall pieces in wood from smaller box-enclosed compositions to formulate her mature style in the mid-1950s. Hesse used a wide range of nontraditional materials—latex, wire, string, etc.—to create works in self-conscious reaction to the vocabulary and materials of Minimalism, the prevailing modernist idiom for sculpture of the 1960s.

All four artists speak with candor about their lives, both personal and professional, as well as their understanding of what it means to be a "woman artist" in the modern world.

23

Lee Krasner (1908–1984)

Like Alice Neel and Louise Nevelson, Lee Krasner had to wait many decades for some recognition of her participation in the first generation of Abstract Expressionists. Unfortunately, she could enjoy her success for only a brief time. Her major retrospective at the Museum of Modern Art occurred only a year before her death. The catalogue for that exhibit, written by Barbara Rose, is an important source for this artist. In conjunction with that event, Krasner was interviewed by Michael Cannell.[1] This interview is characteristic of the primary sources for this artist, who wrote no autobiographical statement. It is one of the last published interviews before her death. Krasner discusses, among other topics, her perceptions of her position within Abstract Expressionism, attitudes toward women in this circle in the 1940s and 1950s, and trends in contemporary art.

Like Nevelson, Krasner was born into a Russian Jewish immigrant family with no special interest in the visual arts. Already painting seriously as a teenager, she won a scholarship to New York's Cooper Union. She also studied in the traditional National Academy of Design. In 1935 she joined the Federal Art Project, discussed in the first part of the interview. Between 1937 and 1940, she worked in Hans Hofmann's (1880–1966) studio. During this time she absorbed the lessons of Cubism and European Abstract Modernism, including the art of Mondrian, which was the key formative period for her education.

In close living and working contact with Pollock, Krasner spent three frustrating years trying to develop her own independent stylistic idiom; this "gray slab" period is also discussed. In 1946, following their move to Long Island (she had married Pollock in 1945), she began creating the "little image" paintings which today have earned her recognition as a key participant in the "first generation" of Abstract Expressionists. However, it was only from 1950 that Krasner began to create mature, large-scaled abstract paintings. These paintings vary enormously stylistically, with their astonishingly diverse surfaces and color schemes.

Krasner has characterized her own development as a painter in the following way:

My own image of my work is that I no sooner settle into something than a break occurs. These breaks are always painful and depressing but despite them I see that there's a consistency that holds out, but is hard to define. All my work keeps going like a pendulum: it seems to swing back to something I was involved with earlier, or it moves between horizontality and verticality, circularity, or a composite of them. For me, I suppose that change is the only constant.[2]

Barbara Rose notes that, for Krasner, "the pendulum swings back and forth from the abstract to the figurative, the geometric to the organic."[3] A painting such as *Gaea* (Fig. 16) illustrates one pole of Krasner's art. Active, visible, and seemingly spontaneous brushwork define the moving, energetic forms. The palette is characteristically restricted, in this case to black, white, rose pink, and a fleshy-toned, higher-valued pink. *Gaea* is the Greek name for the Earth Mother of the primordial past, a reference which underscores the sense of a prehuman, prehistoric life force pulsing through undifferentiated nature. Almost seven feet tall and over twelve feet across, the sheer scale of the work overwhelms the viewer with its power and energy.

Krasner's restoration into the pantheon of Abstract Expressionists began in 1978 with her inclusion in an exhibition curated by Gail Levin and Robert Hobbs for the Whitney Museum's *Abstract Expressionism: The Formative Years* (1978). Her reputation, so consistently overshadowed by her position as the wife of Jackson Pollock, began to emerge independently when the artist was over 70. Feminist revisionism has helped us reevaluate the art of this major creator.

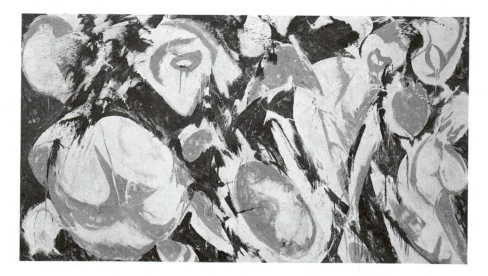

Figure 16. Lee Krasner, *Gaea* (1966). Oil on canvas. The Museum of Modern Art Collection, New York. Kay Sage Tanguy Fund.

An Interview with Michael Cannell

MICHAEL CANNELL: You were involved during the 1930s in the Public Works of Art Project, the Temporary Emergency Relief Administration, as well as the Mural Division of the W.P.A. Federal Art Project.

LEE KRASNER: Yes, they were primarily opportunities to work during the the Great Depression. Right, at that time they formulated the W.P.A., and prior to that was what you identified as what?

MC: The Temporary Emergency Relief Administration.

LK: Right, and that immediately went into the Mural Division of the Art Project. I was involved in the first aspect of it, as well as later on.

MC: Were these solely opportunities to work, or were you involved in the politics of the projects as well?

LK: I wasn't concerned or even aware of the politics as an artist. I was solely aware of the fact that I needed a job desperately, and here was an opportunity to work. So that is all I was aware of at that point.

MC: Your work as a mural painter with the W.P.A. involved large-scale horizontal formats. How did this affect your later compositions?

LK: It's hard to know. It possibly did, but certainly not in a conscious way. But I did have the experience of working large-scale on the W.P.A., and whether it affected me later I can't break down and say. Deep down I believe that all our experience goes into what we are doing as painters.

MC: But not self-consciously.

LK: It's not self-conscious and I'm not aware of it in that sense.

MC: You studied with Hans Hofmann for three years. The art historical community describes him as playing a crucial role in bringing European ideas to America, and spreading them among young artists.

LK: There seems to be some chaos and confusion in regard to Hans Hofmann and Abstract Expressionism. I would like to point out that I studied with Hans Hofmann for three years, but some of my contemporaries, and I'll name a few, never went near Hofmann: Arshile Gorky, Willem de Kooning, Jackson Pollock, Mark Rothko, Franz Kline, to name but a few. These were some of my contemporaries and they were never near the Hofmann school and knew nothing about what Hofmann was doing or not doing at this point.

Hofmann is at the age where he is contemporary to Picasso and Matisse and not the New York School. The point is that Cubism came to my contemporaries as well as to me, even though I was studying with Hofmann, via Picasso and not Hans Hofmann. Because he was of that age one tends to feel he was sort of the father of the New York School. It is not so factually. I did study with him but I am the exception to the line-up I have just given you. Every member of the so-called Abstract-Expressionist first generation . . . none of these people even worked with Hofmann. They got their Cubism via the direct source.

MC: What was your experience working under him?

LK: He had a terrific enthusiasm for painting. He was very demanding in his teaching of Cubism, and adhering to those principles. And it took me many years to break from that, just as it took me many years to break from the Academy to get to Cubism.

MC: Is it true that the entire time he was teaching, very few of his students saw the actual work that he did on his own?

LK: No idea . . . He never showed his paintings so one did not know what his painting was like. He didn't have his first show until, I believe, 1944 or 1945 at Peggy Guggenheim's[4] and that's only after a very dramatic confrontation, when I brought Hofmann to meet Pollock.

MC: And this was a great confrontation of the conflicting voices in your own life.

LK: Was it ever a confrontation! They didn't make it at all! Hofmann, who worked rigidly from a model, said to Pollock, "This is no good. You work from heart. You will just repeat yourself. You must work from nature." Jackson's response to that was, "I am nature." In other words, he was identifying with nature, and not separating himself from nature. He was saying man is part of nature, not man is here and nature is over there which is what Hofmann said.

MC: What did this confrontation do for you in terms of sorting out your own direction?

LK: I was trying to move from the principles of Cubism, which I had pretty thoroughly by now, and I was trying to grasp what Pollock was talking about. Now that took quite a bit of doing. It didn't happen quickly or easily. It was a major transition.

MC: What were other major transitions?

LK: When I went from the Academy to Cubism.

MC: And since then? Any subsequent transitions?

LK: No, that's it. I don't think we have had anything then that has been major in the continuity of the history of art. There will be at lot of people that disagree with me on this, but I have not seen any such thing as yet. Let me put it this way: I'm not convinced by anything I've seen.

MC: Before your successful "Little Image" series emerged, you went through what must have been a frustrating period when the inspiration just would not come.

LK: I would imagine you are referring to the period when I'm trying to break through . . . to lose Hofmann and break into Pollock's style. Oh yes, it was almost a three year period and the pigment would just build up into masses of gray sludge, and nothing happened.

MC: Something like writer's block?

LK: I don't know; I suppose you could call it the equivalent of that. But it wasn't a block. I was trying to get through and I couldn't. Well, I suppose that's what a block is.

MC: Then, all of a sudden . . .

LK: Yes, then it opened up and these little image things started for the first time. Finally something began to happen after three years of these gray slabs.

MC: In 1942 you participated with Pollock and Matta and Robert Motherwell in automist Surrealist games. What sort of an experience was this?

LK: This is something that has been played up so highly. We used to do it as an after-dinner game.

MC: So it doesn't have the weighty significance art historians seem to think it does.

LK: Right! Today they have made such a heavy number of this thing. It was really just a game we would occasionally play after dinner, and about as lightweight as a feather. We thought nothing of it.

MC: I know that Pollock was interested in Pre-Columbian art, but are there any ancient or primitive styles that influenced you? Some of your works from the 1940s contain geometric motifs, some almost like hieroglyphics. Were these non-Western in inspiration?

LK: I have always been interested in calligraphy. Marcia Tucker[5] pointed something out when I had the show at the Whitney of large-scale paintings; she pointed out that I always started out my canvases on the upper right and went across them. I wasn't aware of this, and she said it undoubtedly was related to the time when I studied Hebrew as a child, since that is exactly how you would write it. I was astonished.

Well, you also must remember that back when I knew John Graham, and that goes into the late Thirties and early Forties, he had on Greenwich Avenue something that he called his Primitive Museum. He had magnificent pieces of Oceanic sculpture and all sorts of primitive masks. I used to see him very frequently so I saw a great deal of it. He had a real connoisseur's eye, so the pieces he got were quite magnificent.

Also, at that time one was reading publications like *Verve* and *Cahiers d'Art,* all published in France. They were aware of Picasso's awareness of this, so this thing was moving around, and one saw beautiful examples.

MC: When you made the break from painting the external world, and began painting in the mode of what later was known as Abstract Expressionism, were there accompanying changes in the mechanics of your painting process?

LK: You mean did I have to paint on the floor and all that nonsense?

MC: Right.

LK: No, of course not. I never painted on the floor. In other words, Pollock found his way of doing it and I had no desire to copy his way. I had to find it for myself on my own. No, I didn't pour paint, I didn't do the things that Pollock did, or the things that a great many people who copied him did. Of course that is just copying technique and that's absurd, and very academic to put it in its best sense. I was never comfortable about viewing a painting from that position. Never.

MC: Your works have a smattering of primeval forms. We talked about your exposure to primitive art, but what about Carl Jung? Were you ever in Jungian analysis, or did you engage yourself with any Jungian literature?

LK: I never had Jungian analysis. At one point, way back, I read his *Integration of the Personality* which interested me enormously, until I reached the point where he began to discuss his students' dreams and there were illustrations. When I heard him on art, I lost all interest in him. Up to that point I was fascinated. In that sense I had a little bit of contact with him.

MC: You felt that he was overextending his theories when he spoke of art?

LK: Well, he just didn't know what he was talking about. He was brilliant in his field, but when he brought his ideas to art, they just disintegrated. Later, when I met Pollock, he was involved in Jungian analysis.

MC: I want to ask you about the titles of your paintings. Let me name a few: *Crisis Moment, Cornucopia, Noon, Pollination,* and *Peacock.* Are you afraid that these titles make suggestions for the viewers, and nudge them towards some interpretation?

LK: If I think of the paintings connected with these various titles, I don't think you get nudged too far. I'm thinking of *Noon,* for instance, which is descriptive as a word. But when you look at the painting I defy you to find noon in it. And *Peacock,* for instance, it's not a peacock you are looking at. There is a mood in this thing which suggests a peacock to me, but there is no literal peacock.

MC: At what point did the titles suggest themselves? In the process of painting, before, or after?

LK: Never before. It is always after the painting is completed that a title will come out. Very often I can't title and I will call in a friend to do that. In fact, a friend of mine will have an article coming out in the June issue of *Artforum* called "An Imaginary Interview on the Subject of Titling with Lee Krasner." He goes into the problem of titling at great length. He helped me title quite a few paintings. A lot of people have helped me title.

MC: Your works incorporate a distinct and often disturbing set of colors. How did you arrive at this set of colors?

LK: I am very conscious when I jar with color. It is very often my intention to use color that way. I'm not absolutely sure why I do it, but I must have a reason and I'll get to it at some point.

MC: Which New York museums and galleries were most sensitive to what you and your contemporaries were trying to do?

LK: My own experience was not like that of my contemporaries, because my role as an artist has only recently been accepted. There's a whole long history behind this, of the attitude toward women and the whole situation in regard to women. Finally it's breaking up so that the retrospect of my work which is now being prepared is my first. When you think of my male contemporaries, I don't know how many retrospects they have all had. Finally I'm getting my first in this country. I did have one in 1965, but that was in England. Bryan Robertson organized a retrospective at the Whitechapel, and the British Arts Council traveled it around England, but it never left England.

It's now 1983 and I'm getting my first retrospective in this country. Now just compare that with any of my male contemporaries! The only female contemporary I acknowledge is Louise Bourgeois. She has had a retrospective a matter of months ago.

MC: There's a swaggering macho quality in the Action painting of this period. Abstract Expressionism was dominated by men, and yet you were right there throughout its conception. How did you fit in?

LK: It is quite clear that I didn't fit into it, although I never felt I didn't. I was not accepted, let me put it that way. What made things very possible for me was that Pollock, whom I lived with, respected, appreciated, and did not view my work this

way. However, that was just between us. So then I got going on my merry way. With relation to the group, if you are going to call them a group, there was no room for a woman.

MC: I understand that Grace Hartigan actually exhibited for a time under the name "George Hartigan," in order to gain recognition.

LK: That's absolutely true. In my case I didn't change my name from Lee to John but it was certainly hard. It is a fact that women were not accepted. That part is factual. When I was a student at the Hofmann school, he said to me one day, "This is so good," referring to what was on my easel, "you would not know it was done by a woman." He thought he was paying me the highest possible compliment. So it shows a state of mind that existed at this particular time.

MC: Clement Greenberg has said of you: "Lee should have had more faith in herself and more independence; but then that is the problem of all female artists."

LK: Well, he claims women artists couldn't paint, with the exception of his special friend Frankenthaler.[6] But she was his close amour, so she could paint. Well, that's for the birds! Who could take that seriously? Either women can't paint, or some can. It isn't just who your amour is.

MC: I don't know if you have been to the Whitney Biennial show . . .

LK: I don't go anymore. It depresses me too much to see what's happening at the moment. After the last couple of shows, I have had it.

MC: Well, one-third of the work shown in the Biennial is by women artists. Does this indicate that the resistance to women artists, which you experienced, is finally breaking down, or will it always be with us in some manner?

LK: I hope it isn't always with us, but we learn very, very slowly. The fact that one-third of the art in the Whitney is by women . . . well . . . O.K., but the Whitney is another story altogether. It's easier for the women today. There is not that kind of prejudice which I encountered. On the other hand, it is not all gone by a long shot. It will slowly ease off. Women will eventually stop being so aggressive about it. For them to relax and the norm to be found may take some time.

MC: Could you name some recent artists that you like?

LK: So much of what I see really appalls me. Right now the field is wide open to every possible form of art, and everybody can get an exhibition. It's chaotic. Male, female, anybody! Let's see what it brings out finally after it's had its run for awhile.

MC: Paris of the 1920s and Greenwich Village of the 1940s are coupled in my mind as particularly fertile settings for artists and intellectuals. Most people of my generation, probably at some point, have wished they were living in one of those two scenes. Tell me about the mood and activity of the Village in those days as you knew it.

LK: When I first came to the Village I had to work as a waitress, and that meant working at night. I worked at a place called the Sam Johnson, where a great many intellectuals came. They read poetry and they had symposiums. In that way I met quite a few people. As a matter of fact, that was where I first met people like Harold Rosenberg, and through Harold Rosenberg I met Clem Greenberg, and Maxwell Bodenheim used to be down there. . . .

I can remember a place called the Jumble Shop. I think it still exists on MacDougal Alley. We used to gather there in the evenings, me and Gorky and Jackson and a whole bunch, just to sit around, talk, and have some beer. Much later on, something called The Club started up at the Cedar Tavern. That was much later though, and I loathed the place. I had nothing to do with it.

Louise Nevelson (1889–1988)

Louise Nevelson did not formulate a mature artistic style until she was in her sixties. Her reputation is based on her large-scaled wooden constructions enclosed in boxes and piled up to form walls. These works, dating from the mid-1950s, have received widespread critical acclaim.

Although she wrote a number of poems (which have never been collectively published), Nevelson, like Krasner, did not write an autobiography. All her published accounts of her art and her life were recorded by interviewers. By 1976, when *Dawns and Dusks* (edited by Diana MacKown) was published, Nevelson's reputation was secured. This volume is the most extensive record of Nevelson's words. The frontispiece reads: This is not an/autobiography./This is not a/biography./This is a gift./L.N.''

The prose retains a sense of spontaneity that we can assume was an authentic part of Nevelson's conversations. Though it begins with her childhood, it does not follow a strictly chronological format. In following this anecdotal, discursive account, the reality and intensity of Nevelson's personality, even in her eighties, comes across from the printed page vividly. And she was right—*Dawns and Dusks* is a gift.

Born of Russian-Jewish parents, Louise Berliawsky and her family settled in a small town in Maine when she was 6 years old. Her father owned a lumberyard, so she lived amidst wood, the medium of her future sculpture. The first excerpt discusses her early vocation as a sculptor. Her marriage to Charles Nevelson, a wealthy New Yorker, liberated her from small-town life. A son, Michael, was born two years later, in 1922. During the 1920s Nevelson studied drama, voice, and dance. Only in 1928 did she begin to study visual arts at the Art Students League. This inaugurated a lengthy apprenticeship, punctuated by a stay in Munich to work under Hans Hofmann. Separated from her husband in 1931 and divorced in 1941, Nevelson continued to patiently absorb the lessons of both European abstract modernism and American Abstract Expressionism. She continued to study with Hofmann when he came to New York, expelled from Germany by the Nazis.

Nevelson was a sophisticated artist, well aware of the major modernist developments of the twentieth century. She was familiar with Cubism and acquainted with the Surrealists who lived in New York, such as Marcel Duchamp and Max Ernst. She also

mentions the boxes of Joseph Cornell. But from this diverse collection of sources emerged a formal vocabulary and iconographic structure of extraordinary power and originality. The next segment deals with her identity as a woman artist, and her attitudes toward the differences between the sexes.

Despite some recognition for her sculpture in 1936, when she won a competition at a New York gallery, Nevelson continued to struggle in relative obscurity. Around 1939 she presented herself to gallery owner Karl Nierendorf; this event is described in the next excerpt.

Until his death in 1946, Nierendorf supported Nevelson's work and exhibited it regularly. Between 1946 and 1955 Nevelson did not exhibit her sculpture. This long period is discussed in the fourth excerpt, where her motivating anger is communicated clearly. In the next excerpt, Nevelson defines her individuality and her independence from Abstract Expressionism.

Laurie Wilson's detailed research on Nevelson has helped identify the autobiographical references embedded in the seemingly totally abstract imagery of her mature style, which was consolidated in a series of annual exhibitions between 1955 and 1961. Wilson identifies three recurrent themes in Nevelson's art: royalty, marriage, and death. The king and queen, the royal couple, symbolize the parents. Giacometti, Duchamp, and Moore all used royal imagery in their sculpture. Nevelson visited Mayan ruins in Guatemala in 1950 and 1951. In Mayan lore, the West Queen is associated with black, Nevelson's color of choice for much of her sculpture. The theme of marriage, with or without a bridegroom, is a second leitmotif in Nevelson's art. The third pervasive theme is death, which first appears in 1943, the year her mother died. Nevelson believed in a continued existence after the death of the body. All three themes are united in one of her most important works, the environmentally-scaled *Mrs. N's Palace*. Painted black, it is a royal tomb for a king and queen.[1]

Wilson's interpretation of Nevelson's iconography is supported by the artist's statement in the next two excerpts. Nevelson here talks about the complexity of her attitude toward black. The acceptance of the totality of black may be paired with her resistance to accepting the finality of death. Her description of the creation of *First Personage* (Fig. 17), uniting black with the theme of marriage, helps us understand the intensely personal feelings from which Nevelson worked in the mid-1950s. *First Personage* was the last sculpture in the round that Nevelson executed. When the work was donated to the Brooklyn Museum, she told one of the curators: "I wanted to be more secretive about the work and I began working in the enclosures. . . . There's something more private about it for me and gives a better sense of security. So this piece sort of cured me from trying to do something in the round."[2] Nevelson's creative leap from individual boxes to walls of boxes is described in the last excerpt.

Nevelson's vital, intense personality is communicated vividly in these statements, and the reader has a sense of actually being in the presence of the artist.

"I want to be a sculptor"

So my parents believed the children, no matter what sex, should be educated. They had a son and three daughters and they felt we had the same opportunities that anyone had.

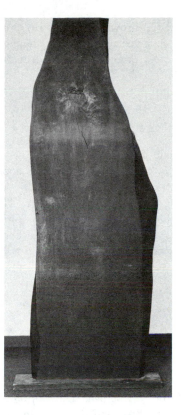

Figure 17. Louise Nevelson, *First Personage*. The Brooklyn Museum, New York.

And they began to give us every advantage. When I told them at an early age that I wanted to be an artist, he was as proud as he could be. And she was. And so they helped in every possible way. They helped me in every way. There was no problem. With them. So I must say that I didn't feel being a female was any handicap. I felt it was one's ability that counted. And I just thought I had it.

Who is an artist? I say, we take a title. No one gives it to us. We make our lives. You start when you're very young, say in school. And there you recognize that you have it. In the first grade, I already knew the pattern of my life. I didn't know the living of it, but I knew the line. I drew in childhood, and went on painting and moving and everything, daily. Daily and holidays too. I felt that that was my strength. And my good fortune was that many, many years ago, even in a small town in Maine, every teacher knew it too. As a child everybody knew that I had these two things. Pianissimo and fortissimo. Always. My teachers praised me. From the first day in school they said I'm an artist.

When I was about seven years old our art teacher came once a week and would demonstrate what she wanted us to do for the following week. This particular day she brought in her own crayoned drawing of a sunflower on paper and said that she wanted each of us to make a sunflower drawing for the next week as the assignment. I drew a

large brown circle for the center and surrounded it by tiny yellow petals. When she reviewed the drawings she picked mine and held it up to the class and said it was the most original because I had changed the proportions of her drawing.

All the way through school I was fed by these art teachers. There were other problems, but that was not the problem. From the first day in school until the day I graduated, everyone gave me one hundred plus in art. Well, where do you go in life? You go to the place where you got one hundred plus.

You know, people always ask children, what are you going to be when you grow up? I remember going to the library, I couldn't have been more than nine. I went with another little girl to get a book. The librarian was a fairly cultivated woman, and she asked my little girl friend, "What are you going to be?" And she said that she was going to be a bookkeeper. There was a big plaster Joan of Arc in the center of the library, and I looked at it. Sometimes I would be frightened of things I said because they seemed so automatic. The librarian asked me what I was going to be, and of course I said, "I'm going to be an artist." "No," I added, "I want to be a sculptor, I don't want color to help me." I got so frightened, I ran home crying. How did I know that when I never thought of it before in my life?

On Women Artists

I remember I was in the Waldorf Cafeteria in the late thirties. There were several men and myself and Mike was with me. We were talking about sculpture. This Greek sculptor . . . he painted his things. They were talking very seriously about art, particularly sculpture, and they said to me, "You know, Louise, you've got to have *balls* to be a sculptor." And that's when I said, "I *do* have balls." So I knew then that nothing like that was going to stand in my way.

No one has a monopoly on creativity. I never recognized that whoever created humans gave a brain only to one sex or the other. I never recognized that distinction. It seems to me that I was just quite sure that I was born this way and I wanted to live my life as I understood it. I was so *absorbed* into what I was doing, the creative problems, that *at the time* I wasn't so aware of that kind of prejudice.

But I'm thinking about the women that are fighting so desperately now, and I have the greatest respect for them. If they're not given an opportunity, we know that they're going to take it now, and nothing will stop them. And rightly so. I hope they do. I think that you have to look into yourself and do what you feel is your fulfillment. If women have not taken their rightful places, they were in a world that was male-oriented and it wasn't ladylike. They were taught to look pretty and throw little handkerchiefs around but never to show that they had what it takes. Well, I didn't recognize that, and I never never played that role. If you play that role, you don't build an empire. But if you want to look in history, we have a lot of women who have built empires.

Now I feel that a woman's work will always be a little different than a man's. There's always a difference in the thinking between male and female. When women are

women artists and don't try to ape men, I see a great difference. I feel that through nature I'm totally female, in that sense. Of course, we know that females have male genes and vice versa. But I mean . . . that my whole mind. And then the work that I do is feminine. When I work, I don't work like males. I have never used a ruler to make one piece in my life. It's too mechanical for me. Then I use a scissors to cut certain thin woods. No male would do that. Now, most people feel that because of the abundance of work . . . and it's rather monumental . . . they would like to say, you work like a man. Well, that isn't true at all. That's a preconceived idea.

I think that if a woman is gifted and she's attractive she's going to have a great time on earth. Why would she want to be anything else? I don't think of myself as a strong woman. I never even heard that word about me until recently. I always thought bluntly that I was a glamorous goddamn exciting woman. I didn't want to be strong at anything. I wanted to have a ball on earth. But I wanted it through the channels that I want.

I don't think that anyone that knew me in the beginning ever suspected that I would be the one to arrive at certain things. They didn't because we're camouflaged.

I could have played the role of the down-and-out artist, but I wanted to have fun, and not only fun, I think I fed on it. It was exciting. I always used to dress with a flair. And I liked to swear and I liked to drink and have romances. Well, little did they think that I'd be the one to arrive. *I* knew it, though. I was very sure of what I was doing. I believed in myself and I was utterly satisfied with what I believed in. I wasn't going to let a soul on earth judge my life. . . .

I'd rather work twenty-four hours a day in my studio and come in here and fall down on the bed than do anything I know. Because this is living. It's like pure water; it's living. The essence of living is in doing, and in doing, I have made my world and it's a much better world than I ever saw outside.

Nierendorf

At that time I was so desperate that I decided—like I always decide my own destiny, I guess—that I had to have a show or I was going to cut my throat. I'd been out with a distant relative of mine, and I think he must have spent a great deal of money, maybe a thousand dollars for the day. We lived it up. The shock of extravagance and the contrast with my situation was so great that—I was at the Plaza at the time and we had lunch and I walked out of there and I said to myself, what's the best gallery in New York? Well, I'm going in there and if I don't get a show, I'll shoot him. So I walked over from the Plaza to the Nierendorf Gallery.

Now Nierendorf was considered at that time to be the best gallery in New York for modern art. He was the one who brought and introduced Paul Klee to this country. He had Picassos, he had all of those European artists. His gallery was on the south side of 57th Street, between Madison and Fifth. Number 18 East 57th Street. So I went in there and I introduced myself. And he said, "What can I do for you?" And I said, "I want an exhibition in your gallery, Mr. Nierendorf."

And I guess he thought something was a little strange. So he said, "But I don't know your work." And I said, "Well, you can come and see my work." He said, "Where do you live?"

At that time I had a little place on 21st Street. When the WPA closed about six months before, they had taken all the sculpture and broken it up and thrown it in the East River. But the man who was in charge asked me if I wanted my work returned, and I said yes. And so I had it in the cellar. So Nierendorf came the next evening, looked at the pieces, and said, "You can have a show in three weeks."

I think we create our lives. I'm not going to accept words like *luck* and *break*, none of it. First, I wouldn't permit it. I don't want breaks. I don't want the outside to superimpose. In my structural mind, I couldn't afford it—"luck." If others think that way, I feel a weakness in their structure of thinking.

So we had the show, and it was received very well by the critics. And Nierendorf was pleased. Nevertheless, there were no sales. I had moved from the house on 21st Street to an enormous loft on East 10th Street, alone in a four story building. Fifteen dollars a month. It was cold and I was miserable and I just lay in bed. And I saw *darkness* for weeks. It never dawned on me that I could come out of it, but you heal. Nature heals you, and you do come out of it. All of a sudden I saw a crack of light . . . then all of a sudden I saw another crack of light. Then I saw *forms* in the light. And I recognized that there was no darkness, that in darkness there'll always be light.

But still I was alone and struggling. And I was emotionally caught in war, that's violence, caught in guilt. Mike was in the war, at sea with the Merchant Marines. When he went to Egypt or Russia and it was secret, they couldn't inform us, and six months at a time I didn't hear from him. It threw me into a great state of despair. And I recall that my work was black and it was all enclosed—all enclosed. I couldn't think of doing a piece in the round.

I would use black velvet and close the boxes. In other words, this was a place of great secrecy within myself. I didn't even realize the motivation of it; it was all subconscious, it was the expression of a mood. But it isn't only *one son*. It's also that the *world* was at war and *every* son was at war. And it was an atmosphere in the world, right through the world. I evidently live so much *in* the world and *out* of the world, both places, that I was right in the middle of it. And I thought at the time that I would *never* have a piece of work in the open again.

I didn't make sculpture to share my experience. I was doing it for myself. I did it because I knew I was in a spot, and I had to move out of it to survive. Almost everything I had done was to understand this universe, to see the world clearer. I think that ultimately what drove me so desperately was . . . I could only understand through working. That means, through myself.

That was when I began using found objects. I had all this wood lying around and I began to move it around, I began to compose. Anywhere I found wood, I took it home and started working with it. It might be on the streets, it might be from furniture factories. Friends might bring me wood. It really didn't matter.

ANGER

Like Nierendorf, the critics were magnificent. In my life, I must say that I always have been very pleased with critics. From the day I ever showed anything they always gave me praise. They really pointed the way. And so I had certain wonderful things, but the general climate wasn't ready at that time, for my work. I was a soloist.

At the end of the show at the Norlyst, nothing sold. Personally, I didn't think that private people would buy it but I did think that the museums would be ready for that work. But under those circumstances, when the work was returned to me, I had to dismantle the whole show. And for lack of space, I took about two hundred paintings off the stretchers and burnt them in the back lot. I regret it. I believe that what I was doing was right for my awareness at that given time. And in retrospect, even the things that were destroyed, I wish I hadn't. Because they were living reflections of that time.

If there had been *one person* that would have come closer, I think it would have changed a lot of things. Not probably in the ultimate but at the time. Well, I was goddamn angry. That you can be sure. And I'm not talking about sweet little anger, I mean a great ANGER that one contains for years—probably forever to a point. For thirty years I wanted to jump out of every window. I think it's a miracle in retrospect that I didn't lose my mind or ever go into a sanitarium. All my life people have told me not to waste my energies on anger, but I kept anger, I tapped it and tapped it. Anger has given me great strength.

I have a fantasy about Picasso. That every morning, when he got up, they'd delivered to him, hours before, a thousand glasses, and he'd take a wall like that [pointing] and smash them before he'd ever start working.

How hard it was, how long I waited, that was my life, but first I didn't want little small successes. That didn't interest me one bit, it would have embarrassed me. If I didn't sell for thirty years, I just felt that the public wasn't ready. You know, if you have an automobile and it goes a little fast and the others are slow, you're out of key. It is always amazing to me that in the nineteenth century when Cézanne lived, there really wasn't one person on earth who saw eye to eye with him. They may have accepted him and thought him sensitive, but they did not see eye to eye. This should be a lesson to the creative mind and give us courage. Just because there is no one on earth for the moment that sees it, that does not disturb a creative person.

I never for one minute questioned what I had to do. I did not think for one minute that I didn't have what I had. It just didn't dawn on me. And so if you know what you have, then you know that there's nobody on earth that can affect you. But I have an opinion of people in the art world who have these big jobs, who overlook creativity and deprive artists of their rightful place—which is murder. I didn't sell for practically thirty years. That meant I was deprived of a livelihood. Because the people in positions who got salaries were blind, I was deprived. I think there's a great, great injustice. Not just to me, but to all artists. I think it is a great tragedy that right now there may be people that none of us are seeing, because they're not in the stream of this or the stream

of that. When a person has a position in a creative way—they have a moral obligation, or they should resign their job. But they don't claim their heritage, so they're unknowing, and anything they don't understand they want to crucify.

There was the anger and the frustration, the whole works, drama, the whole works. I was living a lifetime of things, not one person's. I lived a million lives. And as I say this now and speak about it, I do think that my present work reflects *that* livingness as well as others. It was never lost and still isn't lost, because we just never forget things. It is true we put them in storage, but we don't forget them. All that experience has gone into the work. It still gives me new revelations.

The one thing that must have saved me is, I was a terrific worker and really I thought it was the most important. I must say I don't think it would have been human for anyone on earth to have worked more than I. I had that, you see. I've said that we project, and that you don't really depend so much on people on that level. I wasn't making anything for anybody. I was trying to fulfill a reality for myself. At the time, in the 1940s, I felt that every breath that I took, I was aware, and I didn't feel that there was much breathing outside of myself. And so there I was working and working quite desperately. Now I feel better, thirty years later, only for one reason—that I have made a kind of reality that is a personal reality. Since I did not find a reality, so-called, according to my thinking, on the outside, I have built a whole reality for myself.

"I don't belong to any movement"

Through personal choice and necessity, I never became involved with a group of artists. I don't belong to any movement. Of course, there is no mistake that the times I was living in had influence on me. We pool our energies with other creative people. I feel that, say, if some of our people weren't around where sparks fly, maybe I would not have come to this. That *must* be. My work is bound to be related to that of others. I think what we do is take what *we* understand of both ourselves and what we see around us. Our own nature makes a selection; it selects which things please you more. When you feel that rapport, you work along those lines, consciously or not. I don't mean you copy. But I think when you live in a hunk of time, you reflect a hunk of time. What takes place in it.

But you know . . . I wouldn't feel in the right place if I was in the stream of Abstract Expressionism. Now I think they are marvelous. I love their art, and I love their energy. Nevertheless I had to go my own way. Yes, I believe artists reflect their time, but they have to stand on their own two feet . . . not on someone else's. I chose at quite an early age to be a soloist. Because I realized that the rhythms of people are different. Consequently, I wouldn't assume to impose that on somebody else. And by the same token, I had to make my decisions, I had to make my moves. Everything came back to *me*.

The Dawns and the Dusks: Black

So the work that I do is not the matter and it isn't the color. I don't use color, form, wood as such. It adds up to the in-between place, between the material I use and the manifestation afterwards; the dawns and the dusks, the places between the land and the sea. The place of in-between means that all of this that I use—and you can put a label on it like "black"—is something I'm using to say something else.

About what black . . . the illusion of black means to me: I don't think I chose it for black. I think it chose *me* for saying something. You see, it says more for me than anything else. In the academic world, they used to say black and white were no colors, but I'm twisting that to tell you that for me it is the total color. It means totality. It means: contains all. You know, this is one of the most interesting things to me, that people have identified with black all their lives and, for some reason, they identify black with death or finish. Well, it may be that in the third dimension black is considered so. It's a myth, really. . . . Now, I don't see colors, as I've often said, the way others do. I think color is magnificent. It's an illusion. It's a mirage. It's a rainbow. But why not? It's great. I was considered quite a colorist, and I can appreciate that artists in the past centuries used color—that it was right. And they were symphonies. Certainly I'm a great admirer of Bonnard or Matisse. I think Bonnard used color of that tone, we'll call it not a minor key but a major key—the treble clef. Well, he reached a symphony of color. Now if you can do that and you *want* that it almost becomes no color, because it's a mirage of light. There isn't a color that isn't of that intensity if you can get that essence and *not* think of it as color. Not only black and white and gold and silver, but you can also go to the rainbow and you can see in the sky the purples and the blues.

But when I feel in love with black, it contained all color. It wasn't a negation of color. It was an acceptance. Because black encompasses all colors. Black is the most aristocratic color of all. The only aristocratic color. For me this is the ultimate. You can be quiet and it contains the whole thing. There is no color that will give you the feeling of totality. Of peace. Of greatness. Of quietness. Of excitement. I have *seen things* that were transformed into black, that took on just greatness. I don't want to use a lesser word. Now, if it does that for things I've handled, that means that the *essence* of it is just what you call—alchemy

First Personage (Fig. 17)

What happened was, I acquired those planks and things, and I got so involved in my work that I really was creating a novel, because I had myself being the bride . . . it was my autobiography in that sense. So I did then *First Personage* [Fig. 17], and that must be at least six and a half feet tall and it's two inches wide—thick. In width it's about two and one-half feet but I mean in depth it's only about two inches. The interesting thing, while I was filing and working away at it there was a knot where the mouth

was supposed to be, just a plain knot, and I, being so concentrated, all of a sudden I saw this knot, mouth moving. And the whole thing was black by then and it frightened me. At that time I was so geared in that I . . . made . . . a black wedding cake. I'm always taking these trips, you see, and I suppose this trip I didn't have a bridegroom, but I had a wedding cake. If you're going without a bridegroom, naturally it's going to be a black wedding cake. Then I made a bridge to cross over. The bridge was a single two-inch lath, but it was about six or seven feet long and I put a few little so-called houses . . . a couple of little wood blocks on either end. To change the texture of light I glued a one-half-inch-wide ribbon of black velvet to one edge of the lath. See, I'm returning to that period. That's a certain virility there and simplicity, you know. Anyway . . . I crossed that bridge. I was caught in that state of mind and then I was coming out of it. I realized you couldn't go on that bridge, that it was impossible for a human to go on that bridge and that there are no black wedding cakes and that personage was sculpture. But they had all become realities. And so I had to fight to come back.

The Walls: "I had loads of energy"

I attribute the walls to this. I had loads of energy. I mean, energy and energy and loads of creative energy. And no matter how much space—now it's different, but at that time if I'd had a city block it wouldn't have been enough, because I had this energy that was flowing like an ocean into creativity. Now I think a brook is beautiful, and a lake you can look at and it's just peaceful and glorious, but I identify with the ocean. So I did begin to stack them. It was a natural. It was a flowing of energy.

I think there is something in the consciousness of the creative person that adds up, and the multiple image that I give, say, in an enormous wall gives me so much satisfaction. There is great satisfaction in seeing a splendid, big, enormous work of art. I'm fully aware that the small object can be very precious and very important. But to me personally, I think there is something in size and scale. We have all heard of quantity, of quality. I want a lot of quality in a lot of quantity.

Alice Neel (1900–1984)

The art of Alice Neel is focused on portraiture, an unusual choice in the twentieth century, and its investigation of the individual psyche. Recognition for Neel's highly original oeuvre came very late in her life, when the artist was in her sixties.

Neel's comments excerpted here are mostly derived from a series of taped conversations with Patricia Hills published in 1983, the year before her death. Like Nevelson's comments, Neel's text retains the energy and rambling quality of the spoken word. Although she begins with a retrospective discussion of her childhood, no strict chronological organization is maintained. What the text may lack in structure is more than compensated for in its vitality and immediacy.

Born into a nonartistic family, Neel was raised in the suburbs of Philadelphia. From 1921 to 1925 she attended the Philadelphia School of Design (now Moore College of Art), which was still under the direction of Mary Cassatt's traveling companion, Emily Sartain. In the first excerpt Neel recalls her early interest in becoming an artist, and traces her art education through 1925 and her graduation from the Philadelphia School of Design. In quick succession, Neel married, bore and lost an infant from diphtheria, separated from her husband, tried to commit suicide, and suffered a total nervous breakdown. By 1932 she had relocated to New York. Like Krasner and Nevelson, Neel was supported during the thirties by the New Deal assistance programs targeted at artists. The next two excerpts concern some of her paintings and experiences from this decade, as well as her beliefs in the political force of paintings.

During the late 1940s and the 1950s, Neel continued to paint images of specific individuals, going very much against the modernist movement of Abstract Expressionism. Her attitudes toward abstraction are discussed in the fourth segment. During these years, Neel worked in total obscurity. Because she did not execute commissioned portraits but instead selected her own sitters, she has recorded in paint a very broad cross-section of society. From the Puerto Rican man in *T.B. Harlem* (1940) to members of her family, pregnant women, and art-world luminaries such as Red Grooms, Andy Warhol, and the critic John Perrault. Neel's sitters seem to reflect the times. Her comments on portraiture, as she understood it, and the role of painting as a form of history communicate her aesthetic beliefs vividly.

Major honors came to this artist in her seventies. In 1971 she was awarded an honorary doctorate by Moore College of Art, her alma mater. Her address on that occasion, reprinted here, is one of the few written statements she authored. In 1974 a major retrospective at the Whitney Museum in New York finally brought her works into wider public view. Neel was a prominent and active supporter of the women's movement in the 1970s; her comments in the address to Moore College connect her political views against injustice and racism with her feminist positions.

In the last statement reprinted, Neel defines her art as "truth." Nowhere does Neel seem to "tell the truth" more accurately than in her own *Self-Portrait* (Fig. 18), painted in 1980 when the artist was 80 years old. This work is remarkable for its forthright honesty and absence of vanity. She combines incisive psychological realism with a visible paint surface. Even Neel's nude portraits are never idealized, generalized, or abstract, but always retain an individualized likeness. Neel tends to draw with paint. This

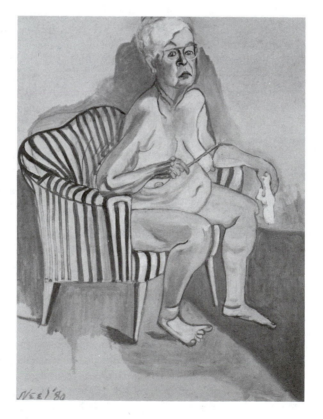

Figure 18. Alice Neel, *Self Portrait*. The National Portrait Gallery, Smithsonian Institution, Washington, D.C.

is visible in the prominent blue contour lines that enclose and define her body. This work illustrates Neel's characteristic preference for a shallow, undetailed space that focuses attention on the figure.

With the breakdown of a monolithic modernist critical discourse, we can now better appreciate the integrity and power of Neel's portraiture. Resolutely nonacademic in her style, independent of art movements, Neel courageously pursued her own artistic vision over nearly half a century, producing a richly innovative oeuvre of unquestioned quality and originality.

"I always wanted to be an artist": The Philadelphia School of Design for Women

I always wanted to be an artist. I don't know where it came from. When I was eight years old the most important thing for me was the painting book and the watercolors. I'm not like Picasso. He loved the Katzenjammer Kids. Even though I was given a book of the Katzenjammer Kids when I was ten years old, I hated them. I liked romantic couples, and pears and flowers, and that kind of stuff. And I'd get watercolors for Christmas. I didn't take art in high school, but I used to draw heads on the edges of my paper. I was so unsure of myself that the back of the head always went off the paper.

I felt such an obligation to my family, because they didn't have much money, that after the two years of regular high school I took the business course. I became an expert typist and stenographer. At the end of school, I took the Civil Service examination. Since I was so good at mathematics, I immediately got a very good job with the Army Air Corps in Philadelphia, just at the end of World War I. I made what for those days was considered very good money, $22 a week. I took care of the filing and the letters. I worked for a man named Lt. Theodore Sizer. Later he became an art historian in New England. He used to take me on his shopping trips for his family.

I never told anybody about my art. But even then, at night after work, I went to art school, to the School of Industrial Art, and then to another one in downtown Philadelphia. The teacher there was an old German, very dogmatic. In one picture I was putting the hair on the head like it grows, and he said: "You don't have to do that. You can just put a tone in." So he showed me how to fill in the side of a head with up and down strokes. I said: "Well, that isn't the way the hair goes. I don't want to put in a tone." So he looked at me in fury and said: "Before you can conquer art, you'll have to conquer yourself. Even if you paint for forty years you may not get anywhere." And I said: "That's not for you to say because you are only my *beginning* teacher." He didn't bother me, though. I just kept going.

In the three years after high school I worked in various Civil Service jobs besides the Air Corps job. At the end I was making about $35 a week, which was a lot of money for then. Then I quit and answered an ad for a job in Swarthmore. I was offered a job for $30 a week. I remember walking home from the interview through the fall leaves and thinking how discontented I was just to go to work every day. Art was at the back of my mind, always. So I wrote the interviewer that I didn't want the job.

I then enrolled in the Philadelphia School of Design for Women, now called Moore College of Art. I didn't want to go to the Pennsylvania Academy of the Fine Arts because I didn't want to be taught Impressionism, or learn yellow lights and blue shadows. I didn't see life as a *Picnic on the Grass*. I wasn't happy like Renoir.

The Philadelphia School of Design was only a women's school. I liked that better, because I was young and good-looking, and the boys were always chasing me. And here at the Philadelphia School of Design I wouldn't even be able to notice a boy. Because I liked boys. It's all right at sixty or more to say that men are unimportant, but at twenty-one they can be the most important thing in your life. I went to a school that was just a girls' school so I could concentrate on art.

At that point I could always handle men easily. I much preferred men to women. Women terrified me. I thought they were stupid because all they did was keep children and dogs in order. Even though they were "the conscience of the world," I didn't think they had all the brains they should have, nor all the answers. I thought the most they ever did was back some man they thought was important.

Miss Emily Sartain was the dean of the school, a very conventional lady. And of course I got in all right. I paid the first year's tuition. It was only $100, I think, and I had saved a little money. They taught fashion there, too. I enrolled first as an illustrator, but that was a mistake, so I changed to fine arts before the end of that year. After that they gave me the Delaware County Scholarship because I was very good.

I was too rough for the Philadelphia School of Design. I didn't want to pour tea. I thought that was idiot's work. And I once painted a sailor type with a lighted cigarette. And, you know, when you paint a picture, there is a certain range. So having this lighted cigarette made the range different—from bright fire to the shadow—and it was very hard to paint. But none of them realized that. This shocked them. They liked pictures of girls in fluffy dresses with flowers better, so they didn't give me a European scholarship. I stayed until I was twenty-five and got a diploma, equivalent today to an M.F.A.

The 1930s: Art and Politics

I painted *Symbols* in 1932. A short time before, Roger Fry had written a book where he gave Cézanne's apples the same importance in art as the religious madonnas.[1] The doll is a symbol of woman. The doctor's glove suggests childbirth. The white table looks like an operating table. And there's religion in this, with the cross and palms. In my opinion all of this is humanity, really. This wretched little stuffed doll with the apple, and you see we're still a stuffed doll. Look what's happening to us. Do you think we want to die of a nuclear thing? Do you want your son to go to war? We are powerless. I can't bear that. I hate to be powerless, so I live by myself and do all these pictures, and I get an illusion of power, which I know is only an illusion, but still I can have it, because I'm not confronted with this grim reality. You see all of the artists of yesterday, none of them have two cents of importance beside the great structure. The

Pentagon is here. It's not the art world, it's the Pentagon. But you see, one thing they're learning here, maybe, is the importance of art, because the socialist countries always gave importance to art. They saw it as a great propaganda weapon. Here, they're finally learning that art has some importance. They never knew that before. They were too dumb. . . .

In the winter of 1934, Kenneth Doolittle[2] cut up and burned about sixty paintings and two hundred drawings and watercolors in our apartment at 33 Cornelia Street. Also, he burned my clothing. He had no right to do that. I don't think he would have done it if he hadn't been a dope addict. He had a coffee can full of opium that looked like tar off the street. And it was a frightful act of male chauvinism: that he could control me completely. I had to run out of the apartment or I would have had my throat cut.

This was a traumatic experience as he had destroyed a lot of my best work, things I had done before I ever knew he existed. It took me years to get over it. The level of the watercolors in this book show the level of the watercolors he destroyed. They were also personal history.

Since all this had been a major disaster for me, I was in a very rational mood when I painted Max White. Because of the irrationality of Doolittle's actions, I began to think rationality was the most important thing. Anyway, I've always had a rational streak. . . .

The first time I joined the Communist Party was about 1935, around the time I painted *Pat Whalen.* But I was never a good Communist. I hate bureaucracy. Even the meetings used to drive me crazy. I didn't participate in the meetings because I was too timid. I didn't dare to speak out. But it affected my work quite a bit.

I got an important critic on the WPA by lending him two pictures. The reason I loaned them to him—it was obviously dishonest—was because of left-wing influences. I had reached the conclusion that to eat was the most important thing in the world, and also I thought he knew so much about art that even though he couldn't paint he had a right to be on the project. Once he got in there he became a supervisor and a big theoretician and a great dictator. When he brought Elaine de Kooning up to my house in the early fifties, I got drunk, and I accidentally told this story. And of course he could have killed me.

I went to the demonstrations of the Artists' Union. We cooperated with the picketing workers of May's Department Store. We picketed, and an Irish policeman arrested a big batch of people. He walked up to me and said: "No, I won't arrest you. You're too Irish." And he didn't arrest me. But many people were in jail overnight. I hate to tell you that I was glad not to be in jail, because I had claustrophobia.

I was a Communist when I painted *Nazis Murder Jews,* about a Communist torch-light parade in about 1936. The people in the front are Sid Gottcliffe and others who were on the WPA project. I showed the painting at the ACA Gallery. A critic wrote: "An interesting picture, but the sign is too obvious." But if they had noticed that sign, thousands of Jews might have been saved.

QUESTION: Do you think that painting can be in the service of the revolution?

Look at Goya, look at the Mexicans! If it is real enough, it can be. Do you know to how many lectures I went on this question? At least fifty. In the 1930s, this was the big question. The Communists said then—the big Communists—when there is socialism there would be no need for art. I thought they were just stupid. They meant that everything would be so good you wouldn't have to correct it. Now I always hated being dictated to, although I myself painted these things. I thought *Pat Whalen* was important.

On Being a Woman Artist

I didn't let being a woman hold me back. There was a man on the Project: "Oh, Alice Neel! The woman who paints like a man!" And I went to all the trouble of telling him that I did not paint like a man but like a woman—but not like a woman was supposed to paint, painting china. I felt it was a free-for-all. And I never thought it was a man's world. I thought women were always there, even though they may not have participated fully.

Art doesn't care if you're a man or a woman. One thing you have to have is talent, and you have to work like mad.

I was in the exhibition *The New York Group* in 1938 at the ACA Gallery—seven men and I. They were so embarrassed because I was a woman, but I didn't feel any different from them. They didn't understand.

I always needed Women's Lib. I had it inside of me, but outside, these people ran over me even though I was a much better painter.

Abstract Expressionism

Abstract Expressionism was becoming very attractive then. I'm not against abstraction. Do you know what I'm against? Saying that man himself has no importance. I'm grateful to trees and things that still put out their leaves. And skies that still operate for us. The Van Allen Belt has not collapsed yet. I think those things are very tolerant with human beings. What I can't stand is that the abstractionists pushed all the other push-carts off the street. But I think when Bill de Kooning did those women it was great. You know why? I think he had something the matter with him sexually and he was scared of women. He probably saw teeth in vaginas.

Ortega y Gasset was prophetic. He predicted in *The Dehumanization of Art* a whole era of art. I think he states there that Juan Gris said Cézanne's arm goes into a cylinder; whereas I paint a cylinder that perhaps becomes an arm.

There is room for different kinds of art. You know what the Bible says: "In my father's house, there are many mansions." And of course Robert Rauschenberg is good today because he shows the world falling to pieces, and he shows the bombardment of the brain with all those things.

On Portraiture

I went to see a big show of Cézanne's, at least twenty-five or thirty years ago at the Metropolitan. He had a lot of portraits there, and I was amazed at his psychological depth. I didn't think he had it. And guess what he said: "I love to paint people who have grown old naturally in the country." But you know what I can say? "I love to paint people torn by all the things that they are torn by today in the rat race in New York." And maybe one reason I love that so much is because as a child I had to sit on the steps in that dreary small town. But I also think I have an awful lot of psychological acumen. I think that if I had not been an artist, I could have been a psychiatrist. Only I wouldn't have known what to tell them to do, but they don't know either.

I do not pose my sitters. I never put things anywhere. I do not deliberate and then concoct. I usually have people get into something that's comfortable for them. Before painting, when I talk to the person, they unconsciously assume their most characteristic pose, which in a way involves all their character and social standing—what the world has done to them and their retaliation. And then I compose something around that. It's much better that way. I hate art that's like a measuring wire from one thing to the next, where the artist goes from bone to muscle to bone, and often leaves the head out. I won't mention who does that.

When I paint it's not just that it's intuitive, it's that I deliberately cross out everything I've read and just react, because I want that spontaneity and concentration on that person to come across. I hate pictures that make you think of all the work that was done to create them.

Pregnancy in Art

It isn't what appeals to me, it's just a fact of life. It's a very important part of life and it was neglected. I feel as a subject it's perfectly legitimate, and people out of false modesty, or being sissies, never showed it, but it's a basic fact of life. Also, plastically, it is very exciting. Look at the painting of Nancy[3] pregnant: it's almost tragic the way the top part of her body is pulling the ribs.

"A painting . . . is the *Zeitgeist,* the spirit of the age"

Art is a form of history. That's only part of its function. But when I paint people, guess what I try for? Two things. One is the complete person. I used to blame myself for that, do you know why? Because Picasso had so many generalities. And mine were all—mostly a specific person. I think it was Shelley who said: "A poem is a moment's monument." Now, a painting is that, plus the fact that it is also the *Zeitgeist,* the spirit of the age. You see, I think one of the things I should be given credit for is that at the age of eighty-two I think I still produce definitive pictures with the feel of the era. Like the one of Richard, you know, caught in a block of ice—*Richard in the Era of the Corpora-*

tion. And these other eras are different eras. Like the '60s was the student revolution era. Up until now, I've managed to be able to reflect the *Zeitgeist* of all these different eras.

I see artists drop in every decade. They drop and they never get beyond there. That was one of the things wrong with the WPA show at Parsons in November, 1977. Hilton Kramer's[4] attitude toward that show was absurd. You can't dismiss the Great Depression as having very little importance. He flattered me. He said at least I didn't join the crowd and do just the same thing they were all doing. He was right, in a way. Those people dropped, back in the '30s, and they never got over it. Many artists developed an attitude and a technique, and they never changed. Even though the world changed drastically, they kept right on doing the same thing.

Address Presented at Moore College of Art, on the Occasion of the Award of an Honorary Doctor of Fine Arts Degree, June 1971

This is a great era of change and it is very exciting to be an artist—even with the terrible things that are going on, such as the war in Vietnam and the fact that society is almost in a state of chaos. In reviewing the International Show in New Delhi, a critic refers to the American Section which was devoted to examples of the currently moribund minimal-conceptual esthetic debacle, and tells how many Indian artists found the American exhibit insulting and withdrew their work. Things move so fast today that before a movement dies the next movement is already felt. . . .

Destruction and bitter criticism are a reflection of the overall picture. However, great attention is being paid to art and the artist is being lifted out of his idiosyncratic alienation (witness me) and all society is taking an interest in him. Giacometti is a tale of what was and the great Picasso reviewing all art and presenting it with a destructive virtuosity is perhaps the end of an era.

The women's lib movement is giving the women the right to openly practice what I had to do in an underground way. I have always believed that women should resent and refuse to accept all the gratuitous insults that men impose upon them. The woman artist is especially vulnerable and could be robbed of her confidence. . . .

I have only become really known in the sixties because before I could not defend myself. I read a quote from Simone de Beauvoir saying that no woman had ever had a world view because she had always lived in a man's world. For me this was not true. I do not think the world up to now should be given to the men only. No matter what the rules are, when one is painting one creates one's own world. Injustice has no sex and one of the primary motives of my work was to reveal the inequalities and pressures as shown in the psychology of the people I painted. It is not for nothing that Samuel Beckett won the Nobel Prize. His world view, encapsulated capitalism, carries the theory of dog eat dog to its ultimate outpost.

When El Greco and Raphael painted, religion was powerful and the great art was

done in relation to faith and the church. A Campbell's soup can has supplanted Christ on the cross.[5] Money is king and advertising and technology religion for the arts, and now complete destruction and anti-art. In *The Village Voice* an artist offered as his work the fact that he thought blue all day. This destruction also relates to a desire to destroy the market place and the art combines—nothing to buy or sell is the slogan.

My choices perhaps were not always conscious, but I have felt that people's images reflect the era in a way that nothing else could. When portraits are good art they reflect the culture, the time and many other things. I once saw a print of a portrait of Commodore Perry who commanded the fleet that brought about "the Open Door Policy" in Japan in 1854, done by a Japanese artist. It resembles Perry but was seen and executed in an entirely Japanese manner. (By the way, Perry received $20,000 as a reward for intimidating Japan.) The great portrait by Goya of the Duke of Wellington is a super Englishman and hero seen through the eyes of a Spaniard who admired him as the conqueror of Napoleon who had committed so many crimes in Spain. Crimes that Goya did great etchings of in his series, "The Disasters of War." This by the way is evidence that the artist can be socially committed without lowering his level.

Never has prejudice of all sorts come under attack as it has today. There is a new freedom for women to be themselves, to find out what they really are. Freud's "What do they want?" is easy to answer. They know what they do not want, but just as the slave can only dream of what he will have after freedom, which he knows he wants, women must first be free and live and discover what they want. The March edition of *Harper's* has a great article on women's lib by Norman Mailer, seen from the male point of view, and then there is the book *Sexual Politics* by Kate Millet presenting the case for women.

As to the role of the museum. Nothing could be more important than that one's work be shown. In 1963 I painted Bill Seitz when he was still curator of The Museum of Modern Art. He would disclaim any influence on the art world by saying "we just reach out there"—I told him that what he hung on his walls in turn had a great influence and became sanctified. In the portrait there is an arm resting on its elbow with a completely non-committed hand doing nothing which was my way of presenting his attitude. I'll admit this is rather subtle, and picketing is much more effective. The human image for many years was not considered important. In 1962 when the Museum of Modern Art had its *Recent Painting U.S.A.: The Figure* show I went to a symposium there (all men, by the way) and none of the speakers really connected with the kernel of the subject.

Statement from the 1970s: "I told the truth, as I perceived it"

I do not know if the truth that I have told will benefit the world in any way. I managed to do it at great cost to myself and perhaps to others. It is hard to go against the tide of one's time, milieu, and position. But at least I tried to reflect innocently the twentieth century and my feelings and perceptions as a girl and a woman. Not that I felt they were all that different from men's.

I did this at the expense of untold humiliations, but at least after my fashion I told the truth as I perceived it, and, considering the way one is bombarded by reality, did the best and most honest art of which I was capable.

I always was much more truthful and courageous on canvas.

I felt that profundity in art was the result of suffering and deprivation—but I am not sure that this is so.

26

Eva Hesse (1936–1970)

Eva Hesse's mature career as a sculptor was concentrated within the brief span between 1966 and 1970, but her works created in those five years are recognized as influential and innovative. She is widely acknowledged as one of the leaders of the early 1970s movement of "Process Art." As a reaction to Minimalism, Hesse used a biomorphic, organic, yet abstract vocabulary and experimented with highly unusual and often impermanent sculptural materials. Hesse created an oeuvre of about seventy sculptures before she died from a brain tumor at the age of 34.

A few months before her death, Hesse talked extensively to Cindy Nemser about her early life, her understanding of her art, her attitudes toward materials, and other matters. This interview is the most complete extant statement about her work, and thus an extremely important and frequently quoted source on the artist. An excerpted form of the interview was published in *Artforum* in May 1970, the month Hesse died. This longer version was included in Nemser's anthologies of conversations *Art Talk,* published five years later, in 1975. Two years after her death, Hesse's art was showcased in a retrospective exhibition at the Guggenheim Museum, with an essay by the critic Robert Pincus-Witten. And in 1976 Hesse's friend Lucy Lippard published an extensive monograph on the artist documenting her career in detail. Thus, within a short period of time, Hesse's posthumous reputation was firmly secured.

As she tells Nemser, Hesse and her sister miraculously escaped the Holocaust and settled with her family in New York City in 1939. Her determination to become an artist was set by the age of 16. After several years in New York art schools—Pratt Institute, the Art Students League, and Cooper Union—she attended Yale University's School of Art and Architecture, then run by the Bauhaus minimalist Josef Albers. She married the artist Tom Doyle in 1961, but it was not until the couple went to Germany to spend a year under the patronage of a German industrialist who had admired Doyle's sculpture that Hesse began to find her own direction. As Lippard explains:

The German period had provided a lonely but crucial apprenticeship. It was, in fact, fortunate that the seeds of Hesse's mature work emerged and could first be nurtured away from the New

York scene, away from the pressure of an art world becoming increasingly incestuous and competitive, away from the advice and criticism of well-meaning friends and away from the influence of new shows. . . . She returned to New York with her drive and ambition undiminished, with a body of respectable work behind her, a head full of new confidence and ideas, and an image of herself as a sculptor.[1]

1966 proved to be a year of immense importance for Hesse. Her marriage with Doyle broke up, her father died, and she established a supportive network of artist friends in Manhattan. One of her works was included in the show *Eccentric Abstraction,* curated by Lippard, which also included works by Louise Bourgeois, Bruce Nauman, and Keith Sonnier.

From this period until her death a few years later, Hesse developed a sculpture of contrast, or "absurdity," as she tells Nemser. Structured frequently around the principle of repetition and the geometry of the grid, Hesse's organic variations from these confining structures are always surprising. Finding a form that unified opposites is another underlying theme of her works.

In a clear, highly articulate manner, Hesse defines the major issues for her art in this interview. Her statements are even more poignant when read with the knowledge of her imminent death. A brain tumor was discovered in April 1969. She continued to work, with assistants, through three operations until her death on May 29, 1970.

Interview with Cindy Nemser

CINDY NEMSER: Tell me about your family background.

EVA HESSE: You won't believe it. I was told by the doctor that I have the most incredible life he ever heard. Have you got tissues? It's not a little thing to have a brain tumor at thirty-three. Well my whole life has been like that. I was born in Hamburg, Germany. My father was a criminal lawyer. He had just finished his two doctorates and I had the most beautiful mother in the world. She looked like Ingrid Bergman and she was manic depressive. She studied art in Hamburg. My sister was born in 1933 and I was born in 1936. Then in 1938 there was a children's pogrom. I was put on a train with my sister. We went to Holland where we were supposed to be picked up by my father's brother and his wife in Amsterdam but he couldn't do it, so we were put in a Catholic children's home and I was always sick. So I was put in a hospital and I wasn't with my sister. My parents were hidden somewhere in Germany and then they came to Amsterdam and had trouble getting us out. Somehow they got us to England. My father's brother and his wife ended up in concentration camps. No one else in my family made it. . . . No one in my family has lived. I have *one* healthy sister. There's not been *one* normal thing in my life—not one—not even my art. I never tried to get into a show. Art is the easiest thing in my life and that's ironic. It doesn't mean I've worked little on it, but it's the only thing I never had to. That's why I think I might be so good. I have no fear. I could take risks. I have the most openness about my art. My attitude is most open. It's totally unconservative. It's total freedom and willingness to work. I'm

willing really to walk on the edge, and if I haven't achieved it, that's where I want to go. But in my life—maybe because my life has been so traumatic, so absurd—there hasn't been one normal, happy thing. I'm the easiest person to make happy and the easiest person to make sad because I've gone through so much. And it's never stopped. . . .

CN: Do you feel any of your teachers influenced you?

EH: I don't think so. I loved Albers' color course but I had had it at Cooper. I did very well in it. I was Albers' little color studyist—everybody always called me that—and every time he walked into the classroom he would ask, "What did Eva do?" I loved these problems but I didn't do them out of need or necessity. But Albers' couldn't stand my painting and, of course, I was much more serious about the painting. I had the Abstract Expressionist student approach and that was not Albers', not really Rico Lebrun's nor Bernard Chaitin's approach either. And if you didn't follow their idea it wasn't an idea. And in color you had to. You were given coloring papers so your choices were less and you had to work within certain confines.

CN: Since you didn't feel any strong influence at Yale, were there people in New York who influenced you when you came back and started working on your own?

EH: I think at the time I met the man I married. I shouldn't say I went backwards, but I did, because he was a more mature and developed artist. He would push me in his direction and I would be unconsciously somewhat influenced by him. Yet when I met him I had already had a drawing show which was much more me. I had a drawing show in 1961 at the John Heller Gallery which became the Amel Gallery. It was called "Three Young Americans." The drawings then were incredibly related to what I'm doing now. Then I went back one summer again to an Abstract Expressionist kind of tone—that was really an outside influence. I think that struggle between student and finding one's self is, even at the beginning level of maturity, something that cannot be avoided. I don't know anyone who has avoided it. And my struggle was very difficult and very frustrating. I was conscious of it all the time, and if I ever had any worry in my development, then it was in finding myself. I used to worry: Am I just staying with a "father figure"? Where is my development? Is there a consistency? Am I going through a stage and will I reach there? I was very aware of that and it was a very frustrating, difficult time. But I worked. I never had the trouble of not being able to work although there would be, say, three months where I would work all the time and then maybe there would be a break and that would be very frustrating. But after a while I could always get back. It is true, there were stages, but in retrospect—the steps—Oh, it's so *clear.*

CN: When did you start working in soft materials?

EH: I started working in sculpture when my husband and I lived for a year and a half under an unusual kind of "Renaissance patronage" in Europe. A German industrialist invited us to live with him and I had a great deal of difficulty with painting but never with drawings. The drawings were never very simplistic. They ranged from linear to complicated washes and collages. The translation or transference to a large scale and in painting was always *tedious.* It was not natural and I thought to translate it in some

other way. So I started working in relief and with line—using the cords and ropes that are now so commonly used. I literally translated the line. I would vary the cord lengths and widths and I would start with three-dimensional boards and I would build them out with paper mâché or kinds of soft materials. I varied the materials a lot but the structure would always be built up with cords. I kept the scale, in Europe, fairly small, and when I came back to America I varied the materials further and I didn't keep to rectangles. Even in Europe I did some that were not rectangles, and then they grew and grew. They came from the floor, the ceiling, the walls. Then it just became whatever it became.

CN: How do the soft materials relate to the subject or content of your work? Do they embody unconscious ideas? Looking at your works they seem, to me, to be filled with sexual impulses or organic feeling. I feel there are anthropomorphic inferences.

EH: It's not a simple question for me. First when I work it's only the abstract qualities that I'm really working with, which is to say the material, the form it's going to take, the size, the scale, the positioning or where it comes from in my room—if it hangs from the ceiling or lies on the floor. However, I don't value the totality of the image on these abstract or esthetic points. For me it's a total image that has to do with me and life. It can't be divorced as an idea or composition or form. I don't believe art can be based on that. This is where art and life come together. Also I have confidence in my understanding of the formal to the point that I don't play with it. I don't want to make that my problem. I know it so well. I have complete confidence in my ability. I don't want to be aware of it or conscious of it. It's *not* the problem for me. Those problems are solvable, I solve them, can solve them *beautifully*. In fact, my idea now is to discount everything I've ever learned or been taught about those things and to find something else. So it is inevitable that it *is* my life, my feelings, my thoughts. And there I'm very complex. I'm not a simple person and the complexity—if I can name what it consists of (and it's probably increased now because I've been so sick this year)—is the total absurdity of life. I guess that's where I relate, if I do, to certain artists who I feel very close to, and not so much through having studied their writings or works, but because, for me, there's this total *absurdity* in their work.

CN: Which artists are they?

EH: Duchamp, Yvonne Rainer, Ionesco, Carl André.

CN: Let's talk about some of your early sculptures.

EH: There was a piece I did for that show in the Graham Gallery, "Abstract Inflationism, Stuffed Expressionism," in 1965 or '66. It was called *Hang-Up*—a dumb name. I did the piece when I came back from Europe and I wasn't totally aware of how "hang-up" was being used here. It's unfortunate, but I can't change it. I think it was about the fifth piece I did and I think the most important statement I made. It's close to what I feel I achieve now in my best pieces. It was the first time where my idea of absurdity or extreme feeling came through. It's huge—six feet by seven feet. It is a frame, ostensibly, and it sits on the wall and it's a simple structure which if I were to make again I'd construct differently. This is really an idea piece. It is almost primitive in its construction, very naive. It's a very thin, strong metal, easily bent and rebent. The frame is all tied

like a hospital bandage as if someone had broken an arm, an absolutely rigid cord around the entire thing. That dates back to those drawings I told you about. I would never repeat that piece of construction but there's a nice quality about it. It has a kind of depth I don't always achieve—a depth and soul and absurdity and life and meaning or feeling or intellect that I want to get. And I think that I believe in this piece enough that I have it in the back of my mind (and I never wanted to do this before) to redo it. Not to reconstruct it physically. I think it would be a different piece but I would like to do it again because I think it's valid. Don't let anyone hear this. This is the piece that Richard Serra called about. He said that he saw it and he really thought it was good. It is also so extreme and that is why I like it and don't like it. It is so absurd. This little piece of steel comes out of this structure and it comes out a lot. It's about ten or eleven feet out and it is ridiculous. It's the most ridiculous structure I have ever made and that is why it is really good. It is coming out of something and yet nothing, and it is holding. It is framing nothing. And the whole frame is gradated—oh more absurdity—very, very finely. It really was an effort. And it's painted with liquitex. It is very surreal, very strange. It is weird. It is like those things I did in Europe that come out of nothing in a very surreal and yet very formal way and have really nothing to do with anybody . . .

CN: There is a certain element of chance or openness of possibilities in your work—say in a piece like *Sequel* in which everything can be manipulated.

EH: Everything is loose, totally at random. Yet it's sort of rigid. They're half-spheres and they're cast from half-balls and then they were put together again but not put together completely. They were put together with an opening so that the whole thing was sqooshy. It was a solid ball but it wasn't a solid ball. It's collapsible because it's rubber and then it's cylindrical but yet not. Then they could be moved. The only limitations are the mat and they could roll off the mat because they are basically cylindrical. The whole thing is ordered yet they're not ordered. But this is an old piece and it interests me less, which doesn't mean that I think it's negative or less interesting as a problem. Yet I've said I was not interested in formal problems—again that duplicity— since *Sequel* obviously represented a formal problem to me. . . .

CN: Repetition is very prevalent in your work. Why do you repeat a form over and over?

EH: Because it exaggerates. If something is meaningful, maybe it's more meaningful said ten times. It's not just an esthetic choice. If something is absurd, it's much more greatly exaggerated, absurd, if it's repeated. . . .

CN: . . . Do you think there's anything obsessive in your work?

EH: I guess repetition feels obsessive, and that box—not that I think it's an important work—where I had 4,500 holes . . .

CN: Which box was that?

EH: That huge box. It was called *Accession.* I first did it in metal, then in fiberglass. That's obsessive repetition but the form it takes is a square and it's a perfect square. Then the outside is very, very, very clear and by necessity it just works that way. The inside looks amazingly chaotic although it's the same piece of hose going through, so it's the same thing but as different as it can possibly be.

CN: It's a kind of inner-outer dichotomy.

EH: In that sense the piece is one of the best examples, but it becomes a little too precious, at least from where I stand now, and too right and too beautiful. It's like a gem, like a diamond. I think I'd rather do cat's eyes now or even less than cat's eyes, dirt or rock. I'm giving an analogy or metaphor. It's too right. I'd like to do a little more wrong at this point.

CN: It's a very tactile work. My experience of it was that I wanted to get inside it.

EH: I lost one of the pieces because people got inside of it in a museum and the piece came back wrecked. It was promised to someone and I had to repeat it. And *there's* great irony and absurdity—the day that I finished that piece was the day I collapsed.

CN: All your work is extremely tactile. One wants to touch it, handle it.

EH: I see everybody does. I'm not aware of it. I'm not asking everybody to, but every time I've been in a place where I've seen my work there were hands on it. I guess it was a greater involvement but I'm not aware of it. I don't intentionally do it. I really feel that the most truth is that it just happens.

CN: I feel there is so much of the unconscious in your work, things that are coming out of you that you don't even realize. I guess that's true of every artist, but your work seems to have a release in it that some art doesn't have.

EH: I let it. I want that release. I can't go on a sheer program. At times I thought "the more thought the greater the art," but I wonder about that and I do have to admit there's a lot that I'll just let happen and maybe it will come out the better for it. I used to plan a lot and do everything myself and then I started to take a chance. I need help. It was a little difficult at first. I worked with two people but then we got to know each other well enough and I got confident enough and just prior to when I was sick I would not state the problem or plan the day. I would let more happen and let myself be used in a freer way. They also—their participation was more their own, more flexible. I wanted to see within a day's work or within three day's work what we would do together with a general focus but not anything specified. I really would like, when I start working again, to go further into this whole process. That doesn't mean total chance or freedom or openness.

CN: It seems to me that kind of working together has something to do with expanding art to include other people as participants—not mere spectators. It's as if the artist incorporates others and makes other people part of the art. Did working with others, this new openness, change your art?

EH: I can think of one thing it changed. The process of my work prior to that had taken a long time. First, because I did most of it myself and then when I planned the larger pieces and worked with someone they were more formalistic. When we started working less formalistically or with greater chance, the whole process was speeded up and we did one of the pieces at the Whitney that I love the most, the ladder piece [*Vinculum II*], in a very short time. It was a complex piece, but the whole attitude was different and that is the attitude that I want to work with now—in fact, even increased, even more exaggerated.

CN: That's a later piece, isn't it?

EH: It was one of the last pieces before I got so ill and it was one of the pieces we started working on with less plan. I just described the vague idea to the two people I worked with and we went and started doing it. There were a few things that I said to one of the people that I worked with—I said I wanted a pole. He made a perfect pole. It wasn't what I meant at all. So we started again and then he understood.

CN: How is this piece made?

EH: It's reinforced fiberglass, and then the structure underneath (I shouldn't say that because it's part and parcel) is wire screening in fiberglass and then rubber hose.

CN: You directed making the piece?

EH: No. We did it together. Now I have to learn to do that even more because of the illness. I can't work at all now, and when I *can* it's going to be limited. My physical capacities are going to be limited for some time and it's unreal to think I can handle it all. So I'll have really to give more and more for other people to do, and there's such a personal idiom for me, such a personal involvement, that it's not going to be easy for me to conceive of other people handling—I guess if I'm well enough to participate or at least verbally be there— . . .

CN: What about the idea of environmental art? Do you think of your work as environmental?

EH: No. I don't make them for the outside or the inside. Yet I guess they're for the inside because they are much closer to soul or introspection—to inner feelings. They are not for architecture or the sun or the water or the trees and they have nothing to do with color in nature or making a nice sculpture garden. . . .

CN: Here's this piece I like so much from the Whitney's "Anti Illusion, Procedures, Materials" exhibition. What's it called?

EH: *Expanded Expansion.* It has also been called *Untitled* because I hadn't really completed it when I went to the hospital. They didn't know it had a title. I never call things "Untitled" since things need to be titled as identification. I *do* title them and I give it a lot of thought most of the time because things being called "Untitled" is a sign of uninterest and I am interested. I try to title them so that it has meaning for me in terms of what I think of the piece and yet it's just like a word. I use a dictionary and a thesaurus. I usually use a word that sounds right too but that doesn't have a specific meaning in terms of content. It's straight but not another word for it. Anyway, this [photograph of *Expanded Expansion*] was taken in my studio when we just had this section. You could see we had the rods for the next section on the floor. We were working on it.

CN: How big was the piece?

EH: About ten feet high. How wide depends—it is flexible, you could push it. You could put this very narrow or you could put it wide apart. This is about juxtaposition. It is rubberized cheesecloth and reinforced fiberglass.

CN: You were insisting your pieces aren't environmental before, yet this piece is so large-scale.

EH: Its scale would make it environmental but that is not enough to make something environmental. Then it is leaning against the wall and it looks like a curtain. Those

things make it superficially environmental but I don't think that was the purpose. I thought I could make more sections so they could be extended to a length in which they really would be environmental but illness prevented that.

CN: I look at this piece and I think of the Ku Klux Klan because of its threatening quality.

EH: This piece does have an option. It has connective associations. Maybe that's not so good. The Ku Klux Klan, for me, is a terrible thing to look like. But again it has that feeling—I can't use that word any more—absurdity. Because it potentially has quite a few associations and yet it is not anything. So maybe that increases its silliness. And then it is made fairly well so it contradicts its ridiculous quality because it has a definite concern about its presentation. You think, "Well really—it can't just be a whim, you know, it's too considered." There's a great deal of concern and it's visible.

CN: Are you interested in craftsmanship in the sense of something done in a right or wrong way?

EH: But my right or wrong isn't to have a pure or fine edge. I do think there is a state, quality, that is necessary but it is not based on correctness. It has got to be based on the quality of the piece itself. That hasn't to do with neatness. Not artisan quality for the sake of craft.

CN: But you are concerned with the idea of lasting?

EH: Well, I am confused about that as I am about life. I have a two-fold problem. I'm not working now, but I know I'm going to get to the problem once I start working with fiberglass because from what I understand it's toxic and I've been too sick to really take a chance. I don't take precautions. I don't know how to handle precautions. I can't wear a mask over my head. And then the rubber only lasts a short while. I am not sure where I stand on that. At this point I feel a little guilty when people want to buy it. I think they know but I want to write them a letter and say it's not going to last. I am not sure what my stand on lasting really is. Part of me feels that it's superfluous and if I need to use rubber that is more important. Life doesn't last; art doesn't last. It doesn't matter. Then I have the other thing that I should use—I can't even say it because I believe it less—but maybe that is a cop-out. . . .

CN: Does your work concern itself with the process, in the sense of Richard Serra's saying he is concerned with pushing or pulling or lifting, etc.?

EH: Well, process—that is the mold I felt I was going to be *put* in. I don't really understand it. Everything is process and the making of my work is very interesting but I never thought of it as "now I am rolling, now I am scraping, now I am putting on the rubber." I never thought of it for any other reason than the process was necessary to get to where I was going to get to. I do have certain feelings now to keep things as they are. I have very strong feelings about being honest, also heightened since I have been so ill. And in the process, I'd like to be—it sounds corny—true to whatever I use and use it in the least pretentious and most direct way. Yet you could say that it's not always true, for instance I rubberized cheesecloth . . .

CN: So your work has more relation to painting than to sculpture which one thinks of as carved-out or molded.

EH: But I never did any traditional sculpture. I don't think I ever did any traditional paintings except what you call Abstract Expressionist. I didn't even do much sculpture in school and once I started out there wasn't anything traditional about any of my pieces. I don't know if I am completely out of the tradition. I know art history and I know what I believe in. I know where I come from and who I am related to or the work that I have looked at and that I am really personally moved by and feel close to or am connected or attached to. But I feel so strongly that the only art is the art of the artist personally and found out as much as possible for himself and by himself. So I am aware of my connectiveness—it is impossible to be isolated completely—but my interest is in solely finding my own way. I don't mind being miles from everybody else. I am not, now, possibly. Critics, art historians, museums and galleries do like to make a movement for their own aims and for art history and to make people understand, but I wonder about that. In that way I have been connected to other people but I don't mind staying alone. I think it is important. The best artists are those who *have* stood alone and who *can* be separated from whatever movements have been made about them. When a movement goes, there are always two or three artists. That is all there is.

CN: Do you feel then that you've broken with the tradition of sculpture?

EH: No. I don't feel like I am doing traditional sculpture.

CN: Then your art is more like painting?

EH: I don't even know that. Where does drawing end and painting begin? I don't know if my own drawings aren't really paintings except smaller and on paper. The drawings could be called painting legitimately and a lot of my sculpture could be called painting. That piece *Contingent* I did at Finch College could be called a painting or a sculpture. It is really hung painting in another material than painting. And a lot of my work could be called nothing or an object or any new word you want to call it.

CN: What about Minimal art, so called?

EH: Well, I feel very close to one Minimal artist who's really more of a romantic, and would probably not want to be called a Minimal artist and that is Carl André. I like some of the others very much too but let's say I feel emotionally very connected to his work. It does something to my insides.

CN: What do Carl André's floors represent to you?

EH: It was the concentration camp. It was those showers where they put on the gas.

CN: I wonder what would be André's reaction if you told him your response to his work?

EH: I don't know, because we like each other maybe he'd understand, but it would be repellent to him that I would say such things about his art. You can't combine art and life.

CN: Sure you scare people with that kind of talk . . .

EH: But it's a contradiction in me too because I can't stand romanticism. I can't stand mushy novels, pretty pictures, pretty sculpture, decorations on the wall, nice parallel lines—make me *sick*. Then I talk about soul and presence and guts in art. It's a contradiction.

CN: Are there other artists you admire?

EH: Oldenburg[2] is an artist, if I have to pick a few artists, that I really believe in. I don't think I was ever stuck on Oldenburg's use of materials. I don't think I have ever done that with anybody's work and I hope I never do. I can't stand that. But I absolutely do like Oldenburg very, very much. I respect his writings, his person, his energy, his art, his humor, the whole thing. He is one of the few people who work in realism that I really like—to me he is totally abstract—and the same with Andy Warhol. He is high up on my favorite list. He is the most artist that you could be. His art and his statement and his person are so equivalent. He and his work are the same. It is what I want to be, the most Eva can be as an artist and as a person.

PART V:

Contemporary Trends: 1970-1985

The situation of women artists since 1970 is closely entwined with the broader political conditions of women in society at large. From the perspective of the early 1990s, it is clear that the special roles and activities of women artists and their visibility, whether in or out of the "mainstream," is woven into the larger fabric of social conditions.

Beginning in the early 1970s, fueled by the women's movement, women artists seemed to emerge from their obscurity to question the narrow set of critical criteria of "modernism" that had dominated the art world in the 1960s. Marcia Tucker has defined "modernism" as:

The artistic canon . . . [which] embodied the (masculine) values of the culture at large and virtually eliminated not only women but all artists of color. It upheld the value of a single standard of quality against which all works could be objectively measured and which was formed by a "consensus of educated opinion"—consisting largely of those who wished to perpetuate the values of their own kind.[1]

Women artists formed an influential group that rejected this monolithic approach to art making and diversified not only the forms and appearances of works of art but also the business practices of the art world.

One thing is quite clear, however. Any forms of essentialist reductionism or sweeping generalizations can be misleading and even counterproductive to the efforts of women artists. An artist such as Anne Truitt, for example, continued to work within an aesthetic system that should be characterized as "modernist." Yet her sensitivities to discrimination against women and her roles as wife and mother are informed by a feminist self-consciousness. Her published journals, *Daybook* and *Turn,* written in the early 1980s, are fascinating works.

The growing awareness of discrimination among women art professionals is documented here by the first text. The excerpts from Judy Chicago's autobiography, *Through the Flower* (1975), supply unique insights into the formation of her feminist consciousness in California in the late 1960s and early 1970s. This text was written before the creation of her most famous work, *The Dinner Party.*

277

The decade of the 1970s was, in retrospect, an extraordinarily rich and active time for women artists. In 1979 two major yet extremely different works became public, symbolizing the different approaches to the definitions of women's identity characteristic of the American and British feminist movements. The difference between Judy Chicago's *Dinner Party* and Mary Kelly's *The Post-Partum Document* were reflections of the divergent theoretical approaches to the core issue of what constitutes woman's nature. Where Chicago saw the facts of biology unifying female identity throughout the millennia, Kelly viewed identity formation in a specific cultural context dominated by patriarchal discourse. Chicago's nontheoretical approach contrasts with Kelly's works, which were influenced by Lacanian psychoanalytic theories and poststructuralist philosophy. In her interview, Kelly explains the motivations and theoretical perspectives that stimulated the creation and design of *The Post-Partum Document.*

It was during the 1970s that Eleanor Antin emerged as a leading figure in a feminist-inspired performance art that spoke to the complexities of identity formation in a patriarchal society. The 1970s also nurtured the first works of Faith Ringgold inspired by her heritage as an African-American woman. The interview included in this book traces her development from the 1970s into the 1980s, when she began to explore the formal and narrative possibilities of ''story quilts.''

Cindy Sherman is the youngest artist included in this book. Her works first appeared in the late 1970s and have received widespread critical recognition. Her fascinating photographs of herself are sufficiently ambiguous to permit a number of interpretations. Therefore, her statements concerning her intentions for her imagery are of special interest.

In a frequently quoted article published in the prominent journal *Artnews,* Kay Larson optimistically assessed the contemporary art world of 1980: ''For the first time in western art, women are leading, not following.''[2] In retrospect, it appears that 1980–81 was a peak period for women's visibility in the art world. By 1983 a reaction had set in. That year, in *Artforum,* Kate Linker noted women's under-representation in every major group exhibition in Europe and America, as well as in commercial galleries.[3]

Fortunately, a valuable statistical analysis of women's activities in the arts between 1970 and 1985 was recently published in the catalogue of the 1989 exhibition *Making Their Mark: Women Artists Move into the Mainstream.* Compiled by Ferris Olin and Catherine C. Brawer, these data provide some objective statistics by which to determine women's visibility and professional activity. The statistics document a falling-off of women's inclusion in major exhibitions in the early 1980s, and a leveling-off between 1983 and 1985. For example, 32 percent of the exhibitors in the Whitney Biennial exhibition in 1979 were women, but only 20 percent in 1981. By 1985 the percentage had increased to 29 percent. The percentage of solo exhibitions by women artists in a selected group of New York galleries increased from 9 percent in 1970 to a peak of about 24 percent in 1978–80 and declined to 16 percent in 1985. In Los Angeles, however, women had no solo exhibitions before 1978 but 25 percent of those in 1985. Magazine reviews of exhibitions by women reached their highest level, 29 percent, in 1980 and only decreased slightly to 26 percent in 1985. Since 1977 women have received about one-third of the

NEA grants. This percentage did drop to 28 percent in 1980–81, but had rebounded by 1983–85.

Do these statistics constitute real and significant change? For Marcia Tucker, the answer is no. "Women artists are hardly better off today than in 1970. . . . There is no real community of women, no collective action against repressive attitudes . . . and there is a general paralysis when it comes to establishing an equal division of labor in the areas of homemaking and child care."[4]

This book, however, takes a much broader historical view. Surely women artists have conquered the pre–twentieth-century attitude that women do not even have the right to make art or, if made, that their art is by definition inferior to male creations. We can never backslide into the wholesale institutional discrimination characteristic of the Victorian epoch. The active "male gaze" no longer encounters a passive female "object" among women in the visual arts. While historical perspective should not lead us into complacency, it can help render a realistic appraisal of what has been achieved and what still remains to be accomplished.

27

Judy Chicago (b. 1939)

Since the early 1970s, Judy Chicago has been a highly vocal, outspoken, and visible activist for feminist change. When *The Dinner Party* toured the country between 1978 and 1980, it sparked widespread if controversial public reactions to women's issues in history and body imagery in art. Chicago wrote her autobiography before producing this monumental installation. Published in 1975, *Through the Flower* traces Chicago's development from her childhood through her formal professional education. It deals with the creation of the first feminist art program at California State University—Fresno in 1971, and her collaboration and association with Miriam Schapiro at Womanhouse in Los Angeles in 1972.

Through the Flower is a unique literary document. In no other woman artist's autobiography do we find the psychological, developmental process of an artist's life retold with a fully developed feminist awareness of sexism in American culture of the 1950s and 1960s.

Perhaps the best measure of the distance women artists have traveled since the *Souvenirs* of Elisabeth Vigée-Lebrun is not in the "central" or vaginal imagery of Chicago's visual images but in the form of this literary autobiography. Like those of the male Victorians, Chicago's narrative is a clearly focused account of her professional development. She includes those psychological phases which led toward the creation of her artistic personality. This is the only text that narrates a linear, chronologically coherent development toward artistic maturity. Written relatively early in the artist's life, before the widespread notoriety of *The Dinner Party*, this autobiography supplies those insights so lacking in the writing of nineteenth-century women. Mara Witzling has recently analyzed *Through The Flower* and identifies Chicago's acceptance of the "male" model of the solitary, monomaniacal, autonomous artist with a corresponding denigration and intolerance towards women.[1] Chicago also gives the reader a cogent verbal interpretation of her works of art to supplement the visual image.

Like Lee Krasner and Louise Nevelson, Judy Cohen was born into a Jewish family with no special predisposition toward the visual arts. Her father, who died when Judy was only 13, was a union organizer, so she was raised in a socially conscious and activist

home. Manifesting an early vocation, she took classes at the Art Institute of Chicago while still in elementary and high school. Between 1960 and 1964 she worked at UCLA, where she was awarded her M.F.A. She emerged from graduate school a minimalist sculptor thoroughly socialized out of an identity as a woman. Although emotionally attached to Lloyd Hamrol, whom she eventually married, Judy Gerowitz, as she was then called (in 1960 she had married the writer Jerry Gerowitz, who was later killed in a car accident), had "neutralized" (her own phrase) from her art any references to sexuality. This period of her life is described in the first excerpt.

In 1970, at her solo show at California State—Fullerton, she presented the visitor with the following manifesto written in large letters on the gallery wall:

"Judy Gerowitz hereby divests herself of all names imposed upon her through male social dominance and freely chooses her own name, Judy Chicago."[2]

The second excerpt describes her disappointment in the lack of response to her *Pasadena Lifesavers* series, exhibited in her 1970 show, and her motivation to build a women's art community. The ideas leading up to the formation of her pioneering feminist art program at California State—Fresno are discussed.

Chicago's close collaboration with Miriam Schapiro (b. 1923) dates from this time. Working together, they developed the Feminist Art Program at California Institute for the Arts in Valencia, which led to their renovation of a dilapidated house in Los Angeles, Project Womanhouse (1972). Eventually Chicago broke with Schapiro and the male-dominated institution of Cal Arts to become one of the founders of the Woman's Building, which remained active in Los Angeles until 1991. This period, dominated by her break with Schapiro and the creation of her lithography series *Through the Flower*, is discussed in the third segment of the autobiography reprinted here. The importance of role models such as Georgia O'Keeffe and Barbara Hepworth is underscored in this segment of her book.

Chicago would proceed with her professional life after 1975, creating the famous *Dinner Party* and more recently *The Birth Project* (1983). Her unremitting focus on the importance of the female body has sparked widespread controversy across the broadest spectrum of critical discourse. Her significance for contemporary American women artists, however, is undeniable.

1966: "My career was going to be a long, hard struggle."

The two people who helped me most were my dealer and Lloyd[3]; they supported me and stood up for me. My earlier naïvete about my situation as a woman artist was giving way to a clear understanding that my career was going to be a long, hard struggle. Fortunately, I knew that I was okay—that the problem was in the culture and not in me, but it still hurt. And I still felt that I had to hide my womanliness and be tough in both my personality and my work. My imagery was becoming increasingly more "neutralized." I began to work with formal rather than symbolic issues. But I was never interested in "formal issues" as such. Rather, they were something that my content had

to be hidden behind in order for my work to be taken seriously. Because of this duplicity, there always appeared to be something "not quite right" about my pieces according to the prevailing aesthetic. It was not that my work was false. It was rather that I was caught in a bind. In order to be myself, I had to express those things that were most real to me, and those included the struggles I was having as a woman, both personally and professionally. At the same time, if I wanted to be taken seriously as an artist, I had to suppress anything in my work that would mark it as having been made by a woman. I was trying to find a way to be myself, still function within the framework of the art community, and be recognized as an artist. This required focusing upon issues that were essentially derived from what men had designated as being important, while still trying to make my own way. However, I certainly do not wish to repudiate the work that I made in this period, because much of it was good work within the confines of what was permissible.

By 1966, I had had a one-woman show, had been in several group and museum shows, and had made a lot of work that could be classified as "minimal," although hidden behind that façade were a whole series of concerns that I did not know how to deal with openly without "blowing my cover," as it were, and revealing that I was, in fact, a woman with a different point of view from my male contemporaries. At that time, I firmly believed that if my difference from men were exposed, I would be rejected, just as I had been in school. It was only by being different from women and like men that I seemed to stand a chance of succeeding as an artist. There was beginning to be a lot of rhetoric in the art world then to the effect that sex had little to do with art, and if you were good, you could make it.

Lloyd had moved into another studio on the same street, leaving me with a five thousand-square-foot studio to myself. He and I had been having a lot of trouble working together, and we decided it would be better if we each had our own place. This need was particularly strong in me because I felt that if people came to my loft and I was alone, they would be less apt to see me in relation to Lloyd. I felt convinced that the only way to make any progress in the art world was to stay unmarried, without children, live in a large loft, and present myself in such a way that I would *have* to be taken seriously.

Cal State—Fresno: The Development of a Women's Art Community

I realize that most people didn't know how to "read form" as I did. When Miriam Schapiro, the well-known painter from the East Coast who had recently moved to L.A., brought her class to the show, it was obvious that she could "read" my work, identify with it, and affirm it. On the other hand, a male artist friend of mine had told me: "Judy, I could look at these paintings for twenty years and it would never occur to me that they were cunts." The idea that my forms were cunts was an oversimplification, obviously, but at that time, even a greatly simplified perception seemed better than no perception at all of the relationship between my femaleness and my art.

When the achievement and meaning of my show went unrecognized, I was very upset. Not only had the exhibition not resulted in an increased understanding of my stature and intent as an artist, but it had produced a level of denial of my integrity that appalled me. I was accused of "mixing up" politics and art, "taking advantage" of the women's movement, of being "rigid" because I used a structure in my paintings, and of copying a male artist in my domes. I wanted my show to speak to people, to tell them that women possessed all aspects of human personality, that society's conception of the female was distorted and that other values in the culture that grew out of that distortion were also questionable. Fundamental to my work was an attempt to challenge the values of the society, but either my work was not speaking, society didn't know how to hear it, or both.

The full impact of my alienation struck me. I had tried to challenge society's conception of what it is to be a woman. At the same time, I had, in trying to make myself into an artist who was taken seriously in a male-dominated art community, submerged the very aspects of myself that could make my work intelligible. How could I make my voice heard, have access to the channels of the society that allow one's work to be visible, and be myself as a woman? I had tried to deal with the issues that were crucial to me "within" the structure of male art language and a male-oriented art community, a group whose values reflected the patriarchal culture in which we live. My accommodation had been self-defeating, however, for I could see by the results of my show and the evidence of my life as an artist that the male-dominated value structure, by its very nature, could not give me what I wanted and deserved. To honor a woman *in her own terms* would require a fundamental change in the culture and in the cultural values as they are expressed in art.

Men had constructed their community on the basis of their interests and needs as men. I realized that men (and women invested in that male community) *could not* respond to my work the way I wanted them to. There was no frame of reference in 1970 to understand a woman's struggle, to value it, or to read and respond to imagery that grew out of it. What did men know or care about what a struggle it was for a woman to overcome her conditioning as a woman, to feel comfortable about being assertive, to struggle to use tools that she had never been educated to use? And even if the male world could acknowledge that struggle, could it ever allow it to be considered "important" art, as important as the art that grew out of men's lives? I could not be content with having my work seen as trivial, limited, or "unimportant" if it dealt openly with my experiences as a woman, something I had seen happen to women who had not neutralized their subject matter. I also could no longer accept denying my experiences as a woman in order to be considered a "serious" artist, especially if my stature was going to be diminished anyway by the male-dominated community.

I realized that if the art community as it existed could not provide me with what I needed in order to realize myself, then I would have to commit myself to developing an alternative and that the meaning of the women's movement was that there was, probably for the first time in history, a chance to do just that. If my needs, values, and interests differed from male artists' who were invested in the values of the culture, then

it was up to me to help develop a community that was relevant to me and other women artists. In fact, I was beginning to suspect that the reason there were so few visible women artists signified that the art community, as it existed, could not really serve the needs of women artists, unless they were willing to do what I had done and make art that did not deal directly with their experiences as women.

Perhaps I and other women would have to develop all aspects of an art community ourselves—making art, showing art, selling and distributing it, teaching other women artmaking skills, writing about art, and establishing our own art history, one that allowed us to discover the contributions of women artists past and present. I had been reading women's novels for several years, having given up male literature because I couldn't respond to the female characters. I had found a wealth of work by women I never knew existed, work with which I identified, and I was sure that there must likewise be unknown visual art by women. If making art according to male standards had resulted in making my subject matter unintelligible, perhaps looking at the work of women artists would give me clues about how to communicate my point of view more directly. But first, I would have to go back to the point where I had begun to hide my content and learn how to expose rather than cover that content.

I didn't know how to do that in Los Angeles, where the values of the male art community pervaded the environment—values that asserted form over content, protection over exposure, toughness over vulnerability. I decided to go away from the city for a year, to look for a job at a college, something that I had never done before, having supported myself by teaching occasional extension classes. When I graduated from college I had vowed not to become involved with day school teaching, as I didn't want to be like my teachers who had become more invested with their teaching than their artmaking. Now I wanted to teach—but I wanted to teach women. I wanted to try to communicate to female students, to tell them what I had gone through in making myself into an artist. I felt that by externalizing the process I had gone through, I could examine it, which would be the first step in turning it around, and the women's class might also be the first step in making an alternative female art community.

I didn't know for sure if my struggle was relevant to other women, and I needed to find that out before I could use it as the basis for such a community. I felt a strong need to be with other women (something I had never done) and to find out if my own needs as an artist, my desire to build a new context, and the needs of other women interested in art could merge to become the basis for a viable female art community. I also felt a need to be in a place where male values were not as pervasive, and that meant a place where the art scene had less power. I wanted to feel safer, to open myself, to try to reverse the toughening process I had undergone in order to have a place in the male world. Also, I felt that if I worked with female students and helped them work directly out of their feelings as women, I could, through them, go back to that moment in my development where I began to move away from my own subject matter. I had decided to make another series of paintings. After having dealt with issues about the nature of my own identity as a woman, I wanted to move out, to go beyond my female identity into an identity that embraced my humanness. I wanted to make paintings that were

vulnerable, delicate, feminine, but that also reflected the skills I had developed in the male-dominated world. I needed the support of a female environment to expose myself more than I had been able to at that point, and I hoped, by establishing a class for women, that I could provide a context for my students and for me that could serve us all.

At that time in California, schools around the state were hiring Los Angeles artists who "had a reputation," and although my reputation was not consistent with my development, I had made somewhat of a name for myself as an artist. Because of that, I found it fairly easy to get a job. I simply put out the word that I was looking and sent a few notes to places that, I had been informed, were hiring. I received a telephone call from Fresno State College, which I had never heard of. They were very eager to have me come there—so eager, in fact, that they were willing to accommodate me in any way, especially after they received a recommendation from my former sculpture teacher that "the best way to work with me was to let me do what I wanted."

Lloyd and I discussed it. We went up there to look around, and as soon as we drove into the city, I knew that it was the perfect place for me to be for a year. In addition to the other reasons that I wanted to go away, I felt that I should learn to live without Lloyd "being up the street from me," as his presence sometimes provided me with a way of avoiding acting independently. The year apart was difficult for us. Lloyd resented it and was forced by my absence to struggle with his feelings that I should "be there" whenever he needed me, an illusion he had even when we weren't getting along. My leaving the city accentuated my insistence that Lloyd not look to me as his only source of emotional support. At the same time, I put myself into a position where I would be forced to provide for myself in a way I had not yet learned to do. The Fresno year allowed me to examine any ambitions and make plans for my life in terms of my own needs, goals, and desires. It gave me the space that I needed to think, to dream, to experiment, and to change.

"Through the Flower"

I can see now that a split between Mimi[4] and me was inevitable, especially after we brought the Feminist Art Program to the building in which Cal Arts was actually housed. The Fresno program was away from the college. Womanhouse was also in a separate space, forty miles away from the school. At Cal Arts, for the first time, I was actually on a full-time day school campus, and as soon as I set foot in it, I began to be uncomfortable. But before I had a chance to really face my discomfort, the school year was over. Lloyd and I went off to Albuquerque, New Mexico, I to make lithographs, he to build sculpture. All through that summer, I kept hoping that things could be patched up between me and Mimi. But she was committed to Cal Arts. I was committed to the development of a female community. I don't know why I didn't realize then that there was a fundamental split between us. I guess that my needs made me hope that our differences could be accommodated. She, however, never acknowledged that our

disagreement was philosophical. Rather, she insisted that I was not "grown up" or I would know that one just had to struggle within the structure as it existed and try to change it as best one could. Summer allowed me to get away from that situation that was so terribly painful for me. I didn't want to lose Mimi's "approval," but I wasn't sure that I wanted to commit myself to try to change a male-dominated institution. I was glad that I could plunge into my work and forget about the whole conflict for a while.

All through the spring, I had struggled with my feelings about the split with Mimi in a series of works based upon that grid structure. Her images were closed. The spaces inside my grids opened up. You could see into them; they held a beautiful and peaceful space. But you could not enter those spaces. One's way was barred by a series of flesh beams. It was the human condition that prevented one from re-entering "Childhood." These images led me to another series, one that represented the place I felt myself to be at that moment—moving through the limits of female role. I used the flower as the symbol of femininity, as O'Keeffe had done. But in my images the petals of the flower are parting, and one can see an inviting but undefined space, the space beyond the confines of our own femininity. These works speak of my longing for transcendence and the bitter hopes of all womanhood. They are, in my estimation, my first steps in being able to make clear, abstract images of my feelings as a woman.

In the summer, I made a suite of lithographs on the theme "Through the Flower," and I worked on my book. The book grew and changed as I did. At the end of the summer, Lloyd and I made our first trip to Europe, which affected me deeply by confirming my commitment to my own form language. Seeing the work of the great artists helped me see that their achievement came as much out of their investment in their ideas, whatever those ideas were, as out of their "talent." I came back from our trip refreshed and with a new series of work in my mind. These were to combine my interest in women's history, my identification with women of the past, my knowledge of women's art and literature, and my own imagery. For the past few years, I had immersed myself in looking at women's art.

I had first searched out the work of other women who had made abstract art, looking at it, reading whatever I could about the artists. I examined the work of Barbara Hepworth, Georgia O'Keeffe, and Lee Bontecou, each of whom worked in a different historic milieu, but who, in my estimation, had something in common with each other and with me. They all seemed to have made a considerable amount of work that was constructed around a center, as I had done. There also seemed to be an implied relationship between their own bodies and that centered image. In my work, I felt a body identification with both the images I made and the surface on which they were painted. I felt myself to be both the image/surface and the artist working on that painting simultaneously. The canvas was like my own skin; I was the painting and the painting was me. . . .

In 1970, when I became friends with Miriam, she told me of her experiences in San Diego, where she had struggled to make paintings out of *her* feelings as a woman. She also used a central cavity and a spread leg image, as in the painting "OX." When

I saw it, I related to it instantly, seeing in its duality of strength and vulnerability, power and receptivity, a parallel to the subject matter of my own paintings. Then, Mimi and I looked at work together, examining paintings and sculptures of women known and unknown, concentrating on those who had worked abstractly. From our experiences as artists, we both had an understanding of how to look for the hidden content in women's work. What we discovered in our studies and later, in our studio visits overwhelmed me; and reinforced my own early perceptions. We found a frequent use of the central image, often a flower, or abstracted flower form, sometimes surrounded by folds or undulations, as in the structure of the vagina. We saw an abundance of sexual forms— breasts, buttocks, female organs. We felt sure that what we were seeing was a reflection of each woman's need to explore her own identity, to assert her sense of her own sexuality, as we had both done.

It is hard to express the way I felt when I saw the work of so many women artists who had tried, as I had, to deal with their condition as women. Behind the façade of formalized art concerns, these artists had searched out a way to assert their identity through an abstract form language. Mimi and I accumulated a group of slides that focused on work which used a central format as a metaphor for the female self. When we first showed them at the 1971 Rap Weekend in Fresno, women cried and sobbed, throwing themselves into our arms, exclaiming that they had made images like those, that they had been ashamed of them, that their male teachers had sneered at them, that they had thrown them away. This reaction was often repeated whenever the slides were shown and strengthened my belief that my struggle had indeed been a personification of the struggle of many other women artists. . . .

. . . I believed that what I and other women artists had done in our struggle to signify ourselves was important, but within the framework of formalist criticism (which was and still is the prevailing critical approach), that importance could never be recognized.

Mary Kelly (b. 1941)

Although she was born in Minneapolis, Mary Kelly spent the formative years of her artistic career in London, from 1968 through the 1970s. Her *Post Partum Document,* first exhibited in 1979, is contemporary with Chicago's *Dinner Party.* Both works display the very different nature of contemporary American and British feminism. Kelly was part of the consciousness-raising group that included psychoanalyst Juliet Mitchell and film-maker-critic Laura Mulvey.[1] In this environment, Kelly became conversant with the post-Freudian psychoanalytic theories of Jacques Lacan and with Michel Foucault's theories on sexuality as embedded in sociological discourses and institutions.[2] Begun in 1973, *The Post Partum Document* was exhibited at the Institute of Contemporary Art in London in 1979. It is a six-section, 165-part work that deals with the artist's relationship with her son from his birth until he entered school at the age of 6. The work is so different in concept and appearance from traditional art that it requires detailed explanation, which Kelly provides in the following interview with Terence Maloon.

The Post Partum Document does not present images of the mother. All imagery of women, as objects of the male gaze, may be viewed as a mechanism of patriarchal oppression of women. Instead presents memorabilia, such as soiled diapers, clothing, and the child's markings are exhibited. Texts that record the child's developmental milestones and the mother/artist's responses accompany the "fetishes."

The Post Partum Document has been reproduced in book form (published in 1983). Sections of the original have been acquired by a number of museums, including the Tate Gallery in London.

More recently, Kelly created *Interim* (1984–88), a multipartite work which presents images of clothing, juxtaposed with narrative texts. This work is designed to deconstruct "the making and living of the feminine under patriarchy."[3]

Interview with Terence Maloon

TERENCE MALOON: You've said that your *Post Partum Document* comes out of consciousness-raising experiences within the Women's Movement.

MARY KELLY: Yes. I've always maintained that the *Document* should be located within the theoretical and political practice of the Women's Movement. It was the conjuncture of this practice and the personal experience of having a child which resulted in my work on the mother-child relationship. Previously I'd been involved in the Berwick Street Film Collective in the making of *Night Cleaners* and after that in the exhibition *Women and Work* which documented the division of labour in a particular South London industry. Both projects showed me the extent to which all the women we'd interviewed were intensely involved with their life at home, with their family relationships. This seemed a lot more 'real' to them than their circumstances at work. The significance of this involvement was underlined by the debate within the Movement at that time about domestic labour and by the notion that the family had a dual function—ideological and economic, and that it wasn't reducible to one or the other.

TR: So the *Document*'s your contribution to a feminist analysis of the family?

MK: Yes, but my initial conception differed from the way the project turned out. Initially I'd tried to bring in some socio-economic issues. In the first section of the *Document* I'd included material on, say, the number of fathers who participate in child-care, and I'd related the post-partum experience to other economic factors, like the number of children and the living conditions . . . It became obvious that it wasn't possible to integrate all this material, and that the strength of the document, if it had one, was precisely that it was concerned with giving a place to the mother's fantasies and not with giving an account of child development, nor with providing more material for a sociological analysis of housework. Ultimately it had nothing to do with those matters and it had everything to do with how femininity is formed in a psychological sense.

TM: Maternity's the crucible as well as the culmination of female conditioning?

MK: I always saw femininity very much as something constituted within a social process, not simply as conditioning. It's crucial to locate the founding moment of 'difference' in the child's entry into language, although most feminists tend to emphasize the period of adolescence, because that's the moment when women realise that their sexuality, their pleasure, is appropriated in patriarchy and subordinated to their capacity for reproduction. This moment is very repressive, very conspicuously so. I think I originally felt that the moment of childbirth culminated, overdetermined this process. I looked at it as the moment in which femininity was somehow sealed. Then I came to see more clearly the specific ways in which maternal femininity is constructed at a very deep level, that is, at the level of the unconscious. There is a profound desire to have a child, and having one gives real satisfaction and pleasure. Unless you understand that, you can never understand why women would subscribe to the idea of 'biology-is-destiny' at all. The pleasure of having a child makes it possible to see the capacity for maternity as 'natural' and inevitable, and then to see the sexual division of labour as being somehow expedient.

TM: This is the point at which women artists often give up their pursuits. There's a counter argument that men make art because they can't have children.

MK: I think that the main reason women don't make art when they have children is because they're actually looking after them. One of the implicit statements in the *Docu-*

ment is that there had been a dramatic change in the division of labour in my own situation. This came directly out of consciousness-raising on the part of Ray and myself. We lived for quite a long period in a communal household with other men and women who were trying to change their personal lives.

TM: What was the relationship between your maternal responsibilities and your commitment to art? Was there a conflict?

MK: It was quite frightening in the early stages of the work. Some writers (Sollers and Kristeva) have suggested that the first few months after childbirth are very close to the condition of psychosis, at least metaphorically. The imaginary identification between the mother and child is so overwhelming that it's not just a matter of finding the time to work, it's finding the psychological space to breathe in. Actually, the way the material was worked on, the events that took place (like weaning from the breast, learning to speak, starting school) were lived through in a very spontaneous way. It's not as though I thought about it 'scientifically', but the Women's Movement had made me self-conscious about the importance of these events. It occurred to me that I could actually try to record my feelings about them at the time. It took years after each event to analyse the material, so there are two levels to the work, my lived experience as a mother and my analysis as a feminist of that experience. But I wouldn't want to give the impression that the experience and the analysis were separate.

TM: Isn't an acceptance of the child as a whole, indivisible being at odds with an analytical breaking-down of the mother's experience? Is the work about split-consciousness, moments of divided feeling?

MK: No, not exactly moments of divided feeling, but moments of realisation or recognition of the loss of the child, because accepting the child as you say, 'as a whole', and more importantly, independent being means accepting that he will inevitably grow up and away from you. The loss of the child is really the loss of plenitude one can associate with having the phallus. The child's a means whereby the woman perhaps disguises her lack, her negative place. It actually provides her with a positive identification which she only relinquishes with difficulty. Almost everyone sees some evidence of this in their relationship with their mother, the way she continues offering you food, for example, or looking after the way you dress. These are all different expressions of the way in which women fetishize the child, which is in fact a compensation for their sense of lack. In a way the art displaces that fetishizing of the child. That's why all the objects in the work are fetish objects, very explicitly, to displace the fetishizing of the child and also to make an implicit statement about the fetishistic nature of representation. It's almost comical in that the value of the objects is minimal in any commercial sense, yet their affective value—in terms of what Freud called 'libidinal economy'—is maximum for me.

The objects in the work—the stained nappy-liners, the scribblings, the hand-imprints, the insect specimens, and in the recent work the inscriptions of Kelly's pre-writing—all these constitute a strand of extra-linguistic discourse within the *Document*. They're recognition points, particularly for mothers, but at some level for everyone in their relationship with the mother. The juxtaposition of the objects and the diaries, the diagrams and the footnotes, locates the work in such a way that the full impact of the

theoretical language can be felt, though there's an antagonistic relation between various levels of discourse. The footnotes don't talk about art at all. They provide you with my reading of the events, and of course that's not the only reading possible—it's more a matter of what Freud called 'secondary revision'. All this is a way of working through those experiences and locating them temporally, in an historical process. The diagrams introducing the documents do so in a rather schematic or mechanistic way (for example, a chart on metabolism, one on patterned speech, two by Leonardo, one on perspective and another on perceiving objects). So as a whole the work doesn't propose a homogeneous notion of science. It doesn't represent a 'true' interpretation of the topic, but it sets up all those ways of seeing and reading in a discursive relationship.

TM: The formats reinforce the notion of fetishes in various ways.

MK: It's the kind of fetishizing you get in museums, where fragments of significant historical events are set out, labelled, explained. That's why it's presented clinically, with the various markings that give it authenticity. It's only a mock-authenticity though. It's an archaeology of the female subject constructed from a specific case history. I think the most interesting reading of this history will be the one that follows it, rather than my own—that is, the reading the Women's Movement will be able to make of it in the future, in the sense of its representation of a particular historical moment within the Women's Movement, and also within the discourse of pop art.

TM: How do you see your work relating to past art?

MK: I haven't talked about this in the past, precisely because there's a tendency to ghettoise women's practice, a refusal to locate it historically. When I first showed the work at the ICA it was important for me that the men who'd shown there, like Venet, Burgin, Robbins, Art Language, were artists whose work I was very interested in. Those very important years of so-called conceptual work following Kosuth's article refuting synthetic propositions in art was a way of purging art of its level of connotation, of shifting from the metaphorical axis to a metonymic one, emphasising visual syntax. It was implicit in Systems work, Minimalism. Conceptual work restated it explicitly in words—or rather, meta-linguistic paradigms. It provided a polarisation in the history of art practice which subsequently artists could debate openly. It was important that this point should be made in a rigorous theoretical form rather than in some garble about the 'art of the real'.

These events in art coincided with a general development which had brought all the humanities within the sphere of scientific investigation through the developments in linguistics and semiology. It had an effect on anthropology, on psycho-analysis . . . It was very important in terms of my own work—the reading that Althusser gives of Marx, which Lacan gives of Freud. These were only made possible by developments in Linguistics. For the first time it provided a way of analysing the production of meaning based on the premise that the symbolic dimension includes sign-systems other than language, of which art practice is one. These don't mimic language, but they're understood in relation to it.

TM: So-called synthetic propositions have made a come-back though, even among post-conceptual artists.

MK: When synthetic propositions re-emerged they did so with an altogether different self-consciousness than before. This is true of what I suppose you'd call 'post-conceptual' art, though I think you can't understand the post-conceptual outside of the perspective we've just discussed. I mean, you can't be post-conceptual by simply going on as if conceptual art hadn't happened, like making a jump from pop to neodada, or punk if you like.

TM: Another contributing factor was the crisis in the avant-garde's self-definition. Since about 1955 virtually any avant-garde manifestation was almost instantly recovered by the establishment (museums, the market, etc). They could swallow up any dissension, any aberration from the prevailing norms—however eccentric, outrageous and 'impossible' they seemed. The only stance left to the avant-garde was philosophical, and when that proved recuperable, radical politics.

MK: Perhaps we're in the moment of discovering that that's recuperable as well—precisely because art practice in itself isn't an agent of social change. On the other hand it isn't insignificant that the 'death-wish', which seems to be the ultimate characterization of the art of the recent past, was an expression of the 'sons' against the 'fathers', which is what the avant-garde is always about. Women were kept largely outside of that, not being part of the discourse with the 'fathers'. It allowed someone involved in feminist practice not to be intimidated by the crisis, but rather to use it constructively. Everything was open to women because it had been closed. So I think this period has been liberating for women, as well as for men. The levels of language in my work depend to a large extent on reworking or subverting various forms of signification developed in particular avant-garde practice.

TM: How essential is the format you've chosen for your work? Would it make much difference if the text wasn't, say, typed on cotton swatches, or if it were compiled in book form?

MK: It's absolutely crucial. One of the things generally underestimated in the use of texts in art is that it's as important as any painted sign or mark. The formal qualities of a typed script are very important, as well as the internal construction of the *Document*. The diary text is worked over in the same way that, say, poetry would be. The theoretical text is coherent within its own terms. . . . They're all integral to the totality of the work. I always find the suggestion of a book form rather irritating. There's a confrontation between the affective levels of the objects, the texts, and the separateness of the footnotes. It may be necessary at some point to present the material in the form of a book, maybe because it's cumbersome, to make it available to more people. It was crucial in the conception of the work that it would operate within an exhibition context.

TM: How does your work differ from the Radical Feminists' tendency in art?

MK: Perhaps shall I confine the answer to talking about art practice, or try to give an overview of the movement, which is quite complex? Well, I subscribe to the universality of language. I assume in my work that both men and women enter into the same symbolic order. Then I try to work out a woman's problematic relationship to that culture. Given that it's patriarchy we're talking about, the privileged signifier is the phallus. The work is trying to make sense of the lack. Radical Feminists would maintain

that there is no lack, that there is some alternative symbolic system in which we should be represented in fullness. It leads to a practice which is very diverse, but which could be characterised as being concerned with excavating a kind of essential femininity, either cultural or biological. Do you want some examples? Well, say, Judy Chicago's *Reincarnation Triptych,* which tries to rescue 'great ladies' of the past, to appropriate the myths of amazons and matriarchs who are really representations of the phallic mother, the uncastrated pre-Oedipal mother who contains all good things. Or you have the valorisation of the woman's body. Quite a lot of recent feminist art uses the body, particularly the female genitals—as in Suzanne Santoro's *Towards a New Expression* which indulges a kind of primordial auto-eroticism. Then there's a category of art which foregrounds what you could call feminine 'experience'. Most European performance artists are involved in that. Usually the artist uses herself as signifier, as object, and of course necessarily as fetish.

TM: The danger is that woman-as-sign is ultimately so recuperable, particularly with the theatrical lighting, the mirrors, the video, and what have you.

MK: Right. The artist needs some very powerful means of distancing. This usually takes the form of the text, or of the word as an intervention. But I don't want to seem wholly disapproving of these tendencies. It's been an extremely progressive step for women to have consciously attempted to articulate the feminine. Although they've subscribed to an essential femininity, although they've equated the feminine with the unconscious, with the marginal and the extra-linguistic, these representations have still got to be seen as part of the productive processes of meaning. They do produce new definitions of women, but it's not as though we're going to discover the 'true' representation of 'real' women. What we're dealing with is the production of the category 'woman' within a particular signifying system.

TM: Are you bothered by the possibility that the theoretical ramifications of your work won't be generally understood, that sections will be opaque to a lot of people?

MK: I hope that there's an immediate sense in which the work is graspable, but there are simply other levels of discourse included. I've always been very clear about who my audience is: the Women's Movement, other women artists and people generally interested in the issue of patriarchy. Perhaps that's a wider audience than the following for projects which endeavour to generalise.

TM: It was interesting to note at the *Art for Society* exhibition how almost all the politicised men's art abjured qualities of sensitivity, tentativeness and 'inwardness'. The women's work was more absorbing, and more effective for that reason.

MK: It was only in the work by women artists that the personal statement could be political, because the Women's Movement has argued from the beginning that the personal *is* political. I also think that it's a token of the lack of recognition of that position, which is implied in the work by men when they don't deal with it. When they don't deal with the personal, it means that women are still ghettoised. The critique of patriarchy is still one made by women. I think that one of the most exciting prospects for the future is a critique of patriarchy by men.

TM: Do you see an exhibition devoted largely to women's art at the Hayward as a significant breakthrough?

MK: Of course I do. It will be the first Annual to have more than merely token representation for women. The organisers made an impressive effort to see, and include, a wide spectrum of work by women artists. Its limitation is that a general women's exhibition doesn't make much point beyond that. Perhaps that was true for the *Art for Society* exhibition too. It was very inspiring that so many artists were willing to show together in support of a common commitment to social content or purpose in art, but it needs to be followed by shows dealing with more specific issues, like, say, patriarchy or racism. One very important point which applies to all so-called politically engaged art is that there's no such thing as a homogeneous mass-audience. You can't make art for everyone. And if you're engaged within a particular movement or organisation, then the work is going to participate in its debates. This is the kind of intervention which is needed now.

29

Eleanor Antin (b. 1935)

Eleanor Antin's creative energies have spanned the fullest range of performance and media to explore the complexities of identity. Using books, photography, video, and film, she has documented her imaginative leaps into a variety of other personae, most notably "Eleanora Antinova," "the once celebrated black ballerina of Diaghilev's Ballets Russes."

Antin was born in New York and received her B.A. from the City College of New York. She studied and worked as a professional actress prior to the 1960s, when she turned to art making. By her own admission, in the interview with Leo Rubinfien, it was her move to California in the late 1960s that crystallized her artistic identity.

The first conceptual art project to bring her national attention was *100 Boots*. Photographs of these boots traveled through the mail as postcards, appearing in different locales. The boots arrived at the Museum of Modern Art in New York in 1973. The following year marked the first appearance of Eleanora Antinova at the Woman's Building in Los Angeles. In the early 1980s, Eleanora Antinova toured the country in "Recollections of My Life with Diaghilev," and in 1983 she published her journal, *Being Antinova*.

Another important persona for Antin has been "The King," an ecological crusader who waged the *Battle of the Bluffs* in a series of performances between 1975 and 1982. As *The Angel of Mercy*, Eleanor Nightingale, with a cast of forty life-sized Masonite figures, serves in the Crimea.

Antin's most recent creative endeavor has been a film by yet another persona, Yevgeny Antinov, a Soviet silent-film director. His film *The Last Night of Rasputin* has been screened across the country, from the Whitney Museum in New York to the University of Michigan and the Los Angeles Contemporary Exhibitions (LACE).

The first excerpt is an interview published in *Art in America* in 1978. Antin's forthright comments on the role of women in Southern California in the developing of alternatives to the monolithic New York gallery system is a key to understanding the contribution of women creators to the pluralism of the 1970s and 1980s.

Much of her work deals with the inability to define identity in simplified or unified ways, and with the possibilities of multiple selves. In the context of this volume, it is

296

of special interest to read her "Thoughts on Autobiography." Her definition of autobiography as "the present trying to produce the past to take possession of the future" is persuasive.

Antin has also had an active career as an educator. She has taught at the University of California campuses at Irvine and San Diego. The last two excerpts are addressed to younger women artists. They communicate her attitudes as a role model and educator, yet another persona of this multifaceted, complex creator.

"Through Western Eyes": An Interview with Leo Rubinfien (1978)

ELEANOR ANTIN: My work as an artist pulled together here in California. The roles of writer, actress, painter, performer—all of it came together for me here. I was a provincial, I'd almost never been outside New York City before I came west, at about the age of 35, and now I've set up my life so that I live in a hermetic manner, in the country. I work in my studio, which is on campus, and I teach, but then I'll come back home, I won't socialize, I won't see anybody. And I'll spend my nights watching television, which is my narrative relaxation. I'll try out different lives through movies or police stories on TV. And then I'll go back to work the next day. In New York, people tend to sort themselves out into groups—the artists know each other, the theater people know each other, and so on. I walk to the post office, I see all these old, retired people. In New York, if you live in SoHo, everyone standing in line with you is an artist.

I was a New York kid brought up by Marxist and Russian Jews, and out here I discovered America. I opened up the Sears catalogue and discovered the consumer culture, which I had known nothing about. It was very exotic. And I discovered country music, which is a world of narrative and romance, the kind of corrupt romance that's very real. In New York people go around in their schleppy neighborhoods and live real lives. And now I'm in Southern California and I live my life in art.

I also think women are responsible for breaking down the stupid and pedantic academic, Minimal, formalist scene. Conceptualism was the last gasp of Minimalism. It was a body of work based upon an inhuman and corrupt language. It was mystification and alienated professionalism. It was the Emperor's New Clothes. The only endearing thing was the passion those poor guys felt for the sound of that prose, its constipated music. The voice of Atkinson or Ramsden, the voice of a dictionary. I mean what value does a dictionary have except for bad spellers? But women are not ashamed of dealing with their own experience. We talk and we listen with human voices. There are other fortunate things that have helped, but I think mostly it's women who've renewed art's freedom to be human and explore human realities. Women have brought art back to the world, where it belongs. Where literature has always been, and theater and the movies.

LEO RUBINFIEN: Do you think that Southern California is somehow especially accommodating to artistic variety, perhaps because of the absence of major cultural institutions?

EA: Major cultural institutions are irrelevant to art, and the information they send out is usually wrong. But what you're talking about is the lousy '50s and '60s! Which sits there like a lump—especially the '60s—on young artists. There's a kind of New York Syndrome—each artist looking for the one little gimmick which will be his logo, by which everyone will recognize him forever. The idea of dedicating a life to a logo is so insane I can't believe it. A perfectly intelligent, rational artist once told me she started making jewel-encrusted paintings—little gilt pieces—and then found someone else doing it, unfortunately in a gallery, so she had to drop it. What she did with the little gilt pieces was not the concern—the idea of doing gilt pieces was all that mattered. When Lynda Benglis poured something on the floor, no one else could ever pour something on the floor again. I mean, Dick Serra once told me that Carl André owns the ground. If Carl owns the ground and Lynda owns pouring, what does Dick own?

LR: It seems to me there's a clear split between an older group of artists, painters who do very seductive work, and younger artists like Alexis Smith and Chris Burden. There seems to be no relation between one group and the other.

EA: There isn't. I think it's the same in New York, but here the definitions are clearer. The performance people know very clearly that they're not related to anyone else. In New York, artists are always trying to present their work in a way that fits whatever happens to be the current art definition, so their real concerns get blurred.

LR: Do you feel the kind of work done by yourself and other young artists out here—that is, autobiographical work that's highly conscious of its content—grows out of Southern California in any way?

EA: I believe absolutely that the feminist movement in Southern California has affected the rest of the Southern California art world. I really think that women practically invented performance in Southern California. I know there are people who won't agree, and there are some very good male performance artists. There's quite a difference in politics between Southern California and New York. In New York people who are interested in politics have a standard Marxist line, a kind of system they place upon the world without any relation to its fit with experienced reality. New York feminism is more contaminated with Marxist bullshit. In California, feminism has been more a social, political and psychological thing about what it means to be a woman in this society, a particular woman, an artist. . . . Which doesn't imply that the artwork coming out of it is necessarily better, only that very real political questions are often considered. The only kind of politics Southern California *has* is feminism. There really is no other politics here, they're really dumb about politics. But feminism, real feminism, is totally political. That's one of the things in the art world that came out of Southern California.

"Some Thoughts on Autobiography" (1978–79)

Remember Junior High School in September, after the summer, and the teacher asked you to write a composition, "My Summer Vacation"? You can't remember now what it was you wrote, but you know it wasn't about petting under the Boardwalk. You had a very clear sense of the boundaries. Now, supposing you were a troublemaker and you

wrote about your summer abortion, and you found yourself on the other side of the rules. You didn't get there by accident. The rules were so well known to you that violating them at that moment was more important than the abortion. The respectors of propriety and its violators share a concern with the rules.

Take another autobiographical form, the Diary. You are twelve years old, and you bought a diary. The diary has one page for each day because that's the way the publisher printed it. There was no way the publisher could know you were going to have a big experience on January 4th, March 15th, and September 11. It turned out that December 5th didn't even exist as far as your consciousness was concerned. So you had no room to finish on January 4th, and by January 5th you gave up literature and became an artist. Each day you wrote a single sentence on your allotted page. "Today was a boring day." "Today was a boring day." "Today was a boring day." You saved your financial investment and became an academic, conceptual artist.

This is an art work because it makes no claim to truth. It is also not autobiographical, although it may count as an autobiographical art work. Real autobiography makes a powerful claim to truth. Autobiographical art works do not. They only make a claim to the idea of autobiography. The substance is a speech made in the first person.

But speaking in whatever person, the voice of the speaker is situated in the present. The voice defines the locality of the present. Autobiography, regardless of what person is speaking, must speak in the present tense. But the material of autobiography must always be in the past. It is the present trying to produce the past to take possession of the future.

Think of Jean-Jacques Rousseau calling up his moment of humiliation. When he confesses to having been a flasher, to whom does he speak? And what does he want from them? Is this the same as Dostoyevski dragging Turgenev into a corner at a party and remorselessly recounting how he molested little girls? We know what Dostoyevski wanted from Turgenev. Turgenev was an insufferably decent man and Dostoyevski was an insufferably indecent man, and he wanted to force a conspiratorial and guilty complicity with that suave, cultivated belletrist. Under the pressure of this powerful desire to have a companion in the sewer—where one may think we all belong—is it possible that one may mis-remember, make mistakes, lie?

I can see how that could happen. In fact, it is hard not to imagine it happening. So that the claim to truth is itself infected by desire.

Desire is not a record. It may be a fairy-tale, a romance, an allegory or a novel, but it is not a documentary. A documentary is only an impoverished romance, and there is no virtue in a thrifty romance. By the end of the Nineteenth Century poverty ceased being a sign of truth. It is only a sign of misery. Truth may be luxuriously expensive and we may have to pay its price whatever it happens to be.

I'm a spendthrift, and I empty my pockets every time.

Letter to a Young Woman Artist (1974)

I remember, years ago, being invited to join a weekly group therapy session my analyst held regularly for a selected group of clients. There was a star patient there who had

charmed everybody by her considerable beauty, graciousness, kindness, her aura of success. She had created, with the help of the analyst, who adored her, a comfortable, cheerful atmosphere. I had nothing against cheerfulness. Normally, I like it. But I hadn't created this play. It was a drawing room drama and she was the hostess. I succeeded in darkening the tone, so much so that the analyst insisted I leave the group. I was destructive. Cruel. I know now I was rewriting the play so I would have an interesting role. What was in it for me if I didn't? Why should I be a supporting player in somebody else's script?

Rewriting the script is not a comfortable way to proceed. For one thing, it demands a great deal of work. Appearing in the unexpected place means you have to defend your right to be there. If you're successful, people turn to that place expecting to see you but you aren't there. You shout, "Over here, now! Behind this bush, to your right." "What are you doing *there?*" they shout back, a little annoyed. "We're having a picnic here, in *your* place. We've come to keep you company." If you're really skillful, you convince them to join you in the new place. Perhaps you remain for a few hours. You don't like to be lonely. You're tired. Hungry. But all the time you're restlessly looking for an escape. When they least expect it, you make your getaway. Then you appear a good mile off, sitting in a tree and they're angry. How do you seduce them into coming to the new place, they've just settled down into the old one. It has all the charms of home. There's a map.

Perhaps you think you don't need or want them to join you. What they do is their business. You will be a hermit sitting there in your tree. You can listen to the birds, watch the change of seasons. If that's what you want, you had better choose a new profession. Art is the most communal activity in the world. It may be a small community, but without it there isn't any art. You won't have the energy to keep it up.

Real artists recognize this. They are practical. So most of them opt for the discreet career. They learn the proprieties in school. They look for a small room in a tall apartment building and move in. It's a way of doing. It has all the comforts and privileges of tribal living. Above all, it is respectable. I have never had any talent for the discreet career. When I was studying to be an actress years ago, my teacher, Tamara Daykarhanova, made the accusation against me that if I had to pick my nose on stage, rather than stick my finger up my nostril in the shortest, most natural manner, I would twist my arm around the back of my head to reach my nose. That was 20 years ago. I know now that my major vice is my major virtue. Perhaps I acknowledged this out of desperation. I really don't think I had any choice.

On Skills (1975)

Recently a young art student at UCSD where I'm teaching now came up to me and asked "but what about skills?" I was confused. I normally don't think about skills. I'm an artist. We do the best we can. I thought for a while then I said to her "Look, you're

from California, right? You know how to drive, right? You have to, in order to get around here. But I come from New York where you don't normally drive. Only people who make a living out of it, like cabbies, drive. Most of us took the subways. They're faster, cheaper and easier. Then I moved out to San Diego. I thought driving was uncivilized and for several years managed to live and work here by hitching rides from friends and strangers. Two years ago, John Mason called and offered me a job at Irvine. I accepted and that day took my first driving lesson. In a week I was driving the highways well enough to get to Irvine and back without killing either myself or anybody else. A month ago, I was stopped by a cop in Encinitas. "Don't you ever look in your rear-view mirror?" he yelled. "I've been following you for five miles." "I saw you," I answered wondering what he was yelling about. "Don't you know you're supposed to stop when a car with a flashing light is behind you?" I didn't know. "You're the lousiest driver I ever saw," he shouted. "That's hitting below the belt," I told him in a dignified voice. "You shouldn't say that to me. I drove back and forth to Irvine and never killed or hurt anybody." He stared at me. "How can I give you a ticket?" he muttered. "Where would I start? You broke so many laws I'd have to throw the book at you. Put you in jail probably." I stared back at him in disbelief. He waved me away. I saw him shaking his fist as I turned the corner leaving rubber. "Now," I continued to my student, "in those few minutes I learned yet a new skill. How to talk myself out of a ticket."

30

Anne Truitt (b. 1921)

Although Anne Truitt's mature career as a sculptor began relatively late in her life, she is widely recognized as an early innovator in minimal objects which incorporate a unique coloristic sensibility. Her art, characterized by rigorous simplicity of form, participates in modernist abstraction. Represented by the prestigious André Emmerich Gallery in New York, her works have been widely exhibited and are part of many major museum collections.

Truitt was born in Baltimore and received a liberal-arts education at Bryn Mawr College, where she majored in psychology. Over the next fifteen years, her interests in sculpture developed while she raised three children and traveled extensively with her journalist husband. The couple settled in Washington, D.C., in 1960. The following year, Truitt saw the paintings of Barnett Newman and Ad Reinhardt at the Guggenheim Museum in New York. Stunned by the power of simplified color, she conceived of a method of unifying color and form into tall vertical boxes, which she painted with simple bands of color. A fellow Washingtonian, Kenneth Noland, introduced Truitt to the modernist critic Clement Greenberg and the André Emmerich Gallery. Truitt's work has been shown in virtually annual one-person exhibitions at the gallery since 1963. In 1971 she was awarded a Guggenheim Fellowship. She had solo shows at the Whitney Museum in 1973 and the Corcoran Gallery in Washington in 1974.

In 1991 the André Emmerich Gallery mounted a retrospective of the past thirty years of her work. Her sculptures have also been exhibited in a number of group shows around this country and in Europe. Since 1975 Truitt has taught at the University of Maryland, where she received a Distinguished Scholar-Teacher Award in 1990–91.

Despite this active professional career in the visual arts, many people are more familiar with Truitt through her writing. She has published two volumes of her journal. The first, *Daybook,* was written between 1974 and 1980. The second, *Turn,* from which these excerpts are reprinted, spans the years 1982–84, when the author was acting director of the Yaddo artist's colony in upstate New York. Both volumes are beautifully written and insightful on the widest range of subjects. Her journal entries are not limited to attitudes toward her own and others' art, but also touch on the issues of aging,

motherhood, and grandmotherhood. Many sections of *Daybook* approach autobiography in their retrospective nature, while *Turn* is focused more consistently on the artist's present.

The first excerpts deal with Truitt's responses to the publication of *Daybook*. The contrasts between writing and the making of art objects is highlighted.

The next two segments record Truitt's ambivalent feelings toward her gender-inequity case at the University of Maryland. Her new responsibilities at Yaddo are the focus of the next two journal entries reprinted here. The final two excerpts describe the artist's attitudes toward her work, its reputation, and the aging process. The elegant simplicity of language that Truitt uses for complex insights is evident in these texts.

October 8, 1982: "My life has accumulated behind my own back while I was living it, like money in the bank, and I am receiving its accruement"

The Francis Scott Key Book Shop in Georgetown, a part of Washington in which James and I lived for some years, gave me a book-signing party yesterday. Copious copies of *Daybook* were displayed in the front bay window to the right of the shop's narrow gray wooden doors, through which we used often to pass in the early days of our marriage. Perhaps it may have crossed James's mind then that he might one day see a book of his there (I wish he had), but never once did it cross mine that I would see one of my own.

I have been taken by surprise by the recent events of my life, but this can only be because I have not been alert to the signs that in retrospect intimate their direction. If I could tune in now, the future would be as legible as the past. An unassuming gratification underlies the layers of my feelings about what is happening to me. My life has accumulated behind my own back while I was living it, like money in the bank, and I am receiving its accruement.

Alexandra came down from New York for the book-signing party, and for the lovely, friendly dinner that followed it. It is a joy to wake up and know that she is under my roof, to take her breakfast in bed, to listen to her speak of her life, and to shelter her under my wing. She is tired, as the mothers of little children are usually tired; Sammy is three years old, Alastair one year. I always feel a unique ease when I am alone with one of my children. It is as if we both return gratefully to a condition of mutuality. This is a special pleasure now that they are grown up, as the mutuality that was once exclusive is enhanced by the ongoing history of our lives together.

November 10, 1982: On the Publication of *Daybook*

Two facts differentiate *Daybook* from my work in visual art.

The first is the simple safety of numbers. I am accustomed to one long effort producing one object. There are 6500 *Daybooks* in the world. My contribution to them was entirely mental, emotional. I never put my hand on a single one of these objects

until I picked up a printed book. I made no physical effort; no blood, no bone marrow moved from me to them. I do not mean that I made no effort. On the contrary, the effort was excruciating because it was so without physical involvement, so entirely hard-wrought out of nothing physical at all; no matter how little of the material world goes into visual art, *something* of it always does, and that something keeps you company as you work. There seems to me no essential difference in psychic cost between visual and literary effort. The difference is in what emerges as result. A work of visual art is painfully liable to accident; months of concentration can be destroyed by a careless shove. Not so 6500 objects. This fact gives me a feeling of security like that of living in a large, flourishing, and prosperous family.

Ancillary to this aspect is the commonplaceness of a book. People do not have to go much out of their way to get hold of it, and they can carry it around with them and mark it up, and even drop it in a tub while reading in a bath. It is a relief to have my work an ordinary part of life, released from the sacrosanct precincts of galleries and museums. A book is also cheap. Its cost is roughly equivalent to its material value as an object, per se. This seems to me more healthy than the price of art, which bears no relation to its quality and fluctuates in the marketplace in ways that leave it open to exploitation. An artist who sells widely has only to mark a piece of paper for it to become worth an amount way out of proportion to its original cost. This aspect of art has always bothered me, and is one reason why I like teaching: an artist can exchange knowledge and experience for money in an economy as honest as that of a bricklayer.

The second fact differentiating *Daybook* is that in it I am speaking English, a legible language. What I have said in it is being more understood than misunderstood. By contrast, I realize now how few people can read meaning in the visual syntax of art.

The letters that I am receiving from my readers surprise me, and touch me deeply. When I decided in 1974 to record my life with the hope that I would learn from what I wrote, I felt a dumb faith in the simple act of honest witness. I am seeing that faith extrapolated into a larger field within which honesty is answered by equal honesty. A direct line lies open between an author and readers, and along it feeling flows in both directions. I answer each letter with care, and with gratitude. The word "love" is much abused, but there is a kind of love in this communication.

August 24, 1983: The Gender-Inequity Case at the University of Maryland

Yesterday I drove to the University of Maryland to try to clear up a graduate student's problem. The fact of my having moved legally to make my salary equitable to that of male professors teaching studio art has changed the air I breathe there. I had not realized how much innocent pleasure I took in feeling approved until I felt the chill of disapproval and a discreet echo of malice. I drove home sick at heart. But last night as I watched my hand running the dishrag over the sink after washing the dinner dishes, a smile took me by surprise. I suddenly understood that I have been more attached to my work at

the university, to myself as Professor of Art, than I had known; my pleasure has not been as innocent as I thought. Now, as a result of a probably doomed but nonetheless honest and painstaking effort to right what I feel to be a wrong, I have pierced a bubble of self-deception. As I turned off the light in the kitchen, I felt lighter in spirit and went right to bed and to sleep.

September 3, 1983

My legal resistance to the gender inequity of my salary at the University of Maryland has come to an end. A conference between the opposing lawyers resulted in enough logical clarification of academic governance, of the discrepancy in financial resources between the university (which uses the state's legal services) and me, and of the emotional toll of a prolonged lawsuit, for me to make with reasonable grace the decision to accept the situation. The degree of my relief is a measure of how unnatural bold confrontation is to me. Not even very bold. In effect, I raised my banner, marched up a hummock, listened to reason, lowered my banner, and marched down. Nonetheless, I stood there for the principle of gender equality, and satisfied in myself my personal principle of standing for what I see as right. Wellington, in line with his dictum that a great general knows when to retreat and has the courage to do so, would agree with my decision. Lesser generals, like Custer, die where they stand.

March 30, 1984: Assuming the Acting Directorship of Yaddo

Snow is filling up the woods. Yesterday I walked alone in a wild blizzard.

Curtis Harnack, the executive director of Yaddo, is instructing me in his duties. We quarter the grounds and buildings together. I look and listen carefully.

My daily life could not be more changed. Instead of a solitary effort to maintain a context more or less of my own invention, I find myself becoming a part of a continuity I can serve. I like that very much. More than I would have, had I not realized in Europe the benefactions of community.

April 4, 1984

Aside from walking, nothing I am doing is automatic. Letters that would usually take me a few minutes to write take time because I have first to find and then to learn new information—as I do almost every minute.

I am living in the executive director's house, which I am rearranging to help myself feel at home. Here in my bedroom, a postcard I bought and framed forty-odd years ago, a Greek marble head of Pallas Athena, hangs opposite my bed above an antique mahogany crib that I have covered with a blue and white flowered cloth on which I

have propped up the stuffed animals my grandchildren sleep with when they visit me. They are comforting to me too.

The dimensions of my job are beginning to emerge as if fog were lifting unevenly over an unknown landscape. I more and more understand that I have undertaken an incalculable responsibility.

Early tomorrow morning I go by train to New York City for a Yaddo benefit that night, and a meeting of the National Council for Yaddo the next day, returning late in the evening.

June 22, 1984: "My sculptures live in my mind"

Yesterday afternoon when I woke up from a nap after a morning of work on my sculptures, the thought stepped quietly into my tired mind that I could simply stop making the effort to translate myself into visibility in art. I carefully examined this proposition. An end to encrusted, painty clothes and the wear and tear of ascending and descending ladders; an end to crouching on the floor to see color from a different angle in a different light; an end to catching and tediously fixing tiny fissures in the striation of wood; an end to the demands that handling finished work in the world make on my equilibrium. But this last clause snagged and I suddenly realized that I had been hurt by my exclusion from the survey of contemporary painting and sculpture mounted by the Museum of Modern Art to mark the opening of its recent renovation. The museum owns *Catawba*, a 1962 sculpture. I had to conclude as I walked through the galleries last week that my work had been judged not important enough for inclusion. While I was there I took this fact in stride, struck as I was by a splendid plenitude of the fine work of my generation of American artists. At the time I felt only a generous joy that I have been privileged to live in this era of art, to see and to understand with a delight that had nothing to do with my own work how much beauty and truth had been brought into the world in this country during the last forty years. But a barb apparently remains, slender as the thorn of a wild rose.

I continue to consider stopping work. I could cut the Gordian knot, give my work to my children and retreat into the jobs that put food in my mouth and underwrite the financial security of my family, now including another generation. That would perhaps be a sensible plan. Honest enough too.

But not courageous.

Like all crucial decisions, this one has already been made by the history of my life. My sculptures live in my mind. I can rebuff them only at some psychic peril too deep for articulation.

Also, I have a sturdy loyalty to my work that owes nothing to any opinion any other person might have of it. I have faith in it, virtual trust.

Piero della Francesca apparently lost interest in painting toward the end of his life and took to strict mathematical analyses of the laws of perspective. If I find that I too lose interest in my work, I will stop making it. But that would be a decision intrinsic to the context of my life, inevitable.

December 14, 1984: "I began to isolate a reality of proportion and color which I see gleaming behind the objective world."

I am preparing to leave Yaddo. My sculptures have gone, and some of my household things too. My Washington house is being repaired and repainted. I am neither eager to go, nor reluctant. I am content to know that when I depart over the causeway and out between the granite gate pillars, Yaddo will close behind me, intact, as if I had never lived here.

The earth is hastening toward the winter solstice. A thaw has peeled back the ice from the edges of one lake, revealing it to be encircled by viridian grasses keeping themselves alive for spring. Fog gives way to mist and mist succumbs to fog. Where the earth is clear of snow, its pungent smell is the very meaning of promise.

The other day I came upon an acorn Charlie must have brought into my house. I am holding it in my left hand as I write. Slightly larger than the nail of my little finger, its blunt stem tapers to a point the shape of a Sumerian temple. Narrow streaks of palest black brush its oval length under a blush of tan that deepens toward autumnal red at its tip. I think to take it home and plant it in my backyard. I would perhaps live to see it a foot or so high. I visualize it growing in the clearing between my garden fence and my studio. I see how when the fence and the studio were long gone it would live on at the particular cross of longitude and latitude where the light there would by that time belong to it as it belongs to me, by right of placement. All this is as clear as a film before my eyes—but I will not take the acorn home.

I am beginning to understand that the detached independence I am feeling has always subtly underlain my life and work. My life, because I have never quite lost an ingrained conviction that I do not belong in the world, and have never ceased to search for what I somehow was born knowing. My work, because I never have had a sustained interest in documenting the world. In 1961, impelled by the force of my childhood memories, I made one fence, delicately altered toward what I felt to be the essence of fence. But I immediately left behind the appearance of fence for ever less referential art. I began to isolate a reality of proportion and color which I see gleaming behind the objective world. I have had only glimpses of this other reality. I have made things in an attempt to render it more visible.

31

Cindy Sherman (b. 1954)

Since the first appearance in the New York art world of her highly original photographs of herself, the "Untitled Film Still" (Fig. 19) series in 1977, Sherman has been one of the most visible artists in the "second generation" feminists which includes other figures such as Barbara Krugar and Jennie Holzer. Unlike these two, however, Sherman's imagery is ambiguous and not readily accessible to politically clear interpretations. For that reason, it is especially important to listen to her own voice, in this text, as interviewed by Jeanne Siegel. The immediate motivation for this interview was the ten-year retrospective exhibition of Sherman's photographs exhibited at New York's Whitney Museum in 1987.

Born in New Jersey, but raised on Long Island, Sherman graduated from State University of New York at Buffalo in 1976 unsure of an artistic direction, as she describes in the first part of the interview. Despite her easy access to the New York avant-garde art world through her relationship with Robert Longo, her sense of distance and isolation from a community of artists is also described here. Her own definition of herself as "the girlfriend," not a full participant in the male-dominated art world, indicates how persistent the myths of male genius have survived into our own times. Like virtually all the artists included in this book, Sherman in the late 1970s perceived herself as an outsider not privileged to inhabit the realm of "art." Who better than an outsider could create a group of works designed to explore "the fakeness of role-playing." As she then states, the "Untitled Film Stills" were also addressed not to rouse scopophilic male gazes, but "as contempt for the domineering 'male' viewer who would mistakenly read the images as sexy."

This ambiguity of interpretation, the ease with which the "film stills" may be read as either irony or addressing the "male gaze," is used by Susan Rubin Suleiman as an example of the problems of feminist postmodernism in maintaining a critical stance outside the commercial marketplace. It is difficult to avoid the fate of becoming one commodity among others, rather than truly politically resistant to hegemonic cultural forces.[1]

Following the "stills" her next group of works shifts appearance dramatically. In

Figure 19. Cindy Sherman, *Untitled Film Still* (1978). Metro
Pictures, New York.

place of the black and white 8″ × 10″ photos, Sherman uses a rather large (2′ × 4′)
horizontal color format inspired by the centerfold "pin-up." Again, in this interview,
Sherman reiterates her intent to mock male viewers' expectations and denies any expli-
citly sexual content. In her next group of works, after realizing the ambiguity of the
imagery and their vulnerability to misinterpretation of her intentions, Sherman switches
format to again a more powerful, vertical figure. In discussion of her more recent images
using false body parts, she reiterates her intentions of repulsing the male gaze, "So it's
a kind of a slap in the face to those who would get off on nudity."

Despite the diversity of physical appearances and overall format, one constant in
Sherman's oeuvre is the use of herself as subject in front of the camera as well as the
auteur of her compositions. One could see her works as a comment on the nature of
autobiography which can never fix on a "true" unchanging sense of self but is a patch-
work quilt of constantly fluctuating, unfixed personae. Although Sherman explicitly
denies any personal fantasy projection and autobiographical content to her imagery, it is
undeniably true that she is the only actor in her dramas. Using herself in this way must

be interpreted beyond the stated desire for privacy to project herself into these different roles if only for the brief time needed to fix the image photographically.

Another theme of interest to critics is Sherman's use of photography. Given her stated lack of interest in issues of specific concern to photography, the medium becomes the most efficient tool to communicate her imagery to the audience. After the release of the "film stills" series, the scale and use of color of the images occupies the same visual weight and attention as painting. Therefore, the medium itself embodies ambiguity. The term Siegel employs, "fine art photography," indicates the need to view Sherman's works in a broader context than the traditional category of "photography."

Given the admittedly grotesque elements of Sherman's imagery since 1985, the need to interpret these complex and at times horrifying images has propelled one critic, Ken Johnson, to find an overall pattern to her works, in the context of the Whitney retrospective. Johnson, perceived Sherman's imagery as "a sort of archaeological excavation of the self."[2] She moves from the past, in the film stills, into the present, in her "pink bathrobe series," which describes a depressed "antiself," to the "domain of the subrational," a realm of insanity. The making of the art image is the means by which Sherman "therapeutically releases the contents of psychic disturbance."[3] Giving visual form to psychic elements that are normally buried in repression becomes a means to regain sanity, a healthy catharsis for artist and viewer. Such an interpretation appears even more convincing, given the most recent body of Sherman photographs which take famous images from art history as points of departure. Sherman seems to have returned from the brink of irrationality with the confidence to confront the patriarchal "authorities" of the Old Masters.

The youngest artist in the group included in this section, Sherman demonstrates that feminism has impacted the creative energies of artists in the post-war baby-boom generation. One can eagerly anticipate the artistic development of this cohort, and generations to come who have yet to make their marks or articulate their voices. The desire to communicate to a broader-based audience than the New York art world is a healthy side of the survival of women artists in the politically repressive 1980s.

JEANNE SIEGEL: You received your B.A. in 1976 at the State University College at Buffalo. What was your work like in those formative years?

CINDY SHERMAN: I was using photographs of myself but I began to cut them out. They were like paper dolls in kind of a corny way; I would put them together to make scenarios printed in different sizes to portray children, or women.

JS: Hadn't you been making paintings before this?

CS: Yes, but I didn't do anything serious with painting. It was when I started taking pictures of myself that I felt like I was doing something different.

JS: This is all while you were in school?

CC: Yeah. I don't know if there was that much of a leap, because I was the kind of painter who would copy things. I copied things to make them look as real as they could possibly look, whether it was from a photograph or a magazine ad. It wasn't even about art, it was just about realism. I didn't have a good art history background. I've never

acquired one, even at this point. But I was just interested in reproducing a picture with somewhat surrealistic overtones.

I started in the painting department. I tried to switch and they wouldn't let me; but I became more interested in photography as a tool, and I think when I finally made that switch, it was as a result of about a year's worth of frustration of not knowing what to do. This was about the point where I met Robert Longo and the Hallwalls crowd and learned what was going on in the art world up to that moment. I hadn't learned anything about this in school and never knew about it from growing up on Long Island. Once I learned about what was going on, I felt like it was useless to paint anymore.

It was really exciting for all of us having New York artists come up and visit. We were so far away from the real art scene in the city but we would read about these people in magazines, and they were our heroes. It was funny; when I finally moved to New York I'd see those so-called heroes walking in the street in SoHo looking like everybody else, and it kind of brought me back down to earth a bit.

JS: Who were these people?

CS: Oh, Hannah Wilke, Liza Bear, Willoughby Sharp, Robin Winters, Vito Acconci . . . people who either did installation or performance work. I was inspired by a lot of performance like, say, Chris Burden (although what he did at Hallwalls wasn't too great). One person who I don't think ever came to Buffalo who did influence me (but only mythically in what I *heard* about her "performances") was Adrian Piper.

JS: In 1976 you were included in a show at Artists Space in New York. What did you show?

CS: As I said, I was doing these cut-out figures. Cutting them out was the only way to fit all the different characters together, but it was presented in a filmic sort of way; scenes went all the way around the room. The one at Artists Space was like a murder mystery. It was more experimental for me, because it wasn't a story that I would really want to see on film, but about how to put all these different characters together and tell a story without words.

JS: Were you the only figure in the story? Why?

CS: I just wanted to work alone. I didn't even think of asking my friends, and I certainly couldn't afford to have an assistant or model. It was the most natural thing for me to do—just hide in the back of Hallwalls, because Hallwalls was a very busy sort of place; it was communal in that respect. There were three of us living upstairs from the gallery, and it was kind of the game room where all the other kids from all the other little studios and places around the city would come and watch TV every night and hang out with the current visiting artists. So it was a very busy place. I got sick of it often and retreated into the back room into my studio and bedroom and would work back there by myself just to get away.

JS: The need for privacy seems to be a continuing characteristic of yours. How did the "film still" images come about?

CS: When we moved to New York, I had grown tired of doing these cutesy doll things and cutting them out. It was so much work and too much like playing with dolls. I

still wanted to make a filmic sort of image, but I wanted to work alone. I realized that I could make a picture of a character reacting to something outside the frame so that the viewer would assume another person.

Actually, the moment that I realized how to solve this problem was when Robert and I visited David Salle, who had been working for some sleazy detective magazine. Bored as I was, waiting for Robert and David to get their "art talk" over with, I noticed all these 8 by 10 glossies from the magazine which triggered something in me. (I was never one to discuss issues—after all, at that time I was "the girlfriend.")

JS: In the "Untitled Film Stills," what was the influence of real film stars? It seems that you had a fascination with European stars. You mentioned Jeanne Moreau, Brigitte Bardot and Sophia Loren in some of your statements. Why were you attracted to them?

CS: I guess because they weren't glamorized like American starlets. When I think of American actresses from the same period, I think of bleached blonde, bejeweled and furred sex bombs. But, when I think of Jeanne Moreau and Sophia Loren, I think of more vulnerable, lower-class types of characters, more identifiable as working-class women.

At that time I was trying to emulate a lot of different types of characters. I didn't want to stick to just one. I'd seen a lot of the movies that these women had been in but it wasn't so much that I was inspired by the women as by the films themselves and the feelings in the films.

JS: And what is the relationship between your "Untitled Film Stills" and real film stills?

CS: In real publicity film stills from the 40s and 50s something usually sexy/cute is portrayed to get people to go see the movie. Or the woman could be shown screaming in terror to publicize a horror film.

My favorite film images (where obviously my work took its inspiration) didn't have that. They're closer to my own work for that reason, because both are about a sort of brooding character caught between the potential violence and sex. However, I've realized it is a mistake to make that kind of literal connection because my work loses in the comparison. I think my characters are not quite taken in by their roles so that they couldn't really exist in any of their so-called "films," which, next to a real still, looks unconvincing. They are too aware of the irony of their role and perhaps that's why many have puzzled expressions. My "stills" were about the fakeness of role-playing as well as contempt for the domineering "male" audience who would mistakenly read the images as sexy.

JS: Did you see these "narratives" as stories or parables?

CS: At the time I never analyzed it. Looking back now, I think they are more related to allegory.

JS: How much influence did advertising images have on you?

CS: I don't remember consciously thinking about it. I was commenting on it later when I was mocking advertisements, when I did the ads for Dianne B and Dorothée Bis. I've always been interested in ads on TV and in magazines, in terms of the artificiality and the lying. But I never thought in terms of incorporating it into my work at any one point.

I was interested in film noir and psychodrama. I was more interested in going to movies than I was in going to galleries and looking at art. Sam Fuller's *The Naked Kiss, Double Indemnity,* those kind of classics. I would go to the Bleecker Street Cinema just to look at the Samurai movies. But I'd go to see any kind of movie, really. I was more interested in that media than art media. . . . I've only been interested in making the work and leaving the analysis to the critics. I could agree with many different theories in terms of their formal concepts but none of it really had any basis in my motivation for making the work.

JS: Another critical issue attached to the work was the notion that the stereotypical view was exclusively determined by the "male" gaze. Did you see it only in this light or did it include the woman seeing herself as well?

CS: Because I'm a woman I automatically assumed other women would have an immediate identification with the roles. And I hoped men would feel empathy for the characters as well as shedding light on their role-playing. What I didn't anticipate was that some people would assume that I was playing up to the male gaze. I can understand the criticism of feminists who therefore assumed I was reinforcing the stereotype of woman as victim or as sex object.

JS: You're referring to the work you did in 1981 where you enlarged the image and more or less eliminated any background except for a few tiny props? They were studio shots, and they were mostly in horizontal positions—you on the floor reclining or half-reclining. They became less situational and more assertive physically and psychologically. Exactly what were your intentions here?

CS: I was asked to propose a project for *Artforum,* which included a centerfold project. And I liked the idea of mocking traditional centerfolds, so that's how the format of that oblong rectangle came about. But I wanted to make the viewers embarrassed or disappointed in themselves for having certain expectations upon realizing that *they* had invaded a poignant or critically personal moment in this character's life. That was my intention.

The problem with filling up the horizontal format is that the subject is usually prone, which can be a potentially suggestive position, no matter what the character's state is or how she looks. The locations are either on a bed or on the floor, which would suggest having been thrown down or waiting for someone to lie down next to her. But I don't see these women (or girls) as enjoying their angst, agony or anguish, which is usually a factor in intentionally suggestive photographs which one would find in a detective magazine.

JS: In other words, their victimization or vulnerability was not primarily sexual?

CS: I've never quite figured out how people read them as sexy, except when they are thought of as my personal, sexually motivated fantasies.

JS: You certainly have avoided focusing on the erotic. You set up the opportunity for yourself to show naked parts of the body only later, when you began to use fake body parts. You never did it when you were just showing your own body.

CS: I wouldn't consider that a viable costume. Even if I was using another model I wouldn't do that because it automatically implies "get a load of this." There's too much of a cheesecake implication. Especially since people are so preoccupied with what I must really look like, that would be counterproductive.

JS: As a matter of fact, I read them as romantic, occasionally sentimental.

CS: Yes, like the girl waiting by the phone. Well, after reviewing the problems with that work and how people interpreted it, I consciously switched to a vertical format featuring strong, angry characters, women who could have beaten up the other women, or beaten up the men looking at them.

JS: You had described those vertical works yourself as "emotions personified."

CS: That's when I got tired of using makeup and the wigs in the same way, and I started messing up the wigs, and using the makeup to give circles under my eyes or five o'clock shadows, or hair on my face—to get uglier. I also emphasized the lighting much more. That's why the moodiness of the whole series made me think of personified emotions, although I hate that phrase now. . . .

JS: By 1983, you abandoned the image of the romantic young woman for something more extreme, perhaps more exotic, often less beautiful, on its way to becoming more grotesque, certainly more costumed, staged (I mean more explicitly staged so that the viewer is aware of the staging). You even introduced false body parts. By '85 they had fake asses or pigs' noses. What inspired that series?

CS: I was asked to do some ads for Dianne B using clothes from Issey Miyake, Comme Des Garçons, et al. They were really weird clothes that were fun and inspiring, but also very powerful on their own terms—overwhelming in fact. To balance them, I started making the characters as bizarre as the costumes so that they would fit together and neither would overshadow the other. Then I did a job for this French designer, and right away I started feeling antagonism from them, not really liking what I was doing, because they expected me to imitate what I had done in the last series. But I wanted to go on to something new, and since they were going to use these pictures for Paris *Vogue,* I wanted the work to look really ugly. The clothes were boring and not the ones I had asked to use so I thought I'll just go all out and get really wild. That's when I started using the rotting teeth or bad skin on my face, while trying to mock those *Vogue* model poses. They hated it. And the more they hated it, the more it made me want to do it, and the more outrageous I tried to be. Finally I had to finish the job and shot some less insulting pictures just to end it. I was real disappointed that they didn't use the best ones in the magazine, because it would have looked great.

JS: Wasn't the source for these images fairy tales? If so, do you interpret mythological characters as stereotypes in the same way?

CS: No, that was about a year later when *Vanity Fair* suggested I illustrate a fairy tale. That's when I really crossed over the line into using theatrical masks and so forth. I wasn't stereotyping these mythical figures in any conscious way (the witch with the hooked nose is the one I found least successful, perhaps because it looks like a Halloween character). While I was reading fairy tales for research I did find an abundance of standard characters but I was seeking to find the quirky characters, or most bizarre scenes.

JS: These works brought out your sense of humor, coupled with mocking (a characteristic to which you frequently refer).

CS: In a sense, that's become the most important thing to me in the work. Perhaps it's the easiest protection against criticism; whether or not the work is really mocking some-

thing, at least it's pleasing to me. My critics just don't get the joke or see who or what I'm referring to. I suppose it's a built-in defense just so long as it's entertaining somebody out there. It's the way I feel about the art world and the critical world; after being around for a while, I don't want to take anything that seriously in this field. So I'm making fun of it all, myself included, in various stages.

JS: Your black humor connected here with the exaggeration of fakeness—the big asses, the false breasts . . .

CS: Well, again, the false ass and tits were, at first glance, perhaps as much of a lure as nudity would be in any photograph, but once the viewer looked up close, not only are they fake, they belong to a hideous character, the face, the teeth and everything. So, it's a kind of a slap in the face to those who would get off on nudity to think that I would have to stoop to that.

JS: You have relentlessly pointed out that you are not interested in self-portraiture. In the traditional sense, this is true. But, in light of your choosing the character and garb, isn't it plausible to assume that as fantasies they are extensions of yourself?

CS: No, I don't fantasize that I'd like to look a certain way or be in a certain situation in order to take a photo or set up a scene. Fantasy only comes into play after I've made myself up and I need to imagine how this character would behave in order to capture the expression I'm after. I work in a very logistical, methodical way, from series to series, analyzing faults and trying not to repeat myself. While working, I'll look at what I've done so far in a series and make generalized decisions about what I need to add to it. I may have too many images that are similar in color, character, mood or composition, so I'll construct a new work solely on the basis of adding variety and although all the other details are more intuitively constructed, it's really a matter of what kinds of props or body parts I've purchased rather than some deep-rooted fantasy.

JS: It would appear that where, at the start, your images typified glamour or prettiness, now you concentrate on ugliness.

CS: I think the early work was misinterpreted as being about these pretty young actresses, because I never saw them or myself as an imitation of prettiness. Looking back, perhaps applying a lot of makeup in a style from the past is now synonymous with a stab at beauty. But I was involved with this work before the age of retro-fashion. Coming out of the 70s, which were concerned with the "natural" look, I was intrigued with the habits and restraints women of the 50s put up with. I remembered as a preteen, sleeping with orange-juice-can-sized rollers in my hair, wearing a girdle and stiff, pointed bras. At that time, the idea of putting all that together with heavy, exaggerated makeup seemed more amusing and ridiculous than pretty.

JS: Do you feel a distance from ideas that concerned you, for example, the idea of the stereotype of the self?

CS: Stereotypes don't concern me so much anymore now that they're everywhere in fashion. I feel my old concerns helped me to grow to where I am today, but I don't need them anymore. Perhaps these issues are like so many givens now.

JS: To return to the beginning, what artists have influenced you?

CS: My friends, mostly. But early on it was people like Vito Acconci and Bruce Nauman, the ads that Linda Benglis, Robert Morris and Eleanor Antin did in *Artforum*.

JS: What appealed to you in those ads?

CS: That they were using themselves as a commodity, to make fun of their art as a commodity. And, that they made fun of the art world as a sort of playground for hype.

JS: One of the most innovative features of your work is that you not only drew on film and photography but absorbed elements from performance art, which had been central in the 70s, and incorporated them into a pictorial mode. In regard to performance, was Acconci an influence?

CS: Definitely.

JS: In what way?

CS: He mocked everything—himself, the art community, sexuality, even the notion of performance art. When I first saw a catalogue of his, I was appalled. There was a series of pictures showing different places to hide his penis and one of them was in the mouth of some assistant of his. I thought, my god, what do people go through in the name of art? But when he came to Buffalo, I realized that he was mocking people with attitudes just like my uptight background. Seeing what a gentle, shy person he was I found it remarkably funny that he made the work he did.

JS: What was your exposure to John Baldessari?

CS: When I was in school, what interested me was his sense of making a game out of art. It didn't seem highbrow; it didn't seem like you had to read magazine articles to figure out what he was trying to do. He was funny, like William Wegman; you can just watch TV and relate to their work, and yet it wasn't about TV. It was much more interesting.

JS: One thing you have repeatedly pointed out is that you create intuitively. Yours is not an intellectual pursuit; you're not involved in reading theory.

CS: Yeah. Yeah. Yeah.

JS: There's no question that you're still very involved in the art world, but I have become aware of the fact that you like the idea of infiltrating or associating yourself with a larger audience. You are more interested in that world out there.

CS: It could be seen in two different ways. It could be seen as just trying to be popular, which is not what I'm making out of it. I just want to be accessible. I don't like the elitism of a lot of art that looks like it's so difficult, where you must get the theory behind it before you can understand it.

JS: Are you saying that you think when people saw the Whitney show there was immediate readability?

CS: I don't really know if people understand what my intentions are, looking at it, but they can recognize things right away and recognize whether they're turned off or laughing or what sort of immediate reaction they have.

JS: Would you say, then, that you're communicating on two levels? There's the immediate reaction where the viewer can get something that seems valuable and then there's the other one that requires longer thinking.

CS: Some of them are like portraits so the audience can relate to it like portraiture, and some of it looks like it could be a movie poster.

JS: What do you see as your relationship to photography?

CS: It's kind of a love/hate relationship, I guess, because I hate the technology of it. I hate people who are obsessed with the technology of it.

JS: You don't concern yourself with technology at all?

CS: Well, I've had to learn much more than I ever would have cared to, but only because I needed it for what I wanted to express. It was necessary for this work to grow. In the beginning, in the black and white stage, I purposely would underexpose or overexpose and wouldn't care if it was printed properly because it was about cheapness and not high art. That's very opposed to the concerns of the photographic community—the sacred image/print in full frame, etc.

JS: One area where you have made a considerable contribution is in the changing role the art institutions are playing in acknowledging so-called fine art photography. You showed first in the 1983 Whitney Biennial. In the 1986 Biennial the Whitney Museum took a step by incorporating and presenting photographers side by side with painters of similar perspectives in a move toward comprehensiveness. In the summer of 1987, the museum mounted a 10-year retrospective of your photographs. This represents a radical step in that you are the first fine art photographer (as well as one of the few women) to be given a retrospective there. This admits you into the exalted realm of high art . . . Within the museum context, your work looked more like painting, particularly the new work which suggested an all-overness reminiscent of Abstract Expressionism. . . .

CS: I wasn't thinking of painting per se (although the toy penises were a reference to the pervasive macho-dom in ''high'' art). I was concerned with fields of matter that, objectively, were colorful, tactile as well as textured, and subjectively could inspire amusement, curiosity or revulsion. I see them as landscapes of a sort, but not based on any reality. . . .

JS: Is it possible for you to sum up what you're trying to communicate?

CS: Maybe I want people to look at my work and use what they're seeing to help themselves to either see or recognize something that they realize is really stupid, like, ''See, I'm sort of like that and I shouldn't be,'' or, ''Why am I attracted to that? It's really ugly.'' The role-playing was intended to make people become aware of how stupid roles are, a lot of roles, but since it's not all that serious, perhaps that's more the moral to it, not to take anything too seriously.

32

Faith Ringgold (b. 1930)

By any standards of success in the art world, Faith Ringgold measures up to a level of creative excellence shared by only a small group of African-American women artists of her generation. Since 1990, a major retrospective exhibition of her works has toured the country, exhibited not only on both coasts but in selected sites throughout the Midwest and the South. The interview reprinted in this book is excerpted from the text published in the catalogue for this show.

Ringgold has been the recipient of two separate National Endowment for the Arts grants, and in 1987 a Guggenheim Fellowship. In 1986 Moore College of Art (Alice Neel's alma mater) presented Ringgold with an honorary Doctor of Fine Arts degree. In 1991 similar degrees were awarded by the artist's alma mater, the City College of New York, and the Massachusetts College of Art. Her works are found in major museums such as the Museum of Modern Art, the Metropolitan Museum, the Studio Museum of Harlem and the High Museum, Atlanta. Her works are in the corporate collections of the Chase Manhattan Bank and Philip Morris, and in selected private collections.

What makes this impressive list of official credentials remarkable is the type of work Ringgold has created: a body of imagery insistently focused on her identity as an African-American woman of the twentieth century.

"After I decided to be an artist, the first thing that I had to believe was that I, a black woman, could penetrate the art scene and that I could do so without sacrificing one iota of my blackness, or my femaleness, or my humanity."[1] From this strong and focused sense of communal and individual identity, Ringgold has created a highly personal body of works of formal, technical, and iconographical originality. Her mature works are consistently outside of neatly defined categories of painting or sculpture, utilizing fabric, quilting techniques, and literary narrative in highly original ways.

Ringgold was born in Harlem in the midst of the Depression. Her father had a financially secure job as a driver on a city sanitation truck. Her fashion-designer mother stimulated a love of cloth and fabrics which the artist has creatively employed in her mature works. Upon graduation from high school in 1948, Ringgold enrolled in the education program of the City College of New York, since the liberal-arts program was

318

not open to women. She taught art for eighteen years in the city's public-school system. By the mid-1960s, inspired by the civil-rights movement, Ringgold was painting murals such as *Die* (1967) illustrating the theme of interracial hatred and violence. Her early involvement in the women's movement in the early 1970s, combined with the experience of teaching a course on African art in 1972, was a major turning point for the artist. She began working with fabric and incorporating African motifs into her art in 1973. This resulted in the soft-sculpture series of the *Family of Women*. In the early 1980s Ringgold began making quilts, exploring not their abstract forms but their potential for narrative. Using a range of fabrics as support, the artist stitched, painted, and wrote directly onto the quilt, in works such as *Tar Beach* discussed in detail in the following interview.

This interview was conducted by the curator of Ringgold's retrospective exhibition, Eleanor Flomenhaft. It addresses a number of key issues of interest for this artist, in addition to the genesis of *Tar Beach*. She describes her experience of European art in the early 1960s and the way this affected her own determination to become an artist. The integration of Western artistic traditions with African art is another key concern. The artist discusses the relationship of her art to "craft" and the definition and separation of these two categories. Ringgold also clearly articulates her sense of identity as a "black woman artist" in contemporary America.

Interview with Eleanor Flomenhaft

ELEANOR FLOMENHAFT: When was your breakthrough? When did you know how to paint black people?

FAITH RINGGOLD: In the early '60s. I was out of school; had gotten my master's degree, and I had gone through a period of trying and being exposed to African art. I wanted to find a way to create visual images of black people that were acceptable to me. And it was long and I had to teach myself to do it. I had received a good technical education at City College. I knew a great deal about the chemistry of making colors; and about what all the different combinations of colors could achieve; I could control the intensities of colors; and I had a lot of information. But that's not the only thing that helps you when you're painting. There are other magical kinds of things that come into using color, shape, form and so on, creating art that comes out of a combination of skill, technical knowledge and experience; and a confidence you get from doing it a lot.

EF: So then your own voice, if you will, came through in the '60s?

FR: Right. I went to Europe in '61 because I wasn't sure that I understood what being an artist was. I was out of school now and I was teaching. My uncle wanted me to go ahead and get a doctorate, but I thought a master's degree was fine for someone being an artist. So I decided to go to Europe and I went with my mother and my two daughters. I wanted a chance to see the pictures in person that I had seen all through my schooling. I wanted to go to the Louvre, and the Uffizi in Florence. And I felt that if I could see

these things and go to the Montmartre and be where Picasso was, then I would have some notion of whether I really wanted to be an artist. The whole concept of contemporary art was still not a real thing for me, because the art scene was nothing like it is now. There were very few galleries; few artists had galleries; and it hadn't formulated in my mind in that way yet. So I went to Europe, and I came back feeling, yes! And I said well if you want to do it, you have to have a place to do your art so I decided I would set up a studio in my dining area. I started working very hard, painting a lot. Then I began looking for a gallery; and found one to represent me in '65.

EF: That was the Spectrum Gallery.

FR: The Spectrum Gallery. It was a co-op with a director. I had my first show in '67; and then another in '70; and all that time I was painting people in the way that I had discovered which I called superrealism. This other Superrealism came out some time later; but I called what I was doing superrealism because I wanted people to feel like they were looking at themselves; I wanted it to be realistic but I also knew that in order for me to paint black people in the way that I needed to, they had to have a certain abstract quality. That was when I decided I would not paint chiaroscuro, painting light and shade, because when you're painting black people and you're going to paint shade you have problems, because you're painting dark and then the shade is darker, so it becomes less clear than I wanted it to be. And that's also when I began painting flat. It always interests me when people say that I'm naive or painting primitive. That's not what I'm doing. I'm dealing with the problems involved with painting the images I'm trying to paint. I'm using whatever method I need to use. It's not that I don't know how do it another way. It doesn't apply to what I'm trying to achieve. . . .

EF: How do you start a subject?

FR: Well, like for instance *Tar Beach*. My show was coming up. Often what I'm doing is inspired by somebody or something but mostly by somebody. So *Tar Beach*—by Bernice Steinbaum. I was in California and I was to come home, get *Tar Beach* started and then we were going to Atlanta. No time for anything, just zip zip run, and she had to get it quickly because she wanted to do a poster for my show. She wanted it like tomorrow and there wasn't anything done. So I had to think fast. I said, "Oh my god, what do I need this pressure on me. You better do something you feel very close to," which is what I do anyway. So right out this window here you're looking at *Tar Beach*. Now I was going to do a whole series on women on a bridge, so this would just be the first one about this kid on the roof having her dreams. And I started writing my story.

EF: Does the story always come first?

FR: The idea or sometimes the story comes first.

EF: Okay. Now you have the story. What's next?

FR: I have the story but of course it's not finished. I have this little girl and I know she has a family. She has a mother and father and then she has neighbors next door. So I know who the characters are. Then I have to work on the story. I have to think about a beginning, middle and end, so I have some concept of what the imagery is going to be about. So I thought, well this little girl is going to be on the roof and food will be there. The mother, father and neighbors will be playing cards. That's what adults did

on the roof. But I didn't know she'd be flying. That came later. I wasn't sure about how she worked her magic or what she did with the dreams she had. And then I realized that in order to deal with bridges she would have to fly.

EF: Well, why not?

FR: Yea why not, right? So I just let her go ahead and fly.

EF: Okay, now you have your narrative and you've got your characters. Do you start drawing?

FR: Oh yes, I do many, many drawings until I get it the way I want it. And then I paint it. But I never just start painting. I draw first. When I do the drawing it's important to know all the dimensions. I have to know the dimension of the inside picture, then there's the area for the writing, and another dimension for images. It all has to be very clear. And I always work on graph paper so I have the images scaled down. Then I want to know what are my predominant colors. What kind of colors am I thinking about, whether it is at night. It's not dark night; it's dusk, so I know the colors I need for that. Then I keep building, and building and building. Then I start drawing. I don't actually make a cartoon and fit things in. I'm not interested in that much accuracy. I know generally what's going to be in it because I've done all these drawings for it; I have a real good feeling for it so now I can do the creative stuff; I can start painting.

EF: And how do you do the writing? Do you use a magnifying glass?

FR: What for?

EF: To write it all in; to see what you're doing.

FR: Oh no, on the drawing? No, its not that little. First it goes on paper that's cut just to see if it fits. When the canvas is sewn I use a Sanford Sharpie marker.

EF: So when the writing goes on you're getting down to the end?

FR: Yes, the story has been written; lots of people have read it; we've been over it and over it. It's been edited down; down; down; and it's been put on the paper and everything has happened to it; now it's ready to go.

EF: Do you ever run into a problem on the quilt?

FR: Not really. I have it all here in the palm of my hands. If I can see it and feel it, it's just like it's real; and until it gets to that stage I don't paint. It's not so much the drawings or what the drawings say. It's how I feel about the new work. Can I see it? Because I see it in a way that's not on that drawing. The drawing just has to do with space and what I'm going to do with the space; what kinds of things will be in the space. But things will be changed around.

EF: And can that be done while it's on the canvas?

FR: Oh sure, because I'm not going to run out of the ideas. I've got all my ideas on the drawings.

EF: But you have the exact placement for the words and story.

FR: Well the exact placement for the words is set because that has to do with the space that I need for my painting. But I don't just let that flow. I'm sure that the space will be say six by six feet. Within that context I can do a lot of changing. In the drawings of *Tar Beach* I decided to have certain areas of potted plants on the roof; and I changed

them around. Instead of putting them in one place I put them in another, but I knew there were going to be potted plants. I wanted them there for a lot of reasons; I wanted them for color; for mood; I wanted them to suggest that people who lived in ghettos, in tenement houses at that time took plants up to the roof; they stayed there and nobody touched them; and people would go up and water them for somebody if they were away. I mean it was part of bringing out the idea that a lot of people had come to the north from the south and had gardens, and all kinds of flowers, and they were bringing that to their new environment. . . . Many of the things I see reflected in African art, like I make heads larger than bodies and a large head in African art means that the soul or the seat of intelligence or whatever, is more significant than just the mere body. Also, I like to keep my paintings flat. It's not because I don't understand perspective but I don't want perspective in my work. It's flat because I like the all overness of painting. I like to include all areas with equal intensity. And so I don't want perspective distorting things for me. I can bring out the opposite of perspective; I bring the back forward by making the top part of my picture bigger and the top people bigger. I don't know why I do that. I actually tried to make them smaller, but it doesn't work. They're always bigger. . . .

EF: Have you heard people define your art in negative ways or call it craft?

FR: I guess what I don't like is when people say my work is primitive or naive. Not too many people have actually said my work is craft.

EF: How do you define your art?

FR: I'm a painter who works in the quilt medium; and that I sew on my painting doesn't make it less of a painting; and that it's made into a quilt does not make it not a painting. It's still a painting.

EF: Do you determine whether the other quilts are craft or art before you agree to enter a quilt exhibit?

FR: I'm not up tight about that. I realize that people want to make that distinction, and I feel that maybe by the year 2000 people will be asking what that was all about. At one time I thought that what we meant by craft was the use of certain kinds of materials. But that's not it either because Claes Oldenburg's soft typewriters are sewn pieces, and I never heard anyone call them craft. It's who's doing it that makes it craft; but I can't afford to conduct my business by what other people are thinking although I know it affects me. I do not make crafts. The difference for me is that craft is the process of doing something that has not a lot to do with the idea but the process. It's something that you can tell someone how to do and they can do it, some better than others. It has no individual distinction to it, and nothing to do with ideas. Fine art has to do with ideas.

EF: But I imagine you must have heard the word craft used in reference to your work, and thought about it.

FR: Oh sure, a lot in the beginning; not so much anymore because there's definitely a revolution going on in terms of quilts. In fact I get to show in a lot of quilt exhibits and I feel very honored to be included. It stretches me and I do not want to be slotted or limited to any one thing. I want the option to do as I want, and what I'm involved

with now is the African American quiltmaking tradition of quilters who are also wonderful, who have a separate kind of movement and history and have not been known about very much. I mean they have been on the bottom of the list and are very upcoming now.

EF: I've been reading about the African tradition in quiltmaking, in the use of quilts, the dyeing of quilts and the written imagery, the *vai celabrai*—that's used on the protective clothes of the Mali—and cloth woven by the Bbomano . . .

FR: Yeah (laughing).

EF: Well you've forced me into a whole lot of new places.

FR: Is it fascinating?

EF: It's truly fascinating.

FR: That stuff is at the bottom of everything I do. You see, that is the reason I'm making quilts, because I was inspired by African art in the '60's. Here I was doing all these paintings on canvas and I felt there was something very distant and cold about the process that I was using to paint. Also I wanted a more earthy kind of support. I wanted no support actually. And I wanted to write stories. So all of these things together; the quilt just seemed to accept them.

EF: Do you use any African symbolism in your art?

FR: This system—eight triangles in a square is African; it's a whole design from the Kuba people that I've used over and over again and in endless variations. It's ancient. It's just the basis for everything. And I use it in my quilts. But first I used it in my paintings. It's all over my paintings in the '60's.

EF: It also relates to the grid; and a quilt is a kind of a grid.

FR: Yes, and that helps me to put order into the disorder that I like in my art, to organize it and put it together; it helps me to deal with space. It makes the space richer, and it also helps me with the rhythm which is another very African thing; the polyrhythms, the concept of having different rhythms around you at the same time. I try as much as possible to keep that going, to have different sizes of things, even people in different directions moving in different places almost in different spaces within the same compositional space. . . .

EF: Did your works grow out of each other or were they conceived separately for different reasons?

FR: They all grew out of each other, but overlapped, going backwards and forward. Before 1970 I was just painting on canvas in oils. Then there was a series of watercolor paintings, but I went back to painting on canvas because the glass on the frames of the watercolors were always breaking. The first dolls that I did—for a lecture I was asked to give at the Museum of Natural History—were gourd heads. Later coconuts took the place of the gourds, and then faces that were soft, that had foam rubber sewn features were the masks coming forth and developing. With doll features they became soft sculptures who were really the people coming out of my painting and where the quilts were concerned, going back into it. The tankas in '72 were my early quilts without my ever calling them that. . . .

EF: Other issues that you have been very involved in are African Americanism and the

women's revolution. Where do you feel they are now, and what do you expect for them?

FR: Well for me they're very much connected in that I had to find my way as a black woman in America. I was a child when I figured out that I am an African American whose ancestors came here as slaves and that therefore certain things are put upon me, and will probably go on for the rest of my life. For the extent of my whole life I will deal with that issue in a very up front way. Now the realization of being a woman and a black woman came later and what I had to do about it came at the end of the '60's. The two of them together are issues that really focus my whole life. Everything about my life has to do with the fact that I am a black woman. The way I work has everything to do with that, because I am struggling against being a victim which is what black women become in this society. The reason I lose weight is because I don't want to become a victim of all that fried chicken and greasy food. So many black women out of despair and lack of opportunity and lack of this and that and the other, eat and grow fat and get sick and die, early. I am determined that's not going to happen to me. I am trying to have some control over my life. Black women like me think that way. You might call it a middle class way of thinking. But we live our lives in a way that safeguards us from many of the traps that befall black women.

EF: How does one safeguard oneself against those traps?

FR: Okay, we don't take chances on certain things. We're very conservative about how we live because we can't afford any setbacks. Now of course this is not an unusual way to think today because we're living in a world of AIDS and drugs and people being homeless in the streets who thought they never would be. But that way of thinking is not new to me. I am a black woman, so I was raised to be careful because the possibilities of bad things happening to me has always been there whereas for other people who are not black there are more chances. In that context I could live a nice life and be an artist which is to take a helluva chance.

EF: You didn't have much choice.

FR: Okay. But work hard. Cover yourself. Don't take anything for granted. And when there is an opportunity take it. And those are things that I was brought up on and no one ever said to me what do I want to be when I grow up. What was said was you're going to college. You're going to Elementary, then Junior High, then High School, then you're going to College. And my mother never talked to me about getting married.

EF: Why do you think that was?

FR: She wanted us to have careers.

EF: She was afraid marriage would hold you back?

FR: She was afraid we would opt for marriage instead of a career. . . .

EF: So what do you see as the artist's role in all of this; are you a seer, a prophet, a voyeur; are you a chronicler?

FR: All of that.

EF: Are you a teacher in your art?

FR: Oh yes!

EF: Tell me your attitude towards art today. Do you think in terms of what is mainstream? Are you affected by the tastemakers' superstar system?

FR: As far as the art world is concerned, I have not had to think about that, because I'm not a member of those groups that would profit from being on the cutting edge. I'm not a man and I'm not white. So I can do what I want to do and that has been my greatest gift. It's kind of a backhanded gift but it sets me free. I do what I want to do because I'm not lined up for those things anyway. I may get those things but I'm not in the lineup. I'm over here, you see, and that's fine. I believe that what you do in this world is figure out where you are and go ahead and do what you can do, and that's what I'm doing.

EF: Then you haven't given much thought to what's happening out there?

FR: I like to be aware of it. But I don't see any reason why I should be affected by that. I have a responsibility to myself and to coming generations of artists. I would like to be the one who helps them do what they want to do. That's the point of being an artist. You can communicate things that you feel and see. You are a voice. You have a power to do that. You don't have to ask anybody's permission. You don't need anyone's help. Once art is made, it can be seen. That is a very powerful thing.

Notes

Notes to Introduction

1. Chris Weedon, *Feminist Practice and Post Structuralist Theory* (Oxford, Blackwell, 1987), 167.
2. Nancy Fraser and Linda J. Nicholson, "Social Criticism without Philosophy: An Encounter between Feminism and Postmodernism," in Linda J. Nicholson (ed), *Feminism/Postmodernism* (New York and London, Routledge, 190), 34.
3. Griselda Pollock, *Vision and Difference: Femininity, Feminism and the Histories of Art* (London and New York, Routledge, 1988), 56.
4. Griselda Pollock, review of Mary D. Garrard, *"In Artemisia Gentileschi: The Image of the Female Hero in Italian Baroque Art,"* *Art Bulletin,* LXXII, no 3 (September, 1990), 501.
4. Teresa de Lauretis, *Alice Doesn't: Feminism, Semiotics, and Cinema* (Bloomington, Indiana University Press, 1984), 5-6.
5. Ibid., 186.
6. Nancy K. Miller "Changing the Subject: Authorship, Writing and the Reader" in Teresa de Lauretis (ed), *Feminist Studies/Critical Studies Issues, Terms, Contexts* (Bloomington, Indiana University Press, 1986), 104
7. Katherine R. Goodman, "Elisabeth to Meta: Epistolary Autobiography and the Postulation of the Self," in Bella Brodzki and Celeste Schenck (eds), *Life/Lines: Theorizing Women's Autobiography* (Ithaca, N.Y. Cornell University Press, 1988), 308-09.
8. Linda S. Klinger, "Where's the Artist? Feminist Practice and Poststructural Theories of Authorship," *Art Journal,* 50, no. 2 (Summer, 1991), 44.
9. Ibid. 47.
10. Elaine Showalter, "Feminist Criticism in the Wilderness," in Showalter (ed), *The New Feminist Criticism: Essays on Women Literature and Theory* (New York, Pantheon, 1985), 263-64.
11. Susan Rubin Suleiman, *Subversive Intent: Gender, Politics and the Avant Garde* (Cambridge, MA, Harvard University Press, 1990), xvii.
12. Judith Newton and Deborah Rosenfelt, "Introduction," in Newton and Rosenfelt (eds), *Feminist Criticim and Social Change: Sex, Class and Race in Literature and Culture* (London, Methuen, 1985), xxix–xxx.
13. Ibid., xxiv.
14. Ibid., xxvi.
15. Catharine Belsey, "Constructing the Subject; Deconstructing the Text," in *Feminist Criticim and Social Change,* 57.
16. de Lauretis, *Feminist Studies Critical Studies,* 8-9.
17. Sidonie Smith, *A Poetics of Womens' Autobiography: Marginality and the Fictions of Self-Representation* (Bloomington, Indiana University Press, 1987), 42.
18. Ibid., p. 44.
19. Susan Stanford Friedman, "Women's Autobiographical Selves: Theory and Practice," in *The Private Self,* 40.
20. Ibid.
21. Ibid.
22. Jane Marcus, "Invincible Mediocrity: The Private Selves of Public Women," in Shari Benstock (ed.) *The Private Self.*
23. Ibid., 114.
24. Smith, *Poetics of Women's Autobiography,* 42.

326

25. Mary Jane Moffat and Charlotte Painter (eds), *Revelations: Diaries of Women* (New York, Vintage Books, 1975), 5.
26. Virginia Walcott Beauchamp, "Letters as Literature: The Prestons of Baltimore," in Leonore Hoffman and Margo Culley (eds), *Women's Personal Narratives: Essays in criticism and Pedagogy* (New York, The Modern Languages Association of America, 1985), 40.

I. European Artists, 1600–1800

1. Ann Sutherland Harris and Linda Nochlin, *Women Artists: 1550–1950* (New York, Alfred A. Knopf and Los Angeles County Museum of Art, 1977), 41.
2. Ibid.

Artemisia Gentileschi

1. Mary D. Garrard, *Artemisia Gentileschi: The Image of the Female Hero in Italian Baroque Art* (Princeton, N.J.: Princeton University Press, 1989), 189. For rest of discussion, see 183ff.
2. Ibid., 462.
3. A pun on the verb "partorire," meaning "to give birth" and "to produce."
4. This refers to her second daughter born after 1624.
5. The "Prior" is Don Fabrizio Ruffo, Prior of Bagnara, and nephew of Don Antonio.

Rosalba Carriera

1. The first four letters were written in French and translated by Jane Serumgard Harrison, Associate Dean, College of Arts, California Polytechnic University, Pomona. The remaining Carriera texts, written in Italian, were translated by Nicoletta Tenozzi, Assistant Professor, Middlebury College.
2. Harris and Nochlin, 161.
3. Mlle. Argenon was the niece of the painter de la Fosse. She had lived in Crozat's home when Carriera was there, in 1720.

II. Expanding Opportunities, 1800–1914

1. Estelle C. Jelinek, *The Tradition of Women's Autobiography: From Antiquity to the Present* (Boston, G. K. Hall, 1986), 41.
2. Nancy K. Miller, "Women's Autobiography in France: For a Dialectics of Identification" in Sally McConnell-Ginet, Ruth Borker, and Nelly Furman (eds.), *Women and Language in Literature and Society* (New York: Praeger, 1980), 263.
3. Carolyn Heilbrun, *Writing a Woman's Life* (New York: W. W. Norton, 1988), 24.
4. Carroll Smith-Rosenberg, "The Female World of Love and Ritual," in *Disorderly Conduct: Visions of Gender in Victorian America* (New York: Oxford University Press, 1985), 53ff.

France

1. Harris and Nochlin, 46.
2. Tamar Garb, "Revising the Revisionists: The Formation of the Union des femmes peintres et sculpteurs," in *Art Journal*, 48, no. 1 (Spring, 1989), 63ff.
3. Ibid., 68.

Vigée-Lebrun

1. Joseph Baillio, *Elisabeth Louise Vigée-Lebrun: 1755–1842* (Fort Worth: Kimbell Art Museum, 1982), 6.
2. Ruth Perry, *Women, Letters and the Novel* (New York: AMS Press, Inc., 1980), 68ff.
3. Valerie Sanders, *The Private Lives of Victorian Women: Autobiography in Nineteenth Century England* (New York: St. Martin's Press, 1989), 46.
4. Ibid., 47.
5. Quoted in Baillio, 130.
6. Ibid., 105.
7. Carol Duncan, "Happy Mothers and Other New Ideas in Eighteenth Century French Art" in Norma Broude and Mary D. Garrard (eds.), *Feminism and Art History: Questioning the Litany* (New York: Harper & Row, 1982), 201ff.
8. Griselda Pollock, "Women Art and Ideology: Questions for Feminist Art Historians," in *Vision*

and Difference: Femininity, Feminism and the Histories of Art: (London and New York: Routledge, 1988), 47ff.

9. Elisabeth Louise Vigée married Jean Baptiste Pierre Lebrun on January 11, 1776. He was a painter and son of a painter.
10. Marie Guillemine Leroux de la Ville Benoist (1768–1826), see Harris and Nochlin, 209ff.
11. Jeanne-Julie-Louise Le Brun was born in February, 1780.
12. The daughter from her second pregnancy died in infancy.
13. Rubens's *Chapeau de Paille* is now in the National Gallery, London. Vigée-Lebrun's *Self Portrait* is in a private collection, Switzerland.
14. This is a pun on "pierre," which translates as "stone."
15. Anne Vallayer-Coster (1744–1818) and Marie Suzanne Giroust-Roslin (1734–1772) were elected in 1770. Marie Thérèse Reboul (1729–1805) wife of Joseph-Marie Vien was elected in 1757. Adélaïde Labille-Guiard (1749–1803) not mentioned by Vigée-Lebrun was elected the same year, 1783, bringing the total to four women, the maximum permissible quota.
16. Vigée-Lebrun, no doubt, means *The Last Judgment*.
17. Vivant Denon was Napoleon's chief artistic advisor.
18. Hubert Robert (1733–1808), painter of landscapes and ruins, was appointed curator of the Musée du Louvre in 1784.
19. Baron Antoine-Jean Gros (1771–1835) was famous for his large propaganda paintings of Napoleon.

Rosa Bonheur

1. Pamela Gerrish Nunn, *Victorian Women Artists* (London: The Women's Press, 1987), 12.
2. Albert Boime, "The Case of Rosa Bonheur: Why Should a Woman Want to Be More Like a Man?" in *Art History* 4, no. 4 (December, 1981), 384ff.
3. This portrait in now in the Metropolitan Museum of Art, New York.
4. Translated by Jane Serumgard Harrison, Associate Dean, College of Arts, California Polytechnic University, Pomona.
5. This sentence is particularly troublesome because it can be translated either as **"I really missed my masculine attire" or "I really regretted my masculine attire."** The sketch accompanying the text suggests that the black velvet suit Mlle. Bonheur was wearing resembled a gentleman's great coat of the period, and was not similar to the late afternoon dress typical of feminine fashion which would have probably included a short cape. The ambiguity in the statement serves to underscore the ambiguity of her attitude (J.S.H.).

Berthe Morisot

1. Denis Rouart (ed.), *Berthe Morisot: The Correspondence with Her Family and Her Friends,* translated by Betty Hubbard (Mt. Kisco, N.Y.: Moyer Bell, Ltd., 1987), 19.
2. Quoted in Charles F. Stuckey and William P. Scott, *Berthe Morisot, Impressionist* (New York: Hudson Hills Press, 1987), 26.
3. Ibid., 34ff.
4. Griselda Pollock, "Modernity and the Spaces of Femininity," in *Vision and Difference,* 63ff.
5. Marni Reva Kessler, "Reconstructing Relationships: Berthe Morisot's Edma Series," in *Woman's Art Journal,* 12, no. 1 (Spring/Summer, 1991), 24ff.
6. Quoted in Kathleen Adler and Tamar Garb, *Berthe Morisot* (Ithaca, N.Y.: Cornell University Press, 1987), 56.
7. For a thorough analysis of one facet of this issue, see Linda Nochlin, "Morisot's Wet Nurse: The Construction of Work and Leisure in Impressionist Painting," in *Women, Art, and Power and Other Essays* (New York: Harper & Row, 1988), 37ff.
8. Berthe was one of the sitters in Manet's painting, *The Balcony* (1868–69).
9. Victoria Dubourg (1840–1926), painter of floral still lifes, married Fantin-Latour in 1876.
10. Edma's husband, Adolphe Pontillon.
11. Paul Durand-Ruel took over his father's gallery in 1862.
12. Julie Manet was born on November 14, 1878.
13. Stephane Mallarmé (1844–1898), symbolist poet and art critic.
14. The last sentence is addressed to her niece, Yves' daughter, Jeannie Gobillard.

Marie Bashkirtseff

1. Harris and Nochlin, *Women Artists,* 257.
2. Rozsika Parker and Griselda Pollock, Introduction to *The Journal of Marie Bashkirtseff,* translated by Mathilde Blind (London: Virago Press, 1985), first published in English in 1890.

3. Quoted in ibid., vi.
4. Tony Robert-Fleury (1837–1912), history and genre painter, instructor at the Atelier Julian.
5. Jules Joseph Lefebvre (1836–1912), painter of myth, allegory and history; instructor at the Atelier Julian.

Victorian England

1. Gerrish Nunn, *Victorian Women Artists,* 73.
2. Paula Gillett, *Worlds of Art: Painters in Victorian Society* (New Brunswick, N.J.: Rutgers University Press, 1990), 134.
3. Gerrish Nunn, 36ff.
4. Gillett, 133–34.
5. Ibid., 167–68.
6. Gerrish Nunn, 218.
7. Gillett, 190.
8. Ibid.
9. Ibid., 161.
10. Paul Usherwood, "Elizabeth Thompson Butler: The Consequences of Marriage," in *Woman's Art Journal* (Spring/Summer, 1988), 30ff.
11. Gail Twersky Reimer, "Revisions of Labor in Margaret Oliphant's *Autobiography,*" in Bella Brodzki and Celeste Schenck (eds.), *Life/Lines: Theorizing Women's Autobiography* (Ithaca, N.Y.: Cornell University Press, 1988), 203.
12. Sanders, 11ff.
13. Linda H. Petersen, "Gender and Autobiographical Form: The Case of the Spiritual Autobiography," in James Olney (ed.), *Studies in Autobiography* (New York: Oxford University Press, 1988), 212.
14. Ibid., 215.
15. Sanders, 13.
16. Ibid., 2.
17. Ibid., 164.
18. Ibid.
19. Ibid., 2ff.

Anna Mary Howitt

1. Gerrish Nunn, *Victorian Women Artists,* 94.
2. Gerrish Nunn, *Canvassing* (London: Camden Press, 1986), 23.

Louise Jopling

1. Gerrish Nunn, *Canvassing,* 143.

Elizabeth Thompson Butler

1. Usherwood, "The Consequences of Marriage," 30.
2. Paul Usherwood and Jenny Spencer-Smith, *Lady Butler (1846–1933): Battle Artist* (London: National Army Museum, 1987), 15.
3. For a thorough discussion of *The Roll Call,* see Usherwood and Spencer-Smith, 31ff, catalogue number 18. For the influence of French military painting, see 163ff.
4. Matthew Lalumia, "Lady Elizabeth Thompson Butler in the 1870s," *Woman's Art Journal* 4, no 1 (Spring/Summer, 1983), 9ff.
5. Paul Usherwood, "A Case of Tokenism," *Woman's Art Journal* 11, no. 2 (Fall 1990/Winter 1991), 14ff.
6. Usherwood, "The Consequences of Marriage," 30ff.
7. For a discussion of *Evicted,* see Usherwood and Spencer-Smith catalogue number 46, 94ff.
8. *Missing* was begun in 1872 and exhibited at the Royal Academy in 1873, present whereabouts unknown. See Usherwood and Spencer-Smith, 54.
9. Charles Galloway had commissioned *The Roll Call.* He was a Manchester businessman who had purchased a watercolor from the artist in 1873.
10. Note from Butler's text: "Only a few survivors of the original division . . . were left" (1916).

Anna Lea Merritt

1. Gerrish Nunn, *Canvassing,* 48.

2. Mary G. Mason, "The Other Voice: Autobiographies of Women Writers" in Brodzki and Schenk (eds.) 19ff.
3. Quoted by Galina Gorokhoff in Introduction of *Anna Lea Merritt, Love Locked Out: The Memoirs of Anna Lea Merritt* (Boston: Museum of Fine Arts, 1982), xi.
4. Gillett, 176ff.
5. *Lippincott's Monthly Magazine* LXV, no. 387 (March, 1900), 463ff. The article was developed from a lecture, "Art as a Profession for Women" presented to the Women's Art Congress and the Cambridge Discussion Society. See Gorokhoff, xix.
6. Sir John Everett Millais (1829–1896). Successful English painter; one of the original members of the Pre-Raphaelite Brotherhood.
7. This is inaccurate since the Slade had just opened its doors in 1871 with the specific intent of training young women in the visual arts. See Gerrish Nunn, *Canvassing,* 46.
8. John Ruskin (1819–1900), the most influential art critic of the Victorian Age.

America

1. Gerrish Nunn, *Victorian Women Artists,* 219.
2. Smith-Rosenberg, *Disorderly Conduct,* 13.
3. Wanda M. Corn, "Women Building History," in *American Women Artists: 1830–1930* (Washington, D.C.: The National Museum of Women in the Arts, 1987), 26.
4. Smith-Rosenberg, "The Female World of Love and Ritual" in *Disorderly Conduct,* 53ff.
5. Ann D. Wood, "The 'Scribbling Women' and Fanny Fern: Why Women Wrote," *American Quarterly* 23, no. 1 (Spring, 1971), 5.
6. Mary Kelley, *Private Woman, Public Stage: Literary Domesticity in Nineteenth Century America* (New York and Oxford: Oxford University Press, 1984), 220.
7. Ibid., 308.
8. Estelle C. Jelinek (ed.), "Introduction: Women's Autobiography and the Male Tradition" in *Women's Autobiography: Essays in Criticism* (Bloomington: Indiana University Press, 1980), 5ff.

Harriet Hosmer

1. Susan Waller, "The Artist, the Writer and the Queen: Hosmer Jameson, and *Zenobia,*" in *Woman's Art Journal,* 4, no. 1 (Spring/Summer) 1983, 21ff.

The following two notes are from Cornelia Carr.
2. The Atheneum was, at that time, Boston's only art museum.
3. The Tremont Temple was, at that time, Boston's only concert hall.
4. Bertel Thorwaldsen (c. 1770–1844), Danish neo-classical sculptor living in Rome after 1797.
5. "When the cat's away . . ."
6. *Oenone.*

May Alcott

1. William Morris Hunt (1824–1879), studied in Dusseldorf and Paris and taught art in Boston. William Rimmer (1816–1879) ran the school of Drawing and Modelling in Boston (1864–66), then became director of the Cooper Institute, School of Design for Women (1866–1870), in New York City.
2. Caroline Ticknor, *May Alcott: A Memoir* (Boston: Little, Brown, and Co., 1928), 103.

Mary Cassatt

1. Nancy Mowll Mathews (ed.), *Cassatt and Her Circle: Selected Letters* (New York: Abbeville Press, 1984).
2. Pollock, *Vision and Difference,* 50ff.

The following notes are derived from Mathews.
3. The Spanish called the Prado museum the Real Museo. It was established in 1785 to house the royal collections of paintings.
4. Cassatt had broken her leg in a riding accident in the summer of 1888.
5. Paul Durand-Ruel had opened a New York branch in February, 1881.
6. Monet had organized a successful fund-raising project to purchase Manet's *Olympia* and donate it to the French government. Eugène Manet was Edouard's brother and husband of Berthe Morisot.
7. 725 Ukiyo-è prints were on display at the Ecole des Beaux-Arts on April 15, 1890.
8. Henri Fantin-Latour (1836–1904), painter and friend of the Impressionists.

9. James Joseph Jacques Tissot (1836–1902), painter and etcher; had moved to London in 1871.
10. Charles Frederick Worth (1825–1895) was a prominent dress designer in Paris, a favorite of Empress Eugènie. The Cassatts often ordered clothes from this fashionable couturier.
11. Joseph Durand Ruel (1862–1928) was Paul's son.
12. Mrs. J. Montgomery Sears was introduced to Cassatt by Louisine Havemeyer.

Enid Yandell

1. Charlotte S. Rubenstein, *American Women Sculptors: A History of Women Working in Three Dimensions* (Boston: G. K. Hall, 1990), 117.
2. Julia Dent (1826–1902) married Ulysses S. Grant in 1848 and had four children, one of whom, Fred, married a sister of Bertha Palmer.
3. Vinne Ream (1847–1914) sculptor of portrait busts and statues of many Washington dignitaries. She married Richard Hoxie, and was the first woman to receive a commission for a full-scale statue of Lincoln in 1866.

Janet Scudder

1. Rubenstein, 153.
2. Stanford White (1853–1906), partner of McKim, Mead and White, leading New York architect firm from the 1880s.
3. Bessie Potter Vonnoh (1872–1955), sculptor of small-scaled works in bronze.
4. Caroline Brooks (1840– after 1900)
5. Clio Bracken (1870–1925), sculptor, studied with Macmonnies in Paris and Saint Gaudens in New York.

Germany

1. Jean H. Quataert, *Reluctant Feminists in German Social Democracy: 1885–1917* (Princeton: Princeton University Press, 1979), 22–23.
2. In addition to Quataert, see Richard J. Evans, *The Feminist Movement in Germany: 1894–1933* (London and Beverly Hills, CA: SAGE Publications, SAGE Studies in 20th Century History, vol. 6), 1976.
3. Amy Hackett, "Feminism and Liberalism in Wilhelmine Germany, 1890–1918," in Berenice A. Carroll (ed.), *Liberating Women's History: Theoretical and Critical Essays* (London and Urbana, Chicago, IL: University of Illinois Press, 1976), 127.
4. Juliane Jacobi-Dittrich, "Growing Up Female in the Nineteenth Century," in John C. Fout (ed.), *German Women in the 19th Century: A Social History* (New York and London: Holmes and Meier, 1984), 211.
5. James Albisetti, "Women and the Professions in Imperial Germany," in Ruth-Ellen B. Joeres and Mary Jo Maynes, (eds.), *German Women in the Eighteenth and Nineteenth Centuries: A Social and Literary History* (Bloomington: Indiana University Press, 1986), 94ff.
6. J. Diane Radycki, "The Life of Lady Art Students: Changing Art Education at the Turn of the Century," in *Art Journal* 42n no. 1. (Spring, 1982), 9ff.
7. Patricia Herminghouse, "Women and the Literary Enterprise in Nineteenth-Century Germany" in Joeres and Maynes (eds.), 78ff.
8. Juliane Jacobi-Dittrich, "The Struggle for an Identity: Working Class Autobiographies by Women in Nineteenth Century Germany," in Joeres and Maynes (eds.), 321ff.
9. Sigrid Weigel, "Double Focus: On the History of Women's Writing," in Gisela Ecker (ed.), *Feminist Aesthetics,* translated by Harriet Anderson (Boston: Beacon Press, 1985), 66.
10. Ibid., 67.
11. Gudrun Wedel, ". . . Nothing More Than a Woman: Remarks on the Biographical and Autobiographical Tradition of the Women of One Family," in Joeres and Maynes (eds.), 309.

Paula Modersohn-Becker

1. *Paula Modersohn-Becker: The Letters and Journals,* edited by Gunter Busch and Liselote von Reinken, translated by Arthur S. Wensinger and Carole Clew Hoey (New York: Taplinger Co., 1983).
2. Jeanna Bauck (1840—?), painter of German-Swedish origin, instructor at the Drawing and Painting School of the Verein der Kunstlerinnen.
3. "The wife of a very distinguished painter."
4. "Work, that is my happiness."

5. At the concert Lamoureux, the first three symphonies of Beethoven were performed. Herma was Paula's twin sister (1885–1963).
6. Bernard Hoetger (1876–1949), sculptor and painter.

Käthe Kollwitz

1. Stephanie Barron, *Degenerate Art: The Fate of the Avant-Garde in Nazi Germany,* (Los Angeles: L.A. County Museum of Art, 1991).
2. Beate Bonus-Jeep was a friend whom Kollwitz had met in 1885 at the Berlin school of the Verein der Kunstlerinnen. Jeep wrote a memoir, *Sechzig Jahre Freundschaft mit Käthe Kollwitz* (Berlin: Boppard Karl Rauch Verlag, 1948).
3. Peter Kollwitz (b. 1896) was killed on October 22, 1914.
4. Ernst Barlach (1870–1938), sculptor and printmaker.
5. *The Weavers* was a play by Gerhart Hauptman.

III. World War I to World War II: 1914–1945

1. Marilyn J. Boxer and Jean H. Quataert, *Connecting Spheres: Women in the Western World, 1500 to the Present* (New York and Oxford: Oxford University Press, 1987), 207.
2. Alice Kessler Harris in Carroll (ed.), ''Women, Work and the Social Order,'' 330ff.

Barbara Hepworth

1. Jean Arp (1887–1966), a leading member of the Dada movement, lived in Meudon, a suburb of Paris, from 1925. His wife Sophie Tauber-Arp (1889–1943) was an abstract painter.

Emily Carr

1. Doris Shadbolt, *The Art of Emily Carr* (Seattle: University of Washington Press, 1979), 12.
2. Ibid.
3. Ibid., 195.
4. Ibid., 192ff.
5. Paula Blanchard, *The Life of Emily Carr* (Seattle: University of Washington Press, 1987).

Georgia O'Keeffe

1. Anna C. Chave, ''O'Keeffe and the Masculine Gaze,'' in *Art in America,* 78, no. 1 (January, 1990), 124.
2. Jack Cowart and Juan Hamilton, *Georgia O'Keeffe: Art and Letters,* letters selected and annotated by Sarah Greenough (Washington, D.C.: National Gallery of Art, 1987).
3. Arthur Wesley Dow (1857–1922) was head of the fine arts department at Columbia University's Teachers College. O'Keeffe studied with him from 1914 to 1915. Alon Bement (1876–1954) was a professor at Columbia University and met O'Keeffe at the University of Virginia Summer School in 1912.
4. Chave, 119.
5. Vernon Hunter (1900–1955), a New Mexico artist, was State Director of the WPA Federal Art Project from 1935 to 1942.
6. Willard Huntington Wright, *The Creative Will: Studies in the Philosophy and the Syntax of Aesthetics* (New York, 1916). Clive Bell, *Art* (London, 1914, New York, 1915). Marius De Zayas, *African Negro Art: Its Influences on Modern Art* (New York, 1916). Arthur Jerome Eddy, *Cubism and Post-Impressionism* (Chicago, 1914), Charles H. Caffin, *Art for Life's Sake: An Application of the Principles of Art to the Ideals and Conduct of Individuals and Collective Life* (New York, 1913).
7. *An Organic Architecture* (1939) or *Frank Lloyd Wright on Architecture* (1941).
8. In 1947, after Stieglitz's death, O'Keeffe gave Wright *Pelvis with Shadows and the Moon* (1943).
9. Anita Pollitzer was an active member of the National Women's Party which campaigned for the Equal Rights Amendment. Pollitzer probably encouraged O'Keeffe to write this letter.
10. Sweeney organized a retrospective exhibition of O'Keeffe's works which opened at the Museum of Modern Art in New York on May 14, 1946.
11. *Lake George Window* (1929), Museum of Modern Art, New York. *Red Hills and the Sun, Lake George* (1927), Phillips Collection, Washington, D.C.

Frida Kahlo

1. Hayden Herrera, "Why Frida Kahlo Speaks to the '90s," in *The New York Times,* October 28, 1990, Arts Section, 1 and 41.
2. Peter Schjeldahl, "Frida Kahlo," in *Mirabella* (November, 1990), 64ff.
3. Janice Helland, "Aztec Imagery in Frida Kahlo's Paintings: Indigenity and Political Commitment," in *Woman's Art Journal,* 11, no. 2 (Fall, 1990/Winter, 1991), 8ff.
4. Salomon Grimberg, "Frida Kahlo's Memory: The Piercing of the Heart by the Arrow of Divine Love," in *Woman's Art Journal,* 11, no. 2 (Fall, 1990/Winter, 1991), 3ff.
5. Quoted in Harris and Nochlin, 336.

IV. The United States: 1945–1970

1. Quoted in Harris and Nochlin, 63ff from K.A. Marling and H.A. Harrison, *Seven American Women: The Depression Decade* (Poughkeepsie, N.Y.: Vassar College Art Gallery, 1976).
2. Barbara Rose, *Lee Krasner, A Retrospective* (New York: Museum of Modern Art, 1983), 9ff.

Lee Krasner

1. Michael Cannell, "An Interview with Lee Krasner," in *ARTS Magazine,* 59, no.1 (September, 1984), 87ff.
2. Rose, 139.
3. Ibid., 148.
4. Peggy Guggenheim was an influential patron, art dealer, and gallery owner in the 1940s.
5. Marcia Tucker (b. 1940) was a curator of the Whitney Museum (1969–76). She is currently director of the New Museum of Contemporary Art, New York.
6. Helen Frankenthaler (b. 1928) is an important abstract expressionist painter, inventor of the soak-stain technique.

Louise Nevelson

1. Laurie Wilson, "Bride of the Black Moon: An Iconographic Study of the Work of Louise Nevelson," in *ARTS Magazine,* 54, no. 9 (May, 1980), 140ff.
2. Quoted in Wilson, 144.

Alice Neel

1. Roger Fry (1866–1934), English art critic and theorist, early advocate of Post Impressionist painting. He wrote *Cézanne: A Study of His Development* (1927).
2. Kenneth Doolittle was a seaman and a member of the Industrial Workers of the World, who lived with Neel (1932–34).
3. Nancy is Neel's daughter-in-law, wife of Richard.
4. Hilton Kramer was then critic for the *New York Times.*
5. Neel is referring to Andy Warhol's paintings of *Campbell's Soup Cans,* from the 1960s.

Eva Hesse

1. Lucy Lippard, *Eva Hesse* (New York: New York University Press, 1976), 47.
2. Claes Oldenburg (b. 1929), sculptor associated with Pop Art.

V. Contemporary Trends: 1970–1990

1. Marcia Tucker, "Women Artists Today: Revolution or Regression?" in Randy Rosen and Catherine C. Brawer, *Making Their Mark: Women Artists Move into the Mainstream, 1970–85* (New York: Abbeville Press, 1989), 198.
2. Kay Larson, "For the First Time Women Artists Are Leading Not Following," in *Art News,* 79, no. 8 (October, 1980), 64ff.
3. Quoted in Tucker, 199.
4. Ibid., 201.

Judy Chicago

1. Mara R. Witzling, "*Through the Flower:* Judy Chicago's Conflict Between a Woman-Centered

Vision and the Male Artist Hero," in Suzanne W. Jones (ed.), *Writing the Woman Artist: Essays on Poetics, Politics and Portraiture* (Philadelphia: University of Pennsylvania Press, 1991), 196ff.
2. Quoted in Charlotte S. Rubenstein, *American Women Artists: From Indian Times to the Present* (Boston: G. K. Hall, 1982), 409.
3. Lloyd Hamrol, her husband.
4. "Mimi" is Miriam Schapiro.

Mary Kelly

1. Rubenstein, *American Women Sculptors,* 542.
2. Whitney Chadwick, *Women, Art, and Society* (London and New York: Thames and Hudson, Ltd., 1990), 355.
3. Pollock, *Vision and Difference,* 188ff.

Cindy Sherman

1. Susan Rubin Suleiman, *Subversive Intent, Gender Politics and the Avant Garde* (Cambridge: Harvard University Press, 1990), 193ff.
2. Ken Johnson, "Cindy Sherman and the Anti-Self: An Interpretation of her Imagery," in *ARTS Magazine,* vol. 62, no. 3 (November, 1987), 47ff.
3. Ibid., 53.

Faith Ringgold

1. Thalia Gouma-Peterson, "Modern Dilemma Tales: Faith Ringgold's Story Quilts," in Eleanor Flomenhaft, *Faith Ringgold: A 25 Year Survey* (Hempstead, N.Y.: The Fine Arts Museum of Long Island, 1990), 23.

Index